'Gavin's book is extraordinary: his easy prose and gasp-making encounters make for a gripping and very funny read. It's a roller-coaster ride with a complete professional. I loved it'

Joanna Lumley

'Gavin Thurston's book has all sorts of strengths. His camera has captured some of the most eye-catching images of the natural world ever seen on television. And he can write. He brings the process home to us in a style that is modest, down to earth and full of humour. This is one of the best books about filming I've ever read'

Michael Palin

'[Gavin is] a great cameraman with infinite patience, but also a writer with great powers of observation and expression. Brilliant!'

Alan Titchmarsh

'This is an absorbing account of a fascinating career'

BBC Wildlife Magazine

'His no-holds-barred memoir plunges you into the serendipities and perils of working in the remote wilderness, as he stands stock-still to 'hide' from short-sighted African elephants in Kenya, films demoiselle cranes flying 6 kilometres up above Nepal, or marvels at the hiss of Mauritania's dryland crocodiles' Barbara Kiser, *Nature*

Journeys
in the
Wild

The Secret Life
of a Cameraman

GAVIN THURSTON

SEVEN DIALS

First published in Great Britain in 2019 by Seven Dials
This paperback edition first published in 2020 by Seven Dials
an imprint of The Orion Publishing Group Ltd
Carmelite House, 50 Victoria Embankment
London EC4Y 0DZ

An Hachette UK Company

1 3 5 7 9 10 8 6 4 2

Text copyright © Gavin Thurston 2019
Illustrations copyright © Erin Hickey 2019

The moral right of Gavin Thurston to be identified as
the author of this work has been asserted in accordance
with the Copyright, Designs and Patents Act of 1988.

A CIP catalogue record for this book is
available from the British Library.

ISBN (paperback) 9781841883113
ISBN (ebook) 9781841883120

Typeset by Born Group
Printed and bound in Great Britain by Clays Ltd, Elcograf S.p.A.

MIX
Paper from
responsible sources
FSC® C104740
FSC
www.fsc.org

www.orionbooks.co.uk

For Maggie, Thomas and Harry.

Sorry for spending much of the last thirty years away.

FOREWORD

Catching sight on television of a wildlife cameraman in the wilderness was once not an easy thing to do. Natural history films usually presented a picture of a world in which human beings did not exist. They showed the Garden of Eden as it was before Adam and Eve appeared. And that was not such a bad thing to do. It was what lots of us wanted to see – how the world worked when allowed to operate by its own rules.

But then, quite suddenly, that changed. Major natural history programmes were followed by short mini-films showing the production team at work. Directors turned to the camera to explain the huge problems they were facing; blizzards arrived and confined the team to their tents for days on end; cameramen in jungles, dripping sweat, sat dejectedly having failed once again to catch even a glimpse of their quarry. And then in the last minute or so, just as the team – having failed to achieve their task – are starting to pack up their gear and return home, the difficulties vanish, the long sought-after animal appears and all is well – as indeed viewers knew it would be, having already seen the successful sequence in question.

These entertaining glimpses behind the scenes were not made because the producers felt a sudden need to meet the demands of a few television critics for 'transparency' about the way such programmes were made. Nor did they stem from a desire by cameramen to share the limelight with their animal stars. The instruction came from a much more mundane source: television schedulers.

Natural history programmes, then as now, were usually made as co-productions with networks in the United States. There, every hour of television had to contain ten minutes of commercial advertising. So natural history only lasted for fifty minutes. BBC networks, of course, do not show commercials and as a consequence such a length produced a certain untidiness in an evening's schedules: programmes began or ended ten minutes before or after the hour. Eventually, the moment arrived when British schedulers, in an effort to tidy things up, suddenly ruled that wildlife programmes themselves should occupy the full hour.

That was something of a shock to those of us who were making them. I was in the middle of filming a twelve-part series. Several of our programmes had already been finished and they only lasted – as instructed – for fifty minutes. They had been carefully scripted and filmed to suit that length and it would, we claimed, be very difficult to extend the existing sequences without making them seem tiresomely inflated. Eventually we solved the problem by adding something new, something we began to call, among ourselves – clumsily but nonetheless accurately – the 'Making-of'. So directors, sound-recordists, researchers and cameramen, suddenly stepped into the limelight.

From such films, viewers were able to see proof of what I have known for many years – that if you are going to get into difficulties when travelling in some remote and hazardous part of the world, your ideal companion would be a natural history cameraman. (I should perhaps add that during most of my time there were not many camerawomen.) They have powers of persuasion that soften the hearts of customs officials and even armed military border guards. They can produce edible meals from the most unpromising ingredients. They can, of course, diagnose and usually

cure almost any problem involving a vehicle of any kind and drive it with imperturbable aplomb through the densest and most aggressive traffic. They can even improvise solutions to problems with new-fangled, high-tech devices that they have never seen before. I recall one occasion in the Galapagos when a cameraman fixed a sudden fault that developed in his electronic camera by using a hypodermic needle taken from the medical kit and held in position, deep in the camera's entrails, with a blob of chewing gum.

Gavin Thurston, the author of this book, is one such cameraman. I have worked with him, on and off, for over thirty years and I can vouch for the fact that he has all these talents and more. He is, as his diary entries reveal, a most knowledgeable and perceptive naturalist. He has endless patience and that invaluable and extraordinary ability to anticipate what an animal is about to do before it does it, so that the camera is immediately ready and able to follow it. But now I realise that he has one talent I had not previously suspected. He is a vivid writer with an ability to describe scenes with great economy and unflinching accuracy.

So here is the written version of the visual Making-of. I sometimes meet people who tell me – with the intention of being entirely complimentary – that they enjoy Making-ofs even more than the programmes to which they are attached. I would not be entirely surprised if some might feel the same about the following pages.

David Attenborough

PROLOGUE

Outside Boots the Chemist,
Cheltenham, UK

It's summer, and two weeks ago I was on our annual *Discovering*
school choir outing to Dudley Zoo. My kind Auntie *magic*
Mary lent me her camera to take some photos as a
record of the day. A small, squarish black box covered
in black fake leather, it fit comfortably in my two
hands. At the front it has a two-pence-sized recessed
lens and two smaller viewfinder objectives, making it
look like a gawping, wide-eyed robot. Made by Kodak,
it's affectionately called a Box Brownie, probably the
most common camera available. With only 12 photos
to a roll and a waist-level viewfinder, who knew what a
nine-year-old boy might capture on film – if anything.

Having popped into Boots the chemist to collect
the developed photographs with my mother, we stand
outside on the pavement. Now with no pocket money
left for sweets, I fumble open the envelope. Some nega-
tives half-fall out and I clumsily put my fingers on them
as I shove them back. In the front sleeve, though, is
what I've eagerly waited 14 days to see. I start to slide
the 12 photos out.

An overexposed shot of our front door.

A rather silhouetted camel.

Three elephants by a fallen tree.

And then – the photo that is perhaps to change my
life. Cuddles, a male orca, is almost fully out of the

3

water and his glossy black nose is touching a plastic ball hanging on a rope above the small pool. That split-second moment in time, captured forever when I pushed the button.

I will later learn that orca – incredible, intelligent animals – should never be kept in captivity. But seeing one so close with my own eyes has without doubt instilled in me the beginnings of a passion for wildlife in general. I don't know it yet, but this spark of passion will one day lead to me going on journeys around the world to see animals in their natural habitat.

I show the photo to my mother; I am so excited to be able to share that extraordinary moment I had witnessed.

INTRODUCTION

Hindsight is a funny thing. You can piece together a series of moments from your past and realise how you came to be in a certain place, doing a certain job – but whilst on the journey, you have no clue how it will all end up. I look back now at my memory of me as a little boy standing outside Boots and wonder if it was all meant to be, but I can't believe that – partly because I'm still on the journey. I'm still waiting to find out what happens next.

What I know for sure is that there was a great deal of chance involved to get me to this point, or in my case a series of very fortunate events. I never started out thinking I would make a career in wildlife film-making, but I did like cameras and my first stroke of luck was that I had a loving and helpful family. Not just my Auntie Mary lending me the Box Brownie, but my grandfather leaving me money in his will with which I bought my own camera, and my step-father, as soon as I'd set it up, encouraging me to use it by taking me to the airport. (He was in the RAF; it was already dark and I'll never forget him calling the control tower at Brize Norton to see if the runway lights were on. They weren't, but the guys in the control room switched them on – an extraordinary and memorable gesture for me, aged 13.)

Then at school, eager for extra cash, I earned pocket money by photographing my mates showing off their sporting prowess, spending my evenings processing and printing in a makeshift dark room. This also led to me starting up the school photography club. It was also

at school that I watched the natural history television series called *Life on Earth* – I remember so clearly the presenter, a certain David Attenborough, leading us through the story. An amazing evolutionary journey from primitive cells to plants to animals. He opened my eyes and mind to a magical world. He brought the natural world into our sitting rooms.

But my greatest fortunate event was the night before I left school forever. I had enough money to get me and my belongings home to my parents in Carterton, Oxfordshire, but I made the epic decision to spend it all on beer. This meant that to get home, I had to hitchhike. The man who kindly stopped and gave me a lift was driving a 1962 Bentley. When I told him that I hoped to get a holiday job at Oxford Scientific Films, he said it wasn't far off route. He drove me there and waited whilst I went in. I got an interview there and then. If proof was ever needed that good things come from drinking beer, or that strangers can be inordinately kind – the first, but not my last, experience of both these things. Also that you can help make your own luck; I could have gone straight home to nurse my hangover.

I have now been a cameraman for over 30 years. I have worked on some of the most prestigious natural history documentaries of the day and have co-won BAFTAS and EMMYs. I have worked on every continent, scaled mountain peaks and journeyed to the depths of the oceans. I have filmed both the rarest of creatures and some of humans' greatest achievements. All in all I have witnessed more of nature's wonders than anyone has the right to do. It is the wild places that grab me; I have more connection there than in our towns and cities. Away from the man-made I feel most at peace. It's where, when I stop and reflect, I can't quite believe my luck.

With the highs, though, come the lows. I have an ever-forgiving wife who raised our two sons single-handedly for much of the time, and who has understood when I've missed birthdays and family events because I'm on the other side of the world. My boys suffered me missing school plays, awards days and just generally not being around when I should have been. Spending an average of over 220 days per year away from home, in wildernesses around the world, has given me more than enough memories to fill a lifetime, but it has starved me of others. It also hasn't all been plain sailing. There is a less glamorous side to making TV shows (you don't want to know how many dodgy places I've stayed in or how many upset stomachs come with shooting in the wild, but I'll tell you anyway). When I went freelance back in 1989 it was the biggest and scariest risk I've ever taken – threats from the bailiffs are far more frightening than a pride of lions hunting you, and I know which one made my hair fall out. But you take the rough with the smooth and I've never once regretted doing what I do. (Well, maybe once: when I was arrested by two military guards in Iran for photographing a 'do not photograph' sign – what an idiot!)

This book is a meander through those highs and lows, with some plane crashes, wars, coups, near-death experiences and a kidnap attempt thrown in to boot. It's also a letter of two halves. In writing this book I've remembered how many talented people I've met and friends I've made over the past few decades. Also people who – in so many countries, whether I could speak their language or not (I can only really claim to speak English and schoolboy French) – have gone out of their way to help me. Penniless in Tanzania, an American pilot called Mike bailed me out paying for my food and hotel. Out with

the Dinka in Sudan, a child saved my life when a venomous snake was about to bite me. When filming treehouses in West Papua, there were always hands from the Korowai tribe ready to catch me if I lost my grip. This book is a thank you letter to people the world over; my job has taught me that humans – individually – are mostly kind.

And then, of course, it is also a love letter. An ode to the natural world, the wild places, to nature's ingenious and intricate designs. To the beauty and colour, to the mighty and the small, to every facet of mother nature. This feels important to stress because as a world we are at a crossroads – if anything we've actually gone too far heading down a dead end, and need to back up and take a left. How we act in the next few years will determine the fate of life as we know it. I know that's deep and dark and depressing, but it's also a fact.

One thing I have learned over the years from my colleague and friend Sir David Attenborough is that people who want to save something only do so because they have come to know, appreciate and respect what needs saving. I have always been interested in nature and the animal kingdom, but I never aimed to be a naturalist or work with animals. It is only by observing things first hand that I have come to love and recognise the beauty of nature. A spider spinning its web, a robin feeding its chicks, an Arabian oryx roaming the desert dunes, the spectacle of half a million sea birds heading out to sea. As a result of being a privileged witness to these and so many more wonders, I now fully appreciate the balance of all life on earth.

Not everyone will have the opportunity to wander into those situations and experience what I have seen – I get that. So, whilst I hope my stories will entertain

and give you an insight into my journey, I also hope they nurture whatever fervour you already have for the animal kingdom, and for our planet.

Bristol, February 2019

The Glamour of TV

JUNE 1981

Oxford Scientific Films,
Oxfordshire, UK

I'm learning the ropes at my first proper job at OSF. It's kind of an apprenticeship and initially I am just making teas, coffees and sweeping floors, but I am also being roped in to help out with various tasks in the studios. Each day I come to work wide-eyed and keen, intent on hoovering up as much knowledge as I can. As film companies go, OSF is a large one and growing – 17 plus me – and each person working here is extraordinarily talented. When I look back in years to come, I'm sure being so good at recruiting that talent is why OSF will become so successful. Who knows why they let me in through the doors!

It seems quite a young bunch working here, even the older directors are at least young at heart. OSF has a good sense of team spirit, a welcoming family feel about it. We all eat lunch together, a picnic affair, and in the summer this spreads out into the car park in the sun. Commonly, these outdoor lunches end with a water fight, the scale and ingenuity of which even saw some individuals pre-loading buckets of water up on the flat roof for a revenge drenching. This was before the killjoy of full-on health and safety damp-ened the fun.

For some reason there is real machismo among all the men here, and everyone wears shorts regardless

of the weather or the time of year; a little bit like a holiday camp. It makes sense when you're inside and filming under hot lights, and the studios are quite warm – but not so much when you're outside scraping ice off your car window in the middle of winter. But I like the quirkiness of it.

There is one eccentric and very talented photographer called George, who specialises in wildlife stills for the company. He makes me realise that work isn't just 'work', you can enjoy it – this makes sense because to have a creative atmosphere I think things need to be fairly relaxed; it can't be too regimental. It's also the early eighties: things seem a lot less serious.

George is always doing ridiculous things, which will go on to influence the way I work forever. One of these involves a rabbit named Piss Dick ...

There is a small courtyard in the middle of OSF, about 30 feet by 30 feet, which is open to the elements and houses a rabbit warren. George is doing a photographic book on rabbits and most of it will be shot in this tiny set within the confines of the building. This involves lots of hours of George lying on his belly with a long lens, photographing details of rabbits eating grass and generally doing what rabbits do.

Piss Dick is the dominant male rabbit that lives in this warren, imaginatively nicknamed because he basically pisses on everything. On the tripod, on your shoes, on the other rabbits: everything.* 'He's just marking his territory.'

One day George is lying face down, perfectly still, photographing some lovely little baby rabbits. Piss Dick sees a territory-marking opportunity: George's ear. Understandably, George is very annoyed. I don't know what a normal person would do in that situation,

* A behavioural trait of dominance known as eurination.

but George, being an eccentric, jumps up, unzips his trousers and starts running round the courtyard trying to piss on the rabbit to teach it a lesson, show him who is boss.

Unfortunately for George, there are some guests in the building down from the London-based company Anglia Television. They've come to talk about funding future wildlife programmes and are being shown around by one of the directors of OSF. As they come into view of the courtyard, the director saying, 'And this is our pièce de résistance: our rabbit set where we're doing a photographic book', they are met by a half-naked George charging around with his penis in his hand. George is heavily reprimanded – not least because it almost costs OSF the series commission – but, looking back at it, maybe that is how you stop a rabbit pissing on you? Ethically, I don't know how this will go down in the future, although I should add no animals were harmed during the making of that book – only George's pride.

15 SEPTEMBER 1982
Studio 77, Dean Street, London, UK

51° 30' 50" N
0° 7' 58" W

Slow-motion cameras can capture images of events that you can barely register with your own eyes. For instance, a butterfly taking off from a flower, which in real time happens in a split second. But if you slow that down 40 or 50 times, you can see how the butterfly folds up its proboscis, each individual wing beating, and how the flower bends and springs back as the butterfly takes off. Slow down the camera speeds even more and

Up the smoke

you can see the wings of the butterfly bend as it does so. These specialist slow-motion cameras, designed initially for military ballistics research, can reveal magical worlds beyond what our eyes can perceive.

OSF takes these tools and skills and employs them in other genres, such as special effects for feature films and commercials. I've learned how to load and use one particular slow-motion camera – a 'Hadland high-speed' camera that chews through film like nobody's business – filming splashing water droplets, pigeons taking off, water-filled balloons bursting, shattering glass and so on. Because of this I'm now often sent out as a technician with the camera. One such shoot is in London, to film some of the opening title sequence for a new TV music show called *The Tube*.* I turn up on location at Studio 77, Dean Street, in London's Soho, and am met by the crew, including two special effects guys, who look out of place in their very smart suits.

The concept for the title sequence is a family watching their television in their sitting room, with a montage of images of the *Tube* logo in a variety of historical events showing on screen. The director explains the ending: 'I want to see the *Tube* logo burst through the top of the television and loads of sparks fly out. The shocked family watching then sit up from their slouched position on the sofa.'

Under his guidance I set up the camera looking over the back of the sofa towards the bulky television† in its wooden cabinet frame.

* *The Tube* TV music series, presented live by Jools Holland and Paula Yates, ran successfully for five years. It became a launchpad for many 1980s bands.

† TVs used to have a large thick glass cathode-ray tube as the screen, housed in a sturdy wooden frame. They were a piece of furniture unlike today's flat screens.

The well-dressed special effects guys step forward to demonstrate what they can do to make the director's vision a reality. One takes the *Tube* logo mounted on a short pole and lays it down by the television. The other has an angle grinder used for cutting and grinding metal. They turn to the director and say, 'Okay, are you ready? Three, two, one – go.'

At that, one pushes the *Tube* logo up through the top of the (fake) television cabinet, while the other one touches the angle grinder on a bit of metal and some sparks fly up. It doesn't quite work because the whole top of the television flies off and there's one thin stream of sparks.

The director says, 'No, no, no. The top of the TV's got to splinter and I need more sparks.'

The two special effects guys take their jackets off and get down to business. One gets a Stanley knife and starts scoring a replacement fake wooden top for the TV cabinet, so that when the *Tube* logo pushes up through it, it will splinter rather than just come off as one plank of wood. The other guy gets a second angle grinder and scrap of steel for more sparks.

'Okay, are you ready?' and they demo the effects. The first guy has by this point cut his finger while scoring the top of the TV, so now there is blood all over his white shirt and on the studio floor. But this is TV land, so he carries on.

They push the logo up through the top of the TV, which does sort of splinter, and now there are two streams of sparks from the angle grinder. The director says, 'Yeah, the TV's good, just need to score the lid so it will splinter even more. But we definitely need more sparks.'

One of the special effects guys says, 'We can give you more sparks.' He reaches into their box of tricks and pulls out a firework, a Roman candle. Then he places

it upright in the middle of this small studio and says calmly to the director, 'See what you think of this.'

I make a mental note of the studio exits.

He lights it and sparks shoot about six feet up in the air. The director approves and says, 'Perfect, perfect. I love it.'

At that, the firework falls over and shoots across the floor to the side of the studio, into a whole load of stage flats stacked against the wall. The two special effects guys chase after it trying to stamp out the flames, ripping scenery out from the side of the studio and causing absolute mayhem. Luckily nothing catches fire, but it is quite close to being a disaster – imagine if the modern-day version of 1666 had been started by something this ridiculous.

The two special effects guys are no longer looking quite as sharp. Their jackets off. Dusty knees and clothes from grubbing around on the studio floor. One has bandaged fingers. Their trousers and nylon shirts dotted with burns from the sparks.

The day continues. I obediently keep reloading the camera and we do take after take with the fireworks and bursting logo. As a fresh-faced boy up from the country-side, this is a real eye-opener as to how the mainstream TV industry apparently works.

Despite the day appearing to be a complete shambles, ultimately the director is very pleased with the shot.*

* Deep down, though, I was nervous – as after all that effort and chaos he wouldn't actually see the shot until the next day when the rushes came back from the lab. Very different to today with instant video replay.

1 APRIL 1987

Poole, Dorset, UK

50° 42' N
1° 56' W

April fools

This has been an exciting few days working with model-aeroplane pilot, Clive. Conventionally, aerial shots are filmed from a helicopter or light aircraft,* but the producer, John, asked if it was possible to put a miniature film camera inside a model glider to be able to film more dramatic, low-level aerial shots for the series *Lifesense*, currently in production for the BBC. The shots would also be much cheaper to shoot. (In theory.) This is a real 'boys' toys' idea and well before the age of sophisticated camera-carrying drones.

After a bit of research, we found Clive, a model-plane enthusiast who designs and builds his own aircraft. Over the past few months he has built a powered glider with a seven-foot wingspan. He designed the nose of the aircraft to carry a lightweight fibreglass ball, just a bit smaller than a football. The ball is lined with a foam cutout, within which we can place a small 'gunsight' (GSAP)† camera with battery and lens. The idea is that the ball can be rotated, like an eye in a socket, to shoot different angles from the model aircraft.

* This is decades before drones became the norm for aerial photography.

† Gun Sight Aiming Point cameras were designed to record footage of aerial combat and bombing runs during the Second World War. They faced backwards from the aircraft to film whether the bombs hit their targets. They only had a 50-foot cartridge of film and could only record for a maximum of one minute 20 seconds. They are very basic, rugged cameras but don't have a viewfinder.

The story we want to get shots for is how seagulls feed on untreated sewage being dispersed into the sea. In doing so, the gulls ingest parasites such as tapeworms. When the gulls then head up to rest in the fields, they inevitably defecate tapeworm segments and eggs onto the grass. This grass is pasture for cattle, so when the cows eat the grass they can also get tapeworms. So the first shot is to get seagulls at a sewage outlet and the location we have chosen is Poole on the Dorset coast.

It is early morning on a Wednesday and the car park nearest the sewage outlet is empty. Clive has devised a genius way of getting his large model airborne and proceeds to lay out a huge length of bungee elastic, attaching each end to two concrete parking bollards along one side of the car park. This is then tensioned back to a hook held by the tow hitch of his car. He assembles the long wing onto the fuselage as I ready the camera. Having taped the focus and iris off on the lens to prevent them from being jogged, we load the camera ball into the nose of the aircraft, judging the angle by eye. Clive connects up the remote record switch and we are ready to go.

I can't help noticing that the catapult seems to be lined up perfectly with the corresponding bollards on the other side of the car park and, not wanting to overstep my station, subtly mention this to Clive. He dismisses my observation, saying that the glider will be well airborne by the time it gets that far.

Clive fuels up then starts the engine on the little plane and the propeller begins to cut the air. We check that no one is coming and Clive ups the revs. Once the plane is at full tilt, Clive releases the catch holding the tensioned elastic and the aircraft shoots off along its car park runway. It is building speed nicely. However, at this point of no return, a van comes round the corner on the road beyond the bollards.

I see the future.

The plane's engine is screaming, the aircraft now travelling fast and heading straight towards the bollards and the rear of the van that has turned into its path.* It's too late to abort the launch procedure and I'm not Superman so I'm hardly going to overtake the speeding plane to lift the van clear of danger.

Clive's hands wrestle the sticks on the remote control – in vain. The aircraft is still on the tarmac and accelerating and, as I predicted, the wingspan is just too wide to fit through the bollards. The wings snap clean off, the fuselage veers left and the resulting jolt wrenches the camera ball from its socket and it rolls off down the road, miraculously missing the rear of the van, overtaking it on the nearside. Thankfully, it is saved by hitting a pile of cardboard boxes stacked beside the council bins.

While Clive stands white-faced in shock, I leg it down the road and retrieve the camera in its ball. The van driver doesn't look shocked; I think he thinks I'm picking up a football. He clearly hadn't seen Clive's catapulting aircraft and little does he know what nearly hit his van.

Apart from a few cosmetic scuffs on the ball, the camera and lens are absolutely fine. I'm just relieved no one was hurt – but disappointed the camera wasn't rolling (excuse the pun).

17 APRIL 1987 50° 39' 58" N
Studland Bay, Dorset, UK 1° 56' 59" W

The weather forecast is amazing, it's going to be unseasonably warm and sunny. Despite it being a bank holiday weekend we want to take advantage of the

* If only YouTube were invented, this scenario would go viral.

conditions for filming. We searched for somewhere we could fly the glider and camera low over calm sea. This search took us to Studland Bay. In theory, the long sandy beach will allow us to use the tried and tested bungee launch technique.

We trudge down with all the kit to find the beach quite crowded. But further along there don't seem to be so many people so we head in that direction. After a few hundred metres or so I can't help noticing that some of the women are topless – although we are filming for a wildlife documentary this is not the BBC's thing. We carry on to a clearer stretch.

As Clive builds the glider I load the camera with a fresh film cassette. I clean the lens, set the focus and exposure and fix them again with tape to avoid them being jogged accidentally. Clive lays out the elaborate bungee, not a concrete bollard in sight. A crowd is gathering so I decide I ought to explain what we are attempting to do and so gain their cooperation in keeping out of the way when asked. But as I approach the crowd I feel a slight unease. I'm not a prude, but apart from the odd beach ball for modesty, I can't help realising almost everyone is stark naked. Not just a few topless women: we're actually at a full-on naturist beach. Nevertheless, I am on official BBC business and must give my spiel to the gathering throng. Too embarrassed to look at any of them, I direct most of my chat over my shoulder, gesturing towards the glider and open sea. Chancing a quick glance (at their faces), everyone seems quite excited by what we are trying to achieve and they agree to keep out of the way for their own safety.

Clive starts the engine, ups the revs and releases the bungee catch. The glider hurtles off down the beach and is airborne. Hooray! Thirty seconds later it belly-flops into the sea about 200 metres out. Fortuitously, a small

dive boat is returning to shore and they kindly pick the glider out of the water for us. I can see my evening is going to be spent trying to salvage the camera and lens. Clive has a bigger task.

18 APRIL 1987
Durdle Door, Dorset, UK

50° 37' 20" N
2° 16' 37" W

Flight of the phoenix

Clive was up most of the night again but he managed to fix the glider. It is now late afternoon and the light is perfect. We are standing on the cliffs on a beautiful stretch of the Jurassic Coast. I vaguely remember visiting here as a child in the summer holidays, staying with my mum and sister at the campsite above the cliffs and beach.

Our challenge today is to film a shot flying through the 200-foot-high natural limestone arch that juts out from the cliff known as Durdle Door. It's supposed to represent a dramatic point of view of a seagull flying out to sea.

Today is sunny and, as expected, there are quite a few people down on the beach. While Clive and I prep the camera and glider up on the cliff, we send Graham, the researcher, down to explain to each family group what we're aiming to do. We hope he can persuade them to cooperate and move further along the beach away from where we are flying in the very unlikely case that the glider crashes. Also as a precaution, Graham befriends a couple of kayakers so that should, God forbid, the glider land in the sea again, they can paddle out and retrieve it for us.

This is a complicated shot to pull off. Clive explains that I need to hand-launch the glider by throwing it downwards off the cliff. Clive will then fly the glider directly towards the centre of the archway. Graham will be against the left-hand rock face of the arch and, as

soon as the glider is going through it, he will signal by dropping his arm. At that precise moment I will tap Clive on the shoulder, and he will pull back on the stick. After a moment of the glider being out of vision behind the arch, Clive will be able to regain control and fly the glider back up to us and land it on the grass above the cliff.

I shout down to Graham and the crowd that we are ready to go. There is a hush broken only by the starting of the engine. Clive carefully hands me the glider with the propeller spinning. I hold it aloft like a giant paper plane and await his command to launch. Clive ups the revs and I feel the power in my hands. He nods and I launch the glider over the edge of the cliff. The wings wobble slightly but Clive has control and the craft is dead on target. Seconds later Graham drops his arm, I tap Clive on the shoulder and he pulls back on the stick.

There is a moment's silence as the arch shields us from the screaming motor. That moment's silence seems to last a crazy long time, but, like a phoenix, the glider appears again. It's almost upside-down and Clive wrestles the sticks on his remote to regain control. I can sense another impending disaster. But Clive heroically brings the glider back to level flight and sets it for home. The crowd on the beach goes wild with cheering and clapping. They too must have thought it was a goner.

It is a perfect landing with the belly of the glider sliding up the grassy slope to a halt. I rush forward to check the camera. It is still running. I take it out from its protective ball and look closer: the footage counter is still on 50. Bollocks! The cassette jammed and no film's run through!

'Erm, Clive,' I say tentatively.

Clive is understandably disappointed after such an epic flight. We know we have to have another try. I shout down to Graham and the crowd that we are going to go again.

Clive refuels the small tank and we repeat the same routine. Engine started and I'm ready to launch. Clive nods and I throw the glider forwards and down. Once again it flies steady and fast towards its target, the centre of the arch. Graham drops his hand and again I tap Clive on the shoulder and he pulls back on the stick. Silence follows as it goes out of sight behind the rock. This time when it reappears the glider is facing straight up. Clive pushes the stick forwards to lower the nose. The glider responds but there is no sound. The engine has stalled! It doesn't have much height and a water landing is imminent. The glider swoops then climbs a little. Swoops again then climbs. The crowd on the beach are on their feet. They too know what is coming. The kayakers are paddling like billy-o as the glider heads for the sea's surface. Looking down I see the gentle splash and hear a disappointed hush fill the cove.

It takes a while to get the glider back up to us on the clifftop. Meanwhile, there has been a slow procession of people heading back from the beach to the campsite. All of them have a sympathetic manner like well-wishers at a wake.

30 APRIL 1987
39° 40' N
19° 50' W

Corfu, Greece

I am part of a huge crew out in Corfu for three months and am enjoying the perfect warm sunny weather. Instead of staying in a hotel, six of us are sharing adjoining villas with a pool. We are here to film a BBC One mini-series dramatising Gerald Durrell's book *My Family and Other Animals*. The lead characters are

Houdini

being played by Brian Blessed and Hannah Gordon. I'm on the wildlife team, the second camera unit,[*] and assisting cameraman and mentor Alan Hayward. We are mostly operating independently from the main drama crew, but overlap on shooting some scenes. I am quite glad to be away from the mayhem of the first unit but it's nice to see the workings of a large drama in production, a behind-the-scenes peek and a first for me.

There's a scene in Gerald's bedroom and Peter, the director, wants the room dressed with tanks and cages containing interesting creatures, just as Gerald's room would have been when he was a boy. So there's going to be a toad, fish in a tank, some butterfly pupae in a netting cage, some praying mantids and so on. Peter thinks that it would also look good to have an octopus in a tank and so asks Nigel, who's coordinating the wildlife filming, to arrange it. Nigel passes responsibility for getting the octopus on to Andrew, the production manager.

The problem in Corfu and probably the Mediterranean in general is that if someone catches an octopus it is usually pounded against the rocks there and then to kill it and tenderise the meat. So trying to convince a fisherman to catch an octopus and keep it alive proves difficult. A few days before we are due to shoot that scene, Peter reiterates to Nigel and Andrew, 'Don't let me down on the octopus – it's going to be the main feature in Gerald's room for that scene.'

No pressure then.

[*] The main unit films all the scenes with the actors. The second unit films most of the scenes that don't include the main actors, such as scenics and wildlife sequences.

It's mid-morning on the day of the bedroom scene and finally there's a fisherman who says he has a live octopus. Andrew drives two hours to the north of the island to collect it. He takes with him a cool box with a firm lid to transport it back.

Andrew arrives back as all the crew are having lunch and rushes over to show us the prize. We gather round with interest and Andrew opens the cool box. The box is empty bar some seawater. Andrew's jaw drops.

'The octopus was in there! It was definitely in the box and the lid sealed down!'

The rest of us are laughing because clearly he has made a mistake. 'How much did you pay for the invisible octopus?'

Andrew is genuinely shocked and puzzled and goes back to his hire car. The cool box had been behind the driver's seat for the journey. He looks in the back, in the boot, in the front, under the seats. Nothing. He's just about to close the back passenger door and there, holding on with all its legs spread, is the octopus.

Somehow, on the two-hour journey this clever sentient animal had done a Houdini. It managed to squeeze its whole body out through the tiniest of gaps between the cool box and lid! I'm sure after another half an hour it would probably have worked out how to open the car window too.

Andrew tries to imagine what might have happened had the octopus climbed up and tapped him on the shoulder on one of Corfu's treacherous hairpin bends. They might both have ended up back in the sea.

Out of respect, Houdini is returned to the sea that evening and hopefully won't end up fried in batter on a tourist's plate.

51° 27' 38'' N
2° 36' 26''W

FEBRUARY 1990

Bristol, UK

Lost in
translation

Readying for the upcoming trip to the Soviet Union for an ambitious wildlife series, *Realms of the Russian Bear*, I get a phone call from the production coordinator at the BBC asking if I have any requests. I have designed my own simple ladder dolly, a camera tracking device that can run on pretty much any parallel-sided ladder, but obviously we can't fly a 12-foot ladder over there. Can the Soviet British Association, the organisation sorting all logistics in Russia for the BBC, source an aluminium ladder for me? It would make sense as we could leave it out there for other shoots to use over the next two years.

A week later the PC comes back to me saying they can source an aluminium ladder in Moscow but it would be very expensive. When I ask how much, she says thousands of dollars, which I think is ridiculous. I ask her to please double check as that can't be right.

Eventually, after messages and phone calls back and forth, the problem is solved. It was a pronunciation misunderstanding. The fixer* in Moscow had been trying to source an aluminium Lada, a common brand of Russian car but manufactured from steel. They were indeed able to buy an aluminium *ladder* and it was about the same price as the UK, £60.

* Often when working on location we will employ a local 'fixer'. They do what the name suggests. Using local knowledge they can sort access or permissions and source materials needed for the job.

21 MARCH 1990 51° 27' 38" N
Bristol, UK 2° 36' 26" W

Friend and producer Nigel has gone on ahead of me to the Soviet Union to set up the deserts shoot. The day before I am to leave to join him, I get a telex* from him in Ashgabat (south-east of Moscow) telling me to buy us some food. 'Sort of survival rations,' he says, 'should we not be able to get food out there.'

I head to Tesco, the renowned supermarket for intrepid explorers, and hurriedly fill a trolley with a rather random selection, including sardines, corned beef (protein), dried fruit (energy), nine tins of Ambrosia creamed rice (once-a-week treat), Heinz tomato ketchup and some Colman's English mustard. On the way home I also buy a £5 suitcase from a charity shop to transport my 'rations' in.

The food bill comes to around £80, not bad for nine weeks' subsistence, I thought, but being grossly overdrawn at the bank I need to claim the expense back from the BBC straight away so that my Tesco cheque doesn't bounce. I have to go into the BBC anyway to pick up my tickets and passport, etc., so while in there I fill out a petty cash claim for the food. As no one of high enough authority is in the office to sign my claim I go to the NHU manager, Nick, and explain my financial plight. He is remarkably unsympathetic and refuses to pay for the food out of the programme budget. He claims that a deal has been struck with the Soviet British Association, our fixers in Moscow, and that they are providing all our food for the trip. 'But what about Nigel's telex?' I protest. 'He's out there already and has mentioned this matter specifically.'

* Telex was a system for sending text-based messages worldwide before the invention of faxes and email.

The answer is still no.

Angry and desperate, I play it cool and call his bluff. 'Right then, I'm not going. You can get another cameraman to take my place for nine weeks from tomorrow.' (I have learned my lesson from dealing with this man before.)

He immediately backs down, saying, 'Well, it needn't come to that. We'll pay you when you get back.'

'I need the money now!' I insist. 'I'm overdrawn!'

He signs the form and I head for the cash office. Phew!

51° 28' 14" N
0° 27' 9" W

22 MARCH 1990
Heathrow Airport, London

To the USSR For the first and only time, the BBC has bought me a business-class ticket, with Aeroflot – apparently it was the same cost as economy with British Airways. This is my first time flying with Aeroflot and the cabin is full of 15 or so tracksuit-clad Russian athletes. Along with the aircraft styling in grey and orange, this gives the impression that I have stepped back into the 1970s. They are all smoking duty-frees with enthusiastic abandon and chatting to each other animatedly about their Western purchases – bags full of Levi jeans, Marlboro cigarettes, Walkmans and the like. There is also a choking smell of aftershave, notably Brut 33. I assume all these are nigh-on impossible to buy in communist USSR.

The aircraft doors finally close and we push back from the gate. Five or six of the athletes are still standing, comparing aftershave and discussing their duty-free purchases as the indifferent air hostess rather begrudgingly goes through the safety

instructions. She makes no effort to ask them to sit down and buckle up. Instead, she finishes her demonstration, puts away the lifejacket, sits down and straps herself in for takeoff. With the athletes still standing and chatting, the engines rev, the brakes release and we accelerate off down the runway. The athletes merely speak louder and brace themselves so as not to fall over while demonstrating their wares, holding up 501s and bottles of Johnnie Walker. I am a little shocked, not because they were in any great danger, but simply because on every single flight I have ever taken before, the stewards or air hostesses always come round before takeoff to check your tray tables are locked away, seat backs are upright and seat belts fastened. I find it quite amusing that on this flight with Aeroflot they couldn't give a toss!

Four hours later we land in Moscow. I am met by Igor, our Moscow fixer from the Soviet British Association. He is a large-built man who seems to whizz me through immigration. We then wait a while for all my bags to turn up, by which time quite a queue has built up at customs – mostly because of a hold-up with a group of tracksuit-clad athletes trying to bribe their way through by handing out Marlboro cigarettes. Igor beckons me to follow him as he barges forwards with three of the five trolleys piled high with gear. I nod apologies to the other passengers as I push past, embarrassed. The customs man angrily looks up past the athletes to Igor pushing to the front of the queue and a few harsh words that I don't understand are spoken. Igor then flashes something at the customs man from his coat pocket. I don't see what it is, but suddenly it's all smiles and we are ushered straight through. A few days later I'll see another official situation quelled by the flash of an ID or something. Tanya, our interpreter, will tell

me it's a Communist Party ID card and that it opens many doors otherwise shut.

The drive into Moscow is cold and wet. I wipe the condensation from inside of the van window with my sleeve and watch the traffic and buildings go by. My first impressions are that Moscow is grey and depressing. I see people walking, carrying heavy shopping bags, their heads down, oppressed. Is this the sign of 70 years of communist dictatorship, or am I just seeing a grey rainy city through capitalist eyes?

I spend the night in a massive hotel. I have to surrender my passport for registration to the police (KGB) and won't get it back until we leave for the next location.

35° 47' 13" N **APRIL 1990**
61° 27' 41" E Arkar-Cheshme, Badkyz Reserve,
Southern USSR

I fly to Ashgabat with Tanya and we meet up with Nigel. From here we take a two-hour flight in a rather tired-looking Soviet helicopter, a Mil Mi-8, down to Badkyz right on the Iranian border and not far from the border with Afghanistan. I look out of the porthole-style windows as we fly over endless featureless steppe, bare undulating grassland. I also see lines of Soviet tanks and soldiers dug in every half-mile or so parallel to the border, presumably still not withdrawn following the ten-year Afghan war. We unload our gear and take it into one of three rustic single-storey Turkmenian-style houses in front of us. The other two are occupied by families who come to meet us. They seem friendly and I doubt they get many visitors here. This is going to be home for much of the next eight weeks. But before the

helicopter leaves, Nigel and Tanya arrange for its return on the evening of 14 April so that we can film aerials of the poppy fields in the early light the morning after. After much discussion the plan seems clear and it is all agreed.

What Nigel neglected to tell me in his telex was that despite it being a desert, at this time of year it is bloody cold. If I had done my homework I would have known that the temperature here ranges from 42°C in the summer to minus 15°C in the winter. It certainly is well below freezing now and there is a dusting of snow on the ground with shallow drifts on the hills.

Our water for drinking, cooking and washing comes from a shallow well beside the house. Drawing water involves dropping a metal bucket with a rock in it to break the ice. The locals advise us to boil the water for five minutes to make it safe to drink.

We share an outdoor toilet with the two families. It is a three-sided tin structure with no roof that faces away from the houses but into the wind. It's about four-foot square and has a wooden floor with a crude hole cut in the middle. Below is an unhygienic shallow pit. For a bit of privacy or modesty, between us BBC lot we have a simple system: you tell the others you're going to use the loo. The two families don't have a system. They come and watch until you are finished. I switch to night ops.

Our accommodation isn't the best and one night I'm kept awake by rain being driven in through the broken window panes and dripping through the roof. There isn't a dry spot in the house the next day.

But once a week the women make a stack of Turkmenian flatbread. This is cooked outdoors in a domed oven a bit like a pizza oven, except the opening is just at the top. A wood fire is lit in the base and left to burn for about an hour. Once the whole oven is hot the bread is wetted and then stuck to the inside of the

dome. The hot bread is delicious but brings a whole new meaning to the idea of Russian roulette. Because the walls of the oven are made from mud, occasionally when chomping away on the bread you crack your teeth on a bit of grit. I will break two teeth in nine weeks.

In return we share our precious supplies of chocolate and red wine. The families are fascinated by the concept of the wine box. It seems to provide so many glasses that they nickname it the 'bottomless wine box'.

For this two-year-long production, the BBC has spent part of the series budget on a 110 turbo diesel Land Rover. The morning after we get here our 'chariot' arrives. The two local families come out of their houses to see the new machine. It's quiet and stylish, unlike the ancient Soviet vehicles. Then the men rush back to their houses and come out with mugs. They seem particularly keen to look at the engine, so I pop the bonnet open. Perhaps these men are mechanics, since they are surveying the various engine parts? Eventually they point to the radiator cap and wave their mugs. Tanya translates for us that they want to drink the radiator fluid for the effects of the antifreeze. These guys are after a fix, so I give them a small glass of whisky each instead and make two new best friends. Tanya adds that during the ten-year-long war in Afghanistan, tens of thousands of Soviet troops drank so much of the water-methanol mixes used as antifreeze in tanks and aircraft that they were poisoned or blinded. Okay then.

With Tanya interpreting we discuss all sorts of cultural differences. They ask us about credit cards; it's something they've heard about. Nigel tries to explain the concept and shows them his American Express card. The men try to buy it off him for $50. Clearly we haven't explained it correctly.

We are working here with Russian scientist and, I'm soon to discover, brilliant naturalist Leonid. Leonid

appears slightly older than me. Dressed in obligatory camouflage, he is of slight build but clearly tough. Like many Russians, he appears to have worries on his shoulders, but they melt when he reveals a big smile hidden below his 1980s Magnum moustache. Leonid has spent time here before and has huge experience in this area. He is therefore very knowledgeable about the local flora and fauna.

Badkyz is an amazing location for the desert programme because of the mix of wildlife here. It's pretty much centrally placed between Asia, Africa and Europe, so you find many species common to all three corners. European hoopoe, a colourful almost tropical-looking bird with an expressive crown of feathers that it can lay flat, vultures, wolves and hyenas, antelope and wild ass, tortoises, red fox and the rare and elusive Persian leopard – animals I wouldn't have expected to be in the same location.

Leonid leads me on an hour's energetic hike to a gentle valley where there are Eurasian black vultures nesting on the tops of pistachio trees. These birds are huge, with a wingspan of up to ten feet. It's amazing that a nesting pair of such big birds will generally lay only one egg. They are also notoriously nervous birds and can desert their nests and chicks if disturbed, so we recce using binoculars from about half a mile away and choose where to place a hide.* We wait until dark before hiking in and setting it up, tucked right into a

* A hide or blind is generally a small camouflaged tent with openings for the camera lens and letterbox-style slots covered with netting to look out through. When positioned thoughtfully – for example, tucked into a bush or under the low-hanging branches of a tree – and then camouflaged further with twigs, tufts of grass, etc., the hide can pretty much disappear, blend in. Once inside, the only thing showing is the end of the lens.

pistachio bush about 50 metres across a narrow valley from one nest.

Very early the next morning, while it's still dark, Leonid and I hike back in with my camera kit and I install myself in the hide. Leonid leaves: he'll come back to collect me in about 14 hours, once it's dark again.

As the light comes up I'm pleased to see one of the adults still on the nest. When she shifts I can see she has a single fluffy grey-white chick with her. We've chosen well.

A vulture doesn't do a great deal on the nest and the big event of the day is when the other parent bird returns with food and they do a swap, as both parents share duties in raising their chick. The chick is then fed by the bird that has just returned. That's about it, so I daren't miss that moment.

It's such a quiet, peaceful setting. There's something very restful about being secretly tucked in a hide with my camera. I can peer out through the letterbox netting slots on three sides. Straight ahead is the nest; to my left I can see about 200 metres up to the head of the valley; to my right the valley drops away, green undulating steppe leading off into the distance. I'm wrapped up warm as it was chilly this morning. Inevitably, after many long filming days and early starts I fall asleep in the hide. I wake up with a searing pain round my right eye where I've been resting on the eyepiece. I check my watch: nearly 11.30am. I must have been asleep for hours. A little frantically, I peer down the lens and can see the vulture on the nest cocking its head sideways to look up. I look out through the gauze of the hide and can see a tiny speck in the sky that seems to be approaching. As it gets lower, I can see it's a black vulture with its wings tucked in to lose height. I train the camera on it and film its descent. I then tilt down and line up on the nest, filming as the bird lands and the two adults greet each other. The first bird flies off, presumably to get the next meal. The returned adult

then spends 20 minutes delicately feeding its chick before nestling down to shield it from the sun.

This is my first experience of the 'sixth sense', something I can't scientifically explain. I had been sound asleep for several hours but managed to wake up at that crucial moment. Vultures don't call to each other and the air rushing through their feathers as they fly makes minimal noise. You could put it down to coincidence but I'm not so sure, especially as the exact same routine happens the following day. In the hide at 5.20am, accidentally falling asleep, waking up at 10.40am to see a parent returning to the nest. On the third and last day of filming for the nest sequence, I don't wake up until 12.05pm, but yet again the timing is perfect and I get to start filming just as the adult bird is returning to the nest! Definitely more than a coincidence.

Back at the accommodation the long drop toilet is now dangerously full.

15 APRIL 1990
35° 47' 13'' N
61° 27' 41'' E
Arkar-Cheshme, Badkyz Reserve,
Southern USSR

The poppies are now in full bloom and the hills are speckled with red like a Monet painting on steroids. They contrast with the lush green grass of spring and blue skies, and the landscape is mostly a palette of these three basic colours: a rare and striking sight. This afternoon the helicopter is supposed to arrive ready for tomorrow's aerials. In typical Soviet fashion, it doesn't.

The next morning we are woken by the sound of a helicopter and rush out to see the big orange beast landing on the grass by one of the other houses. We

have already missed the best morning light for filming, so, feeling pissed off, Nigel, myself and Tanya go across to talk with the pilot and crew.

Nigel kicks off with, 'You're late. You were supposed to be here yesterday afternoon as we agreed.' Tanya translates.

We are ready to continue with the bollocking, mainly to vent our frustration as there is nothing to be done about it now, when the pilot – who I notice looks a little subdued – speaks with Tanya. She silences us with an open palm as she listens.

Tanya then turns to us and explains in hushed tones. 'The helicopter was on its way to us yesterday afternoon when the main rotor failed. The pilot, co-pilot and engineer were all killed in the crash. This is a replacement helicopter.'

The crew stay the night and we film our aerials the next morning. Unusually but quite rightly, I see the pilot and engineer do a thorough check of the rotor, main bearing, nuts, bolts, oil levels and so on before we take off.

For what it's worth, I tie a safety rope around my waist and film with the camera on my shoulder out of the big side sliding door. The colour and scenery of Badkyz is stunning from the air, but in the back of my mind I am feeling for the families and friends of the crew who died two days ago. I am also hoping that this helicopter holds out and we don't end up suffering the same fate.

APRIL 1990 35° 49′ 35″ N
Kyzl Jar, Badkyz Reserve, 61° 50′ 39″ E
Southern USSR

We have packed up and moved location to a small hut 40 miles to the east, a two-hour bumpy journey on a dirt track. It's at the head of Kyzl Jar, an impressive ten-mile-long, dry canyon that's 400 feet at its deepest. Long steep slopes climb up each side, with vertical cliffs at the top. Leonid has been observing an eagle owl regularly visiting one of the medieval caves halfway up these cliffs, very early each morning. He climbed along a ledge to the cave and could see two fluffy white chicks near the entrance and suggested it would be possible to film them. So, having talked through a strategy, we hike there to set me up for a night in the cave.

Leonid goes ahead of me, shuffling along the foot-wide ledge, and I start to follow. The kit is going to get lowered down from the top of the cliff by rope. Halfway along the ledge, I look down. My head starts to spin. Below me is a 30-foot vertical drop, and then a 250-foot slope to the bottom of the canyon. For the first time in my life I discover what vertigo is. My brain is thinking of it as a 300-foot drop and the wall of rock behind me suddenly feels as if it's physically pushing me forwards; terrified, I force my head and back against the cliff. Leonid looks at me. 'Are you okay?'

Probably with fear showing in my eyes, I look straight back. Recognising that I'm struggling, Leonid then kindly shuffles back along the ledge to me. By keeping eye contact with him I'm able to make it the last 20 feet to the cave, then I'm fine – only marginally petrified that I have to leave the same way once I've got the footage.

The cave has two adjoining sections, each with an entrance looking out over the gorge. They both go back about 15 feet into the cliff, with the ceiling just under 5 feet high. Leonid explains that these are historic caves carved out by man as early as the fifth century. The floor is littered with broken old clay pottery and I can see the two white fluffy chicks staring at us from the furthest cave. I quickly erect a cloth screen at the back of the cave and set my tripod and camera up behind it, looking out towards the mouth of the cave. Once installed, Leonid wishes me good luck and leaves. I am now stuck in here for 16 hours until the morning.

As the light fades the chicks become more active and wander about the cave. They stand at the edge and look out down the canyon, presumably waiting for a parent to return to feed them. With darkness looming, I have no way of filming, and I don't want to use any light for fear of scaring the birds or causing the parents to desert the chicks.

On my own, three miles from anyone, 30 feet up a vertical cliff in a medieval cave in the dark, my mind starts to play tricks. I'm enjoying the adventure of it, but knowing I have no escape until morning is a bit disconcerting. There are all sorts of spooky sounds through the night and it gets so dark I can see absolutely nothing. What I hadn't bargained for was all the other wildlife in the cave. The floor is riddled with ticks, mites and fleas and I am getting hammered with bites. I sit as still as possible, though, to remain undetected.

Eventually, at about 4.30am, I hear one of the parent owls return. The chicks screech and call in excitement and, even though I can't see, I can tell that the adult is staring at the new 'fake wall' at the back of its cave. I stay stock still and silent and eventually I hear it feed the chicks.

Dawn hints at its arrival and soon I can make out the cave entrance in the darkness. Five minutes later I can see the silhouetted outline of the adult eagle owl perched majestically on the edge. It stands about 30 inches tall and has distinctive ear tufts; the two chicks sit by its side, looking out down the canyon. The three of them posing for the perfect shot. It's still too dark to film but now I am excited: the uncomfortable night is going to pay off and hopefully I'll have something to show for my blood-starved legs, having sat motionless all night. I wait. Finally, as the sky brightens and the camera light meter needle comes off the end stop, I decide to try the first shot, even though it's likely to be underexposed. I am just about to roll when the eagle owl takes off and flies silently away, directly across the canyon. Bollocks.

I wait for another three hours but it doesn't return, and eventually I hear Leonid: he's come to collect me. This had been a possible bonus for the film but it hasn't paid off: you win some, you lose some. I was still personally excited to have seen the owl, and no shot would have been worth putting it off coming back to feed its chicks. Leonid had been watching with binoculars from afar and said that was the normal time he'd seen it. It's a shame that the film stocks aren't sensitive enough to work in such low light.

Out in the daylight I can see I am covered in insect bites. As we hike back to the hut across the steppe, Leonid asks me if I've had a typhoid inoculation. Great!

34° 45' 36" N **APRIL 1990**
61° 27' 7''' E Badkyz Reserve, Southern USSR

Wild *close*
encounter

The clouds look nice today so Nigel and I drive to a vantage point to shoot a scenic time-lapse. I set up the camera and tripod by the Land Rover and start to click away. I have to do this by hand, taking a single frame every six seconds.* Nigel wanders off bird-watching.

Shooting time-lapses is a bit like meditation. I have to be disciplined and not miss a shot or there would be a jump in the cloud action on playback. I need to film for around 30 to 40 minutes to see significant movement in the clouds and to give a long enough shot.

Clicking away, I am enjoying the scenery in front of me when for some reason I know that something is watching me. That sixth sense again? I look round to the hill a hundred metres or so behind me. Just over the ridge I see the head and eyes of a cat looking straight back at me. It turns and carries on walking diagonally towards me. I watch its head and back, while clicking the time-lapse every six seconds, until the cat disappears. I wonder what it was, maybe a steppe cat.

The time-lapse has run for long enough so I sprint up to the ridge to see if I can get a better look. I run 20 paces – then run back, grabbing my tripod handle for protection 'just in case', before sprinting up the hill, taking a line to intercept where I think the cat will now be. As I get close to the ridge I slow down: what if it's a leopard? Meeting one eye to eye might not be so clever. Both nervous and excited, I drop to my hands and knees and crawl the last few metres, then cautiously stick my head above the ridge. There, only

* Nowadays, time-lapses are shot using digital stills cameras, DSLRs. The cameras have plug-in or built-in timers so fire automatically. Much easier and less concentration needed.

40 metres from me, walking away down the slope, is a magnificent Persian leopard.* It's slinking away with feline grace, its long round tail curved up at the end revealing a patch of white fur. My heart is pounding in my chest, partly from running up the hill but more from the exhilaration of seeing the leopard. The dark rosettes on its flank and back mix with its orange-brown fur in a mesmerising swirl. It's beautiful. I retreat back out of sight and sprint back down to the Land Rover to grab my camera and tripod.

'Nigel,' I gasp for breath. 'I've just seen a Persian leopard. It's just over the ridge and it's really close.' I see jealousy and excitement in Nigel's eyes, and we both race back up the hill and cautiously peer over the ridge. No sign, but I set up my camera. The two of us scan the hillside and gully for the next few hours, but we don't see the leopard again.

MAY 1990 35° 49' 35" N
Kyzl Jar, Badkyz Reserve, Southern USSR 61° 50' 39" E

First up in the morning, I go to draw water from the well to make a pot of tea. Nigel joins me and we sit quietly for a while, waiting to fully wake up as we drink. Then the ranger rushes in from the other hut and starts to frantically gabble on in Russian, pointing to our teapot and mugs. I offer him a cup but he seems distraught. Tanya hears the commotion and comes to translate. She looks horrified. 'Don't drink any more tea!'

The ranger has been trying to tell us that his friend is very ill. He had got up in the night and went to draw some water to drink. As he was leaning over the well,

* *Panthera pardus tulliana.*

pulling the bucket up, he'd been violently sick. Nigel and I look at each other and then at the tea. No words.

This is the only water source apart from 50 miles to the west. We have things to film there so decide to up camp and move back there until this well situation has been resolved.

The Land Rover is laden with jerrycans of fuel on the roof, all our camera kit, camping gear, bedding and food. It has been raining and the mud roads are slick. The terrain is fairly featureless steppe with gentle hills off to the north and more rugged mountainous landscape 25 miles to the south in Iran and Afghanistan. We've gone about 20 miles when I come to an almost straight piece of road. I'm doing about 35mph and there's a big puddle all along the left side of the road. I steer slightly right to drive round it on the flatter grass – the Land Rover starts to skid to the left so I turn in to correct the skid. Then it all happens in an instant. The car doesn't correct but instead swerves sideways, tips over on its side with a colossal crash, the engine screaming, before rolling and ending up on its roof. None of us are wearing seat belts and it's like being in a tumble dryer along with heavy metal cases. The windscreen and left side windows have smashed. Nigel's arm is cut badly. The tripod grazed and cut Tanya's ear and head open. My legs are in so much pain I think I've broken them where, upside-down, I've fallen and whacked them on the steering wheel. I switch off the ignition.

We all crawl out through the broken glass and stagger away in shock from the vehicle.

Shit, shit, shit. Nigel is not happy. None of us are, to be honest. I stagger around almost doubled up in pain, but the good thing is that clearly my legs aren't broken. I grab the first-aid kit from under the mountains of

stuff in the back of the crashed vehicle and attend to Tanya's cut head. She looks dazed but seems okay. Nigel dabs his arm with a bandage whilst pacing the grass.

It takes us 20 minutes to calm down and take stock. We are literally miles from anywhere. It is probably 20 miles to the house we were trying to get to and this road barely sees one vehicle a week, if that. We have a high-lift jack and two spare wheels, but I can't see how we can right the car without another vehicle helping. With no form of communication, Nigel and Tanya decide to start walking for help, while I stay with the vehicle. As they head off I begin to unload the car and stack the kit to one side.

Just as the two of them disappear over the horizon I notice smoke starting to come from the underside of the car, right next to the reserve fuel tank. That's all I need. Now the bloody thing is going to burst into flames.

I look for something to hold water – all I can find is the funnel we use to pour fuel. I ram my finger in the bottom and run to the puddle that caused the skid. Filling it with muddy water, I run back and forth to the car, pouring it in where the smoke is coming from. While I am doing this, a herd of horses has come trotting up towards me and stopped. They watch this madman running to and fro with a funnel on his finger. After a few minutes the pain in my legs worsens; it feels like burning. I am wearing shorts and look down at my bare legs. They are red raw. I suddenly realise what the 'smoke' is. Acid from the two batteries is obviously leaking out and eating away at the car. I have been splashing around in a small puddle of that battery acid right by the car as I've been pouring the water. The acid burning is now intense – I run to the long puddle and sit down in it, massaging my skin with handfuls of wet mud, trying to neutralise the acid. This disaster is getting worse.

As the pain recedes I start to calm down a bit. But what really makes me smile is the herd of seven horses, which has now come over and is standing just feet from me, staring. It's as if they know something is wrong, they can see I am suffering.

It suddenly dawns on me that this is the most ridiculous situation I've ever been in. Miles from anywhere on the Turkmenistan–Iran border, having crashed a Land Rover. Acid burns on my legs and now sitting in a muddy puddle with horses for an audience. 'Hello, you lot. Yes, my legs are burning, that's why I'm sitting in this puddle. I've just crashed that car. Pretty stupid, uh?' And then I just laugh.

Two hours later and the sun is setting; soon it will be dark. In the distance I hear a vehicle. I look up and there, sure enough, is a Russian Jeep coming up the track. In it are two men with Nigel and Tanya. This is the first vehicle we've seen in at least a week – what a stroke of luck.

The two men jump out and I shake their hands. They actually both look a bit beaten up too – one has his shoulder heavily bandaged and his arm in a sling. They look very concerned for us and we talk briefly about what to do next. They seem the practical type and set about rigging a tow rope to the side of the Land Rover. Then, with some pushing and heaving by us, they use their vehicle to pull the Land Rover back on its side. We adjust the tow rope again and then they pull our vehicle upright. I can't drive it as all the oil has drained out, so we load up the kit again between the vehicles and they tow us back to where we've come from.

We arrive at the hut around midnight. The scientists and rangers rally round and light the stove. They make us hot drinks (with the sick water) and give us blankets to help us with the shock. Then they set about treating

Nigel's cuts on his arm and Tanya's on her head. They give me painkillers for my bruised legs. While in medicine mode they also change the dressing on our rescue driver's shoulder. Watching on, I see his wounds are deep. There are two entry wounds on the front of his shoulder, big enough that I could have fitted my little finger in, and two similar wounds on his back. They look like bullet wounds to me and I wonder if they've been shot at by the Iranian border guards. I ask Tanya about the injury and she explains that they are both photographers and two days ago they had been hiking in an open area not far from here, when a leopard jumped down from a boulder and sank its teeth into this man's shoulder. It then tried to shred his stomach with its back legs. So the man hit it repeatedly with his tripod and the leopard gave up and ran away. I ask exactly where they saw this leopard and it was right where I had seen mine! I bet it was the same leopard. Was it that sixth sense that told me to go back and grab my tripod handle for protection? Would it have been any use?

MAY 1990 35° 49' 35" N
Kyzl Jar, Badkyz Reserve, 61° 50' 39" E
Southern USSR

Since we arrived, the scientists have been making some kind of home brew called *braga*. Any potato peelings, apple cores, tea bags – in fact anything organic – has been put into a big milk churn with water and yeast and a generous amount of sugar. Over time this brew has been gurgling away, and although it looked disgusting, the guys would have the odd ladleful to drink. I tried it too: it basically tasted of frothy yeast, but it had the alcoholic strength of mild beer.

Blind drunk

Today, though, there is to be no cooking as the small kitchen area and gas stove have been commandeered and turned into a makeshift distillery. A big bucket has been set up on the stove with a fixed lid and a long, curled copper pipe. After several hours of warming, clear drops of liquid are dripping from the end of the pipe into a glass jar. Every few minutes a serious-looking scientist collects a teaspoonful of the liquid and then lights it. The flame briefly burns blue and the scientist peers through his spectacles as he compares the colour with a tatty magazine cutting of an alcohol colour chart – each type or fraction of alcohol burns a different colour and what he's after is ethanol. Other alcohols are poisonous or potentially lethal so are discarded. Finally, when the blue looks right, bottles are moved under the dripping tip and the 'ethanol' collected. This fiery high-strength alcoholic drink is called *samogon* and it fuels perhaps 80 per cent of the Soviet population.

The next night we have a big party. Shot glasses are laid out and *zakuski* – Russian hors d'oeuvres and snacks mostly consisting of fatty preserved sausage, whole pickled cucumber, garlic cloves and fresh fennel picked from the steppe – prepared. The glasses are filled and for each round someone different takes a turn to make a toast. At the end of the toast we all chink glasses and then down the liquor in one, slam the glass on the table and then reach for a whole clove of garlic or something similar to try to take the taste and burn away. All in all a pretty unpleasant experience apart from the social side of it. With the strength of the alcohol and the frequency of the drinking, we all get drunk quite quickly. I'm sure this culture has evolved to escape from some of the misery of Soviet rule.

There are eight of us sharing a room in this particular hut, six of whom chain-smoke. At night we all sleep on

mats on the floor and six people are Olympic snorers. This is the first night that I manage to sleep through the snoring, probably contributing to the chorus after all that alcohol.

The next morning my alarm goes off very early as usual. I get up and dress, feeling worse for wear. Nigel drives me in the fixed Land Rover to go and do some dawn scenics looking over the distant mountains of Iran and Afghanistan. It's a good hour's drive and the whole way I find myself worried because I can't seem to get my eyes to focus. I saw how dodgy and unscientific the alcohol distilling was and start to worry that I have done permanent damage to my eyes. Thankfully, by the time we arrive on location my eyesight has recovered.

MAY 1997
0° 44' 54" S
90° 18' 37" W

Galapagos Islands, Ecuador

This is my second filming trip to the Galapagos Islands and I am no less excited than I was the first time around. The islands are sprinkled at the equator in the Pacific Ocean. They are 600 miles straight west from the mainland of Ecuador, about as isolated as it gets. I am part of a team of eight spending three weeks on board a chartered boat. We are here to film various sequences for use across eight programmes in the series *The Life of Birds*, with David Attenborough talking in vision to link them into the storytelling. Albatross, flightless cormorants, Galapagos hawks, both blue- and red-footed boobies, storm petrels, mocking birds, frigates

In Darwin's footsteps

and penguins. No doubt we will see many of the total
181 species too – a bird-watcher's ultimate dream.

Apart from the beauty of the islands and the extraor-
dinary variety of wildlife, there are four things from
this trip that will stay in my memory forever . . .

0° 23' 7" S
90° 17' 7" W

3 MAY 1997
North Seymour Island, Galapagos

*What came
first?*

Having sailed to North Seymour Island, we go ashore to
film magnificent frigates.* The island is covered by low
bush scrub and the frigate birds roost and nest on the
top of these at about eye level. These amazing birds are
extremely agile in flight and have a distinctive look,
vaguely prehistoric, more like a pterodactyl. They have
long hooked beaks and predominantly black plumage, long
pointy wings and a forked tail; their wingspan can be up
to seven feet, the largest wing area to body weight ratio
of any bird. This means they can hang effortlessly in the
air for weeks. Equally they can turn into agile fighter
pilots in an instant, chasing down and scaring other
bird species to steal their food. They are also known
as 'man-o'-war', the pirates of the skies.

Something that no one has yet filmed for this series
about birds is one laying an egg. Once we've shot the
sync piece with David, I stay on to film some details
of frigate behaviour to fit in with the segment. While
I'm filming the prehistoric-looking frigates cruising
overhead, I look to my left to see a bird behaving
very strangely on its nest. Its wings are outstretched
and it is rocking forwards and backwards. It slowly
pirouettes several times and, as I see its rear end turn

* *Fregata magnificens.*

52

to face me, it looks very odd. Like a giant eye. I quickly spin my camera round and start to film. Just by chance the bird pushes out a pure white egg, about the size of a goose egg, which drops neatly into its nest of sticks. If you had scripted this it never would have happened; I am really lucky to have seen and filmed it. A surprisingly common yet difficult bit of behaviour to film.

9 MAY 1997
Bartolomé Island, Galapagos

0° 17' S
90° 23' 26" W

My good friend Nigel broke a tooth very early on in the trip and is suffering. It's not enough of an emergency to sail back to port to get it fixed, but left untreated a damaged tooth in the tropics can turn nasty. On trips like this where we are going to be remote, we carry with us a comprehensive BBC issue first-aid kit. In it is something I've never used before: an emergency dental repair kit. Nigel is in pain so I offer to try to fix the tooth for him. The rest of the team watch with interest as I spend 40 minutes following the intricate instructions. Nigel patiently (and trustingly) sits with his head back and mouth open as we rock on the waves and I fashion the repair.

Finally, it's time for Nigel to 'bite gently down' to check the new filling isn't standing proud. It is, so I see where the impression is and gently work the filling to smooth it down further. He bites down again and all seems good and he thanks me. Like every good dentist I tell him not to eat or drink anything for at least two hours until the filling has set properly. Nigel sits up and seems pleased; the nerve is no longer exposed and there is less pain. Forty minutes well spent helping out

a friend on location, and great to have had the kit in the first aid to do the job.

Then Nigel reaches into his mouth just to feel the filling with his finger. He offers it up to me to see. Damn it! There is the whole filling perched on his fingertip. No wonder dentists are paid so much money.

Perhaps the reason Nigel had broken his tooth was through stress, biting hard or grinding his teeth at night when asleep. Divorce can happen to anyone but I think the strains of this career cause a higher than average marriage failure rate. For whatever reason, Nigel is sadly on the verge of splitting up with his wife. Trying to manage that from afar is compounding the issue. We have a satellite phone with us, the sort that looks like a laptop computer. To use it you line up the antenna, which is the lid, with a satellite. You need to be quite accurate with this to get a good signal. This is straight-forward enough to do on the land, but from a boat at anchor it's nigh-on impossible. Nigel, desperate to talk with his wife, asks me if I can try to hold the satellite phone and keep it lined up while he rings home. So, we stand on the bow of the boat with me doing my very best to hold the base unit steady, connected by a four-foot curly cable to the handset, and Nigel pleading and arguing with his wife. I really didn't want to listen to this personal conversation, 15 minutes that should have been private between the two of them. Unable even to use my hands to block my ears, I feel very sad to have witnessed it, but I suppose I did what any friend would do.

The next day, Nigel and I do a recce near Pinnacle Rock on Bartolomé Island. The water is clear and warm as we swim the bay to find a place to do a sync piece with David swimming with Galapagos penguins. We saw the penguins travelling and feeding a little way off and we swam to intercept their path. As we return to the

boat Nigel shows me his left hand and says, 'Shit. I've lost my wedding ring.' He's lost so much weight on this trip that the ring must have slipped off while we were swimming. 'I have to find it or I am definitely divorced.'

I happen to have a very good memory for routes and landmarks, so I suggest we swim the same route to look for the ring. Twenty minutes later Nigel spots it perched on the top of a boulder 25 feet down. Two feet left or right and it would have been gone forever. We take it in turns to dive down but we can't reach it. Nigel gives it one last attempt and manages to retrieve it, gasping for air as he breaks the surface. He desperately wants his marriage to work.

1 APRIL 1997 1° 13' 54" S
Floreana Island, Galapagos 90° 26' 54" W

When it is hot during the day and the light is too harsh for filming, we return to the boat for lunch and a regroup. The team are relaxing and David is working away on his laptop, writing *The Life of Birds* book to accompany the series. I sit across from him on a bench seat in the saloon, headphones on and listening to the CD *Monty Python Sings*. It's a great album (available in all good record stores) and one of my favourites: a compilation of popular songs from the *Monty Python* series and films. I am occasionally chuckling to myself at the lyrics.

David looks across at me and mouths, 'What are you listening to?'

I remove my headphones and reply, '*Monty Python Sings*. Have you heard it?'

He hasn't, so I cue up three tracks for him to sample: 'Penis Song (Not the Noel Coward Song)', 'Eric the

Half a Bee' and 'Bruces' Philosophers Song'. David puts on the headphones and I hit play.

Within ten seconds David starts to smile, then chuckle. Thirty seconds later, he keels over on his side on the bench seat, disappearing behind the table. I think to myself, *Christ, I've killed David with a Monty Python song.* The quote 'It's obvious this joke was lethal' springs to mind.

Thankfully David sits back up, laughing and with tears in his eyes, and he listens to the other two tracks. I can't believe he'd never heard those songs before: did you know he was actually responsible for commissioning the sketch comedy series for the BBC back in 1969? He has a wicked sense of humour.

0° 26' 48" S **23 MAY 1997**
90°' 16' 8" W Baltra Island, Galapagos

At the end of the trip we have a charter flight booked to take the eight of us and all our baggage back to Quito on the mainland in Ecuador. We take off from the airstrip on Isla Baltra and start heading east. The aircraft is a twin-engine turbo prop and would normally seat 20 people, but we've had the first three rows of seats removed and stacked with our baggage. I have a window seat next to the right-hand engine, and after about an hour I can't help noticing an oil stain on the paintwork. As the flight goes on, the oil stain gets worse until it becomes an oil leak. I point it out to the air hostess: she pulls a slightly concerned face and disappears into the cockpit. The co-pilot then comes and has a look: he too looks concerned and returns to the cockpit. Then the pilot comes and has a look and finally the engineer. To my mind it

should probably have been him who looked at it from the start.

We are now about an hour and a half over the Pacific Ocean; that's when the pilot switches off that engine. I look across at David and the producer: I suppose we were looking at each other for reassurance. That's not too much to worry about as these planes can easily fly on one engine, we tell each other, but we are right over the ocean with another hour and a half to go. But we now have no redundancy.

With about an hour to sunset, the light through the windows suddenly starts to swing gently round the cabin: we are turning back. There is a certain tension in the cabin as we know we have to make the islands by dark. I have to say I'm not feeling good about this. My mind is dancing everywhere and strangely I picture the headlines: 'Much-loved David Attenborough in air disaster'. Let's be frank, I don't think myself and the rest of the crew would get a look-in.

I have my small DV video camera with me and film a light-hearted piece to my family. For a little while, I kind of do think this might be it, and think that if we were to crash and this tape was found, they would see that I had thought of them in my last moments.

As we approach the nearest island, San Cristóbal, to compound the worry I can see a big storm cloud hanging over it, unleashing a thick grey stripe of rain. The sun dips below the horizon and the light is fading. The pilot makes a beeline directly for the small airstrip on the south-west of the island. Thankfully, as we turn into our final approach, the rain has passed but the runway is now a sheet of water. I video the wheel as the pilot touches down. Unable to use reverse thrust, as it would spin the plane, he has to bring us to a halt using just the brakes. I watch and film as the brake disc glows red hot and sparks fly off the wheel. I can see the end of

the runway fast approaching and the ocean is not far beyond that. Thirty feet, twenty feet, ten feet to go … I start to brace for what's coming.

Much to my relief the pilot brings the plane to a halt literally at the end of the runway. He doesn't even have space to turn the plane. We disembark and have to walk back along the runway and find a place to stay.

For most of the next day the pilot, co-pilot and engineer strip down parts of the right-hand engine and rebuild it. They test the engine on the ground and then lead us like sheep to re-embark. We take off and fly back to Quito without a hitch.

Firsts

JUNE 1982

Oxford Scientific Films,
Oxfordshire, UK

Today, after tea-making duties, I am given the task
of collecting branches of hazel from the local woods.
Once back in the studio, I then have to build a set from
them, trying to replicate what I'd seen in the woods
and making sure the studio wall behind can't be seen.[*]
The cameraman, Sean, spends some time lighting the
leaves[†] before coming back with our protagonists in a
glass collecting jar. Weevils. Tiny beetle-like insects,
just 8mm long. Beautiful ruddy-brown armour, a bold
black head and six legs. To me they look almost like
clockwork toys.

An inordinate
fondness for
beetles

With Sean poised at the camera, I delicately coax one
weevil from the container using an artist's paintbrush.
Making sure it is holding tight to the bristles, I manoeuvre
the brush and let the weevil walk up onto the set. Straight

[*] Historically, most insect behaviour was filmed on small sets in
studios where you can control lighting, temperature, day length and
humidity, thereby providing the optimum conditions for both the
insects and filming.

[†] This was before cold light sources like LEDs. Tungsten film lights
are inefficient and give out loads of heat. This can make the plants
wilt and alter insects' behaviour. OSF had built their own cooler
tungsten lights with copper cowlings to act as heat sinks. To focus
the light and filter out more heat, the light was shone through large
round laboratory flasks filled with water.

away, it seems more comfortable and begins to explore the branch, inspecting each leaf along the way. Eventually, it finds one it likes, and starts its intricate work: nature's origami. It uses its six legs to methodically curl the leaf in, and its mouth to bite the various ribs to secure each fold. Over the course of 30 or 40 minutes, it has created this tightly rolled cylinder, no bigger than a cigarette filter. Once happy with the construction, it turns around, sticks its rear in, lays an egg, and delicately closes the entrance, tucking the remaining flap of the leaf into place. It walks off, leaving the egg to do its thing, and searches for another suitable leaf. It repeats the exact same, almost mechanical, pre-programmed process. And over the course of the day in the small studio, the weevil rolls six or seven more cylinders, laying an egg in each one.

Sean films the creature, getting a variety of angles, changing lenses to obtain detailed close-ups and wide shots. All the while, I am being drawn in and totally captivated by this weevil. It's the first time in my life I've watched something so intently, working in its own world, seemingly programmed to fold and cut and lay. As Sean moves closer with the camera, so do I.

After the film has been unloaded and labelled for the lab and the weevil returned to its jar, I am alone to tidy the studio. I am still so entranced by what I have just witnessed that I take some tweezers and a pair of nail scissors and try to copy the weevil's work. I choose a leaf and, with the utmost concentration, attempt to replicate the weevil's craft. How difficult can it be? But however carefully and patiently I proceed, and no matter how hard I try, it doesn't work. The leaf springs open. Man's great brain and modern tools cannot match this tiny insect's art and craft.

I realise I haven't just seen this weevil. I have observed it, studied it, and am beginning to understand it. This

will be a turning point for my interest in wildlife and nature. To think I had perhaps walked past these weevils, or any other insect for that matter, and missed their world of work. Up until now through my life, I have been taught or told to look. But only now I understand and know what that really means. After today, my eyes are open to nature.*

OCTOBER 1983

3° 21' 47" S
38° 35' 43" W

Tsavo East National Park and Tiva River, Kenya

It has been a real privilege to meet Simon Trevor and Alan Root out in Kenya. These two legendary cameramen are pioneers in African wildlife filmmaking and their films stand the test of time. Brilliantly made, great storytelling and stunning photography. Years ago, Simon Trevor used to be a warden in Tsavo National Park, and he was part of the anti-poaching team when the poaching of elephant and rhino became a big problem back in the 1960s and 70s, so he is very knowledgeable about this vast area. Having grown up and lived in Kenya his whole life, he is an expert in terms of bushcraft and how to behave around the animals that roam out here. I can't wait to learn from him.

* I took great joy in returning our weevil star to the woods where it came from. I placed it on a hazel branch and within 30 seconds it was sizing up another leaf to transform with its origami skills.

We are driving through the wilds of Tsavo East, scouting locations for scenics for a four-part series on beetles, ants, wasps and spiders. It's by far the largest of Kenya's national parks, with its distinctive rich red dirt roads carved through a generally flat dry grassy landscape dotted with acacia bushes and trees. The air is dry and warm with the dusty smell of Africa.

One thing we need for the dung beetle sequence is a backdrop of elephants crapping: that will then lead into the story of how dung beetles can smell the shit, find the shit, make little balls with the shit, and then roll them away, bury them and lay their eggs in them.

We've spotted some elephants, so Simon stops the Toyota and says, 'Gavin, come with me. Let's quickly scout whether these elephants are well behaved or not and then where we can put the camera.'

No gun, no protection, just me and Simon in our sandals heading towards a herd of elephants in an open forest. 'Sure,' I say.

Simon says, 'Right we're going to stay downwind of them, but sometimes the wind changes. If it does, we'll have to move so we're not *up*wind of them, so they don't smell us. Elephants have got an amazing sense of smell, 400 times better than humans, and because they've been hunted and poached, they are quite nervous. If they smell you they'll do one of two things: they'll run away, which we don't want because we want to film them, or they'll run at you, which we don't want because we might get flattened!' I must look a little nervous because he adds, 'Just stay with me and do exactly what I do; we'll be perfectly safe.' Hmm, having just told me that they might flatten us.

'One thing, though: when you're following me you should keep an eye on the elephants. If you think that one has seen you and it swings its head up and starts staring at you, just stay stock still. Elephants have very

poor eyesight and, as long as you stay absolutely still, the elephant probably won't be able to see you. Don't move, even when it lowers its head and starts to feed again, because what the elephant will do is swing its head up and stare at you again to try and catch you out.'

Stay downwind, follow Simon, watch the elephants, stand stock still (twice). Got it. My first introduction to wild elephants – baptism by fire.

Simon picks up some dry sand and, as we move forwards, he lets it trickle out of his hand a little at a time to see which way the dust is blowing and therefore judge the wind direction.

We get closer and closer to the elephants. Before I know it we are in the forest surely less than 30 metres from these massive animals and, to be quite honest, I am feeling pretty scared. But I trust Simon, I am going to stick with him – and, anyway, I don't really have a choice at this stage. Now I can see them clearly and can count seven among the trees. They must all be around ten feet tall at the shoulder and their dark wrinkled skin is caked with drying mud. The animal nearest me has large elegant curved tusks, very intimidating, especially as I'm on foot.

Simon heads between two sets of trees with me stumbling at his heels, keeping a watchful eye on the elephants. As he makes it to the next set of trees one of the elephants swings its head up and stares straight at me. I stop dead, poised on one foot, mid-step: playing musical statues with an elephant. Its huge ears are spread, and honey-brown eyes scrutinising the space where I stand. The elephant continues to stare and my heart is racing. But sure enough after a few seconds the elephant puts its head down and starts to feed again. I follow Simon's advice and don't move just yet: I watch it, staying stock still, and a second later the elephant swings its head up again and looks right

at me. A few seconds later, clearly satisfied there's no threat, it lowers its head once more and carries on grazing – I move forwards to catch up with Simon. I am still feeling frightened, but it's really reassuring that Simon's observation of what that elephant would do if it thought it saw you was spot-on. Every time I work with elephants in the future, it's an observation I will remember.

That is the first bushcraft skill I learn from Simon but it won't be the last: I will learn many more before the trip is out.

We are spending a few days up towards the Tiva River in Kenya and are driving along the dry riverbed one day when the car gets stuck in the sand. No luck with revving it and the car starts to overheat. We all get out and, while Simon opens up the bonnet, Sean, second cameraman Dave and I grab the shovels to start digging the car out of the sand. Simon takes the lid off the radiator to let the engine cool down, and water and steam start spewing out – and amid the mayhem he is stung by a bee. Quick as a flash he takes out a handkerchief from his pocket, grabs the bee that was stinging his arm, wraps it in the hanky and buries it in the sand.

Looking up, Simon says, 'Right, everybody stay still, everybody stay quiet. We're right under a tree with an African bees' nest. I've been stung and the pheromone from that bee sting could cause the rest of the bees to attack. If we get attacked by bees, run as fast as you can. Run through bushes and just keep running. Don't worry about animals. These bees will kill you. They'll sting you to death.'

Doing as he says I stay stock still. Sean, Dave and I slowly look up into the tree. Sure enough, halfway up the trunk I can see bees angrily buzzing round a hollow.

Very slowly, Simon starts collecting dry sticks from the riverbed. He gets his lighter out and makes a small fire. Then he picks some green leaves from the bushes at the base of the tree and puts them over the fire to make it smoke. 'Right, just stand in the smoke and the bees won't attack you. Now we should be fine to let the car cool down, top up the water and dig it out – but if you're attacked by the bees come and stand in the smoke.' A little apprehensively we return to the task of digging the car out.

African bees kill lots of people every year.

29 DECEMBER 1988

9° 03' 59" N
79° 23' 21" W

Panama City, Panama

Just eight days ago, on 21 December, at 31,000 feet above Lockerbie in Scotland, a terrorist bomb ripped apart Pan Am flight 103, killing all on board and 11 people on the ground. The whole world is in shock.

'Donation' to customs

Cameraman Alan and I experience the inevitable security reaction when we check in 19 bags of camera kit onto an American Airlines flight at Heathrow. We are flying to Panama City via Miami, en route to the jungle to film a sequence about bivouacking army ants for the new Attenborough series *The Trials of Life*. Each bag is opened and thoroughly searched three times before we even get to check-in. Both of us are quizzed as to the purpose of our trip, where we are going, what is in the bags and so on. Although tedious, I don't mind the extreme nature of the security checks. After all, I want to know that the flight I am taking is going to be safe to get on. Alan,

pragmatic as always, pointed out that probably the safest time to fly is after a disaster, so he isn't worried at all. After a meal, a film and a few gin and tonics I manage a few hours' sleep sitting upright in my economy seat by the toilets.

Luckily, we don't have to claim our bags in Miami and re-check everything, as they are tagged all the way through. After another three-hour flight we land in Panama City. The air is warm and a dank smell of mould fills the terminal. The sign 'Bienvenidos a Panamá' welcomes us, but there is a sense of tension and edginess, with armed police on patrol. Immigration, though, is straightforward and a firm stamp in my passport means I'm in.

However, it's a different story in the baggage claim hall, where there is chaos. Everyone has crowded the belt so bags have to be passed over people to get out. Thankfully there are some helpful porters on hand, each with a numbered waistcoat and beaten-up trolley. Once all 19 of our bags are accounted for, Alan kindly gives me the responsibility of dealing with customs and getting our equipment list and paperwork stamped. The customs officer leads me through to a back office and offers me a chair next to him at his desk. Glancing round the room at upturned chairs and empty bottles, it is clear that they've had quite the Christmas party. The officer asks me what I need him to do, so I show him my duplicate equipment lists and ask if he'd mind stamping them to show what we've brought into the country. Then, when I leave in nine weeks, I'll be able to prove that I'm taking everything out of the country that I brought in, thereby avoiding any import or export charges. He nods, understanding, and pulls open the drawer and gestures towards the official customs stamp.

With a Spanish accent he says, 'We had quite a nice Christmas party last week, and, as you know, soon it will be New Year's Eve. Would you like to make a donation to our customs New Year's Eve party?'

My God, I've never had to deal with a situation like this. I keep smiling and diplomatically wish him all the best for New Year's Eve and explain that I hope to have a drink or two myself in Panama to celebrate. However, I don't think it appropriate to donate to their party.

Raising an eyebrow, the officer looks down at the customs stamp and pushes the drawer closed. He then looks back up at me and shrugs slightly as he folds his arms.

I push again for him to stamp the equipment lists. Without saying anything, he opens the drawer again to expose the stamp.

'Are you sure you don't want to make a contribution?'

I really wish that Alan was here, but I am very aware of the consequences of not having customs forms stamped in and out of countries and the taxes can be hefty.

So, reluctantly, after a few awkward minutes of the drawer being opened and closed, punctuated with raised eyebrows and the folding of arms by the officer, I make a donation to the party fund. I hand him the smallest note I have, $50. With that he smiles, puts it in his pocket and stamps my customs form and equipment lists. He shakes my hand and, with his arm round my shoulders, shows me back out to the baggage hall, where Alan and the porters are waiting.

Finally, we spill out onto the busy pavement and Alan hails a large station wagon taxi. However, our handful of porters have other ideas and all go their separate ways to different taxis. Trying to keep eyes on our 19 cases, I whip out a fistful of dollars and shout to the

porters, 'If you want paying, then put all the bags in here', gesturing to the open boot of the station wagon. Within a minute all 19 bags have been stuffed into the taxi. I dole out another $50 note and leave the porters to fight it out. Our driver, Pacifico, then takes us to our hotel, giving us a running commentary along the way. Architecture, state of the roads, unrest in the city, the best bars for music and dance. More than we can really take in after 18 hours' travel.

Having checked into the Holiday Inn, I meet Alan in the bar in time to get an order in during happy hour. Alan suggests we get two drinks each as happy hour is about to end. We both order piña coladas. What we had misunderstood, though, is that 'two for one' means something different here and the barman delivers eight piña coladas to our table. Needless to say, I sleep very well.

9° 06′ 22″ N 31 DECEMBER 1988
79° 41′ 46″ W Gamboa, Panama

After stocking up on some essential supplies – namely, whisky and beer – we are dropped off at the dockside in Gamboa with all our kit. It is late afternoon and we are waiting for the boat that will take us to Barro Colorado Island, better known as BCI. Run by the Smithsonian Institute, the island is in the middle of Lake Gatun, which was formed when the Chagres River was dammed back in 1913 to form the Panama Canal.

The sun is starting to warm in colour as it descends in the west over the Panama Canal. Fifty metres or so from us along the jetty, a group of people are unloading some big speakers from the back of a pick-up. They are already on the beers and rum, obviously preparing for

a New Year's Eve party. Minutes later, on comes some music, a gentle Latin beat. As chairs and tables are being laid out, a man and woman start to dance. It is such an atmospheric, romantic image. The rhythm of the bass and the couple's coordinated, natural moves are backlit by the setting sun. This is one of those moments that reminds me of the richness of travel. Witnessing other people's cultures. How rare would it be to see something similar in England?

The boat arrives and we load up. As we head up the Panama Canal I look back at the dancing figures as they and the music fade into the distance.

It is about an hour's travel to BCI but it feels like a lot further from civilisation. It is now just before sunset. As the boat slows, I look down into the water. I can see the ghostly pale tops of trees as we drift over them. It suddenly hits home that this was once all tropical forest. When the Panama Canal was being constructed and they built Gatun Dam to block the Chagres River, it flooded 164 square miles of forest. Eighty or so years on I am seeing the skeletons of the hardwood mahogany trees still standing, but now totally submerged.

We unload the kit onto a floating jetty. From there it is a short walk to the base of the hill, but then at least 100 steps to the huts at the top. It is hot and humid, and, with the light fading fast, the mosquitoes are already feasting on our fresh English blood. Thankfully, to the left of the steep steps is a very Heath Robinson winch railway trolley. Our 19 bags are piled onto that and it is dragged up to the top at a snail's pace. A damn sight easier than carrying it.

The accommodation is basic, to say the least. Wooden clapperboard huts with simple bunks, each with a tatty mosquito net. There is a similar-design kitchen and a communal mess, termite-ridden library

and a sitting room with sofa. This is when I remember a valuable piece of advice from a veteran cameraman Hugh, who has filmed here before. 'Don't, whatever you do, sit on the sofa!'

Apparently, it is possible to pick up every parasite going from it.

Myself, Alan and a handful of scientists sit on the veranda, looking across at the ships cruising past on the canal, their lights appearing and disappearing through the gaps in the trees.

Five hours behind England, it is too late to try to ring home. I see the New Year in (just) and head to bed.

9° 09' 57" N
79° 50' 11" W

1 JANUARY 1989
Barro Colorado Island, Panama

Beware the Jiggers!

I have a restless night's sleep coping with the heat and humidity. The noise from the forest around is constant – I presume it is mostly crickets and frogs calling. Also, I had to get up and patch a few holes in my mosquito net with gaffer tape:* a single mosquito buzzing past my ear inside the net was keeping me awake. Bastard things. Why didn't God invent a parasite that didn't make you itch or give you a deadly disease? Then I am woken early in the morning by the most extraordinary roaring sound. It grows and fades and seems to echo from different directions. Is it a jaguar?

First light is coming. Excited to explore the island, I put on shorts, T-shirt and flip-flops and head for breakfast: fresh fruit and coffee. Alan arrives too, wearing the same attire. I ask a scientist what that

* Gaffer tape is indispensable. It's what holds the film industry together – sometimes literally.

roaring sound might have been and he said it was the howler monkeys. 'You can hear them from up to three miles away.'*

Can't help but notice that the scientists heading out into the forest are all dressed the same: long-sleeved khaki shirts, long trousers and boots, the sleeves of their shirts and their trouser legs taped tight with duct tape (inferior to gaffer). They each have various collecting gear, nets and jars, and all carry a machete. Before they head out, I ask if they have any advice on an easy trail for Alan and me to explore. They show us the trail map and it seems quite straightforward. But they all say, 'Watch out for the jiggers!'

Alan and I thank them for the advice and they head off into the forest. Being macho and not wanting to appear ignorant, we don't ask where we might see these 'jiggers', if they are common or dangerous. I had done some research before coming out to Panama and had mostly read about jaguars, monkeys, armadillos, anteaters, snakes, sloths and tapirs. Not to mention over 900 species of bird. I don't recall reading about jiggers, though.

Unfazed, I grab my stills camera and we gingerly head out along a trail to explore. Either side of the cut trail the forest is sometimes so thick you can barely see six feet. Tangles of lianas and spiky plants hang down from the trees to meet the understorey. It seems that every stem, branch and bough has spines or thorns. This forest certainly is hostile. All the while, though, we are both peering into the shadows and up above us into the trees for the jiggers. Surely they can't be that dangerous or they wouldn't have let two English rainforest virgins out on their own?

* When I get home I look them up: according to the *Guinness Book of World Records* they are the loudest land mammal.

We make it back to base alive and ready the camera kit for that evening's filming.

As the scientists return, each one smilingly asks how we got on with the jiggers. 'Never saw any!'

That evening, though, we both discover what jiggers are. We are both itching like crazy. It turns out that jiggers are parasitic fleas that burrow into your skin and lay eggs. They cause itching and swelling and multiply while feeding on your flesh.

Now we know why the scientists dress the way they do and tape up their clothing.

The tricky thing for us is that, because we are here to film army ants and their behaviour, we can't use any insect repellent as this will obviously upset the ants. So we just have to tape up our sleeves and trouser legs like the scientists and grin and bear it.

An army ant colony can contain more than 10 million insects. They don't have a fixed nest but are nomadic and have a fairly rigid cycle. While they have eggs and pupae, they will remain stationary for around 20 days, with only adult mouths to feed. When they have larvae, the ants will move the whole colony and bivouac every night. This is because they need much more food at this stage and would deplete an area if they stayed still. They can hunt, kill and eat up to 500,000 prey items a day. These can be anything that moves, right up to lizards and small mammals that fail to get out of the way. We have eight weeks to film this story, working days and nights to fit in with the ants' activities.

That evening we head out to an army ant colony that our scientific adviser, Dr Franks, found in the day. It is a good half-mile away and we have to hike our filming equipment, including generator and lights, over several journeys.

Once it's dark, the ants start to move house. They are currently just a big bundle of ants about twice the size of a rugby ball. A procession has started, like a mini motorway in rush hour. We have to push our way through the jungle by torchlight to see where they are heading. The ants seem to be settling and forming a new bivouac about 100 metres away. Alan and I then stage the generator halfway along their route and run out cables for the lights. It is a hot, sweaty and gruelling first night's work. We both get hammered by all sorts of biting insects, not to mention highly defensive army ants despite doing our best to keep out of their way.

Exhausted, we give up at around 4.30am, ferrying the vulnerable bits of camera kit and the generator back to base and leaving the tripods and lighting stands to pick up during the day.

7 JANUARY 1989 9° 09' 57'' N
BCI, Panama 79° 50' 11'' W

Pretty exciting day. David (Attenborough) arrives with the sync crew from England: director Brian, cameraman Brian, sound recordist Bruce and production coordinator Pam.

It's quite funny that they shipped in a different crew to film the pieces to camera with him, considering that, as a senior BBC cameraman, Alan used to film the Queen's Christmas speech for many years.

It is great to see David on location, delivering pieces to camera with 'our' army ants. He is really keen to know what footage we've got and not afraid to get up close and personal with the ants, even using our endoscope to peer inside the bivouac, inevitably getting bitten but genuinely excited to see the internal structure,

as we were: how the millions of ants cling to each other to form baskets to hold their eggs and pupae.

We won't, of course, see the results until the film is processed and printed back in the UK.

This evening a bat flies into the supper hall and gets distressed flying into the light. David swiftly catches it in his glass and then sets it free out through the door. Everyone cheers.

9° 09' 57" N **10 JANUARY 1989**
79° 50' 11" W BCI, Panama

Alan and I have barely had any sleep now for the last week. Both of us are peppered with insect bites and scratches from thorns and plant spines. I count 400 ticks on my left arm alone. I've been waking myself up just through scratching and with blood under my fingernails. It's driving me insane. Also, many of the bites are starting to get infected.

Clearly, we need to recuperate and so Alan and I have been allowed the night off. We take the boat back to Gamboa, then the bus to the Holiday Inn. En route we buy 4kg of salt. Alan has the idea that we should soak our wounds in salty baths back at the hotel to try to help them heal.

At 7pm we rendezvous at the bar with the sync crew. David announces that he has been invited to dinner at the British embassy in Panama City, but being a generous team player, he informed the British ambassador that there were eight of us in the crew and would they be able to extend the invitation to all of us? You can imagine the ambassador wincing as he agreed.

We all have a splendid evening taking full advantage of the free-flowing wine. I sit at a table with the chief engineer of the Panama Canal, who invites me on a tour of the locks, which are currently being serviced for the first time in 80 years. I sadly have to decline as I need to be back on BCI the next morning to carry on filming.

We say our thank yous and goodbyes at 11.30 and head back to the Holiday Inn. David then says, 'Everyone back to my room.' He and the production coordinator have prearranged a cake and three bottles of champagne, as it's Bruce's birthday. David hands Bruce and me a bottle each and the three of us step out onto David's balcony. We pop the corks, firing them off the 17th floor over the rooftops of Panama City. I think to myself, *This is a moment I will remember forever*. So uplifting to find out that Sir David – as well as being a top naturalist and broadcaster, the inspiration to launch my career, a respected figure recognised by the Queen with a knighthood just four years ago – is also a top bloke.

Back inside, Bruce cuts his birthday cake with the only knife available, a machete.

———————

24 MAY 1989
51° 29' 4" N
2° 35' 18" W

Southmead Hospital, Bristol, UK

At 10.10pm and two weeks late, after a long, arduous labour for Maggie, our first son, Thomas, is finally born. Weighing nine pounds, he's a good-looking boy with his spiky hair like a little hedgehog. Now, it sounds awful to say, but I thought I never really wanted

First born

children. The weird thing is that as Thomas draws his first breath and cries I'm suddenly aware of an innate connection. This fragile, vulnerable newborn boy is my flesh and blood. *Our* flesh and blood. I am overwhelmed and tears flood down my face. Maggie is exhausted and, as the midwife, doctor and nurses go about their business of weighing, note-taking and so on, I watch their every move. Suddenly, I feel ultra-protective of Thomas. If one of those professionals so much as hurts a hair on his head I know I will step in to protect him. It is a strange feeling: a defensive instinct I never knew I would have. I am now a dad and very proud to be so.

41° 54' 7" N
12° 27' 25" E

20 JUNE 1991

St Peter's Square,
The Vatican, Rome, Italy

On the
Pope's turf

My first visit to Rome. What a stunning city. Great history, arguably the best architecture in the world, coffee and, of course, Italian food. Rupert and I grab a quick dinner in McDonald's.

We are here to film pigeons, of all things. It is for the BBC series *Lifesense*, looking at the relationship between animals and humans. Our brief is to shoot a short sequence talking about Christianity, and man's increased domination over animals, rather than a more symbiotic relationship.

I happen to quite like pigeons. Up close they are beautiful, with subtle iridescent colours in their plumage. I love to see flocks of them swooping through the air in our cities. Apart from the odd tree, it's sometimes

the only small connection and reminder of the natural world in among our man-made structures.

We have film permissions from the Vatican; Rupert, the producer, just has to pick them up from the office. So the two of us take a taxi to St Peter's Square with the camera kit. Rupert helps me carry the stuff to a good position in the square and then heads off to the office to get the paperwork.

The square is actually oval-shaped and larger than a football pitch. It was designed to give the greatest number of people a view of the Pope when he gives his blessing from the balcony. It's cobbled in dark granite, with lines radiating from the central obelisk in white limestone. The whole square is encircled by a spectacular colonnade four columns deep. I set up my camera and tripod. Initially, I plan to pick off shots of flocks of pigeons swirling round the square against the fantastic and recognisable backdrop of the Renaissance dome of St Peter's Basilica. Also, slow-motion shots of the pigeons flying in front of one of the two famous fountains to the sides of the square. In my opinion, architecture is probably the best thing ever to have come from religion.

The sun is shining and the pigeons are doing their thing. I look up briefly from the camera and can't help noticing a number of men in smart dark suits making their way across the square from different directions. I look to my right: another; to my left: another. It is soon pretty clear they are heading for me in some kind of mafia-style pincer movement.

The first Italian accent to reach me asks: 'Sir, do you have permission to film?'

'Er, yes, but, er, Rupert, the producer, is, er, picking up the paperwork from your office.'

'If you don't have permission then you will be arrested.'

Within seconds my camera, tripod and lens bag have been picked up by three of the suited men. Two others grab my elbows and I am marched quickly across to the corner of the square. Not sure if concrete boots are still the order of the day, I am slightly unnerved. But just as they duck my head into the office door, much to my relief I meet Rupert on his way out.

'Here's Rupert. He's the producer. He has the permit.'

One of the suited men checks the paperwork. He then smooths my ruffled shirtsleeve and gestures to the door. 'Have a good day, sir.'

Quite chuffed that I have been frogmarched by the Vatican secret police, we film the pigeons uninterrupted for the rest of the day.

30° 38' 31'' N
104° 2' 18'' E

25 FEBRUARY 1995

Chengdu, China

Another tedious 12-hour flight. Landed in Chengdu and met with producer, Justine. The two of us have travelled out ahead of the sync crew arriving with Hollywood actress Debra Winger. I remember Debra playing the part of love interest Paula carried off into the sunset by Richard Gere in the 1982 film *An Officer and a Gentleman*. I won't lie; I'm quite excited to meet her.

We are filming a 50-minute documentary called *In the Wild: Pandas with Debra Winger*. It's a clever series formula by Tigress Productions which takes Hollywood stars to see charismatic animals in the wild. It draws in both the wildlife audiences and the viewers more interested in the celebrities themselves. This programme is going to be about giant pandas: their plight and issues

they have to deal with, and why they're disappearing in the wild.

This is my first visit to China and, although it sounds stupid to mention, China is the most foreign foreign country I have ever visited. People and bicycles everywhere; really busy, loads of traffic. But the weirdest thing is that there is no sign of anything Western. Most countries I visit now, in the cities at least, I'll see a McDonald's sign or Burger King, Coca-Cola or whatever. Western signs, logos and branding seem to creep in across the world. In Chengdu there is none of that at all. It's all Greek to me – well, Chinese.

We stay overnight and my hotel room is on the 15th floor overlooking a very busy crossroads. Jet-lagged by the long journey and eight-hour time difference, I sit at my hotel window looking down at a busy traffic-light-controlled crossroads and watch, in awe, the world's best ongoing bicycle-versus-car stunt I've ever seen. Alternate streams of bikes crossing diagonally, then cars at right angles, without the slightest flinch or swerve from anyone. I'm very impressed and can't work out quite how they do it.

26 FEBRUARY 1995 31° 01' N
Wolong, China 103° 11' E

It was a long and terrifying car journey to Wolong,* home to the giant panda sanctuary set up in 1980 by the Chinese government and WWF (World Wildlife Foundation *not* World Wrestling Federation!).

* The Wolong Panda sanctuary is no longer at this location. It was moved in 2008 after a huge earthquake devastated the area.

Our driver clearly has an unfulfilled death wish as we spend perhaps half our time travelling at great speed on the wrong side of the road, displacing oncoming traffic. Hats off to him, though, for winning every game of 'do or die' chicken he's played with several thousand lorry drivers along the route.

Our fixer-translator must have taken a handful of Valium, or the Chinese medicine equivalent, because he sleeps almost the entire way.

It's very late here and I'm exhausted. So after a 21-dish dinner, which was mostly surprisingly good despite being laced with MSG, I'm off to bed. Tomorrow I go to see and film my first giant panda.

31° 01' N **27 FEBRUARY 1995**
103° 11' E Wolong, China

My God it was cold last night. The only heating in my room was a small electric wok heater glowing red hot but barely touching the chill. I slept fully clothed under the heavy blankets and still felt cold.

Had a '7', a '14' and a '9' with lychees for breakfast before Justine and I head up to the panda sanctuary. The valley looks stunning. Above the less than tidy town, the slopes either side are steep and jagged, the peaks and ridges are dusted with snow and a mist hangs in the air, mixing with the smoke rising up from the buildings below. The scene looks just like a classic Chinese silk painting, with the ranks of mountains fading off into the distance in ever paler shades of grey. Silhouetted against the greys is the odd gnarly tree clinging precariously on knife edges of rock. They look like classic bonsai sculpted trees. It just needs a big red Chinese character proverb and you could put this picture straight in a frame.

As we approach the panda sanctuary, we pass several men pulling carts up the hill, all laden with stacks of fresh-cut bamboo. It turns out that it is a daily ritual to go and harvest bamboo and bring it to the enclosures for the pandas to feed on. There's very little nutrition in bamboo, so pandas have to eat an awful lot of it. Once at the sanctuary we meet with the keepers, and have a brief meeting to explain what we are hoping to film. Here is our chance to get intimate close-ups of the pandas doing their thing, which will supplement the footage we hope to get in the wild.

The idea behind breeding them in captivity with a view to releasing them back into the wild is to try to keep the gene pool alive. Justine and I are about to spend four days filming in Wolong and it won't be the happiest of experiences. Some well cared-for but very sad-looking pandas. Archaic 1900s-looking cages with steel bars and bundles of bamboo being thrown in for the pandas every day. Quite depressing to see that man had caused such destruction that these animals only have a chance of surviving if we keep the gene pool going in captivity.

There is one, more open enclosure, about the size of four or five tennis courts with a few proper trees in it, a few real growing bamboo stands, and we are able to release a couple of pandas into that space for the day and film them looking like they are kind of in the wild. The good thing about filming them in captivity is that I am able to get quite close to them and shoot big close-ups of their features, their hands. Pandas have really weird hands, because they only eat bamboo. Literally 99 per cent of their diet is bamboo and, to ingest enough of it, they'll be eating for 12–14 hours a day. A giant panda will eat an occasional bit of carrion or meat, but the rest of the time it's bamboo all the way. In order for

them to break the bamboo, they've got an adapted wrist, almost like a sixth finger, that they can use to snap it in two. Pandas have very strong jaws. I don't know if you've got bamboo canes in your garden, but they are really tough and woody. Obviously, the younger shoots are more tender, but it takes a lot of chewing before your guts will have a chance to digest the bamboo. And that's pretty much all giant pandas do.

31° 48' N **4 MARCH 1995**
103° 3' E Qinling Mountains, China

Starstruck Justine and I head off into the mountains in Qinling with the local scientist and trackers, to try to find and film the pandas in their real habitat. It's about a four-hour hike into location over a steep mountain ridge. We are joined here by the main crew: another cameraman, sound recordist, assistant, director and, of course, Debra Winger, who has also brought along her boyfriend and son. Debra is lovely, genuinely. It has been a real joy to meet her. I've had a crush on her since she was in *An Officer and a Gentleman*, so it's great to find out she's good fun to be with.

The mountains we are trekking through have steep slopes up to a knife edge, then down the other side to a river, then up to another knife edge, down to a river, and we're up at around 5,000 feet (pandas live between 5,000 and 15,000 feet). Of course, being a panda, they'll quite happily trek up and down those slopes to find their bamboo. Being a camera crew and burdened with film camera and tripod, batteries, warm gear, food and water, it is a little slower going.

At least, though, a panda is quite easy to find: 12–14 hours' worth of bamboo chew has to go somewhere,

and a panda will crap 30–35 times a day – they're leaving us a breadcrumb trail of turds through the bamboo forest. As it's fairly easy for the trackers to see whether faeces are fresh or a day or two old, we are able to find where the pandas are active.

However, what I should point out is that bamboo forest is incredibly thick. There are places where you literally can't see six feet in any direction. We are sometimes quite close to a panda and can hear it crunching away on the bamboo, but to get a shot of it is very difficult indeed and we're not achieving a huge return.

The other thing the director is really keen to get, of course – for the cute factor – is a mum with a young baby. A lot of the pandas are satellite-collared, so the scientists can keep tabs on some of the population and also learn about their range across the mountains. They've found one with a ten-month-old baby; now that's a very, very cute age. A ten-month-old baby panda is just learning to climb trees and be a bit more independent of its mother. We all know what a panda looks like – essentially a black and white, fluffy, cuddly teddy bear. Incidentally, the Chinese for panda is *dà xióng māo*, which in English, directly translated, means 'big bear cat' – that's exactly what they look like. The weird thing about pandas is they're one of the few mammals, other than cats, that have a vertical slit iris.

The scientist who told us this says, 'The best chance you've got is if Gavin goes on his own with a tracker, finds it, stays up overnight on his own, and then tries to film it in the morning so he doesn't spook that mum and cub away.' Pandas are very solitary – they don't like bumping into other pandas. This is part of the reason they're endangered: they only breed about every four years and they try to steer clear of each other. They also

have an excellent sense of smell and so, because they've been persecuted for years, if they detect a human then they'll move away; they don't want to get shot, eaten or sold off for body parts.

31° 48' N **10 MARCH 1995**
103° 3' E Qinling Mountains, China

So, the next morning, I head off with the tracker. We walk for about two or three hours up and down the knife-edge mountains and, once we get close, the tracker uses a radio receiver to home in on exactly where the panda is: up at about 12,000 feet. It is already pretty cold, I can see snow right up on the tops of the mountain ridges, but we find her – or rather we get close enough to hear her crunching away. The tracker, who speaks no English at all, helps me set up my tent. The only flat place is a ridge about three feet wide, so not much wider than my shoulders – a foot narrower than the actual width of the tent. Twelve inches of tent is therefore hanging over a slope with a 400-foot scree slope down to some trees at the bottom. If I roll around in my sleeping bag tonight I'm going to end up at the bottom of the hill.

About 50 metres back we set up the hide, on a slight ridge, about 30 or 40 feet above a sea of bamboo where we think the mum panda is. We haven't seen the cub or heard it yet, but we have our fingers crossed.

The tracker waves goodbye and leaves me there for the night. I have a couple of hours before darkness, so I spend the time crawling very slowly between the hide and my tent, clearing every leaf, every little bit of bamboo, any twig. The idea is that, when I get up in the morning, I'll be able to crawl from my tent to the

hide without making a single sound – because the last thing I want to do, having spent all night up there on my own, is frighten the panda off if it should be there.

Anyway, I have a flask of soup, get into my sleeping bag, and try to get some sleep. A few things are getting in the way: I'm miles from anywhere, totally on my own. I am sleeping on this ledge with a massive 400-foot scree slope to my right. It is bloody cold. And all I can hear all through the night is the crunch, crunch, crunching of the panda working its way through its bamboo dinner. Plus I'm excited to see a real wild panda.

11 MARCH 1995
High up in the Qinling Mountains, China

31° 48' N
103° 3' E

As the light comes up in the morning, I'm excited to go and get into the hide to see if this panda is there. I pull on my boots, slip out of the tent, and crawl slowly along the path I've cleared. I get to the hide, very carefully lift up the flap, climb inside, tie the laces up on the tent flap behind me. Very slowly I roll up the front of the hide, and poke the camera lens out. To my joy, just below me, the panda I'd heard crunching away on the bamboo through the night has cleared a beautiful arena about 30 feet across. She is in the middle of it, just 30 or 40 feet below me, about 50 feet away, and God, I am so excited to see her. She is sitting almost facing me directly, her feet towards me. Casually leaning back, she grabs a stem of bamboo and adeptly snaps it towards her. Then, holding it to the side of her mouth like a flute she starts to crunch. That's the sound I've been hearing all night. It wasn't a pointless night for me after all. I start filming.

Truly wild magic

87

Meanwhile, I am also scanning around hoping I can see her baby, and after about an hour, sure enough, this tiny little cub crawls out of the bamboo, comes back to mum and plays around. It rolls and tumbles like a toddler whilst mum continues to feed. Eventually, not getting the attention it wants, it squeezes in and sits comfortably in mum's lap. This is TV gold. But more selfishly than that as I watch is that my excitement feels as if it's overflowing: I am seeing a real giant panda in the wild and experiencing it totally on my own. It is the ultimate wildlife experience. As I continue to film and watch, it starts to snow: beautiful, cartoon-like giant snowflakes are drifting slowly down, floating side to side like falling feathers, and it just completes the scene: it looks beautiful. The snow settles on the bamboo leaves and I am watching a live picture postcard.

On cue, the baby starts to perform almost as if I've passed it a script. It climbs up a branch that hangs over the arena mum has cleared, and is level with me and my camera! I frame and choose my shots: snow falling, mum crunching on bamboo, baby climbing up the tree. Then, to my horror, the baby falls out of the tree – a good 30 feet – and I hear a sickening dull thud. The sound of its skull hitting a rock in the undergrowth below. Far from it being comical, I am in shock. I wait, and I wait, and I look. Mum doesn't seem at all concerned, but the baby doesn't appear. I'm thinking, *Oh my God, no wonder they're going extinct. As well as having a limited diet, being persecuted by humans and suffering habitat loss, they're also blimming stupid!*

Eventually, after another hour, the baby panda reappears looking fine – there is no blood on its fur. It climbs up the tree again, falls out of the tree again, and repeats this several times, and eventually mum and cub

drift back into the bamboo and head off. Half an hour later, the tracker returns to collect me and I wonder if the panda mum had heard or smelt him coming and that was enough for her to move away. I've been really fortunate that the wind was in my favour with the position of the hide and my tent.

I have no doubt that this will be one of the most magical wildlife experiences of my life. To be able to see a rare endangered animal in its natural habitat – and experience that totally on my own – was just beautiful.

1 JULY 1997

Cape Canaveral, Florida, USA

28° 34' 56" N
80° 38' 49" W

Today is the big day. Space shuttle *Discovery* STS-82 launches on its mission to upgrade the Hubble telescope. I'm here with producer and friend Nigel making a documentary for the Discovery channel about the history and future of rockets and space travel. Nigel has sorted permissions for us to set up several remote cameras to film the launch. We also have permission to be on the roof of the vertical assembly building to shoot the liftoff. This is the building where the Apollo and Saturn V rockets were assembled. Possibly the best view, as the building is 160 metres tall.

All our remote cameras had to be set up three days before as NASA understandably didn't want anyone unnecessary near the launchpad once the fuelled-up rocket is there. One of our remote cameras is my old ARRI 16HSR2. I set this up just 200 metres from the base of the launchpad with a wide-angle lens. This camera was going to shoot the initial ignition and liftoff in

slow-motion, 150fps.* I preset the focus and exposure and have to hope the weather will be sunny on launch day. To run the camera, it is hooked it into NASA's remote camera switching system. Shooting slow-motion, though, means it will only run for one minute 40 seconds before running out of film, so I hope NASA don't hit record too soon. Also, not knowing how big the blast from the rockets will be at that distance, I've put my camera in a metal flight case with a toughened glass port and weighed down the tripod with a pyramid of sandbags.

I have also set two cameras in the swamp lakes that lace through Cape Canaveral. Seeing the reflection in the water as the shuttle takes off should look amazing and be different from your average news coverage. I'm also hoping that we might see some sort of shock wave on the surface of the water.

Because we only found out a week ago that the cameras had to be set three days before launch, I've had to devise a way of triggering them using a timer. The simplest and cheapest things I could get hold of at short notice were battery-powered digital hose timers. I took them apart and, instead of turning a valve open or closed, I adapted them to switch the camera to run. The two cameras are Bolexes and will have enough film to run for two and a half minutes, so I had to get the timing precisely right. While Nigel watched out for alligators, I waded out and mounted these two cameras on scaffold poles hammered into the bottom of the swamp. Once set, it was fingers crossed. I won't

* This means 150 frames per second, so when the film is played back at normal speed, 25fps, the action of the flames, smoke and steam from the shuttle will be slowed down. One second of live action will take six seconds to play back.

know if the shots have worked until we have the film processed and printed back in England in a week's time.

It is now two hours before launch, so we take three more cameras up to the top of the vertical assembly building. Here we are three and a half miles from the launchpad. Only a handful of film crews are allowed up here for each launch. I line up my three cameras and now it is a case of waiting. It is hot and humid and there's no shade. The landscape around is dead flat. Other than the two distant launch pad gantries, the only features in this Florida swampland are a few more open waterways and some of NASA's tarmac roads.

Finally, the countdown starts. Up here on the roof, my plan is to set the two Bolex cameras running, one wide-angle and one slightly tighter shot. Then I will man the third camera with the long lens and follow the shuttle as it takes off and heads for space.

Over the Tannoy an American drawl calls, 'Thirty seconds to launch.' I do a quick double check and look down the first camera's viewfinder. What a cock-up!

'... 25, 24, 23 ...'

The old Bolex viewfinders are so grainy and dark I've lined up on the wrong launchpad! I quickly reframe and hit run.

'... 19, 18, 17 ...'

I race to the second camera: that too is lined up on the wrong pad!

'... 15, 14, 13 ...' What an idiot, all that time to set up! I reframe and run.

'... 9, 8, 7 ...'

I just manage to get to the third camera I need to man and start it rolling before the engines fire.

'... 2, 1, ignition. We have liftoff!'

Thank God for that! 2.02pm.

The Tannoy commentary continues. 'The shuttle has cleared the tower.'

I continue to tilt the camera up, following the space shuttle. The flames from the rockets are large and bright, plumes of smoke and steam billow out from beneath. The weird thing is the silence of it all. Only about 15 seconds after ignition does the sound reach us: an exaggerated roar of the engines. The strangest thing, though, is the power of the associated shock waves; I feel it like like someone gently beating on my chest.

'Twenty seconds into launch and the shuttle is at one and a half miles altitude,' continued the commentary.

'Sixty seconds into launch and the shuttle is now travelling at 1,000 miles per hour.

'Ninety seconds into launch and the shuttle is now travelling at 1,800 miles per hour.

And then 'If the mission is aborted now, the shuttle will land 4,000 miles away in the Gambia, Africa, in 40 minutes.'

Suddenly, the magnitude of this whole event strikes me. An extraordinary collaboration of brilliant minds, engineers, visionaries. The calculations and technology. Seven men and women are sitting in that disappearing rocket now travelling at 1,800 miles per hour and still accelerating towards space. On a mission to upgrade the world's most powerful telescope, the Hubble.

I feel small and out of my depth.

Eight and a half minutes into the launch, the shuttle is travelling at 17,500 miles per hour: the speed needed to escape Earth's gravity and maintain high orbit.

It makes me think. Apart from the excitement, the G-force and rush of the launch – and perhaps the view back down to our beautiful planet – why on earth would you want to leave?

20 MARCH 2001

Gualogo Triangle, Republic of Congo

COORDINATES WITHHELD*

Innocent chimps and zombie ants

Years before my first shoot in this part of the world, friend and producer Mark had been to the Congo when he was at Oxford University. He told me a story of an ant that gets infected and paralysed by a fungus. More recently, it's been nicknamed the zombie fungus. For a fungus to reproduce, it creates fruiting bodies that produce microscopic spores: the fungus equivalent of a seed. If you're an unlucky ant in the Congo and you happen to 'breathe' one of these particular spores in through your spiracles (one of the holes on the side of an insect's body used for respiration), this fungus can germinate and grow. It sends out mycelia, threadlike branching hyphae that worm their way through your body. There's all the information needed in one fungal spore, like a computer virus. The mycelia grow into the brain of the ant and reprogramme it to climb up a stick, about two to three feet off the ground, latch onto the stick with its jaws and then let go with its six legs. The ant is doomed and dies as the fungus eats it from the inside. The exoskeleton of the ant remains clamped onto the stick. Eventually, the zombie fungus will send two long fruiting threads, like miniature matchsticks, out the sides of the ant. The 'heads' of the match-like

* I've withheld this information for the chimps' protection.

tendrils are the fruiting bodies that then release more spores and the cycle goes on. Mark didn't see it on his trip, and I've never seen it either, but it's always been at the back of my mind each time I've come to the Congo.

I've now travelled to this part of the world several times and always find it exciting coming back. This time I'm with producer Brian, assistant Ralph, sound recordist Andrew and presenter Charlotte. We are here to make a film for the BBC about a population of 'naive' chimpanzees – *Congo's Secret Chimps*. They live in an area known as the Goualougo Triangle, which is currently under threat from logging. The 'triangle', around 100 square miles, is on the southern end of Nouabale-Ndoki National Park. It is named such because it has the Ndoki River forming a border on its south-west side and the Goualougo River on the south-east. To the north and east it's kind of protected by swamp and marsh. This means it has limited easy access, which has therefore kept it uninhabited and unexplored. Most exploration has been with a view to exploitation, usually in the form of logging for valuable hardwood. The Goualougo Triangle is fortunate in some respects, in that it's one of the few areas left to be logged. Partly because it would be difficult and expensive to get in with machinery, and then there's the cost of transporting the wood out. But those factors can only save it for so long.

The reason we are here is because scientists have very recently discovered a population of chimpanzees who they've nicknamed the 'innocent chimps' because they appear never to have seen humans before. Unfortunately, loggers have prospected this area to work out what types and how much wood is here to fell, and it's currently earmarked as a logging concession. Meanwhile, scientists are trying to find some kind of tag or hook: a reason to protect this area from logging and maybe turn it into a national park. The film we are here to make will hopefully bolster the package to

be put to the government to try to persuade them not to allow logging here.

When the scientists first came across these chimpanzees they observed behaviour totally different from any other known populations. Instead of running away in panic or fear, the chimps approached the scientists in bewilderment. They actually came closer. After some time they climbed up into the trees above the scientists and settled down, resting their heads on their hands and patiently watching. When the scientists still did nothing, the chimpanzees built nests and made themselves comfortable. It's as if they were saying, 'We don't know what you are or what you do, but we're going to sit and watch and find out.'

We are working in collaboration with WCS (Wildlife Conservation Society) and CIB (Congolaise Industrielle des Bois – the Congolese Timber Industry) and in particular a forward-thinking logging company owner called Hinrich Stoll. He has given us unparalleled and unhindered access to film in his logging concessions and timber yards. He claims to have the most responsible approach to logging in Africa and is not afraid for us as journalists to film and question that. Stoll currently has the concession rights to log the Goualougo Triangle area, but has reservations about starting because he recognises that this area may well be the last virtually untouched forest in Africa.

So now we are deep in the jungle looking for innocent chimps. One way the Bayaka pygmy trackers find them is to make the sound of an injured duiker: a high-pitched nasal, plaintive call. A duiker is a tiny antelope that lives in this forest, just a bit bigger than a Jack Russell, and chimpanzees sometimes hunt and eat them. An injured one would be an easy meal.

We settle down at the base of a tree and I set up the camera. Then the Bayaka start making this plaintive

duiker call. Within 15 minutes, we start to hear distant chimpanzee pant-hoots. Sure enough, within another few minutes, two chimpanzees appear in front of us, stopping in their tracks about 15 feet away. They are stocky, well built, and seem bigger than expected, almost my size as I'm kneeling low on the forest floor. Their dark fur blends with the shadows but their faces and eyes are clear and intrigued. They were obviously coming to find the injured duiker with a view to catching and eating it. Instead, though, they have found a film crew, a presenter and a Bayaka tracker, all sitting on the forest floor. Clearly, these two chimpanzees have never seen people before. They stare at us. Their faces are clearly saying, 'What the fuck are you?'

For me, and I'm sure for all of us, this experience is incredible. Like contacting a lost tribe. We are all staying very, very still. We don't want to scare the chimpanzees.

I film with the tripod set quite low to the ground. After a few minutes the two chimpanzees climb up about ten feet into the trees and settle down on a branch to watch us. They are looking at each other. Reassuring each other by holding hands. Looking at the humans on the forest floor. This, in itself, is so exciting. To be able to find a large intelligent mammal on this planet that is still innocent of humans. All too often you go to film animals around the globe and it's very difficult to get close to them. As soon as they see you or smell you, they will run a mile – because so many animals have been persecuted and hunted over the centuries, generations, in all parts of the world. The beautiful thing about these chimps is that they are innocent of man and innocent of man's destruction.

The observation continues. Us staring at the chimps. The chimps staring at us. Then they climb slightly higher. I can't get a clear view and I daren't move the

camera and tripod too fast. I am trying to look for a position very, very slowly, where I can shuffle the camera and tripod closer to be able to get a shot. My head is down, and I am looking for a spot to crawl to with the camera – and there, right in front of me, a foot in front of my face, is one of the zombie ants. Two to three feet off the ground, just as Mark had described, clamped by its jaws onto a twig. Out of its neck grows two grey spindly filaments, the fruiting bodies of the zombie fungus. Eaten from the inside out.

I can't quite believe it: it's a double whammy. To be witnessing and meeting the innocent chimps for the first time, and to see the zombie ant that I'd been told about years before. To have both of those in my vision at the same time is an extraordinary wildlife experience. Discovering the complexities of the natural world is addictive. The more I learn and experience, the more I want to see. There literally is no end to nature's ingenuity and design. The tragedy is that we know man is slowly destroying nature. Slowly taking over those wild places. Today I am guilty of invading these chimpanzees' domain. The only thing I hope is that our meeting is not a negative experience for them. It certainly isn't for me. I hope, too, that the publicity from our finished film will alert people to the fact that logging will disturb or destroy this population of inno-cent chimpanzees.

6 JULY 2001 51° 28' 29'' N
Bristol, UK 2° 35' 15'' W

I am back home and just heard that it's been announced *Good news* today that the Goualougo Triangle will not be logged. Instead, it is going to be added as an extension to the

Nouabale-Ndoki National Park. After a year of nego-
tiation by conservationists and scientists, the decision
was swayed in part by having seen our film, *Congo's
Secret Chimps*. CIB President Hinrich Stoll said, 'The
Goualougo Triangle is a very special place. Timber
industry companies, mine included, are not in the habit
of walking away from timber-rich forests.'

Stoll's company hasn't got anything in exchange
for giving up the harvesting rights. But he said there is
plenty of other land in the Congo available for logging.

This is a very proud moment for me: to have played
a small part in helping protect such a special place. The
television industry is all too often take, take, take, and
it was great that in this instance we have been able to
give something back.

1° 14' S
101° 18' E

2 MAY 2004

Kerinci Seblat, Sumatra, Indonesia

Compared to most of Sumatra, Kerinci Seblat is sparsely
populated and has a wild and lost-world feeling. The
forests we will be working in are shadowed by Mount
Kerinci, an active volcano, whose classic cone towers to
12,484 feet. Smoke rises from its summit as a constant
reminder it is not dead. Everywhere you look is a wall
of rich green trees and foliage, all fed by fertile soil and
plenty of rainfall. Mist hangs in the tops of trees and the
forest coaxes you to explore.

I'm filming and presenting as part of a team of five
for a series called *Deep Jungle* for ITV. Our goal on this
trip is to get the first video shots ever of a Sumatran
tiger in the wild. Tigers worldwide are endangered,

but the population of the Sumatran tiger is critically low, with as few as 400 left in the wild. We will need all the luck and skill we can muster.

Our local expert and guide is Jeremy, an English naturalist who has spent the last seven years here, photographing for Fauna and Flora International. He and friend and assistant Ralph have spent the last ten days setting four video camera traps deep in the forest ahead of my arrival. It is a punishing habitat to hike in and they both returned from the forest having lost about a stone in weight.

Before we set off on our two-week camping expedition, our two local drivers insist that we get our trip 'blessed' by a witch doctor. Here they still have a role in society as traditional healers, spirit mediums and occasionally as sorcerers and masters of black magic. Thinking it might make a nice start to the film, and partly to humour him, we agree. One of the drivers takes us out of town to a village where we pick up the witch doctor and his accomplice with a sack full of props. We then drive another half an hour into the forest, and then walk about a mile or so up a dry riverbed to the base of a low waterfall. Ralph films me with the witch doctor and his accomplice as they set up their wares. First a staff, adorned with a real monkey skull, feathers and beads, is stuck into the gravel. Then they spread out a tablecloth. On it they heap bananas, bowls of rice, food parcels wrapped in banana leaves and some garlands of pink flowers. The accomplice lights a handful of joss sticks and, as the smoke starts to drift upstream, the witch doctor gets dressed up in a colourful robe and head-dress. Then the ceremony begins.

This is where it gets a bit more serious.

The witch doctor takes a long rusty machete-type blade and cuts up chicken hearts and livers in a small

white enamel dish. Then, sticking out his tongue, he cuts it by running the same blade down it. We all wince in horror as blood drips from the end of his tongue into the same dish. He then proceeds to eat and drink half of the bloody mixture. I am now thinking this isn't just a tourist stunt, this is for real.

The witch doctor then starts to chant and dance. A few uncomfortable minutes follow, in which Ralph and I watch on, trying to fathom out what on earth is happening and exchanging shocked glances. The witch doctor then gets onto all fours and starts to paw at the gravel, like a cat sharpening its claws. Over the next 15 minutes or so this pawing and chanting intensifies and his body movements become more animal-like. I am watching his hands on the gravel and can't work out why they aren't shredded and bleeding by now. This is intriguing but getting progressively more uncomfortable to watch. His chanting stops and he starts to snarl and growl more like a cat while still pawing at the gravel. Having filmed animal behaviour for nigh-on 20 years, I am used to seeing how animals move. This man is now moving and behaving just like a cat and he has a wildness in his eyes like he's been possessed. This might sound stupid but forget an Andy Serkis performance – this witch doctor has turned into a tiger.

Then the pawing stops, he keeps stock still and stares with wild eyes at the top of the waterfall. His accomplice is also looking to the same point above the rocks and, without taking his eyes away, he whispers to us in Indonesian (Jeremy translates), 'He says it's here. The tiger spirit is here.'

We all look to the waterfall and stare. I scan the gaps in the bushes and trees and among the moss-covered rocks. As much as I want to behold the spirit tiger, I can't see anything. The weird thing is, though, I can definitely sense the presence of something. It's that sixth

sense again. Something you can't quite put your finger on, the feeling when you know you are being watched. I'm sure we've all experienced that.

Then the feeling goes.

The accomplice is smiling and tells us via Jeremy that we have been blessed. When bringing offerings to the forest they don't expect to see anything or be visited. This time, though, the tiger spirit has come and we are now safe to go on our expedition. He starts to pack up the plates and tablecloth. We all remain quiet, trying to take it all in.

Just as we are about to leave for the car, the accomplice tells Jeremy, 'He is still deep in a trance and hasn't come out. He is still a tiger. It may be that by the time we get to the car he is with us again, but if he isn't, are you happy to travel back in the car with him as a tiger?'

We're all a bit dumbfounded by this but say it's okay.

I stride on down the dry riverbed ahead of the others, still trying to process what I have just witnessed. The man definitely became a tiger! But that goes against all rational thought. I am now about 100 metres ahead of the group and, as I round a corner of the river, I look downstream and see something walking towards me. I stop and look closer. Walking up the right-hand side is a brownish cat about the size of a small Labrador. I get a good look at it as it approaches. Then it looks up as it hears the others coming downstream, and jumps up the bank to disappear into the forest. I call Jeremy over and describe what I've just seen. Gold-brown to fox-red fur, spots and stripes on its chest. Mottled black and white lines across its cheeks and up to the top of its head and a solid-looking tail with a black tip. He tells me it must have been an extremely rare golden cat and he is very jealous as he's never seen one.

Perhaps the witch doctor's black magic is working already.

1° 43′ S **8 MAY 2004**
101° 8′ E Camp Durian, Kerinci Seblat,
Sumatra, Indonesia

Deep into the It takes us two days to reach Camp Durian: the base
jungle Jeremy, Ralph and some local guides set up the week
before. We head off into the forest with 12 porters to
help carry our kit. Up and down multiple steep ridges,
over long, rickety rope bridges, and wading across
the same fast-flowing river six times as we trek up
the valley. We have pitched our one-man tents under
some big tarpaulins strung over simple stick frames.
It rains a lot here and even the best tents leak if you
don't offer them extra protection.

Our first two days are spent setting up three more
camera traps about an hour from camp, two of them
facing opposite directions on a narrow, well-defined
path that runs along a knife-edged ridge. The third
trap I set on a parallel trail lower down the valley.
Each trap has two light-beam triggers set about
25 metres along the path either side, with cables
running back through the bushes to the camera.
Setting them this far down the path gives the camera
time to 'wake up' and start recording before the
animal comes into view. I walk both paths to check
all the triggers are working.

While we are looking for the lower camera position,
Jeremy points out loads of odd dark red, golf-ball-sized
flower buds on the ground. He says they are the flower
buds of a liana and when they open they all do so on
the same night, which seems imminent. Dave the director
thinks this would make a nice time-lapse sequence for
the programme. The easiest way to capture it is to set
up the camera under a small plastic tent and then camp
next to it. Wake up every half-hour and if the flowers

start to open then set the shot going. So late that afternoon we trek back out with all the relevant kit to do the time-lapse, and I stay out there with one of the local Indonesians. We take it in turns every half-hour through the night to get up and check the flowers. They don't open.

After the next day's filming the two of us head back to the time-lapse flower site and try again. No luck.

Night after night we try, each time getting more and more knackered: filming by day and disturbed sleep at night.

As we are getting so tired, Jeremy suggests we have a decent hot meal (of noodles – our diet here is noodles for breakfast, noodles for lunch and noodles for dinner) back at camp before heading out to the flowers. Feeling full and a little warmer, we are trekking back to the flowers and are only a few minutes out of camp when the guide suddenly stops and turns to show me something. At his feet are fresh tiger pugmarks, one of which is still filling up with water. A weird cocktail of emotions trickles through me: excitement – and fear.

With an animal track this fresh I know the tiger could be within metres of us. An intoxicating release of adrenaline heightens all of my senses and the noise of the forest seems to intensify. Undeterred, my guide carries on down the path. He doesn't speak English, but I ask him if this is a good idea and point back to the camp. There is only one path and clearly a rather large predator just up ahead. He laughs and beckons me on, following the path and the fresh tiger tracks.

From stories in India I know that tigers often hunt their prey from behind, so as I walk I swing my torch around and behind me to check for eye shine. We are walking fast and I can't help feeling we will catch the tiger up. This does seem like madness.

Forty-five minutes later we are still walking over the fresh tiger tracks. At this rate, unless it went off-piste, the tiger will have to pass through one of the two camera traps I set a few days ago. This could be our lucky night – or maybe our very unlucky night. Then the guide stops dead and I nearly walk into the back of him. He points down. There are two pugmarks side by side, its front paws. The tiger stopped here. Shining our torches forward we can just make out an orange shape. Phew, it is our time-lapse set-up and tent. The tiger must have seen it too, stopped, and then turned right and headed up the track to the ridge. I am now very excited and have visions of the footage from those camera traps when we check in the morning.

We do what we came here to do: take it in turns to flower watch. Each time I leave the tent I am very vigilant with shining my torch around for eye shine. Needless to say, the flowers don't open.

1° 43' S 101° 8' E **13 MAY 2004**
Camp Durian, Kerinci Seblat, Sumatra, Indonesia

We get up early and head back to camp to collect the others. I can't wait to share the story and news of the fresh tiger tracks. Then, as a team, we head off to check if we've struck gold. Approaching the camera trap on the ridge I can still see tiger tracks. It has definitely passed here. The million-dollar question is: has it triggered the camera? Has the shot worked?

I unclip the lid of the camera case and see that the tape has run. I spool the tape backwards and hit play.

Yes, definitely a black and white infrared image, something has recorded! A bat flew along the path

towards camera through the shot. And then there. There it is. The tiger. Fan-bloody-tastic. What a magnificent animal, regal and elegant, walking straight towards camera, sniffing the air. It paused, looking down to the left, and then walked out of frame right.

We run to check the other trap. I rewind the tape and hit play. Again, a few seconds of empty frame and then, in from the left, comes the tiger. It stops right in frame at the base of the tree. Oh, those beautiful stripes. Success.

These are the first ever video shots of a Sumatran tiger in the wild.

I've been lucky to experience the excitement of being so close and knowing that a tiger was here. I also know it is our centuries' worth of hunting, persecution, conflict and greed that means there are now so few of these beautiful animals alive.

14 MAY 2004 1° 43' S
101° 8' E
Camp Durian, Kerinci Seblat,
Sumatra, Indonesia

Dave and sound recordist Geoff started back for the UK yesterday, leaving Ralph and me to continue filming and check the other camera traps.

It's pissing with rain and Ralph has woken up with a high temperature. As we are a tough eight-hour walk from the nearest road, we crack open the first-aid kit. Ralph has been out here now for over five weeks, so our first suspicion is malaria. I get the behind-the-scenes camera out and film* as Ralph cracks open the malaria blood-testing kit. It's negative.

* This might seem insensitive but it has become one of the intrusive duties for adventure filmmaking these days. Ralph was happy

We talk about the options, including me and the guys clearing some small trees by the river to allow a helicopter to land on a gravel bank if necessary.

Productions who send teams into remote areas like this subscribe to medical emergency assistance companies. They are highly skilled at assessing your situation and can give professional medical advice over the phone, or at the very worst can implement medical evacuation. Thankfully, I've never been on a film trip where we have had to call for help, but bearing in mind how remote we are and worried that Ralph's fever might worsen, we decide to call the 24-hour emergency helpline.

We line up the satellite antenna through a gap in the forest canopy. It has just enough signal strength to make the call. We have a laminated sheet with the instructions on what to do and the information we'll be asked for:

Phone number where we can be reached
Address abroad [I have the GPS coordinates ready]
The nature of the emergency
The name of the company we are working for
Policy number

We put the satellite phone on speaker and I start to video Ralph as he makes the call.

The phone is answered after four rings: 'Sorry. All our lines are busy, please try later.'

Despite how ill and worried Ralph is we are both in stitches. Twenty-four-hour helpline, my arse!

Ralph dials again and this time gets through. He gives all the information requested and is told a doctor will ring back within five minutes.

enough and it was good to see he wasn't too ill to smile about it.

Sure enough, four minutes later the phone rings. The doctor introduces himself and then quizzes Ralph further. After a short consideration, the doctor says it might be typhoid and asks what drugs we have in our first-aid kit.

As Ralph lists them off, the doctor replies, 'Yes, take four of them. And only with water that has been boiled thoroughly.

'Yes, take all of those too.

'And take two of those every four hours.'

From my calculations, Ralph is going to swallow half the drugs in the kit.

The doctor then tells Ralph that as soon as his fever reduces we should get out of the jungle and seek local medical attention.

After Ralph's cocktail of drugs he goes back to bed and I check on him every hour. Normally we are out of the camp all day filming, but as I'm here in the day I take a quick tour and think I discover why Ralph fell ill. The guys in camp are using the river as a toilet, just upstream from where we are collecting our drinking water and the area we were using to wash. Camp etiquette and hygiene 101.

17 MAY 2004 0° 47' 08 S
Padang Airport, Sumatra, Indonesia 100° 17' 10 W

We are heading home. Ralph's temperature dropped to normal and he felt much better after eating half the first-aid kit, so we stayed on in the forest for another two days to collect up the camera traps, then we got the hell out of there.

I'm standing in line for check-in at the airport and laughing to myself. I know I have some weird baggage to

check in sometimes, but I can't resist getting a photo of this. Someone in front of me has just checked in five live chickens wrapped comfortably up in baskets, plus two birdcages, each with an elegant purple silk cover. All now have a baggage tag on. Who knew chickens could fly?

51° 28' 29'' N
2° 35' 15'' W

12 JANUARY 2008

Bristol, UK

The phone rings.

It's a series executive from the BBC. 'Hi, Gavin, it's Mike. How are you?'

'Hi, Mike,' I reply. 'I'm very well, thank you.'

'What are you up to at the moment?' he asks.

'Oh, not a lot. I've currently got nothing until the beginning of April.'

'How would you like to go to Antarctica on Tuesday?'

I say, 'Yes, of course!' thinking he is joking. He's not.

Mike explains that there has been an accident and the cameraman down there has been medevacked to hospital in the Falklands. The boat is chartered for another four weeks so they want to get a replacement cameraman there as soon as possible. It would be to film penguins being hunted by leopard seals for a BBC series, *Life*. Mike arranges for me to catch a lift on a cruise ship from Ushuaia across Drake Passage to the Antarctic Peninsula, where I can meet up with the crew on board the *Golden Fleece*, a 65-foot motor-sailing steel-hulled yacht. There is a chance that I'd get all the way down to the south of Argentina too late to catch the cruise, but Mike would like me to try.

Having never been to Antarctica I don't have the right clothing, so immediately go shopping and spend £1,600 on some specialist cold-weather gear. Thank God for credit cards.

15 JANUARY 2008
Ushuaia, Argentina

58° 34' 44" S
68° 18' 1" W

I am boarding the flight to Ushuaia in Argentina via Buenos Aires. Just typical, my connecting flight has been delayed by two hours. Annoyingly, this is going to be just enough time for me to miss the cruise ship. I call Mike in the UK to let him know. He tells me to carry on just in case.

Hold the ship

When I land in Ushuaia there is a vehicle waiting for me and I am rushed to the port. Mike has spoken to the owner of the cruise company and managed to persuade her to hold the ship for me! As I walk up the gangway the engines are already running and the ship's hands ready to cast off. My last case is passed on board and the gangway raised. I've been aboard barely a minute when we start to move. I am shown up the staircase to the lounge with a welcoming glass of champagne in my hand, to be met by the slightly pissed-off gaze of 80 passengers. They've all paid quite a lot of money for this cruise and haven't taken kindly to me keeping them waiting.

I introduce myself and thank them for their patience. I start to circulate, trying to win people over with my story of adventure for this film trip.

Eight hours later we enter open ocean and sea conditions worsen. It takes four days to get to the Antarctic Peninsula from Ushuaia, and crossing Drake Passage is notorious for being very rough. As the ride gets more

bumpy and the ship begins to rock and roll, passengers start to disappear to their cabins. I seem to be okay and don't succumb to seasickness.

I join a table of six for dinner and we talk about what they hope to see and what I am hoping to film. Halfway through dinner it dawns on me that these passengers think we are heading to South Georgia first and ending up on the peninsula in about 12 days' time. Either I have got it wrong and I am going to be on a long cruise rather than the job, or the ship's itinerary has changed. I speak with the captain. Bloody hell. They have changed the itinerary just for me, to be able to rendezvous with the *Golden Fleece*. I'm sure I will be lynched by the passengers when they find out.

With the crossing being so rough, most of the passengers get very seasick and stay in their cabins for three days straight. I work my charm and magic with the hardy remainders. I talk in detail about the chinstrap penguin behaviour I am going to film. About the penguin chicks taking to the sea for the first time and their vulnerability. How the leopard seals predate on the penguins as they go to and fro from the colony. Slowly I win them over with the fact that if they were to reach the peninsula later, then many of the penguin chicks would have already fledged. Also then the parent birds look pretty grubby as they start to moult. I am going there now as it's the optimum time for all this behaviour. These few passengers at least seem to be convinced and happy.

As other passengers emerge from their seasick beds, word spreads about the change of itinerary and the reason. Thankfully everyone embraces the idea and I don't get thrown overboard.

19 JANUARY 2008 64° 40' 56" S
Antarctic Peninsula, Antarctica 62° 36' 1" W

The scenery as we cruise down the west side of the Antarctic Peninsula is spectacular. I wish I'd paid more attention in geography lessons at school. It's only now dawned on me that Antarctica is a continent, it's not just a big iceberg. Crisp blue-white 100-foot ice cliffs fringe the land. Small icebergs drift in the dark waters, some with seals lounging on top. The clean whiteness of snow and ice contrasts with glimpses of exposed black gnarly rock.

All the passengers up on deck hush except for the click of camera shutters. We round a corner into a bay and, as our ship drops anchor, I catch sight of a small yacht: it is the *Golden Fleece*.

An announcement comes over the Tannoy saying that it is too windy to launch the boats for a shore visit. I am then called to the bridge to talk with the captain. He says that although it is very windy, gusting to 40 knots, and this can sometimes flip the Zodiacs (the inflatable rubber boats), they'll be able to run me over to the yacht. I glance up at the anemometer, just as a gust pushes it to 41 knots, and think to myself, *How come it's okay to drop me off but not to take tourists?*

We load my cases into the Zodiac, then myself and two deckhands move right to the front of the boat to hold the nose down in the wind, and off we go. I look back at the top deck to see all the tourists glaring at me again, probably wondering why I'm allowed out on the boat but not them.

Once on board the *Golden Fleece*, the French skipper Jérôme shows me round the yacht, the dos

and don'ts. Jérôme is the world's most experienced Antarctic yachtsman, having sailed and explored there for over 30 years. He must be in his late fifties, with a well-weathered face that speaks of experience. His wild wispy hair catches the wind and a big grey moustache hides both a smile and a cigarette.

At the end of the short tour I ask, 'Where are the lifejackets?'

Jérôme opens a locker and rummages around under some chains. He points to a few lifejackets. 'They are they are if you want one.'

I think this attitude seems a little cavalier, but quickly realise there's a kind of unspoken reason. If you fall in the water here it is so cold that the 'shock factor' means you gasp water straight into your lungs. Even if you don't drown, the water is so cold you would be unconscious in two minutes and dead in four. It would take several minutes to turn the yacht around assuming someone saw you go overboard. The cold quickly immobilises your muscles, so that even if someone threw you a rescue line you'd be unable to grab it. Unless you are wearing an immersion survival suit – an all-in-one, usually bright yellow or orange sealed number, a bit like a waterproof boiler suit – your chances of survival are slim, lifejacket or not.

64° 50' 21" S
62° 53' 11" W

25 JANUARY 2008

Gerlache Strait,
Antarctic Peninsula, Antarctica

We have motored further south to an impressive chin-strap penguin colony near Gerlache Dome. Getting ashore is an eventful exercise as the resident leopard seal takes an interest in our small Zodiac. This particular

seal is huge, a good ten feet long, and it cruises along-side us and under the boat before 'testing' one of the rubber compartments with an exploratory bite. In a split second the pontoon bursts and deflates, the rear starboard side now limp in the water. He then goes round the other side and bites another section, bursting that too. There're only eight sections on this boat and, holding four people and camera kit, it is now flagging in the water. Assistant producer Jonathan and I arm ourselves with paddles and have to dissuade the seal, in no uncertain fashion, from biting any more holes as we limp back to the boat.

The leopard seal then goes on a penguin-killing spree. It eats the first one or two but then just leaves ten or so dead penguins floating on the surface.

Once the Zodiac is repaired Jérôme heads out and scoops up the penguins, fillets them, and we have penguin breast sautéed in butter. A little too fishy and oily for my taste.

1 MARCH 2008 63° 11′ 57″ S
Antarctic Peninsula, Antarctica 56° 21′ 6″ W

Filming went well with the penguin and leopard seal story and we have slowly been working our way 200 miles north-west up the peninsula hoping to find pods of hunting orca, but have had no luck. Jérôme gets some news that there's a big storm approaching so we head for shelter and he gives instructions to the rest of us to get the ship ready for the storm. We pack away every piece of equipment into cases, then strap the cases down with ratchet cargo straps. In a storm, anything loose flying around the cabin can do damage and potentially hurt or kill you. Jérôme is experienced enough to take this very seriously.

He tucks the yacht in close to an ice cliff of an island and drops anchor. This should give us some shelter from the wind and swell. Now we just have to wait.

63° 11' 57" S **2 MARCH 2008**
56° 21' 6" W Antarctic Peninsula, Antarctica

I am sharing a very small cabin with Jonathan in the stern of the boat. The beds are not much bigger than a coffin and are a similar shape, tapered towards your feet. One side is fixed (the wall), and the other side has an adjustable plank which slots onto the head and foot board. You adjust this plank in rough weather to basically wedge yourself into the bed so you don't roll about or fall out.

In case you were wondering, a boat at sea has six degrees of motion: roll, pitch, yaw, heave, sway and surge. Rolling is a rotation around the long axis of the boat so the top of the mast swings left-right. Pitching is a rocking-horse-like motion and yawing is a rotation around the vertical axis where the bow and stern swing left-right. Heaving is the linear motion up and down, swaying is a left-right motion, and surging is the forwards motion, though it can be backwards too. Lots of opportunities to induce seasickness and to fall out of bed.

I am woken in the very early hours by the sound of the anchor dragging. I notice the wind has picked up and the boat is moving more than usual. I drift back to sleep. A little while later I am woken again by a banging sound in time with the rise and fall of the stern. I get up, dress quickly and head up on deck. The weather has deteriorated and the yacht has dragged the anchor. The stern of the boat is now knocking against the base

of a hundred-foot ice cliff. I rush to get Jérôme and the crew, but they are already starting up the engine and the anchor is being winched in. We motor away from the imposing cliff.

Everyone is now up and in the wheelhouse, the yacht starting to heave with the swell. Over the next 16 hours the sea conditions worsen further. Jérôme holds our position using the engines and we ride up and down on the waves. As it gets darker it feels more threatening still. The yacht is now rolling 45 degrees left and right. Even in the shelter of the ice cliff the waves are huge, at least 25 feet. One minute we are on a crest looking 50 feet down into the troughs on either side, the next we are in a trough with the ocean towering above us on both sides. What makes it more nerve-racking is the proliferation of icebergs all around us in the waves. Some are small blocks the size of a coffee table, others as big as a house that could crush us in a New York second. We are all hanging on for dear life in the wheelhouse: my arms are locked around the steel bannister stair rail.

In tricky situations like this I draw solace from watching the expert. I study Jérôme's face closely as he wrestles the wheel left and right, skilfully dodging the icebergs. His brow is furrowed hard and he is chain-smoking and concentrating intensely. The yacht is leaning to port and starboard so much that Jérôme is often standing on the side of the captain's stool, which is bolted to the floor. Above the wheel is the inclinometer, a brass arrow that hangs like a pendulum on a semi-circular scale with the angle in degrees marked on it.

Forty-five degrees left; 50 degrees right; 35 degrees left; 42 degrees right.

Jérôme is in charge and in control and he says, 'We are okay unless it goes past 60 degrees, then we are in trouble.'

Jérôme tells us that he has rolled once before and 'pitchpoled' once: that's where the yacht gets thrown and rolled forwards completely upside-down – it luckily righted itself both times.

As it gets darker, he steers spotlights outside on the roof of the wheelhouse to keep track of and pinpoint each iceberg. They show up as stark white menaces in the dark turbulent waves.

I can't say I'm not frightened.

The storm worsens and the inclinometer swings more wildly. Jérôme's grip on the wheel tightens and each cigarette shortens more quickly.

Fifty-five degrees left; 56 degrees right.

Each time the yacht lurches with the waves, my eyes are drawn to the dial. I think all of us are watching, dreading what might happen if it reaches 60 degrees.

Then: it happens.

The yacht rolls to port as we corkscrew down a massive wave. I am virtually hanging on the bannister rail looking straight down on the top of Jérôme's head as he stands on the side of the captain's stool. The inclinometer seems to hang for seconds at 60 degrees – before swinging back as the boat returns upright. We haven't capsized this time but Jérôme has gone pale. Now I am really concerned.

A few moments later the same: 60 degrees to starboard and I am flat on my back, pushed against the railings, Jérôme now above me again, standing on the side of the stool. Once more, the dependable *Golden Fleece* rides the wave and returns without capsizing.

These are the two worst waves we hit, but Jérôme and his crew have to man the wheel for another 36 hours, holding position and dodging the icebergs until the storm subsides.

Down below, the galley is a mess. Despite the locking drawers there are tins of food, pots, pans and cutlery

all over the floor. Thankfully, all the camera equipment stayed strapped down. I can see now how, had it been loose, just one 23kg case could have smashed everything like a flying sledgehammer.

26 JUNE 2010

51° 08' 50" N
2° 34' 41" W

Glastonbury Festival, Somerset, UK

Years ago, I invented and built a cable dolly* system. Basically, you string up a very sturdy washing line and hang a remote-controlled two-wheeled dolly on it. Underneath that you mount a remote-controlled gimbal that carries the camera so you can pan it left-right and tilt it up-down. This set-up enables me to fly a camera with precision control along 100 metres or so, monitoring the picture by a small wireless video link. It's a relatively cheap set-up that safely gives cinema-quality tracking shots: a bird's-eye view.†

Glastonbury Festival has been running now since 1970 and has been growing. One of the more recent and dramatic stages is Arcadia. The centrepiece is a 50-foot-high three-legged structure known as 'the spider'. It is constructed from repurposed military hardware and can shadow a crowd of 50,000 around its legs. Under the spider hangs a futuristic DJ booth: the stage. This

* Dolly is a film term for a wheeled platform enabling a smooth camera move known as a tracking shot.

† Nowadays some of these shots can be filmed using a drone, but not silently or with the same precision. And certainly not safely above crowds of people.

huge metal beast has an array of lighting: it fires laser beams across the sky, there are dry-ice cannons, and chip-fat flame throwers that shoot 30-foot jets of fire in time to the music. Interested? I certainly was when I was contacted by its two creators, Pip and Bertie. They had heard of my cable dolly system and asked if I could come and use it to film their spider at the festival. How could I say no?

I rig the 120-metre cable across the arena, passing close to the spider and over a trapeze swing, tensioning it between two 50-foot, specially erected pylons. As I'm going to be flying the dolly over a crowd of 50,000 people, I ask each of the 20 professional riggers there to individually come and check the set-up. All of them take a very close look at it and sign it off without question. They are used to flying people over crowds on wires and cables, so my payload of 13kg is well within the rigging safety limits.

We have one dress rehearsal of the half-hour show and I am blown away by it. I can't wait to see and film the full-blown performance at night with all the effects blazing.

Slowly through the evening the crowd grows and, by the time it comes to 11pm, Arcadia has also inherited the audiences from the other stages. The crowd is massive and fills the field, even spilling out beyond the Arcadia stage boundary: an estimated 70,000 people.

The show begins and I start to film. There's something extraordinary about huge crowds with a common focus. The show involves dance and costume, performers swinging down on ropes and bouncing on bungees: the stage is alive. Top that with flames, smoke, lights and lasers – it is spectacular.

My favourite shot of the whole event is flying over the crowd with the spider on the left of frame. The

shadows of the crowd stretch out behind them, away from the stage. But one lone figure draws the eye. It is Fran on the trapeze. I spoke to her earlier about the cable dolly to make sure she was happy with it flying over her while she was swinging for her performance. She sees the camera coming and builds her swing, higher each time as the camera approaches. Just as I fly over her she looms with perfect timing right up towards the lens.

Cecile B. DeMille* eat your heart out.

I loved it. Such a crazy contrast from sitting quietly in a hide waiting.

(But I know which I'd take if there was only one choice.)

* A prolific American filmmaker, whose films made between 1914 and 1958 were known for their epic scale and cinematic showmanship.

Finding Courage

14 MAY 1983

White Nothe Point, Dorset, UK

I am out for a cliff and beach walk with my girl-friend, mother, stepfather, sister and brother-in-law. We park in the National Trust car park at Ringstead and aim to walk the cliff path west towards Osmington Mills, then onto the beach, heading east round the bay, then back up the smuggler's cliff path to the cars. As we near the coast, not far from the cliff, I notice a few hang-gliders to our east, prep-ping to fly. Once on the coast path, I look back at a fledgling hang-glider pilot as he launches himself precariously off the edge. He looks tiny against the 200-foot drop. I even remark to my family and girlfriend that it doesn't look like the best place for a beginner to learn how to fly.

A dark spring day

We carry on away and down. The sun is shining and the English countryside is looking its best. The gentle lap of the waves below coaxes us on. Occasionally, I glance back to check the hang-glider's progress. The better pilots are able to land back on the grass behind the cliffs where they launched from; the rookie pilot is still unnerving me with his floundering moves.

By the time we reach the pebble beach we are a good mile from the spot where the hang-gliders are taking off. Then, as we walk east, something catches my eye in the sea. Yes. It is a wisp of smoke. Then I spot the fire. As we walk closer along the beach,

I can make out a yacht right in among the rocks by the headland.

I sense something is wrong and want to see if I can help. 'I'm going to run on ahead and see what's happening. I'll see you there.' Young and fit, I cover the ground, the crunch of pebbles under my shoes.

What I thought might have been a cabin fire is now clearly a distress flare from the yacht. I close the distance, toying with what might be the issue. Is the boat sinking? Why is he among the rocks?

Closer still and I can see the yachtsman at the bow. It seems he has his sail caught up under the hull. He is clearly in trouble.

As I draw parallel on the shore there are a handful of onlookers gathering. Even though it is maybe 100 metres or so from the stricken craft, we are all close enough to see the look of desperation on the yachtsman's face. He is beckoning for help.

A man around my age is standing at the water's edge and I ask him if he can swim. 'Yes,' he replies.

'Do you think we could make it to the yacht to help?'

'Yes, I reckon so.'

At that, we both strip to our underwear and nervously start to wade out.

The water is cold. Damn cold. And as the waves reach our waists we both stop, look at each other: too cold to risk it? But, looking up, the yachtsman appears absolutely desperate and once again beckons for our help. How can we leave him?

The two of us set off again.

Once the shock of the cold water on my face has passed I get more into my stride. The other young man and I swim and wade out together, working our way through the submerged rocks and weed. Before long we are halfway, in deeper water and committed. I can now see that it isn't yacht sails caught beneath the bow

but, instead, the sail and frame of a hang-glider. The yachtsman is leaning over the bow and trying to hold the pilot out of the water.

My fellow swimmer reaches the yacht first and climbs the rear ladder. I follow him onto the deck and along to the bow.

Years later, I will still be able to recall the dead pilot's face as the waves rock his head back. His blue skin framed by his crash helmet.

The yachtsman is remarkably calm and in charge. He's been holding the pilot now for nearly 20 minutes but couldn't free him from the harness on his own. The pilot, it seems, had fatefully tied himself in with rope. Perhaps he hadn't fully trusted his harness.

The yachtsman tells me to go below and fetch a blade from his toolbox, under the berth in the bow. The only way I can cut the ropes is to get back into the water. I swim to the pilot and control my shock as I cut through the harness and ropes. The two men on board are then able to haul the pilot up onto the deck. Despite it seeming futile, school bronze medallion lifesaving training kicks in and we take it in turns to give mouth-to-mouth and CPR. No colour returns. No life returns.

The next thing I'm aware of is a lifeboat arriving from Weymouth. The RNLI* semi-inflatable pulls alongside and after a few words our pilot is dragged rather unceremoniously onto their deck. They speed off and we feel alone.

My fellow swimmer says, 'I'm heading back,' and, at that, jumps off the stern and starts to swim to shore. I ask the yachtsman if he needs help navigating his boat back out from the rocks, but he says he'll be okay as he dropped anchor and can haul himself away.

* Royal National Lifeboat Institution.

I then get in the water and start for shore. The beach looks a long way away. The other man is already halfway back and I feel vulnerable. The shock of seeing that unfortunate dead pilot; the fact that the shore seems to have got further away gives me a feeling of panic. I am suddenly aware of the cold water and its depth below me, and am being watched by my family and girlfriend who have joined a growing crowd on the beach. For me to drown now would be pretty stupid. I manage to calm myself and swim on.

I am met on the beach with dry towels. Someone who lives halfway up the cliff had seen the whole episode and called the RNLI. We are now led back up the cliff where they run me a hot bath and make me sweet tea. The kindness of strangers.

As the event sinks in, I feel a sadness. Surprisingly, not for the man who died but for his family, friends or pets to whom he will not return.[*]

50° 44' 4'' N
7° 5' 43'' E

17 JULY 1990

Bonn, Germany

Discovering my phobia

Vampire bats feed exclusively on blood. Their prey can be anything up to 1,000 times their size and they can feed on humans. They can feed for between ten minutes to an hour and can consume more than half their body weight in a single meal. They have specialised thermoreceptors

[*] I think witnessing this tragic event unfold first-hand made me aware of vulnerability and risk-taking early in my career. The fact that I am writing this now, considering the often sticky situations I've ended up in, is testament to a combination of luck and judgement.

in their noses to detect infrared heat from blood vessels near the surface of their victim's skin.

Researcher Rupert and I have travelled to Bonn University in Germany, where they have a captive colony of vampire bats. We are going to try to film the bats biting and feeding on a live mammal for a BBC series called *Supersense*. Rupert has been volunteered as the 'live animal' and weirdly doesn't appear too worried. I should add that this colony of bats has been in captivity for more than 20 years and is known not to carry disease, particularly rabies, which is prevalent in the wild.

The main university is a large, elegant castle-style building over 200 years old.

Professor Schmidt and his researchers have kindly built us a filming cage in the crypt of this building where it is cool, dark and quiet. The cage is roughly L-shaped and about eight feet by eight feet on the longest dimensions with a seven-foot ceiling. It's made from a timber frame fixed in the corner against the walls, covered in a fine plastic mesh to keep the bats in but allow air to flow through. There is a simple mesh double door for us to get in and out without risk of losing the bats. Four bats have been living in here now for about a week and they have been fed fresh blood from a small dish in the same place each evening, under a light to get them used to what we need for filming. Rupert and I have dressed the corner of the 'L' very simply to look like the inside of a generic Central American farm worker's shack using a sheet of rusted corrugated iron as a background on the concrete floor. This will then match the exterior establishing shots of where the bats live. Rupert is going to have bare feet and ankles, with a Mexican rug (which I bought in Tijuana, Mexico, when travelling in 1981) covering his body and head. I have lit his 'sleeping' figure in

a small pool of light, the minimum I can get away with for the camera film's sensitivity.

At 7pm we go down into the stone-vaulted crypt. It smells damp and musty and is the archetypal image from a horror film. Rupert and I enter the cage and get to film. I sit on a chair with my back to the wall, my film camera set up on a low tripod. I have my Zeiss 10-100mm zoom lens on so I can get various shot sizes when the action happens. To give us the best chance of the bats biting and feeding on Rupert's feet and ankles we need to be silent and very still, and we are prepared to wait all night.

Within 15 minutes of Professor Schmidt leaving us in the crypt, the bats start to stir. I tilt my head very slowly and look up to my right. I can see the four bats now active and using echolocation to investigate me and the new objects in their cage. My neck is straining, so very slowly I look back down to the camera. I can faintly hear their claws picking on the plastic mesh, the sound of tiny feet as they fidget. I'm sure they are hungry. This is the time they are normally fed. Once again I slowly tilt my head up to see the four bats. This time they have descended down the mesh about six inches. I look back down.

Then: all is quiet, Rupert is still.

After a few minutes, I once again slowly raise my head to look back up to the corner. Now there are only two bats there. I steadily scan my head round to the left and there, a foot from my nose, is a bat looking straight at me, echolocating. I can just see its tiny teeth in the half-light. Then I slowly look down to see another bat right between my feet. Back up and the bat to my left is gone, down to my feet and that bat is now gone. I look up to the corner and all four bats are there. This is freaky. I didn't hear or see them fly, nor have I heard their claws scurrying on the plastic mesh. How the hell

did they move without me noticing? I rest my neck back down, my eye to the camera eyepiece.

A few minutes later, I strain my neck up to look to their corner. All four bats are now missing. Scanning around, they are all six inches away from me, checking me out. Again I didn't hear or see any of them move. This is weird and quite frankly starting to scare me. It is just like the mystery vampire Dracula in Bram Stoker's novel. Active at night and here in the crypt with me and able to move in silence. I start to panic. The bats just inches from me are playing with my mind. My breathing quickens and my heartbeat starts to race. I try to rationalise my fear: I tell myself that, if needed, I could kill each bat with a gentle swat of my hand – they're the size of a small mouse and have birdlike bones. I also tell myself I could smash my way out through the simple mesh door if needs be: I have an escape route.

My heart still races but I daren't make a noise. The whole reason we are in Germany and in the cage is to film the bats feeding. I mustn't scare them – even if they are scaring me! At least, I think, I am now aware I have a phobia. And now I know what it is like for people who have an irrational fear of, say, spiders or snakes. It may be irrational but it is physically affecting.

I manage to take back some control and slow my breathing and my heart rate follows suit. Eventually, after several more hours of controlling mild panic, a bat finally decides to investigate Rupert's foot. Again, I don't see how it got on the ground, but once down, it walks on all fours. This doesn't help the creepiness. Its front 'legs' are its folded wings – it's kind of walking on its elbows – and its face is raised to echolocate and use its specialised heat sensors near its nose to detect the warmest part of its prey: where the blood is closest to the surface, in this case, Rupert's bare foot. As soon as

I start to film my mind is deflected from the fear. The job of shooting the sequence is the perfect distraction.

Despite several minutes of investigating, the bats never do actually bite Rupert and feed, but by filming Hitchcock-style the shadow of the bat on the corrugated iron, it appears as if it has. I then film close-ups of bats lapping up blood from their normal feeding dish and the story is complete. Thankfully I've only had to spend three nights in the vampire cage in the crypt.

I am, however, dreading having to stay in a tin shack anywhere in vampire bat countries. Maybe I'm going to have to get some hypnotherapy to solve my phobia.

52° 31' 12" N **19 JULY 1990**
13° 24' 18" E Berlin, Germany

History in As part of the same trip for *Supersense*, Rupert and I
the making have come to film a species of gecko that communicates using barks, chirps and clicks. The nearest barking gecko to the UK is here in Berlin in a private menagerie. We are only here for two days but we're also keen to explore a bit of the city.

On 9 November last year the border between East and West Germany was officially abandoned. The Berlin Wall had stood from 1961 and was the most iconic symbol of the Cold War, a physical and ideological barrier between the communist East and the capitalist West. But I remember seeing incredible images on the news of East and West Berliners celebrating the announcement of its fall. Westerners greeted Easterners with open arms and some men offered flowers and champagne. It wasn't until three weeks ago, on 30 June, that the wall's official demolition started. Being

here now I'm fortunate enough to witness the end of an historical era.

The barking gecko is a medium-sized lizard that would fit neatly in the palm of your hand. It has spindly legs with hand-like feet and a fat tail, large appealing eyes and a wide mouth which makes it look happy. The shots of the gecko are fairly straightforward – some portraits and then it 'barking' at its burrow entrance. It feels comfortable in its home setting and behaves naturally. So, once we feel we have the shots for the sequence, we pack up the camera gear and drop it back at the hotel. It is now getting late but Rupert and I head out to see what is left of the famous Berlin Wall.

Despite being quite busy, there is a hush over the city. Already hundreds of metres of the wall have been demolished and taken away. Crowds of people are along the road where the wall once stood. Families huddle together, taking in the scene in apparent disbelief. We walk in silence along the scar – a faded footprint of the wall left on the tarmac. Looking to one side of the road the buildings are clean and well-kept. Glass in the windows and light bulbs in opulent chandeliers. Metres away, on the other side of the road, it is so different. The buildings are grubby and scarred with shrapnel damage. Cracked window panes and lone light bulbs. The buildings seem derelict, but they're not. I imagine the misery of those living and working in the oppressed East with views directly across to those in the opulent West.

Reading the information plaques at makeshift shrines, I see that between 1961 and 1989 thousands managed to escape across the border. However, many failed and 239 people died trying to get to the West, three of whom attempted and failed just last year, 1989.

We walk on past the Brandenburg Gate and towards the famous Checkpoint Charlie. Further on are more

families. Many look on as husbands chip away at the wall with their own tools, each seemingly desperate to be rid of it. Rupert and I try desperately to chip our own bits off to take home as souvenirs. That 1960s concrete is tough, though, so we both end up buying some chunks of graffitied wall from an enterprising businessman who's set up a table with select pieces for sale.

Although I was here to film a gecko, I've learned some important history. I believe humans are predominantly a kind and social species – it seems only politics and crazy ideologies split us apart.

As we carry on back to the hotel, we stop for a while and from a distance watch Pink Floyd rehearsing *The Wall* – one of my favourite albums – on an extraordinary stage: 170 metres wide with a wall 25 metres tall. There's going to be an estimated 300,000 people in the audience for the actual concert in two nights' time. Too bad that work calls us to the next location.

1° 16′ 32″ N
36° 48′ 45″ E

23 FEBRUARY 1991

Nairobi, Kenya

Before I head to Sudan for the BBC, I'm managing to squeeze in a short ten-day shoot for producer-cameraman Richard in Tanzania. He's making a 50-minute natural history documentary about the Ngorongoro Crater, called *Crater of the Rain God*, for National Geographic. Richard has asked me to come and help film some slow-motion and time-lapse sequences and some people-based stories for his film.

It's been a disastrous start. Richard organised for me to travel down from Nairobi, Kenya, in a minibus with a small group of tourists. We met and left at 7.30am and it should have been about an eight-hour drive. On the way I chatted to the six tourists about what they hoped to see on their tour. They were really interested to hear that I was a wildlife cameraman and said watching wildlife films is the main reason they had come to Tanzania. They loved the sound of the adventure: me travelling all that way to meet up with Richard at the bottom of a volcano. What a nice bunch to be sharing the journey with.

En route we entered Lake Manyara National Park to do a game drive. I was able to point out various animals along with the driver and helped a couple of the tourists with their new cameras. Not knowing the route to the crater I was unaware of the unfolding cock-up. So when the sun disappeared behind some menacing storm clouds we pulled into a lodge. The tourists were checking in and, although I already knew it wasn't, I asked the driver if this was the Ngorongoro Crater.

'Oh no,' he said, 'this is Lake Manyara Lodge. We won't be at the crater for four days!'

I don't have any money with me as I thought I was meeting up with Richard this evening. I also have no contact details for him, as he is camping in the base of the crater. Then – the thunderstorm hits and we are plunged into darkness by a power cut. I certainly can't even get a message to him now as the phone lines are down and I'm not going anywhere tonight.

One of the tourists, Mike, a pilot, takes pity on my situation and very kindly pays for my room and dinner for the night: 'You can pay me back sometime, no hurry, though.'

Over dinner with the tourists and driver I explain my dilemma. I assumed I would have been at Richard's

camp tonight and suppose that when the space was booked for me on the minibus to the crater, they hadn't asked when the bus was due to be there. I was supposed to be filming for National Geographic for only eight days, but at this rate I won't arrive there for another four. The tourists chat with the driver and between them they all agree to change the order of their tour. It makes little difference to them which route they travel to take in the sights and they are keen to help me out. I am truly flattered and relieved. I can never repay them for their kindness.

3° 12′ S **24 FEBRUARY 1991**
35° 27′ E Ngorongoro Crater, Tanzania

We finally arrive at the Ngorongoro Crater reserve in the early afternoon and Mike kindly bails me out again by paying my entrance fee. A short drive later and we are at the crater rim. As we head along the red dusty road, I see a Range Rover speeding towards us. As it passes I realise it's Richard driving. I ask our driver to toot his horn and we turn in the road and finally catch Richard up when he pulls into the lodge to get fuel.

Initially he is quite angry: 'Where the hell have you been? You were supposed be here last night!' he asks in his South African twang.

I explain the whole cock-up with the journey and the kindness of the tourists to change their itinerary to bring me here. Richard soon calms down and, having said my heartfelt thank yous and goodbyes to my fellow tourists, Richard and I head down to his camp.

This is my first view of the Ngorongoro Crater, one of Africa's Seven Natural Wonders, and it looks stunning. It's the largest complete caldera of an extinct

volcano, almost circular and about 12 miles across. The crater rim is a dramatic natural encircling boundary wall, lush green with grass and trees. The land slopes away and a gravel road zigzags down 1,300 feet to the crater floor where it is mostly flat grassland dotted with small forests and swamps. Once near the bottom, the encircling line of the crater wall is clear with some wisps of cloud draped over the rim to the east. The crater is huge with a vast sky and is home to an estimated 25,000 large animals, mostly ungulates. It's hard now to imagine this as a 19,000-foot-tall active volcano before it erupted and collapsed 2–3 million years ago.

As the sun sinks in the west the crater starts to fill with shadow, just as we arrive at Richard's makeshift camp: comfortable but low-key. In the shade of a few trees stand three small sleeping tents, a mess tent and a simple toilet tent. Richard's girlfriend Samantha is there to greet us, and a table is already laid for dinner. We all sit down with a drink to talk through the filming ideas and schedule for the next week. While we chat, a herd of about 100 buffalo graze their way slowly towards us. Richard and Samantha don't seem in the slightest bit concerned; they have been camping here for months – clearly old Africa hands. After a few more minutes of watching, the buffalo get closer and I can see they're going to skirt the camp and so I relax somewhat and enjoy the scene.

Richard turns on his radio and tunes in to the BBC World Service. We listen to a live update on the horrors of the Gulf War unfolding, the report of the ongoing ground assault, Operation Desert Storm. It is a very surreal moment, sitting in a breathtaking location, a wildlife paradise with just the sound of a huge herd of buffalo feeding peacefully as they pass our camp, and yet 3,000 miles away people are losing their lives in a pointless war.

3° 12′ S **28 FEBRUARY 1991**
35° 27′ E Ngorongoro Crater, Tanzania

Filming has been going really well. Shot an exciting sequence of black kites stealing food from unsuspecting tourists at the picnic site today. The birds are so bold and acrobatic – I got a shot of one kite taking a cooked chicken leg poised between a tourist's hand and his open mouth. These birds are seriously skilled in flight manoeuvrability and timing. The best thing is that the tourists sometimes don't see the bird at all and can't work out where their food has gone.

After lunch we shoot an opportunistic short sequence of a pride of lions seeking shade from the midday sun by crawling right under one of the tourist Toyota Land Cruisers. The lions won't budge and the tourists get stuck there for hours.

Later, Richard and I go to film time-lapses of the evening shadows sliding their darkness across the crater landscape. We drive partway up the eastern slope, as from there we can look west and get the shadows travelling towards us, and we also set up other cameras looking to the north and south to film the shadow climbing up the eastern wall. The thing with time-lapse photography is you can spend an hour or two filming for perhaps a ten-second shot. So if you are going to be in one location for an hour or so, it makes sense to try to run multiple cameras.

Having chosen one spot, the light is changing fast. Richard says he'll stay and man the camera if I want to drive his car a few hundred metres up the slope and set the other two cameras going. I've never driven his Range Rover before: it's powerful and wallows like a boat. I whizz up the slope and quickly frame up and set the cameras going. Then, I think I'd better just check on Richard – I can just make him out. There's something

odd about his movements, even from 600 metres away: he keeps looking up towards me and then away. I grab his binoculars from the dashboard and check again. To my horror, directly in line and beyond Richard is a lioness. Fuck, fuck, fuck. I leap in the car to race back down to him. My heart is pounding and in the panic I can't find reverse. So I freewheel backwards down the hill towards him. The car is wallowing all over the place and I have visions of rolling it. I jam the brakes and slam it into first gear, do a U-turn across the drainage ditch and race on down the road. I can still see the lioness beyond so, with adrenaline rushing, I drive straight at Richard across the grass and pull up next to him.

'Are you okay?' I ask as Richard climbs in the car.

'Yes, I'm fine. That lioness has been watching me for a good ten minutes, though I was kind of hoping you might bring the car back down sooner.'

'Bloody hell. When I checked with the binoculars from up there it looked like she was almost on top of you. I wouldn't have been so cool about it.'

I really can't believe how calm he is, but made a mental note that his staying still probably gave an air of confidence and courage. Richard went on to tell me that if the lioness had approached, he was going to try a technique the Masai use. If they think they are being stalked or hunted then they sometimes drop right down in the grass. The approaching lion then thinks it is the one being hunted, gets unnerved and has been known to retreat.

Richard has spent years around lions and clearly understands their behaviour. Also knowing these particular prides in the crater and the lion's history living alongside people, the Masai.

Hopefully I'll never have to try that strategy!

1 FEBRUARY 1996

26° 48' 26" N
113° 14' 25" W

San Ignacio Lagoon, Baja California, Mexico

Eye to eye Grey whales have the longest annual migration of any mammal on Earth, around 10,000 miles each year up and down the west coast of North America – from the cold, nutrient-rich waters of the Bering Sea in the Arctic to the warm waters of lagoons in Baja California, Mexico. San Ignacio Lagoon is roughly 600 miles south of Los Angeles, USA, and it's nearly the southern-most point of the grey whale migration. The whales come here to breed. The females have their young here and wait until the calves are strong enough before taking the treacherous journey back north.

I am here with producer Andy to film a portion of a programme about grey whales for a BBC series called *Incredible Journeys*.

When Andy first spoke to me months ago and offered me the job I was really excited. I've never seen a whale and can only imagine their size and awe having seen the huge blue whale skeleton in the Natural History Museum in London as a child. Andy explained that there were two possible boats we might be going on. One, *The Odyssey*, belongs to the Ocean Alliance and was first choice, but unfortunately they were full. The second was a German tour boat that carries around 30 tourists and was also going to San Ignacio Lagoon and they did have two remaining spaces. Andy then had to give me more specific details about the German boat option.

'Er, basically Gavin, it's more of a spiritual tour for the tourists. They have hydrophones and listen to whale song and so on. The other thing is, er, it's a naturist

boat tour. So I just wanted to ask you, are you happy to be naked for three weeks? I mean, obviously you can wear a wetsuit for the underwater work, but on board we would both have to be naked along with the crew and other tourists.'

I thought it would be hilarious and a great story if ever I wrote a book, so said, 'Yes, Andy, I'm up for it. It could be quite funny. And think of the behind-the-scenes publicity photos for the programme!'

I was rather disappointed when Andy called me again a few weeks later to tell me that two spaces had become available on the Ocean Alliance boat. Probably the better boat to be working from but now no funny photos for the book!

We board in Cabo St Lucas and have a two-day journey, 360 miles, up to the lagoon. The weather is beautiful, with near clear blue skies, a gentle breeze and nice big long swell. We travel north about five miles from shore. The land looks dry, rugged and barren. The Pacific Ocean, by contrast, looks lush, alive, blue and inviting.

The Odyssey is a very comfortable yacht, varnished hardwood finish everywhere, a spacious carpeted lounge, quality speakers for music on every deck. I'm intrigued how research grants could afford such a flash boat. The captain explains that they haven't had the yacht very long. They were in port about six months ago and the captain was drinking in a bar. He was chatting to the guy next to him and they got talking about the work the captain was doing with whales and dolphins. The man was very interested and enthusiastic about the whole ocean conservation idea. They carried on talking and drinking for a while. Eventually the captain said he ought to go and get back to his boat. The man asked, 'Which is your boat, then?'

'It's the small one behind that really nice yacht there, *The Odyssey*,' the captain said, pointing out across the bay.

The man replied, 'My God, that's tiny. That can't be comfortable out on the open sea – it must be difficult to do your research on that!'

'It is, and the boat is old and with constant running repairs. But we're a registered charity and don't have much money.'

At that, the man said, 'Look. I like what you're doing and I can see your passion in the cause to help whales and dolphins. I'd like to donate my boat.'

The captain was stunned. 'What?'

'I have ordered a new, bigger yacht and take collection of it in a few months. This boat has paid for itself many times over and it would mean a lot to me that it goes to a good cause. I make, shall we say, a "different" genre of film for a business and *The Odyssey* was designed and built for that purpose. It has good interior space and fittings, great sound system too.'

And that was it. A few months later the yacht was handed over for conservation and research work.

As we sail, we can see the occasional blow from a whale and the intensity grows as we head further north. One thing we'd like to film is a grey whale 'heat run' and mating frenzy. This is when a female on heat is courted and chased by competing males all trying to mate with her. You can often get up to eight or nine males all vying and trying to get lucky with one female. That's around 400 tonnes of whale orgy! As far as Andy knows, the mating has only been filmed once before underwater and that was by hugely experienced and respected cameraman Howard Hall. He had been filming for a German company and the director wanted the mating heat run – specifically graphic shots of the

six-foot pink penises. On the last day, Howard got caught up in the middle of the mating ball, was hit by a tail fluke and had two ribs and his left arm broken. The only consolation was that the director phoned him in hospital a few days later to thank him. He had seen the rushes, and when the camera was knocked from Howard's hands it was still running and caught the perfect shot of a giant pink penis.

We all have our eyes on the ocean looking for whales. My camera is loaded and installed in its underwater housing, ready for action. In the back of my mind, though, I am now thinking about Howard Hall's experience.

We start to see groups of mating whales in the distance. They seem to be active on the surface for a matter of minutes before diving. Then they appear five to ten minutes later a quarter of a mile further away. From experience, the captain knows that the whales can be put off by the sound of the ship's engine. The best plan to get close to a mating pod is to motor towards them and, once within half a mile, cut the engine and drift. To get close with a camera, we're going to then quickly get into a sea kayak and paddle quietly towards them.

The next mating pod we see, we decide to try this. There are two other photographers with us and they nab the two-man kayak. I get into the one-man kayak and Andy passes me down my film camera in its housing. Then we set off towards the group.

It is quite hard going. Although there is virtually no wind, there is a two-metre swell running. But the sun is high in a cloudless sky and the ocean is clear blue.

I quickly realise that the two-man kayak is faster – they are making much better headway. Each time I rise to the top of a wave I take a bearing to the whales. I then paddle like crazy down the wave into the trough and up the other

side. Within five minutes I'm starting to overheat in my wetsuit so unzip it and splash cold seawater over myself. The other two photographers are now a few hundred metres ahead and nearing the pod. Desperate not to miss out on getting the shots, I push on harder.

At the next crest I can see that the whales we are heading towards have dived, but just two hundred metres to my right, another mating pod has surfaced. So instead of chasing the other kayak, I turn and head to the new group of whales. Quickly, I am within 50 metres of them. Excited and nervous, I stow my paddle, zip my wetsuit back up and slip quietly into the water, unclipping the camera from the kayak and lifting it gently in too. No sooner am I in the water than the whales dive. I can see they are coming my way, so I slip on my mask, take a deep breath and dive. My heart is now pumping and the reality has sunk in. I am in 7,000 feet of water, five miles offshore, half a mile or more from the yacht in a two-metre swell. Coming towards me is perhaps a combined 500 tonnes of testosterone-charged whales, led by a female in heat, probably desperate to get away. I have never even seen a whale before, I've certainly never dived with one. Looking straight down into the depths with visibility of at least 150 feet, I suddenly panic and get a weird sense of vertigo. I hold my breath and scan for the whales, knowing that if I see them and get my eye to the viewfinder I'll be fine. My mind will be drawn back to the job and the image and not to my irrational fear. The whales don't appear and I surface to breathe. I look around me for the kayak – it's now 25 metres away. I swim over to it, stow my camera and then, holding onto the side, I look below the water again. No whales and still that weird sense of vertigo. I feel like I could just fall 7,000 feet to the bottom. Totally illogical.

It is a good 30 minutes until the yacht picks me and the other two guys up. None of us got close to the whales or shot a single frame, but it is only the first day.

2 FEBRUARY 1996 26° 48' 26'' N
San Ignacio Lagoon, 113° 14' 25'' W
Baja California, Mexico

We've made good headway north and have been joined by dolphins several times along the journey. I've had fun hanging off the bowsprit with my camera, filming slow-motion footage of the dolphins effortlessly riding the bow. They would turn on their sides as they swam and were definitely checking me out. So cool.

San Ignacio Lagoon stretches like a big blue tongue 16 miles inland to the desert and is around five miles wide. It is late afternoon by the time we pull in and drop anchor. The water flattens out and, as the sun gets lower, we can see constant blows from whales way into the distance – vertical plumes of spray and mist as they exhale at the surface through their blowholes. An experienced eye can tell the different species of whale by the shape and size of the plumes. I have a lot to learn.

As we drop anchor, two whales are slowly approaching us. I think this might be my chance to get the first shots. I pull on my wetsuit and mask and climb down the ladder. I slip on my fins and Andy and the crew pass down my camera in its housing. The whales are going to pass close to the bow so I swim forwards. I choose my moment and, when they are about 50 metres away, they dive. I take a deep breath and swim down the anchor chain. The visibility is not so good in the lagoon – maybe six metres. Suddenly, out of the gloom comes a massive shape, the size of a school bus. A whale

coming straight towards me. Instead of filming I swim backwards and cling onto the chain. The whale passes within a few metres of me, followed by a second. The second whale doesn't seem so pleased to see me and rolls slightly on its side. Its huge eye checks me out and then, in apparent slow-motion, it swings its huge fin very close to me and the anchor chain as it glides past. Once they've disappeared back into the gloom I surface to breathe. Andy and the whole crew are hanging over the bow.

'Did you get it?' Andy asks.

All I can answer is, 'They are fucking big!'

The captain shouts out that the whales are coming round the boat again. Andy is now in his wetsuit and swims to join me. As before, the whales dive and so do we. I follow Andy down the anchor chain, staying just behind him. Once again the first whale appears from the gloom and my mask leaks in a little water because I'm smiling at Andy's reaction. He does exactly the same as me, swimming backwards to hide by the anchor chain. The second whale is close behind and I can clearly see that this is a male. He swings his pectoral fin and his tail fluke at us both as he passes.

Surfacing, Andy turns to me and says, 'Jesus, they really are fucking big. And they look even bigger under-water. I can see why you didn't get a shot the first time round. That's the first time I've ever swum with a whale and I don't mind admitting I was nervous.'

The whales head off and that's our chance done for the day.

5 FEBRUARY 1996 26° 48' 26" N

San Ignacio Lagoon, 113° 14' 25" W
Baja California, Mexico

Over the last few days we have slowly started to build a sequence. I went ashore to the east at sunset with my camera and tripod, and manage to get shots on the long lens of backlit whale blows against the shadowed desert hills.

But mostly I've been filming the whales handheld from the Zodiac dinghy. This gives me a nice low angle to the water and we're able to paddle and get in close. Navigating to another part of the lagoon, it seems that there is a ridge underwater that the whales like to gather along on the incoming tide. With the motor idling, we can hold position. Looking down into the water I can see the backs of whales either side of the boat. It is as if they are just resting their bellies on the ridge facing the incoming tide. The whales are all very relaxed in the lagoon – and also inquisitive of the boats. They've been swimming up to us and spy-hopping to look in the boat. Spy-hopping is when the whales rise up vertically in the water, sticking their heads straight up about eight feet until their eyes are above the surface. They hold this pose for five or ten seconds while they check us out. This has given us a good chance to look at the whales too. Their heads are usually covered in barnacles which live on their skin, as well as scars and scratches from where they have scraped themselves feeding on the bottom.

Something else they've been doing is coming up right underneath the boats and part-lifting them out of the water. This doesn't seem to be an aggressive move, more exploratory – or maybe because they want to scratch their backs on something. What I feel when they're around, but can't quite explain, is that there is something incredibly calming about being so close to

the whales. People may scoff at me for saying it, but each time I stare into a whale's dark murky eyes, I can see intelligence and wisdom. Very much the same as looking into the eye of an elephant. It's as if there is some deeper communication between them and me.

As I look across the lagoon I estimate from the blows, spy-hoppers and occasional tails visible that there must be more than 200 whales within sight. Who knows, there could be thousands with us in the whole lagoon.

We are still keen to film one of the mating frenzies – each time we see them we attempt to get close but the mating pods don't stay in one place for long before the female ducks away and leads them further on. The females are clearly not too happy with the close attention from the groups of randy males – or perhaps they are?

26° 40' 02" N **7 FEBRUARY 1996**
113° 7' 36" W San Ignacio Lagoon,
Baja California, Mexico

Finally, we luck out and a mating pod surfaces not far from us. I am sat in the bow of the Zodiac and start to film as the rest of the crew paddle us closer. It looks amazing. Bodies rolling in the orgy, fins and tail flukes cutting clean out of the water as the males compete. And, yes, the males were clearly aroused as their six-foot pink penises also appeared in the melee. My eye is tight to the eyepiece, keeping the camera as steady as I can as we drift forwards. The shot is developing nicely the nearer we get. Now, fins, tails and penises feel 3D as they break the skyline. In between the deep resonant whale breaths and splashes, I am aware that the crew are no longer paddling. Still filming, I take

my eye from the eyepiece and realise why. We are now right in the middle of the mating pod and the crew are braced for a capsize!

Thank God (in a way) – the pod decides to dive, swimming off to surface 100 metres or so further on. I've got some great shots, probably enough to cut a sequence from that one event. It is a reminder, though, of how my perspective as a cameraman looking down a wide-angle lens can fool me into thinking I'm further away. We were lucky we didn't end up in the water.

The one thing we haven't managed to get shots of are the babies. Although I've seen glimpses of the backs of newborn whales, their mothers are clearly protective. Combined with the murkier waters of the lagoon, these may be shots to get elsewhere. Incredible, though, to think that those babies would soon be heading off with their mums on their 4,000-mile journey north. Running the gauntlet of predators such as orca, not to mention the risk of collision with container and other ships in the busy shipping lanes feeding America.

If lucky, a grey whale can live to around 75 years old.

24 NOVEMBER 1997
19° 23' 13'' N
155° 6' 19'' W

Hawaii Volcanoes, USA

This is my second visit to Hawaii but I've yet to see an active volcano. I'm here with friend and producer Matt, and the BBC series title *Violent Planet* gives a clue to the type of image and story we are here to cover.

We are working under the close guidance of the Hawaii Volcano Observatory team based on the 'Big

Island', Hawaii. Currently, molten lava is travelling 11 kilometres down through lava tubes* from the Pu'u O'o vent (an active volcanic cone on the eastern rift of the huge volcano, Kilauea) at 700 metres, and spewing out into the ocean. The lava is molten and still glowing red-hot as it pours out of two points, a few hundred metres apart, into the waves. Plumes of steam and smoke rise up 1,000 metres into the blue skies like two giant genies emerging from a lamp. It looks very dramatic and it's a good illustration of how Hawaii was formed and how the island continues to grow. I have a vision of filming a time-lapse of those steam plumes at night. The glow of the lava will light up the inside of the plumes; the backdrop will be the stars rotating in a midnight-blue sky. There is virtually no light pollution here so it should look stunning.

We drive along the Kaimu-Chain of Craters road, following the car of one of the resident female volcan-ologists who is going to guide us this evening. Initially the road is lined with lush green tropical bushes, but eventually it comes to an abrupt halt where an old lava flow has cut across the road: nature's barricade. From here we will have to continue the last kilometre or so on foot.

While our expert guide Cristina moves lightly with just a small backpack and notebook, Matt and I trudge heavily, carrying our rucksacks loaded with cameras,

* A lava tube forms when the lava starts to cool and solidify, form-ing a crust or skin on the surface, while the lava continues to flow underneath. The tubes are generally D-shaped with the flat of the 'D' being the bottom of the tube with an arched continuous roof. Often, small sections of the roof collapse, revealing red-hot lava still flowing. These are known as skylights.

You might be interested to know that there is an ancient example called Thurston Lava Tube you can visit on Kilauea (19° 24' 49' N 155° 14' 19' W) not to be confused with the psychedelic experimen-tal surf instrumental band from Leicester, UK.

lenses, film stock, batteries, etc. As we set off I look up to our right and from here can see the smoke rising from the Pu'u O'o vent. The slopes are barren black, solid lava undulating here and there with interesting swirling patterns. There are a few small pockets of lush greenery dotted about, hinting at the past when forests covered these slopes before all-consuming lava engulfed and burnt them. I definitely feel a sense of nervous excitement as we move ahead. It's nearing sunset and the light is becoming dramatic.

Forty metres from the ocean edge we stop at a distinct ledge that steps down. Cristina points at it and gives us some background information. 'This edge here is where the new shelf starts. Some of the molten lava solidifies when it hits the ocean forming new land. This can form an unsupported tongue or shelf that sticks 50 metres or more horizontally out to sea. These shelves can be hundreds of metres wide and are very unstable. A few months ago we lost five hectares of our island overnight when one of these shelves just snapped off. If you happen to be on the shelf when it snaps, you will likely be boiled alive before being dragged down 7,000 feet to the bottom of the ocean.'

Matt and I glance nervously at each other.

'We regularly venture down onto the shelf to take measurements and so on, but I want you to be aware of the danger. Don't spend more time down there than is necessary. Also look out for cracks along this top edge and listen out for any claps or rumbles, they might be signs of things on the move. Also, trust your instinct. If it doesn't feel safe then don't go down there.'

She also warns us of getting caught in the steam and poisonous volcanic gases if the wind changes direction. The steam is largely hydrochloric acid. It also contains thousands of minute sharp glass particles which can accumulate in your lungs. If you breathe enough of this

cuspate ash it can set like cement when it mixes with moisture. This is why so many people die of asphyxia, like in the giant ash eruption of Mount St Helens, in Washington state, in 1980.

The sun has now set and, with these two particularly glorious ways of dying now in the front of our minds, we walk down onto the shelf. Certainly, all that talk has now really put me on edge, and I stick close behind our guide as we venture to the drop-off into the ocean. To our right I can see tonnes of glowing lava oozing into the water, nature's mimic of an industrial steelworks. Waves crashing over it darken its glow from bright 1970s orange to deep rich red. I can feel the heat on my face even from this distance. The noise of the waves and the steam: this is the raw power of nature. It doesn't feel safe to get the camera out so we follow Cristina on the 'tour'.

Darkness has now fallen quickly, and the glow from the lava has become really obvious. The steam plumes now look like giant thousand-foot-high amorphous orange ghosts. The colour contrast against the deep-blue star-scattered sky is better than I could have ever imagined.

As we walk on along the shelf looking for the best angles, the lava crunches under our feet and in the darkness I can see the faint glow of red through the deeper cracks. This now doesn't feel safe at all. We stick close to our expert as she moves quickly back away from the waves, back away from the spewing lava. She skips daintily over the black rock, whereas with the extra weight of our heavy rucksacks Matt and I break through the crust with each step. My feet are now cooking and the soles of my boots are becoming tacky with the heat. We run the last 20 metres and up the short slope off the shelf.

After what felt like a very risky introduction to this zone of the volcano, our volcanologist and guide bids

us farewell. 'Now, stay safe, guys. Good luck, and see you tomorrow.' And she heads off back to her car.

Neither of us is going to be stupid and push our luck here. No bloody way.

We retreat slightly from the action and I set up two time-lapse cameras on two tripods. Once I'm sure I have all the right camera and timer settings, we take a camera and tripod each and approach a little closer to the steam plumes. Not hanging around, I frame up both shots and set them running. They're set to take a long exposure picture every 35 seconds and I'm going to leave the shots to run for about three to four hours.[*]

Matt and I chat for a while about the whole experience and admit to each other how nervous we've been feeling. The soles of our boots are a visual reminder of how hot the ground had been under our feet.

It is now late. We are still jet-lagged. Knackered, inevitably we both doze off ...

Maybe an hour has passed, I don't know, but we both wake up at the same time. Without a word we jump up, grab our backpacks and run. While we were sleeping, molten lava has migrated into a lava tube running directly beneath us. A combination of the sudden intense heat and the acrid smell of sulphurous gas must have woken us with a start. Once clear of the heat and fumes, and both out of breath, Matt and I stop and look at each other. He has the expression of a startled rabbit in the headlights and I must look the same.

'Jesus Christ. What just happened? If we hadn't woken up we would have been fried or asphyxiated.

[*] It is so dark that I'm having to leave the shutter open for 30 seconds each exposure. Running for 3 hours will give me a playback shot of about 12 seconds.

That wasn't in the brochure!' We must have been breathing the gases for a while as we both notice we have sulphur-crusted nasal hairs.

Wide awake from the adrenaline, Matt and I stay vigilant until it's time to retrieve the cameras. We waste no time on the shelf. We just run down, grab the cameras and run back up to safer ground.

After packing up, we hike back to the car and drive back to our lodgings for a well-earned sleep.

En route we get cell-phone reception back and Matt picks up a load of pager messages from Dave, our main volcano scientific adviser for the trip. 'CALL ME URGENTLY – TSUNAMI WARNING FOR THE ISLAND. GET OFF THE SHELF AND GET TO HIGH GROUND.' Matt and I have that startled rabbit look again. Tsunamis weren't in the brochure either!

It's now 3am but Matt calls back to find out more and to let him know we're okay.

The tsunami warning is over now, but was called for the whole island after an earthquake in Alaska. There are early-warning sirens all along the coastline, but not round to the south-east where we were out on the lava flow. We were too far away to hear them. There was us worrying about the danger of the volcano and yet the major threat could have come unseen from the ocean. My God this can be a violent planet.

19° 23' 13" N NOVEMBER 1997
155° 6' 19" W Hawaii Volcanoes, USA

Today we fly by helicopter, with pilot David, up to the rim of the Pu'u O'o vent on Kilauea, one of the world's most active volcanos. Kilauea towers 4,091 feet

out of the Pacific, all the way from the ocean bed 9,000 feet down.

Having circled the vent, our pilot puts down about 150 metres down the slope for a more level landing spot. Matt and I unload tripod, camera and rucksack and follow our volcanologist Carl up towards the rim. As the smell of sulphurous fumes fills our nostrils, he stops and turns to give us a quick briefing.

'Don't go too near the edge, the lava rocks are very unstable. You'll see that it's a near-vertical drop down 50 metres or so to the bottom. If you survive the fall, you won't last long after that and I'm not coming down to get you!

'Also, although I'm an expert I have lost many expert friends to volcanoes so I am well aware that we don't know everything. I'm a great believer in listening to your heart – your gut feeling. If you feel any sense of danger or unease then let me know straight away and we will leave. Our bodies sense things that we can't measure or assess as scientists and there's a reason we have a word called instinct. Learn to trust your instinct and don't ignore it.'

With that, Carl turns and heads up to the edge of the crater, standing way closer than I would have thought safe based on his little spiel just now! As we follow him, the solidified lava crust crunches underfoot.*

The crater is more or less textbook of what you'd imagine. Roughly circular and about 100 metres across. The crater wall drops pretty much vertically down to the flat solid lava volcanic plug. Below us to our right, to the side of the crater, is a raised turret about ten metres high and ten metres across. In this vent, red-hot

* If you ever walk on lava near an active volcano you will know how unnerving it is for lava to crunch and collapse underfoot. Invariably you only sink a few centimetres, but often you feel you might fall through into a cavern.

molten lava bubbles away, issuing a plume of toxic smoke into the blue cloudy sky. I can feel the heat on my face, like sitting close to an open fire. There is something unnerving about being here – I am in awe.

I start to film. Wide shot, close-up, details, slow-motion. To my left I film looking down the slope of the mountain, 11 kilometres to the ocean, and the two plumes of steam and smoke that are rising up, leaning slightly in the wind. This is where two underground lava tubes are spewing molten lava into the waves. The volcano we are on is clearly showing it is active.

Back to my right, the lava in the small turret is gently rising and falling while bubbling away. Perhaps a few hundred tonnes of molten rock are being lifted, then gas escapes and the lava falls back down out of sight. This is incredible to see; it is like Mother Earth is breathing.

Carl has been checking various monitoring devices and live cameras installed on the rim: he calls us round to the left to show us something. Walking round with the camera gear, our feet keep breaking through the lava crust, the jagged edges cutting our boots. Carl explains that the Hawaiians have two words for the different types of lava – *pahoehoe* and *a'a*. (The word 'lava' comes from *labes*, an Italian word derived from the Latin meaning fall or slide.)[*] Where we are standing the lava looks very different,[†] like long strands of hair. This is where, in the past, the molten lava has flowed out and over the rim during a more active time. As the last of the fast-flowing lava cools it does so in long strands, the name for which

[*] The first use of the word to do with extruded magma was apparently in a written description by Francesco Serao when Vesuvius erupted in 1737.

[†] When lava cools slowly and does not move too fast down a slope, it forms smooth, ropey lava called *pahoehoe*. A bit like black folded cake mixture. However, if it cools quickly while moving fast it can tear and tumble into clinker pieces called *a'a*.

is 'Pele's Hair' – Pele being the Hawaiian goddess of volcanoes. When I ask how often lava flows like that, Carl says, 'You never know. The last big activity was two years ago when Kilauea fountained molten lava straight up 2,000 feet for two days!'

I look nervously round to my right at the small bubbling turret.

The weather is changing and it looks like rain is on its way. Having pretty much exhausted the types of shots we can achieve, Matt and I head back to the helicopter. As we are loading in the kit, Carl calls frantically from the rim. 'Quick, quick, get up here with your camera!'

Matt and I race back up just as the rain starts to fall. As we get to the rim, we can see why Carl is so excited. The small turret which has been 'breathing' lava is now overflowing into the crater. I set the camera and start to film. The red-hot molten lava is surging. I only have 120 feet of film left in the magazine – about three minutes' worth. I have to choose my shots wisely. My heart is now racing, nervous adrenaline heightening my senses.

Wide shot – one, two, three, four, five, six, seven, eight, nine, ten: I count under my breath so as not to cut the shots too soon in my panic and nervous excitement. Between shots I glance at Matt and Carl to gauge whether they too feel uncomfortable.

Close-up – one, two, three, four, five, six, seven, eight, nine, ten. My heart is pounding; my vision crystal clear. I can hear the helicopter firing up down the slope. The rain is falling harder now but the lava is radiating so much heat that the water is turning to steam above our heads. The camera is staying dry, but the rubber lens hood is starting to droop in the heat.

I've been filming for only a minute and already the lava has risen ten metres across the whole crater. In my head, I am remembering Carl telling us how this

very crater fountained molten lava 2,000 feet into the air just two years ago. Is that about to happen here? I continue to film but I am now very on edge. The lava rising, second by second. Rising, metre by metre.

Carl suddenly runs towards us and shouts, 'Time to go!' He grabs the camera and tripod from me and runs down towards the chopper.

'Watch the tail rotor!'

We leap in, main rotor blades spinning just above our heads, camera and tripod bundled in across our laps. Before we've even shut the doors and buckled up we're airborne. The nose tilts forward and we gather speed down the slope. Now we are flying though patches of thick cloud, the ground below appearing and disappearing. All the while I'm wondering what's happening behind us. Is the crater overflowing by now? Are we about to be showered with molten boulders? I am almost waiting for the big bang. Looking down I get glimpses through the clouds and mist of previous lava flows, burnt trees and the odd surviving dash of green. Over the headset I nervously ask how David, the pilot, can fly in these conditions: is he using instruments?

'No, man, my GPS busted last week,' David replies in his laid-back American twang.

'This guy flies by the seat of his pants,' Carl says.

The pilot asks us where else we're going to film for this series.

Matt replies, 'Montserrat, Yellowstone, South Africa.'

The pilot says, 'Wow, South Africa!'

Matt asks, 'Are you keen on volcanoes, then?'

'No, man. Killer waves, dude, killer waves.'

And with that he cranks up 'Ride of the Valkyries' over the headset as we fly further into the mist.

18 JANUARY 1999 2° 12' N

Mbeli, Republic of Congo

16° 23' E

I am out in the wilds of central Africa filming for a three-part BBC series called *Congo* for friend and producer Brian. It took assistant cameraman James and myself six days to get here: flights from London to Paris, Paris to Douala in Cameroon, then a charter flight from Douala to a dirt logging strip on the Cameroon-Central African Republic border. After some intimidating customs negotiations we loaded all our cases into a 40-foot pirogue – a dugout canoe carved from a single trunk, powered by an outboard motor – and headed downstream on the mighty Sangha river. It was a seven-hour journey through the heat of the day, the river winding its way south through equatorial forest. At its widest the Sangha spans 500 metres or so, but occasionally narrows to a mere 100 metres wide. Apart from being fried in the sun, James and I got feasted upon by very annoying tsetse flies, clearly enjoying our fresh European blood. My God do those bites itch.

We reached the field station at Bomassa just as it was getting dark. On arrival it was like a scene from the film *Apocalypse Now,* reaching Colonel Kurtz's camp. The pirogue pulled up at the base of some weathered concrete steps and looking up, past bare electric bulbs in the trees, we were greeted by silhouette figures looking down at us. Turns out they are friendly employees of WCS,* and they helped us unload all our kit. The concrete huts here are basic but comfortable and at

* The Wildlife Conservation Society.

least there were some cold beers to soothe us after the journey.

Now time to get filming. This morning, having loaded up all our kit and 18 porters, it is a short trip in a huge ageing truck named Mokele-Mbembe, after the local mythical river-monster (similar to Scotland's Loch Ness Monster). This is literally to the end of the road. From here on, the journey becomes more intrepid. Our kit is transferred onto a small rickety wooden jetty, and from there loaded into small pirogues, around twelve foot long. It is going to take a couple of trips. The boatmen stand and paddle, much like a paddle border, and expertly use a combination of paddling, punting and pulling the pirogue forward by grabbing vegetation. The pirogues are perilously low and James and I sit in half an inch of water.

I know this route is taken often, but I feel like a real explorer as we make our way up the narrow Ndoki river. We glide past impressive trees with wide buttress roots stretching for a foothold. Tangles of lianas drape down like a scene from a Tarzan movie. The forest thickens and closes in.

After a magical half-hour trip we arrive at a muddy landing spot: from here on it's on foot. The porters divvy out the cases and quickly fashion themselves makeshift 'bush' backpack straps out of strips of vine. All apart from one: the last porter has my Samsonite hard suitcase with wheels and he sets off through the forest pulling it as if he is at an airport. These guys don't hang about and it's a fast march to keep up. The first 400 metres is along a raised gang-plank boardwalk through swamp; careful balance here is key. We then follow a natural elephant path. Fresh signs are obvious in the form of huge mounds of dung and I am now fully alert. This is my first time in the Congo and it's an intense experience: a

constant background noise of cicadas and oppressive heat and I can't quite get Joseph Conrad's *Heart of Darkness* out of my head. But I'm excited. Forty sweaty minutes later we arrive at the camp. The two scientists, Dave Morgan and Richard Parnell, along with their two assistants aptly known as 'Grand Marcel' and 'Petit Marcel',* warmly welcome us and we settle in.

19 JANUARY 1999 2° 12′ N
Mbeli, Republic of Congo 16° 22′ E

This forest is mostly thick with trees with understorey vegetation but is interspersed with some natural clearings known locally as bais. These are open areas and mostly marshy, making it difficult for trees to get established. A half-hour walk from camp takes us to one of these clearings known as Mbeli 'bai'. Dave and Richard have been studying the gorillas here for six years where they observe from a 'mirador', a treehouse-like platform built about 30 feet up, this is where I'll be filming from too. Once up on the mirador I can see the whole bai, an open arena around 200 metres across and stretching 200 metres to my left and maybe 400 to my right. The vegetation is mostly tall grassy reeds with waterlilies growing in the patchy water. These bais are a magnet for wildlife: elephants, forest buffalo, sitatunga antelope, red river and giant forest hog, clawless otters to name a few. But what I'm here for of course is Western Lowland gorillas.

I set up my camera and tripod and begin the wait.

* French for big and small Marcel.

2° 12′ N **1 FEBRUARY 1999**
16° 23′ E Mbeli, Republic of Congo

The waiting Still no sign of the gorillas. That's 12 days now. I've
game been here 6am to 6pm every day in the blazing heat,
but no cigar. Thankfully, to help keep me awake
and alert on the platform, the rest of the Congo's
community have been providing me with distractions:
lots of ants biting me trying to get me out of the
way of their path, and the occasional sting from a
bee working wonders on my adrenaline. The biting
insect I've really grown to hate though is the Filaria
fly. It's active in the day and can fly silently, hovering
and landing on your skin without you noticing. For
some reason it favours elbows and knuckles to bite
and when it steals a blood meal from you by drilling
its proboscis into your flesh, it can also unwittingly
inject a parasitic nematode worm. This worm feeds
and multiplies inside you causing itching and swelling
and ultimately elephantisis. An adult nematode worm
migrates around your body at one centimetre a minute,
feeding as it goes. Often infected humans painfully feel
and see these worms inching across their vision inside
their eyeballs! Sometimes these worms will burrow out
through your eyeball on their journey. It is amazing
where your mind can wander when you have so many
hours to kill . . .*

* Whilst writing this book I googled Filariasis and was reminded of
the full horrors. Not least that the adult worms can live for 17 years
in a human host. So hopefully that means I'm in the clear.

2 FEBRUARY 1999
Mbeli, Republic of Congo

2° 12' N
16° 23' E
(vague)

It is early morning out in the bai, the sun is just hitting the far trees and the hint of mist has disappeared. At long last our patience is rewarded.

A family of gorillas enters the bai – two females with an infant each jockeying on their back, some youngsters and the silverback: 15 in total. They stride out with purpose, crossing the tiny streams carefully so as not to get too wet. Some of the females get straight down to feeding. They seem to like two types of vegetation: water lilies and tall grass-like sedges. I like that they wash the mud and soil off the water lilies first by shaking them in the water. Then, holding it with one hand they adeptly prune the leaves and roots using their teeth to leave the tuber: the starchy treat they were after. The infants on their mothers' backs watch wide-eyed, clumsily trying to copy them.

The youngsters meanwhile start to make mischief. One two-year-old is rocking from foot to foot with arms outstretched before pirouetting off, falling backwards into the long grass – the silverback looks on with disdain.

This has been an incredible experience, but I'd like to get closer – even my longest lens can't capture intimate footage of their faces, or details of their skin and hands. Dave and Richard understandably don't want us to go below the platform though: it might alter the gorillas' behaviour or even put them off coming to the bai again. Time to make the trip back home.

0° 10' N **10 MARCH 2000**
14° 31' E Lossi Animal Sanctuary, Republic of Congo

Brian and his team have found us a new location to gorilla-watch in Lossi, where two scientists have spent the past six years habituating two families of gorillas, meaning they're becoming comfortable in the presence of humans. We are hoping to work with the family headed by silverback Apollo.

In general, scientists can be understandably hesitant to let a TV crew film at their study sites. One screw-up, from people they don't know or can't trust to follow protocol, could set their scientific studies back and interfere with long-running data collection. There's also a case to be made that we are skimming the cream off their hard work, taking it home for television and the glory. However, one good thing about film crews apart from paying a filming fee is the huge outreach on television for a scientist's hard work. This can help raise profile and inject some money into their research. Keeping scientists out in the field for 365 days a year, in harsh conditions, costs money. Replenishment of grants isn't easy either. Supporters and companies want to see results, data, findings, to convince them to continue the funding. When the scientists can't deliver, because they are mid-process and so don't yet have results, additional funding is often denied and money becomes tight. Occasionally, film crews can come to the rescue by paying inflated prices for the huge privilege of filming.

The two scientists, Magdalena (Magda) and partner Herman very kindly accept us. James, Ralph and I share a camp with them: five simple wooden huts with corrugated iron roofs sit in a small tennis court sized clearing, forest on all four sides. There's a chef, Michel, who cooks for us every evening and he's amazing: two years prior to this he was cooking at the Congolese

embassy in Paris. He cooks pastry and fresh bread, which is bloody good considering the oven is literally a hole dug in the mud like a shallow grave. It's heated by lighting a wood fire in it, and the oven tray and 'door' are tatty bits of corrugated iron.

This morning we get up early, in the dark as always, and have our usual hero breakfast of porridge.* We then set off to the village where the trackers live, about half a kilometre from our camp. As we arrive, half a dozen villagers are grouped around something on the ground. They greet us with a 'Bonjour' and then return to looking down. In their circle, lying on the sand on its side, is a dead chicken. Apparently moments before we arrived, it had been crossing the courtyard when, mid-stride, a snake had struck at it. The villagers chased it off into the forest but the chicken died within a minute.

James, Ralph and I look at each other: it prompts us to remember that there are venomous snakes all around us. We're wearing wellington boots anyway for the wet and marshy land – but this event reminds me that it's also to offer some protection against being bitten.

We head off into the forest to where the gorillas slept last night – the trackers are quick to pick up the gorillas' onward trail and off we go. Growing up in the forest, away from buildings cars and concrete, their senses are finely tuned and they're able to pick up on the smallest of clues.

Filming gorillas back at Mbeli bai, of course, was relatively easy. No trees, flat land, black amongst the green. But here in the understorey, underneath the canopy, is an entirely new challenge. At times,

* Take note: the best porridge. There's obviously no fresh milk here, so the trick is to mix the milk powder with the oats first, whilst dry, then add the water. Otherwise, it's subject to chunky lumps, which isn't nice. There, that's a free one. Porridge in the Congo.

you can be within three to five metres of a gorilla, but have absolutely no view of it. You can hear it munching away, you can smell its musky odour, but because of the thickness of the forest, you can't even see a glimpse of it to film. Even though Apollo and his group are habituated, it is still nerve-racking. They are still very much wild animals and they will still charge at you if you piss them off. Today we are in luck and I get some lovely footage of Apollo and his family. Close, intimate shots of them sleeping, grooming and playing. They are very calm and gentle, spending most of their time eating. I'm most impressed with Apollo as the gentle protective dad. Such a huge animal and yet he tolerates the young-sters using him as a climbing frame when he is trying to siesta. Gently play-biting him as they rough and tumble.

Primary forest is so called because it has never been logged by man and is essentially characterised by a full complement of species, with mature large trees at their tallest. The ground and understorey is gener-ally less dense as sunlight is restricted by the overhead canopy. Lossi was logged fairly recently, but the forest bounces back pretty fast. The understorey grows up in abundance: there's a plant belonging to the arrowroot family that produces edible sprouts. This is a tasty snack for the gorillas, who pull them out like bamboo stalks. It's the bulk of their diet, topped up with fruits, roots and other vegetation. So, strangely enough, because the result of the logging meant more understorey growth and more food for the gorillas, secondary forest actu-ally has a higher density of them.

We also have a lot of opportunities to film the gorillas climbing trees and Magda points out a very visual depiction of their social hierarchy. The females are first to the trees. They ascend quickly and are able to eat

the fruit from the higher branches. The youngsters, too, climb up to join them. Because the females are smaller, they are able to reach the fruit on the thinner outer branches. The silverback, however, is restricted to the bigger branches nearer to the main trunk. It's impressive to see him climb up with ease, his huge arms hoisting his 200kg body seemingly effortlessly. Quite often though, Apollo doesn't bother to climb up. The gorillas moving around above in the canopy inadvertently knock ripe fruit off the branches and he sits underneath, picking up the fallen fruit from the ground. Occasionally when he hears a downfall of fruit or branches coming he will cover the top of his head with his huge hand. Almost visibly wincing in anticipation of being hit.

Back at camp, we're having chicken for dinner. James, Ralph and I all look at each other again. Tentatively we all take a bite, wait a few minutes, and when none of us die or feel ill, we continue. Delicious.

10 OCTOBER 2000 1° 19' N
Odzala-Kokoua National Park 14° 50' E

Brian is still collecting footage for the BBC *Congo* programme, and so James, Ralph and I make another six-day journey out to the Congo.

We are staying at a camp called Ekanya. The bai we are here to film at is called Maya-Nord. It's a lot bigger than Mbeli, but unlike Mbeli where we were restricted to filming from the platform, here we can film at ground level provided we are well camouflaged. There are the remnants of a very dilapidated hide at the edge of the forest; James, Ralph and I set about fixing it and adding more camouflage before setting up my

camera. It's only our first day and within a few hours we see gorillas. This is fantastic, what a payoff. Watching them slowly move into the open space, feeding as they go, is cinematic, a perfect scene of a gorilla family: just what we need for this programme. However, what really tops this bai as a location is the backdrop of other animals that also visit. We see swamp-dwelling antelopes called sitatunga, clawless otters, black and white colobus monkeys, elephant and red river hog – all out together, grazing and resting in the sunlight, all in one pan of the camera. It really is like a vision of an animal Eden, if you believe there was an Eden.

Our presence doesn't go unnoticed. A few of the animals look at us from a distance, unsure of what we are. James is positioned in a separate hide a hundred metres or so to our right and at one point, he hears some noise behind him. Just feet away, staring through the gauze at him are two chimpanzees, holding each other, curiously looking at the back of James' head. It's likely they've seen humans before but this might be the first time they've seen a white man.

It's been a successful day of filming, and to top it off we have a lovely surprise waiting for us back at camp. Brian and his production team sent us out on this trip with two extra aluminium flight cases. We thought they were first aid kits or additional camping supplies. It turns out that they are hampers of goodies: sweets, chocolates, cheeses, salami, magazines to get us through the six weeks. I can't tell you how much this means. After you've been out in the jungle, filming in the heat and humidity, fighting the flies, and having a diet mainly of vegetables and rice, it only takes a bit of chocolate to relax you – a taste of home! It's a massive morale boost. What a thoughtful gesture by the office.

Also in the hamper, which is very well-received, is some single malt whisky, 12 years old. It turns out Brian had popped into an off-licence in Clifton, Bristol, looking for something to send us off with and the shopkeeper claimed it was his lucky day, saying he had ordered in Glenlivet 12-year-old single malt whisky months ago but it hadn't sold. The reason why was because it was in plastic bottles. Clearly no one buys quality single malt in plastic bottles. He had three crates that would be unlikely to move but they were perfect for us being so durable – Brian took the lot, at £6 a litre! It goes down a treat and is definitely keeping our gut parasite loading at bay.

28 OCTOBER 2000
Odzala-Kokoua National Park

1° 19' N
14° 50' E

Brian has flown out to meet us, bringing with him a special request on my part. There's something I've been thinking about ever since starting filming in the Congo. When you look across the bai, you see all of the animals together, almost shoulder to shoulder. When the gorillas pass nearby to the sitatunga, these swamp-dwelling antelope don't bat an eyelid. Perhaps at most, they'll hop out of the way. If you're visible as a human, however, you're not exactly welcome to the party. It only takes one step out into the bai for all the animals to leg it. They've been hunted and persecuted over the decades and centuries by man and they know that we're dangerous.

My idea is, if I want to get closer to the sitatunga, I could dress up as a gorilla, and they then won't be disturbed. Obviously, this won't be a sensible approach to get close to elephants. They'd smell something is

Dressing the part

amiss (or isn't real gorilla) and they could attack, which wouldn't end well for me. In addition, I wouldn't want to try the gorilla suit to film gorillas or go out in the bai when they were in sight. If gorillas were to see me alone like that, there is a likely chance I could be attacked or raped, which isn't something I really want, either. Brian initially thought the request was a joke but after explaining it, he's now arrived with a suitcase containing a gorilla suit, picked up from a Bristol fancy dress shop.

This morning when the coast is clear, I walk into the bai, carrying a camera and a walkie-talkie, dressed as a gorilla. Brian and the team are hidden back in the bushes on lookout for me. If they see a gorilla or any other potentially dangerous animal, they'll be my extra eyes and ears, as the visibility from within the suit is very limited. Of course, close up, I'm clearly not a gorilla. But from a distance, I'm definitely not a human. It takes some time, slowly picking my way through the marshy ground, sweating profusely inside the costume. I check in from time to time, in hushed tones, with Brian on the walkie talkie. He reassures me that all is well, but even talking in whispers I can hear his stifled laughter. I can only imagine what it must look like from back there. I creep closer and am able to get within 50 metres of the antelope without them running off. Even with three pairs of eyes watching my back I must admit I am nervous. Through the tunnel vision of the gorilla mask I scan the bai perimeter for myself. I am most nervous of seeing a forest elephant emerge into the bai. From out here in the open it would take me at least five minutes to wade and stumble back to the relative safety of the forest. Inching ever closer, it's half an hour later and I am now within 5 metres of the nearest sitatunga. I can't quite believe it. They are a little curious, but certainly

aren't scared nor spooked. It's an amazing experience to be so close them. Whilst I pretend to forage like a silverback, eating some grass, I get some intimate shots of these calm, colourful creatures. I am over the moon.

2 NOVEMBER 2000
Odzala-Kokoua National Park

1° 19' N
14° 50' E

Scary news today from the Wildlife Conservation Society HQ in Mpassa. Dave Morgan, the scientist we were with in Mbeli bai, has been attacked by a gorilla. Dave had been walking back and forth from the bai for six years, he was very experienced working with gorillas. In the past, he had come across one on the path home and nothing had come from it, as Dave followed the protocol* and wasn't labelled a threat. That weekend, he was alone in the camp. The others had either gone home or gone elsewhere for temporary work. Dave was returning to the camp at the end of the day, as he had done hundreds of times before, when he ran into a silverback on the trail. Again, this wasn't unusual. There's usually enough distance between you and the silverback to not cause conflict. Dave encountered this gorilla a lot closer and took it by surprise. There wasn't enough distance nor time for Dave to act submissively and the gorilla charged and knocked him to the ground. It furiously pummelled

* When you encounter a gorilla (if it ever happens to you!) there's a protocol to follow: to avoid angering or intimidating the gorilla, you display submission through your body language by slowly squatting or going down on one knee, pretending to feed, whilst making an appeasement sound: a low, soft grunt, that lets them know you're not a threat and instead, you're calm, you're quiet, you're just minding your own business. You never look the gorilla in the eye, as that's a threatening response.

him and bit into his shoulder with a huge, powerful bite. It roared in his face, over and over.

Dave tells me about the attack and says the gorilla's face was inches from his. He remembers seeing all the vegetation in its mouth, on its teeth, and he could see right down its throat as it roared. Dave had hit the ground hard and thought he had broken his back, that he had been paralysed as he couldn't feel his legs. When he tried to move, the gorilla roared and beat him again. In any second, he thought, it could just finish him off. So Dave slowly put one hand over his face and the other over his testicles and awaited the final blow.

Luckily, the gorilla began to slowly calm down. It backed off and sat on the path. It was seriously pissed though, holding a really tight-lipped face, staring at him. Dave did his best to keep still, despite the blinding pain from the bite, and eventually the gorilla sloped off as darkness cloaked the forest. Dave crawled back to the camp. Normally, there's a 6am and 6pm radio call to the main base, to let them know everything is okay. Dave had missed the evening call and spent the night nursing and bathing his wounds. In the morning, he radioed in and was picked up that morning and taken to hospital. A lucky escape.

1° 19′ N **10 OCTOBER 2000**
14° 50′ E Odzala-Kokoua National Park

We've moved to another bai that's smaller in the hope of getting some more detailed footage. The bai is kind of banana shaped and we've set up two hides, one in the bow of the bai, about halfway up, and a second hide towards one end. This is so whoever's in the second bai (James or Ralph) can give me the heads up to get

ready for the shot when any animals approach. (Unless those animals are elephants, in which case they'll tell me to get ready to leggit.)

Today a band of gorillas, 16 of them, enter the bai from the forest. This is exciting, a beautiful sight, seeing them meander their way, feeding as they go. There are thousands of red blue butterflies around – which the gorillas disturb, sending them spiralling into small tornados before they settle back down in calm descents. It's a perfect scene.

This band of gorillas is particularly distinctive. Unfortunately, there's a disease that affects gorillas called Yaws; it's a type of syphilis, which infects bones, joints and skin. The females of the band have patches on their faces where infection has removed the pigment, leaving pale, white marks that look quite scary. The silverback, however, is slightly boss-eyed. While he is handsome, when he looks towards my hide and I get a full view of his face, I think he looks a little bit like Marty Feldman.

Eventually, the gorillas have come so far into the bai they that they are quite close to the hide, and they become slightly suspicious of it. It's well-camouflaged amongst the thick foliage but there's a camera lens sticking out the front of it. Whilst they look, I don't dare move the lens or the focus. To them, it probably looks like a giant eye and I don't want to spook or scare them. A few of the gorillas carry on into the forest but the rest plonk themselves down, including the silverback who has his back to the hide. Until, of course, he inevitably gets up and starts to approach. I start going over the protocol in my mind, but of course, that only really applies on foot. It's different when you're in a hide because the gorillas are unsure of what it is and for all they know, it could be a predator, a leopard, perhaps, lurking inside. It's either going to frighten them or they'll investigate.

Because the days are so long, and it can be hours before you see a gorilla, days even, I've taken a book with me to glance at pages and paragraphs in between scouting for wildlife. Perhaps rather stupidly, the book I chose for this trip is *Gorillas in the Mist* by Dian Fossey. I say stupidly because whilst it's extremely interesting, well-written and informative, it's instilled fear. In the book, Dian wrote that she had trouble finding volunteers to come out to the mountains and work because, understandably, it's quite intimidating meeting a gorilla. There are hundreds of accounts where people have been charged by gorillas, often multiple times a day. When a 200 kilogram silverback runs towards you, beating its chest, roaring as it goes, saying 'Fuck off!' in gorilla language in an effort to protect its family, to chase you off, it's hard to keep calm and follow the protocol. Dian said volunteers would often piss or shit themselves and make an embarrassing return to the camp. It was a fairly frightening and graphic description of how scary it could be. It turns out to be pretty accurate (minus the pissing and shitting, however) because I'm becoming quickly nervous and my breathing has quickened as the silverback gets closer and closer.

Of course what's also on my mind is Dave. Am I next? I begin to get in quite a state, worrying more and more. I don't dare move the camera nor my body. I'm panicking that I won't be as lucky as Dave because that gorilla knew he was a human. This gorilla doesn't know what's inside the hide. Closer and closer he gets until – at about ten metres – he decides to turn back and walks towards the forest. Thank God for that.

I wait a few moments then turn the camera towards him, to try and get a shot of him leaving the bai. But then he pauses, his right rear foot balanced on tiptoe, and he looks back over his shoulder to me. His face

almost inquisitive, as if he's suddenly thought, 'No, before I leave, I'm going to check out what's in that strange bush.' To my horror, he turns and approaches the hide once more. He's coming directly at me and I can barely breathe, my heart is racing, pounding in my chest with fear. I cower down by the camera as he gets closer and closer, and then when he's inches from the hide I can see his towering shadow on the canvas. Flashbacks to Dianne Fossey's stories and Dave's recent gorilla attack. This is it. There's a smack and I hit the ground hard, knocking me off my seat, throwing the camera with it. The silverback has slapped at the hide, hitting me on the back, shunting everything inside. As I lie on the ground, physically shaking with shock and fear, I can still see his huge shadow cast on the hide of the canvas. Fearing the worst I try to make the appeasement sound as a last resort. In my fear, I can only muster a high-pitched whimper, a tiny, pathetic squeak. To my relief, the silverback walks off, leaving me a crumpled wreck. The rest of the gorilla family too melt back into the forest as I try to calm myself. I'm badly bruised on my back. That is the first, and hopefully last, time that I will be punched by a silver-back gorilla.[*]

14 NOVEMBER 2000 1° 19' N
Odzala-Kokoua National Park 14° 50' E

It's been a stiff few days but I've continued, and boy has it been worth it.

[*] It was three months before my back and kidneys fully recovered. That silverback would make mincemeat of Mike Tyson.

There have been a few moments in my life as a cameraman, and I'm sure I'm not alone in this, when I've seen the best things but didn't manage to capture them on film. The camera can't always be rolling when you're limited by the length of a roll of film, and obviously you want to record the engaging moments, the footage that makes good television. I'm not quick enough to record this moment today, but I see a beautiful gesture from one of the gorillas. She has her back turned three quarters to me, I can just see the left side of her face, and she is feeding on waterlily roots. As she cleans the mud from the roots in the water, butterflies are swirling around her. In between eating though, she snatches with her left hand, catching a single butterfly. She brings her hand close up to her face, stops chewing for a second, and slowly opens her fingers, inspecting the butterfly before letting it go. There is something rather lovely about that. This gorilla just wanted to learn what it was, to reach out and try to understand something else in this world. What are these colourful things flitting about? If it had been a chimpanzee, it might have just caught it, put it in its mouth, and spat it back out. But this moment for the gorilla was purely inquisitive and intelligent. It's one of the nicest film moments I've ever missed.

25° 16′ 12″ N 4 JANUARY 2001
87° 13′ 42″ E Kahalgaon, India

India: such a rich and varied country steeped in history, culture and wildlife. I love it here and generally the people are delightful and, for some unknown reason, love the British.

Kahalgaon, the first location of three on this trip for *The Life of Mammals*, is somewhat different. There has been bandit activity here on the banks of the river Ganges, so to ensure that assistant producer Jonny and I are safe the local authorities have told our fixer, Toby, they will provide an armed escort.

Jonny and I are here to film blind river dolphins. The story: sight is of no use in the muddy Ganges and smell is of little use in the continuously flowing and polluted water. So these dolphins rely on sonar to hunt and navigate. These Ganges river dolphins look quite different from your 'standard' dolphin. They have a more abrupt forehead and a longer, thinner rostrum or nose on which the teeth are visible. They lack an elegant dorsal fin and instead have a small triangular lump. Where their eyes should be it looks more like the eyeballs have been gouged out and the sockets have healed over.

We will be filming from a small boat, also from a tripod on the bank where possible. Our armed escort is a band of ten proud soldiers in slightly threadbare uniforms. They share between them two – very well-worn – 1940s Enfield .303 rifles. Their transport is a 22-foot-long camouflaged motorboat that appears to also be a relic from the Second World War. It would not look out of place on an archive episode of *Dad's Army*.

Jonny and I cruise a five-mile section of the river looking for dolphins. It is going to be tricky to build much of a sequence and story until David (Attenborough) arrives to present and fill the gaps. The Ganges is 1,569 miles long, the water is brown and muddy, dolphins only breathe every 30–120 seconds and the dolphin population is estimated at only 2,000. Surprisingly, though, we do manage to see a few. Also, once I get my eye for the pace that the dolphins swim at, I'm able to capture progressively tighter shots when they surface to breathe. This is obviously easier on a

tripod on the bank, so our small boat drops Jonny and me off with our camera and tripod and we walk along the shore, trying to pick a place where there is a channel or line that the dolphins seem to be using. What is quite shocking is the number of human bones scattered along the shoreline. Even the odd human skull. We ask Toby about this later and he explains that it is traditional for Hindus to cremate their dead relatives and then the ashes are scattered in the sacred holy Ganges. The corpses and bones are from poorer families who cannot afford to buy enough firewood for proper cremation. They are forced to immerse the half-burnt bodies of their loved ones in the river.

As we are walking along the bank, trying to avoid treading on human remains, a man riding a small donkey appears on the horizon about 800 metres to our right. He looks quite comical, as the poor donkey is walking fast but with tiny steps, and the man's feet almost touch the ground each side. What isn't quite so funny is that the man raises a rifle to his shoulder and begins shooting at us. We start walking away as fast as we can but the man is now riding towards us. Meanwhile, the boat with our armed escort starts to turn and head to our bank. The whole scenario seems to be playing out slowly. Donkey man fires another shot at us and the 'Dad's Army' crew take a couple of shots at him. The distances involved between us all are quite large, so the chances of anyone actually being hit by a bullet are slim. There is still enough of a threat, however, to get the adrenaline going.

After a few more shots, donkey man seems to realise he can't get within sensible range of us before the Dad's Army get to him, so he takes one last futile shot at the guards and then trots off at speed out of sight over the horizon, like a clip from a Chaplin movie. Our armed guards land ashore and all of them race after

our attempted assassin. Needless to say, they don't catch him. After that episode, though, our mini security force stays closer to us and joins us each time we go ashore. We have no more trouble.

I later learned that the bandits or *panidars*, feudal water lords, collect their dues by force from anyone using their stretch of the river. I'm just relieved I didn't get shot!

5 JANUARY 2001
Kahalgaon, India

25° 15' 15'' N
87° 12' 25'' E

David arrives with Neil, the producer, Trevor on sound and production coordinator Lisa. The pieces to camera in the boat with David are quite straightforward and complete the story of how the dolphins navigate. Trevor records the dolphins' sonar squeaks and pips underwater using a hydrophone. Being blind, the dolphins rely almost entirely on echolocation for communication and navigation. Commonly, they make clicks, chirps and twitterings, but also sounds like a mewing cat and a creaking boat.

Neil, who suffers from a bad back, is in terrible pain after the bumpy eight-hour journey from Patna. Even dosing himself up with ibuprofen doesn't seem to help. We're sharing a twin room as there's limited space in the small hotel. The next morning, he can barely get out of bed so, being the chivalrous man I am, I help get him dressed. I'm just kneeling to put Neil's socks and shoes on with my back to the door when Toby walks into the room. He immediately says, 'Oh God. Oh God. I'm sorry,' and rushes out of the room. Realising that Toby's just thought he's caught us in some sexual act, Neil and I both laugh, and I rush

into the corridor to get him. Poor Toby looks genuinely shocked and is relieved to see Neil fully clothed. Laughing so violently, though, Neil wrenches his back further and suffers for the rest of the trip.

28° 39' 45" N **13 JANUARY 2001**
77° 11' 7" E Delhi, India

Train Tetris Toby and Neil accompany David, Trevor, Lisa and me to the train. To say it is busy is an understatement. It's more like being an extra in the film *Gandhi*. Crowds of people jostling on the platform with no apparent idea which train they are headed for. Luckily, we are being guided through the noise and melee to the right platform and carriage by India expert Toby. We have a four-berth sleeper car for the ten-hour journey to Bikaner in Rajasthan. In order to get us all on board with our 16 cases amid the chaos of an Indian train station, we have six porters to help. There's only a few minutes to load everything, and then it's tricky pushing our way down the side corridor. Once in the cabin, the cases get passed in thick and fast – a real-life Tetris game against the clock. David, Lisa and Trevor are forced onto their bunks to make way for kit while I stack it on the floor. Within minutes our car is rammed. And now we have ten hours in this cramped space. Looking at each other in this mobile cell we are all about to self-combust. Just when I think one of us is going to blow, Neil sticks his head in through the door to say goodbye and laughs, defusing the situation with, 'Crikey, my hotel bathroom is bigger than this space! Good luck, suckers!'

We all then see the funny side, laughing at this ridiculous travel arrangement. I think what's annoyed

us most, though, is that we know producer Huw has flown to Bikaner yesterday – but of course it's cheaper for us to travel by train as it saves excess baggage and an overnight in a hotel.

14 JANUARY 2001
27° 47' 27" N
73° 20' 27" E
Karni Mata Temple,
Deshnoke, India

Rats! David's one phobia: he absolutely hates rats. Unfortunately for him, for this episode of *The Life of Mammals*, producer Huw wants to film rats – the second most successful mammal on Earth. They are widespread, and now on every continent except Antarctica, and have adapted well to living alongside man.

In India there is a beautiful Hindu temple with a marble facade and solid silver doors: Karni Mata, better known as the Temple of Rats. It's home to 25,000 black rats that are worshipped and revered. These holy rats are called *kabbas* and are fed by priests and workers. People travel from across the country to come for blessings – not to mention the foreigners who come here to see the spectacle. The temple is literally overrun with the rodents. What better place to film David talking about the success of the species.

Being a temple, it is respectful to remove your shoes when entering.* David, while being 100 per cent the professional, is clearly not comfortable with the whole

* Here is the BBC medical advice on the schedule:
Malaria tablets essential.
For Temple: Rats will be prolific!! Verruca socks will be supplied to provide protection from rat pee. And medical wipes for feet and any trailing cables etc.

situation. So, as we set up the camera, David waits outside with Lisa to rehearse his lines. Once we're ready, I head outside to collect him for the piece.

David's going to be seated on a stool with literally a sea of rats surrounding him and behind him on the temple structures. As we round the corner to the camera set-up, David spots Huw pasting peanut butter up the legs of the stool, clearly to encourage rats to climb up for the shot. I'm not sure David will ever forgive him for this, but it will make for good dinner-party conversation. Despite his fear, David manages to nail the piece in two takes before retreating as fast as he can from the temple.

Huw and I spend two more full days finishing the rest of the sequence. Definitely not the most pleasant of filming locations. Rats actually make nice pets – they're intelligent and friendly – but they do smell if you don't clean them out twice daily. These 'holy' rats are not cute and fluffy, more unkempt and greasy. And despite being constantly swept and cleaned, the whole temple complex has an unpleasant odour of rat piss and shit. Because the rats are fed and worshipped, they have no fear of man. On the contrary, they come to you and climb all over. What I find most unpleasant is that often while I'm kneeling with the camera filming low angles, the rats climb up the inside of my trouser legs. Clearly these rats are somewhat inbred because they're not very smart and don't know how to reverse out of a trouser leg once they're in. I have now learnt that it is not the done thing to drop your trousers in a temple.

14 JANUARY 2001 · 25° 25′ 22″ N
Allahabad, India · 81° 53′ 23″ E

Next stop on this India film trip, for the closing piece for the 'Opportunists' episode of *The Life of Mammals*, is the Maha Kumbh Mela. This is a mass Hindu pilgrimage of faith that takes place every 12 years. According to Hindu mythology, while transporting a pot of *Amrita*, the drink of immortality, Vishnu, god of protection, spilt drops in four places. One of those places is the *Sangam* or the confluence of the Ganges and Yamuna rivers. Bathing here is said to flush away sins and free you from the cycle of rebirth. This year, an estimated 100 million pilgrims will visit over the space of two months. There may be as many as 50 million people here at any one time: the largest gathering of humans ever on this planet.

To accommodate so many people, a temporary tented city is built on the sandbanks of the Ganges. These banks are underwater during the wet season and are exposed now for just a few months, allowing for a network of roads, paths, water, sewage, electricity, street lighting and Tannoy system to be put in. Also, 18 temporary pontoon bridges are built across the river Ganges. It is an extraordinary feat of organisation that makes Glastonbury Festival look like child's play.

Having flown into Varanasi, we drive the last four hours to a tented camp at the Kumbh. This camp is specifically for the world's media and press and caters for 400 people. The tents are spacious, with a 24-hour generator for charging and satellite communication for sending press copy. When checking in, I notice a sign behind the desk that says: 'PLEASE NOTE: The Kumbh Mela is a religious festival and it is illegal to have alcohol anywhere on site.' I suddenly remember I have a half-drunk bottle of Lagavulin single malt whisky in my case. I have full respect for the religious festival and I'm

certainly not going to drink while here, so once I'm in my tent I tape the whisky bottle shut and mark the level with a marker pen and date it. I then wrap it in a T-shirt and place it in the bottom of my empty tripod tube.

The noise of the Kumbh Mela is oppressive. A constant roar of people's voices combined with the white noise of millions of shuffling feet on sand. Cutting through all this is 24 hours of religious chanting from various makeshift tented temples. Add in bells being struck and beating drums – it almost amounts to torture. The air is thick with dust and smoke from cooking fires, with occasional whiffs from joss sticks and incense. It is difficult to sleep at night even with earplugs.

Normally, wherever you set up the camera to film in India it attracts a crowd. People will just come and stand very close and stare at what you are doing, almost as if you're some kind of sideshow. This often makes getting shots very difficult. There's also a huge fascination when I sit down with my black changing bag on my lap to reload a film magazine.[*] A few years ago sound recordist Trevor said to me, 'You ought to bring a rubber chicken with you and keep it in your changing bag. That way, when you get a crowd watching you, put a magazine and roll of film into the bag, and then like a magician – ta-da! – you pull out a rubber chicken.'

On this trip to India I have indeed remembered to pack a comedy rubber chicken. So the next time I reload a magazine, and a crowd of a hundred or so people have gathered to stare at me, I place magazine and film in the changing bag, reload the magazine in the camera, and a few minutes later – ta-da! – I

[*] An Indian once said to me, 'Oh, the mysteries of film. You load it in the dark. You expose it in the dark. You view it in the dark – the mysteries of film.'

pull out the rubber chicken. I look up to the crowd expecting a laugh or round of applause. It was even funnier than that, because there is absolutely no reaction at all. Either they've seen the trick a hundred times before or it is quite normal for an Englishman to pull a rubber chicken out of a bag. I won't be trying that again.

I shoot the piece to camera with David using a long-range zoom lens. As David speaks, the shot pulls out and out, revealing a sea of people.

'We are the ultimate demonstration of how successful a mammal can be that is prepared to eat, well, pretty much anything.'

We film a few other pieces to camera and David's work on the series is done.

Once again, Huw and I stay on for a few days to complete the sequence. Two memorable things happen:

One evening, we return to the media camp to be met by a rather serious camp manager and police team.

'It has been brought to our notice that alcohol has been consumed here at the Kumbh Mela. We are conducting a tent-by-tent search and require your cooperation.'

I, of course, agree and lead three policemen across to my tent. En route, I'm told that the consequences of this could mean that the entire world's press and media are evicted from the Kumbh Mela. I feel slightly sick at the thought.

'Sir, have you consumed alcohol here at the Kumbh Mela?' the police officer quizzes me.

I answer honestly, 'No.'

A uniformed assistant writes down each answer on an official form on his clipboard.

'Sir, do you have any alcohol here at the Kumbh Mela?'

Again I answer honestly. 'Yes. When we drove into the Kumbh I had a half-drunk bottle of whisky in my luggage. On seeing the sign about alcohol above the reception area, I sealed my bottle and marked the level with the date. It is wrapped up in a T-shirt in my tripod tube.'

'Sir, can you please show me the bottle?'

The officer and his two sidekicks accompany me into my tent. I open up the tripod case and reach in for the bottle. I unwrap it and hand it over, indicating where I had marked the level with the date.

'Thank you, sir,' said the officer.

The details of the label are then transcribed in perfect italic handwriting, word for word, onto the form.

Lagavulin – Single Islay Malt Whisky – Aged 16 years – Scotch Whisky – Moss water, passing over rocky falls, steeped in mountain air and moorland peat, distilled ...

This is going to take forever and the whole situation feels uncomfortable.

... and matured in oak casks exposed to the sea shape Lagavulin's robust and smoky character...

All sorts of visions march through my head. My name will be mud to the world's press. This is the end of my career.

... Time, say the islanders, takes out the fire but leaves in the warmth ...

'Thank you for your cooperation, sir. And thank you for respecting our zero-alcohol consumption laws. I trust you to replace the whisky in your tripod tube and hope that you enjoy it once you have finished your work here at the Kumbh Mela.'

At that, the three policemen leave my tent and go on to question others.

They do discover who it was who drank alcohol – empty beer cans were found on site. But I, along with Huw and the world's press and media, weren't thrown

out of the festival. Perhaps dipping my toe in the Ganges yesterday washed away this sin.

The second memorable thing happens on our last day's filming. Huw and I are close to the *Sangam*, the most sacred spot to bathe, when once again we are approached by the police.

'Sir, I wonder if you can help us. We have had an Australian passport handed in to us at the information desk and don't know how to pronounce the name. We wonder if you might be able to come over and see?'

Huw agrees to go with them and tells me to stay put and carry on filming.

Announcements over the Tannoy system are frequent and loud in various languages. Often it is a distraught villager miles from home who has lost their family or group. Some of these people might never have been more than a few miles from their villages, so to be lost in a crowd of millions can be understandably upsetting. Most people also don't have mobile phones and may only speak their own dialect. So in between all these desperate Tannoy calls it is very funny to hear a crisp, clear British BBC announcement.

'Would Mr Paul Thompson please report to the lost property kiosk where we have your missing passport. I repeat, could a Mr Paul Thompson from Australia please report to lost property where we have your passport. Thank you.'

I then hear the microphone being put down. It is then picked up again and I hear:

'Oh yes. Would Gavin Thurston please get on with the filming too. Thank you.'

Clunk, as the microphone goes down again.

Hilarious. I chuckle to myself, *Good old Huw, very funny*.

That evening at dinner, several people say they found the announcement amusing. What Huw hadn't realised was that the Tannoy system was for the whole festival. The speakers were spread over maybe six square miles. Huw had just had an audience almost the size of the population of England! Oops.

3 NOVEMBER 2004

Lopé National Park, Gabon

Series producer Alastair and I join friend and assistant James and balloon pilot Dany. For the last week James has been rigging tree platforms in Lopé National Park for me to film forest elephants and gorillas. Dany is an eccentric French pilot who flies the Cinebulle. This is a two-man hot-air balloon with a big motor and propeller. It has a simple bench seat instead of a basket and a camera mount between Dany and passenger, which in this case will be me.

This week I have been reading a book called *Enduring Love* by Ian McEwan. I didn't know what this book was about and perhaps shouldn't have read it before this part of the trip. The first chapter describes Joe out with his girlfriend for a picnic in the countryside. Over the trees appears a hot-air balloon that briefly touches down, tipping out the pilot. The balloon rises, leaving a young boy alone in the basket. Joe and other bystanders grab the trailing ropes to help, but one by one have to let go as the balloon ascends. Tragically, one person holds on and is carried up before losing his grip and falling to his death.

Anyway, our aim is to shoot the sun rising over the misty canopy of the forest for the elephant story of the *Earth* movie. Here's the brief: 'The camera should rise and drift slowly forwards over the treetops through the mist as the sun reveals itself.' We have five mornings to try to bag the perfect shot. So, each day we get up at 4am and wolf down some coffee and bananas, then drive the half-hour to the launch site and ready the balloon for takeoff. Every day so far, the weather has been grey and cloudy, with no chance of seeing the sun so we abort takeoff, pack up and return to base.

It is now our last chance to get the sunrise shot before Dany has to return to France. The weather is looking more promising. Having done this routine daily we are now a well-oiled machine. So for the final time we help Dany lay out the balloon canopy: he inflates it first with the fan and then hot air from the gas burner. James and I prep the camera and Alastair drives up the nearby hill to watch the weather and will call us when it's time to launch.

The Cinebulle is now upright and I sit on the bench seat as ballast. James passes me the camera and I rig it beside me. Dany joins me on the bench seat and we both put on our seat belts. It's 5.30am and we are poised for takeoff. Dany puffs the burner just behind our heads to adjust the lift and now we are waiting for the call from Alastair. We don't want to take off too soon as we have limited gas and certainly don't want to drift too far from the launch site. There's unlikely to be another clearing to land in the forest for miles.

We get the signal over the radio from Alastair: 'Go. Go. Go.'

Dany gives one final blast on the gas, disconnects the ground gas cylinder and we gently lift off the ground. Just as we reach six feet, gas leaks from the small cylinder behind our heads and catches fire. I scan Dany's face which is literally a foot from me. He looks shocked – not

good. I have my hand on the seat-belt buckle – if he jumps, I jump. We drift higher and my mind is racing. I'm recalling what Ian McEwan wrote, the scene of the falling man. I also know that once we reach 30 feet there's little chance of survival if we jump. But if Dany jumps and I don't, I'm screwed. With less weight holding the balloon down I'd probably be a few thousand feet up in no time – the same if I jump and leave him.

Thirty feet, shit.

Dany starts trying to blow the flames out and I do the same. Ridiculous and desperate, amazingly we manage it! Now we are at 50 or 60 feet and still rising. The gas ignites again and flames billow round our heads. Once again we manage to blow them out. Dany fiddles with the connection and thankfully it doesn't ignite again.

Soon we drift up level with the top of the trees and can look across the forest to the east. A watery sun is just visible through the mist. If we don't die, this could be the shot.

Dany pulls the starter cord and the engine roars to life; the big propeller just two feet behind us starts to spin. In theory, he now has an element of control. By pulling on two ropes he can point the fan left or right behind us and drive us forwards. Essentially, so long as the gas doesn't explode behind our heads, Dany has conventional hot-air balloon control for our height.

Forgetting Ian McEwan and gas fires I now concentrate on getting the shot, urging Dany to position the balloon towards a certain emergent tree. The fan can drive us at about 4mph and that is the speed at which we hit the tree. Our legs drag through the top branches. 'Sorry, sorry,' says the mad Frenchman. I appreciate how difficult it is to drive this thing and Dany does get us on a good track. I roll the camera and we drift forwards, and with a quick burn we start to gently rise. I make small, slow adjustments on the pan and tilt head to adjust the

framing. All looks good. We circle round again for a second run, taking a few branches off as we go.

Perfect.

Dany then tells me we need to head back as the breeze is just picking up. So he turns and we mosey our way back towards the launch site.

Looking across the unbroken canopy I realise we would be pretty screwed if the motor fails. We'd fly for maybe half an hour or so and then crash-land in the canopy. With no ropes to get down to the ground and no GPS or walkie-talkie, it could be days before anyone found us. We'd never really discussed any of this before takeoff.

We touch down and I'm very happy to be back on firm ground. James, Alastair and the ground crew have no idea of the dramas we have had. I wonder if they'll even use the shot.

13 NOVEMBER 2004
Lopé National Park, Gabon

00° 13' 16'' S
11° 36' 6'' E

After the balloon aerial attempts I spend the rest of each day up on a tree platform that James has put up, trying to get shots of elephants in the forest. James has devised a clever two-rope system for putting people like me up in trees safely. Two ropes in case one fails, plus they are on a continuous loop over the anchor point so that if someone is incapacitated up a tree, they can be rescued and lowered to the ground by someone at the base. No need to climb up and get them.

My old friends, the African bees

From previous experience of filming in this part of the world, we both know that the African honeybee can be quite a nuisance, if not a threat. It's hot and humid out here, so when you hike anywhere or use effort to climb

up a tree, of course you break out in a sweat. Bees love salt – and sweat is salty. So if a foraging bee discovers you then it will land and lap up your sweat. Now, this is fine if you're on the move because by the time the bee goes back to the nest and tells his mates where he found the salt you've already moved on. If, however, you happen to be sitting on a tree platform 30 feet off the ground for seven or eight hours, that bee can then return with his friends. They in turn tell *their* friends and so on. These bees aren't aggressive in these situations, but occasionally they'll find their way inside your shirt, and of course if you accidentally squash one it will sting you – and these African bee-stings bloody hurt. So, as a precaution, we have brought some beekeeper suits and hats out from England. The bees haven't been too bad so far as, once I'm safely installed on the platform and the camera is set up, I change out of my sweaty clothes and put on clean dry ones – reducing the smell and salt available. So I haven't bothered with the suit but instead I have put up a mosquito net inside the hide as a first line of defence. I have also brought mosquito coils to burn if it gets unbearable.

Today, though, the bees are becoming problematic. Having been in the hide for five or six hours, I count 80 bees on the camera alone. Another hundred on my left arm and the same density all over me. The buzzing is getting intense. It's got to the stage where I daren't move because they are inside my shirt too and I don't want to squash one. Very carefully, I light up a mosquito coil and place it under my stool. Twenty minutes later it doesn't seem to have driven any away or calm them down at all, so I light two more coils and sit with them Zen-like, with one in each hand. Another 20 minutes pass and the bees are still coming! I wonder if they might be thinking about setting up their nest in here with me. Even if elephants turn up now I'll be unable to film them.

Time to radio for help.

'James. James, do you copy?'

'Yes, go ahead, Gavin, this is James.'

'The bees have got pretty bad in here with me and I'm going to need help getting out. Are you able to come now?'

James has sat in the car about half a mile up the track every day just in case he was needed. 'I'll come straight away.'

I first cover the camera slowly with a bin liner in case I have to leave it for the night; then I hold my Zen pose and wait.

James arrives in record time. He must have sprinted through the forest with total disregard for the possibility of running into elephants. He calls to me from across the stream. 'Gavin? Is it safe to come over?'

I check for elephants and shout back, 'Yes!'

I explain to James that if I try to climb down I know I'll get stung because there are so many bees now inside my shirt. I think the quickest way would be for him to lower me down with his ground-based rescue system. He agrees. I warn him that I will be followed by a swarm of bees and so, as soon as I hit the ground, I'll have to unclip from the ropes and then we'll both have to run like shit. I suggest we run up the stream and through as many bushes as possible.

On 'go' I literally fall backwards out of the hide with the ropes taking my weight on my harness. Immediately I am stung multiple times. James lowers me fast to the ground, unclips me and we both run like crazy upstream.

The effect from the bee-stings is weird. My heart is racing, pounding in my chest. All my muscles feel flushed and my skin is tingling. I pull out what stings I can see and splash my face with water. James gets away

with fewer stings and I am very grateful he rescued me from the tree platform and hide.

By the time we get back to camp I have calmed down. The scientists come over to ask if I'm okay. When I had radioed James they had all heard the call on the shared frequency. They say they could hear the buzzing of the bees in the background and it sounded intense.

A large glass of single malt later and calm is restored.

00° 27' 24'' N
9° 24' 35'' E

21 NOVEMBER 2004
Libreville International Airport, Gabon

How to
trigger a
security alert

I was due to stay out in Gabon until 10 December but I'm flying home early as Maggie's mum has been taken into hospital. She's been diagnosed with a brain tumour and I want to be there to support Maggie. I am grateful to Alastair and the BBC, who very kindly changed my travel arrangements and organised another cameraman to replace me for the last two weeks of filming.

James and I have a few hours to kill before check-in opens for our flight. We can't go anywhere because we have ten cases of kit to look after. James puts on headphones and listens to music. I am reading the last chapter of *Enduring Love*, but I'm distracted, so I say to James, 'We never got photos of us wearing the beekeeper suits. We must get a photo for the book.'*

* Yes, people have been encouraging me to write this book for the last 15 years! It's been referred to as 'The Book' on many film trips.

I dig inside one of the kitbags and don the white bee suit with mesh hood and James takes a few photos. Then he puts the suit on and I take some of him.

Just as James puts the suit back in the bag, an airport security man comes over to me and says, '*Il est interdit de prendre des photos à l'aéroport*' – 'Photography is not allowed in the airport.'

I explain in my poor French that it was just a tourist photo and try to tell him the story of James rescuing me from the bees. Security man wants to confiscate my camera so I continue with my schmoozing by showing him the photos, and previous ones of a gorilla. Eventually I delete the beekeeper suit photos in front of him. He is then happy and leaves.

James and I return to our music and book.

Two minutes later, 20 soldiers in full combat gear turn up. With guns raised, they start to methodically sweep the airport, laser sights scanning the walls, checking every corner and doorway. They are clearly searching for some threat.

James and I look at each other with the same sense of horror. We think we know why they are here. Did someone see us in the white beekeeper suit and think it was a hazmat suit? Perhaps they suspected a chemical or biological threat. James and I keep our heads down and try to look nonchalant.

Thankfully, the soldiers leave within ten minutes.

Back in England I try to recover the photos on the card. It's surprising what I do find on there, but sadly no beekeeper suit photos.

5° 55' 22" N
113° 3' 6" E

9 FEBRUARY 2005

Sabah, Borneo

Too far I've been at home for nearly two months and it was
from home really tough to leave Maggie and the boys for this trip.
Poor Maggie's mum has been in a hospice for some
time now, and when I land in Borneo it's to a message
that she's passed away. This is the worst thing about
this job – the glamour of travel but at the expense of
spending the time with one's family. I could hardly be
farther from home. I tell Maggie that I will come back
for the funeral.

Very tearful. I should have been there.

5° 10' 29" N **17 FEBRUARY 2005**
115° 58' 59" E Sabah, Borneo

I've spent the last week filming the start of the giant
bee sequence for new series *Life in the Undergrowth*.
I'm out here with friends Simon (researcher) and James,
who has once again rigged the tree platforms for me.

Giant Asiatic honeybees (not to be confused with the
smaller African honeybee from my previous encounter)
are, well, giant, up to 20mm long, the largest of any
honeybee. They live in colonies of up to 100,000 and
build hanging combs on the underside of branches in
very tall trees. The combs or nests are shaped like a
flattened water drop and can be a metre wide and hang
down to the same extent. The bees are visible as they
cover the surface of the comb. With so much honey
and brood at stake, these bees are understandably and

notoriously aggressive. This is one time I will definitely be wearing my beekeeper suit. If one bee stings, it releases an alarm pheromone that will summon help from the rest of the colony. If I piss them off when I'm up on the tree platform filming next to the nest, I could be attacked by thousands of them. I've also been told that the bee suit won't necessarily stop every bee-sting. James once again will be my rescue guardian at the base of the tree – fingers crossed that won't be necessary.

As I'm sure you know, when a bee stings something it dies, because the sting is barbed and the venom sac rips from the bee's abdomen. So, stinging is kind of a last resort. These giant bees have another clever defence strategy. If a predator such as a hornet comes close, the bees do a sort of Mexican wave, a coordinated shimmer of bodies and wings that can distract the wasp and make it difficult to pick off a single bee. If, however, a predator does land on the comb, instead of stinging it the bees can vibrate their wings and produce heat up to 45°C, cooking the wasp which isn't so heat-tolerant.

There is one other predator I am hoping to film at night using infrared cameras and lights: a moth. This moth comes to steal honey. It hovers close to the nest and the bees do their Mexican wave. The moth is undeterred, though, and dives through the layer of bees and into the comb to sip honey. The bees don't react badly as the moth has disguised itself with a smell, a pheromone that fools the bees into thinking it's one of them. Clever, eh?

A world away from the bees I have been calling Maggie each day. I have also been spending hours on the phone organising flights home for the funeral. This is the downside of this job. The travel, adventure and creativity are addictive. But I am neglecting the ones I love. All too often I'm away when I should be home.

5° 10' 29" N **19 FEBRUARY 2005**
115° 58' 59" E Sabah, Borneo

I arrived back in Borneo this morning from the funeral, landing just hours after David (Attenborough), Stephen (producer) and Andrew (sound), so luckily I didn't hold up the team for the crucial sync pieces.

This is when James had the biggest responsibility. Not only did he have to worry about me being on ropes 70 feet up a tree in a bee suit, he also had the worry of hoisting 80-year-old David up a second tree right next to a giant bee colony for his pieces to camera.

Needless to say, all went well, and, under the guidance of giant-bee expert Eric,* none of us got stung.

* Not Eric the half a bee!

Patience, Young Grasshopper

JUNE 1984

Oxfordshire, UK

In later years, I'll employ time-lapse in the majority of wildlife shoots I work on, but in the eighties it's just getting going and, as I'm still starting out, it's a technique I find amazing. I use a film camera but take the frames one at a time with an interval in between. When I play back the shots at 25 pictures per second, the action is speeded up – a bit like how a flipbook works. A great example of this, which I've been trusted to film, is time-lapse clouds. I've been taking shots of landscapes with bubbling cumulus clouds against a blue sky. The film is processed and printed overnight at Technicolor laboratories in London. The rushes are couriered back down the next day to OSF, where we can watch the results on a film viewer called a Steenbeck. The results are amazing. Depending on the interval between individual shots, the live cloud action that takes an hour or so to film can be played back in a matter of seconds. The clouds really come to life in this exaggerated timeframe.

So, whenever there's a good cloudy day, cameraman Sean sends me out with a film camera, tripod, time-lapse controller and a generator to power it all. I choose a nice high point on a hill with a view of the horizon, best facing the direction the clouds are coming from to get added perspective as they grow. Set the camera, exposure and interval for the shots

and then sunbathe for two or three hours while the camera and clouds do their thing. Yes, this is the life!

51° 50' 1" N
1° 20' 46" W

OCTOBER 1984
Bladon, Oxfordshire

Wow! My first claim to fame. The time-lapse clouds I have been shooting over the last few months have been sold as a backdrop for a Stevie Wonder video: *I Just Called to Say I Love You.* Stevie is on stage playing a grand piano. Behind him are my shots. It's a weird feeling to see my work on *Top of the Pops* knowing millions of people are watching it too.*

35° 39' S
149° 49' E

NOVEMBER 1989
Araluen, New South Wales, Australia

Snakes and kangaroos

I learned something this week. Male lizards and snakes have two penises! Well two hemipenes, to be exact. They can mate with one or the other. Also, female lizards and snakes can store sperm after mating for up to five years, and if they've mated with several males they can then 'choose' which sperm to use! It's not known how they do that, but still bloody clever.

Lace monitors are the second largest lizard in Australia and can grow up to two metres long. They are quite a nice-looking lizard, usually a greeny-brown-grey

* Back in the day, *Top of the Pops* used to get viewing figures of up to 15 million.

colour with mottled yellow stripes on the body and yellow dots or blotches on their legs. When the females reproduce, they dig into termite mounds with their powerful claws and lay a clutch of between four and 20 eggs. They then walk away and leave the termites to repair the damaged mound, sealing the eggs inside. The mud dries and hardens in the sun, protecting the eggs from predators. Termites are world experts at temperature control and keep their mounds at a pretty constant temperature all year round. This temperature happens to be just right for incubating the lace monitor lizard's eggs and, anywhere between 110 and 300 days later, the eggs hatch. However, the baby monitor lizards aren't strong enough to dig their way out, so the females return and dig back into the termite mound and release the babies. It's not yet been proven whether the same female returns to release her own babies, or whether it's a natural instinct to dig into a termite mound if they sense either the smell or vibration of tiny claws scrabbling to escape. Scientist David Carter is studying this behaviour to try to find out the real story. He witnessed a lace monitor female laying eggs in a termite mound nearby and predicts they are due to hatch now. I'm going to stake out the mound with my camera in the hope of filming the female returning to release her young.

Producer Nigel and I arrive together in Araluen and check in at the Araluen Valley Hotel. As we walk into the hotel, two burly men are sat at the bar and one turns and sneers at us. I say, 'Good afternoon,' to which the man replies, 'What do you Pommy bastards want?'

Offended but now kind of used to the macho Ozzie way, I reply cheekily, 'Two stubbies of your best piss, you Ozzie bastard!'

For a second, I'm not sure if he's going to thump me. Instead, he shouts to the man behind the bar,

'Get these Poms two beers on me! Sit down. Welcome to Araluen.'

It's about a 40-minute journey along a dirt track to David's study site and the termite mound. The winding road follows the river and it's a very pleasant commute each day from the sleepy town of Araluen. Now that I know where to go, David and Nigel are going to leave me to it. Fingers crossed that in the next 17 days the female monitor will do her stuff.

Lizards have poor eyesight but do see and react to movement. So, to be on the safe side, I sit each day with a green camo cloth over my head and camera. Just enough to break up my outline and help me blend in. The eucalyptus woodland is quite open but has enough shade to help keep me cool, the ground scattered with dry fallen leaves. Through the tree trunks I can see maybe 50 metres or so in most directions.

Being the Australian winter, the temperature never gets too hot. Another bonus is that the lizards are unlikely to be active before about 10am, so I don't have to get up ridiculously early. Each day I sit and watch and wait. For the first few days I see nothing. Then, on the fourth day, I hear rustling in the leaves to my left. I very slowly turn my head to see what it is. About 100 metres away, a huge male grey kangaroo is slowly working his way towards me. He walks with a slow deliberate shuffle, alternating his weight between his two stubby front legs and tail and then his powerful back legs and feet. At first I'm excited, but as he gets nearer I realise how big he is; plus I've heard tales of kangaroos doing serious damage to humans – they can disembowel you with their powerful kick and sharp claws. I'm sitting on a fallen tree and trying to stay stock still. He keeps

on coming and when he gets to within about ten metres he stands up high and stares at me. Still I don't budge. He stares directly at me but can't seem to work out what I am in my green disguise. Trying to displace me, he stamps his powerful back feet on the ground and I am now shitting myself. Despite being very nervous I have no choice but to stay put. He edges closer still and now stands tall, a good seven feet tall, and his body is ripped with muscle. Once again he stamps his feet and I do my best not to flinch. Obviously not feeling threatened, he carries on his way, passing within touching distance. As he gets downwind of me, he must then catch my scent because he takes off like a rocket – within seconds he bounds off out of sight. What a great encounter but I have to admit I was pretty scared.

A few days later, still without sign of a lace monitor, I am once again sitting on the fallen tree under my camo cloth. Something catches my eye about 30 metres to my right. A brown-coloured snake about two metres long. It slithers slowly towards a tiny bush and disappears completely underneath it. I keep my attention on the bush. About 15 minutes later, it comes out from under the bush and heads diagonally across to the next bush nearer to me. En route it disturbs a small sunbathing skink, a small, smooth-skinned lizard, which it then chases, strikes at and catches. I barely register what's happened it was so fast. The snake swallows the skink whole in less than a minute.

It is now only about ten metres from me. It turns its head towards me and, probably thinking I'm the next bush for shade, comes straight at me.

Now, I'm no expert but I do know that Australia has 100 species of venomous snake and five of the most venomous snakes on the planet. One of those

snakes is called a brown snake. The safest thing in my book is to treat every snake as venomous and leave well alone. However, this snake is coming my way. It's amazing sometimes how fast your mind can work to analyse risk. As the snake slides closer to me, I do some calculations:

One hundred species of venomous snake – most not aggressive.

Five of the world's most venomous snakes in the world live in Australia.

One of the most venomous is called a brown snake and it can grow to two metres.

This snake is brown.

This snake is two metres long.

It thinks I'm a bush.

Will it be pissed off when it discovers I'm not a bush?

I'm a ten-minute walk from the car and a 40-minute drive from the town.

The nearest hospital is Batemans Bay, another one hour 15 minutes away.

I do have a pressure bandage if I'm bitten but can I stay calm and drive?

This snake looks beautiful and shouldn't be hungry after its skink snack.

This snake is now very close.

I don't want to die!

And at that I panic, throw the camo cloth off me, jump backwards over the log and run away. As I do this, the snake too looks shocked (if a snake can look shocked), raises its head slightly, also panicked, and takes off away from me at lightning speed.

I feel pretty stupid. 'intrepid wildlife cameraman runs away from harmless snake' reads the headline in my mind.

Thankfully, I'm totally on my own and nobody will ever know ...

After a total of 17 days staking out the termite mound I've run out of time. I do see two monitor lizards, one of which did walk very close to the mound but did nothing. Looking back, I enjoyed my close encounter with the huge kangaroo and I'm probably one of very few people to have witnessed a snake predating on a lizard in the wild. It's these moments I treasure.

I also think it is very rare today to get to spend time completely alone (other than on the toilet). Remarkably, this situation is probably the furthest I've ever been from the next nearest human being. Think about that for yourself.

1 AUGUST 1991

Bristol, UK

51° 28' 29'' N
2° 35' 15'' W

This is slightly worrying: I received a letter from the Inland Revenue Collector of Taxes warning of legal proceedings if I don't pay the income tax due. I've been stalling paying this as I'm still waiting for some invoices to be paid. My bank manager has kindly increased my overdraft facility so I can pay now and avoid 'proceedings'.

51° 28' 29" N **OCTOBER 1991**
2° 35' 15" W Bristol, UK

This week I had to make a difficult decision. I was offered work on two upcoming BBC series, one called *Life in the Freezer*, the other *Nomads of the Wind*. One is a trip to Antarctica, the other to the Pitcairn Islands in remotest Pacific Ocean. Both involve being away for nine weeks and both over Christmas and New Year. Much as I would love the work and the adventure, I really can't justify going away and leaving Maggie with our two young boys. Nor do I want to be away for that long without any communication home.

Thinking I have been busy and I'm sure I'll get other work, I turn both jobs down.

This is when it all starts to go wrong. Mortgaged to the max as I had to borrow to pay for my tripod and lenses, work has also dried up for the moment partly because of the uncertainty on the ITV franchise bids next year. Production companies like Survival don't want to make more programmes if they don't have a TV channel to show them on.

51° 28' 29" N **22 APRIL 1992**
2° 35' 15" W Bristol, UK

It has been an awful few months. Having turned down the trips to Antarctica and the Pitcairn Islands, I haven't managed to get any other work. Interest rates have been as high as 14.25 per cent. Not being able even to make the interest payments on our mortgage and camera loan, my overdraft has shot into five figures. It's my own stupidity and I have literally been worried sick.

My friend Neil has kindly found me some work as a night watchman at a warehouse. It's a very good offer but the wage won't even start to dent the interest payments alone. I feel I'm better off being awake in the day and trawling round for camerawork.

I have a payment demand from the Inland Revenue for £9,000. The letter is giving me seven days' notice of the bailiffs coming round to take belongings to sell to recover the debt. Going round the house I can see that even if they clear it, they won't raise £9,000. I hardly think a bailiff is going to accept my Zeiss T2 lens, even though it was £13,000 to buy new.

I try to sign on for benefits but as I have assets worth more than £3,000, my camera kit, they can't pay me anything. They suggest I sell the camera. I try to explain that is like a plumber selling his tools. If I get offered work then I won't be able to fulfil it without my camera gear. It's a desperate situation. As if the stress of possibly losing our house isn't enough, my hair starts to fall out in handfuls.

My mum kindly helps us out with food and a cash gift of £300. Maggie and I buy only the cheapest-value range food. I realise now how many people live. Hand to mouth, pay cheque to pay cheque.

My career was going well. I have a family, a mortgage, a roof over our heads. But I have made one stupid mistake, compounded by prevailing circumstances in the industry and ridiculously high interest rates. How is this going to end?

51° 28' 29" N **25 APRIL 1992**
2° 35' 15" W Bristol, UK

By the skin The phone rings. John, a producer I've worked for
of my teeth many times over the years, asks how I am and I mask
my real situation.

'Might you be available to shoot a commercial in
London starting next week?'

'Yes,' I calmly reply, punching the air and conscious
of my otherwise completely empty diary.

'When could you come for a meeting?' John asks.

'I could pop over now if you're free?'

'Great.'

Twenty minutes later I'm with John in his sitting
room discussing the commercial. It's going to be
a one-minute-long story for insurance company
Norwich Union to sell their 'Healthcare' policy. The
idea is to show different generations of a family
dancing in a traditional ballroom, the premise being
that Norwich Union doesn't just look after you, it
looks after the next generation and the next, etc.
The lighting cameraman is Oliver Stapleton of *My
Beautiful Laundrette* and *Absolute Beginners* (David
Bowie) fame, and John wants me to be the camera
operator.

After more chat about the storyboard, equipment and
so on, John tells me what my commercial rate should
be. It is five times what I get for filming wildlife docu-
mentaries. I can't believe it. It's going to be three days'
prep and then five days' filming. I sign a contract for
the work there and then. Doing the maths in my head
this will more than pay off the bailiffs. I come clean to
John about my situation and ask if there's any way I can
get an advance. He says yes and I nearly cry with relief.

I pay the cheque into my account and show the
contract to my bank manager. He kindly agrees to

increase my overdraft short term until the cheque clears, so I can pay my overdue bills and avoid the visit from the bailiff.

Working on the commercial is a huge and enjoyable learning curve for me. I work alongside some of the top people in the industry and it gives me a new confidence. I will always be grateful to John for the break. I may have lost my hair through worry, but I didn't lose our house or my camera kit to the bailiffs.

NOVEMBER 2001

19° 44' 04" S
120° 44' 20" E

Eighty Mile Beach,
Western Australia, Australia

This sounded like a cushy job, starting with three weeks filming on a beach with producer Hugh, friend and gin connoisseur. The idea is to film sawfish hunting shoals of fish in the shallows. Sawfish are members of the ray family but look longer and more slender. The green sawfish that we are going to try to film are one of the world's largest fish and can grow up to 20 feet. The most distinguishing feature is its long, flattened chainsaw-like rostrum or nose extension, lined with horizontal teeth. The saw is usually about a third of the fish's overall length. It's a very impressive-looking fish from the photos I've seen. One of their hunting techniques is to swim into shoals of small fish in shallow water and side-swipe the fish left and right with their saw. The sawfish then hoovers up the stunned and shredded fish. However, the maximum tidal range is huge on Eighty Mile Beach, around 30 feet, and this behaviour has only been seen on incoming tides, so that limits our filming opportunities.

Beach bum

We are staying in 'donga' accommodation, very common across Australia, at the Pardoo Roadhouse. A donga is usually a shipping container converted into three or four very basic rooms, each with a small window and air-conditioner. Pardoo has a population of three, then there's myself and Hugh and two workers: one a smiley Aboriginal Australian, the other an older white Australian with skin like leather from too many years in the sun. They are both here for a week, grading all the local gravel roads.

Hugh and I spend our days down on a stretch of the beach about a 30-minute drive from Pardoo. It is a classic flat white sandy beach that's lapped by the azure waters of the Indian Ocean. It's called Eighty Mile Beach but is in fact 132 miles long. We patrol the shore on foot, me with my camera and tripod. Polarised sunglasses are a huge benefit here, not just to save your eyes but because they cut through the surface reflections and help you see into the water. I give Hugh one of my walkie-talkies so we can spread out and keep an eye on more beach. With the beach so long and flat we will easily see any fins sticking out of the water if the sawfish come into the shallows. The idea is that whoever sees something first will call the other one over. Three days pass with this routine of walking the beach, following the leading edge of the incoming tide in the blazing sun. At one point I look up towards Hugh, who is maybe 800 metres from me, standing ankle deep in the sea. He is bent forwards and staring intently. I radio to ask what he's seen. He doesn't answer, so I try again. No answer. Maybe he can't hear me over the sound of the waves. I try signalling but he isn't looking my way. So, I pick up my camera and tripod and start to walk towards him. When I eventually reach him, I ask what he's been looking at.

'Well,' he answers. 'I caught a glimpse of something in the shallows so went over to have a look. I thought, *Wow! That's interesting, it's a walkie-talkie.* I reached in and picked it up and it looked just like one of yours. I went to compare it with mine and, er, then realised it was yours. I'm sorry, it doesn't seem to be working now.'

'Not to worry,' I say, forcing a smile, 'they weren't very expensive.'

Hugh then gives me some advice. Gesturing to one side he says, 'Producers.' Then pointing to the other he says, 'Equipment. In my experience you shouldn't mix the two.'

Although this is not always the case – I have to say that producers are creative and highly skilled at what they do – a few, like Hugh, are, as he puts it, 'practically useless'.

At the end of each hot day we return to our dongas and watch the last light fade with a cold beer. We chat a little with the two guys who are grading the roads and this evening, just back from work, they come over to us.

'G'day. Did you have any success?' the older man asks.

'Not yet,' I reply.

'Hats off for your perseverance. Stick at it, mate.'

He then holds out his open weathered hand and shows me three huge wriggling larvae, each the size of my thumb.

'Do you know what these are?' he asks me.

Even though I haven't seen them before, I know what they are. 'Yes, they're witchetty grubs. They look amazing, biggest I've seen.'

He thrusts his hand closer. 'Do you want one?'

Now, knowing how Australian bravado works I'm not going to turn one down and then be ridiculed for the rest of the week for being a Pommy wimp. So I say, 'Thank you,' take one, pop it in my mouth and eat it.

The man's face is a picture as I chew and swallow the last bits. The flavour is nutty and, apart from the head parts, it has the texture of cold butter.

The old man looks at his smiling partner and then back to me. He shakes my hand and says, 'Good on ya, mate, but we normally cook 'em first!'

I was still trying to appear cool but couldn't help but show some surprise. For what it's worth, though, I think I've earned a little respect for the Poms.

Hugh and I spend another two weeks on the beach. And although we never spy a single sawfish, I do film some other species and behaviours for Hugh's film. Waders feeding at the water's edge as the tide comes in, along with golden ghost crabs that scavenge the waterline too.

It's always disappointing not to succeed in what you've come to film. This, however, is the nature of wildlife filmmaking. You occasionally have to take risks if you want to film new behaviours. This time, in the case of the sawfish hunting, it doesn't pay off.

2° 40' 57'' S
111° 47' 53'' W

13 AUGUST 2003

Borneo, Indonesia

Elvis is in the
building

Indonesia is a bloody long way to travel from England. My seat is one row in front of the toilets at the back of the plane. But I'm excited about this trip to film orangutans for a new programme looking at the great apes – *State of the Great Ape*. Producer and friend Matt and I are going to meet and interview Dr Birute Galdikas. She is one of the original trio of women chosen by Professor Leakey (Kenyan

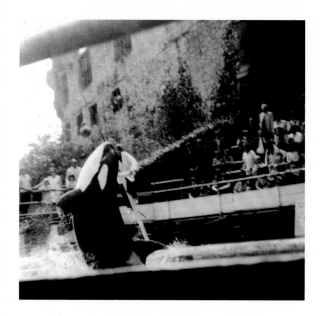

Cuddles the orca. This is from the first set of photos
I ever took – on a Box Brownie camera, aged nine.

The BBC NHU Land Rover on its roof in remote
southern Turkmenistan, just miles from the borders
of Iran and Afghanistan.

Our transport for aerial filming, a Mil Mi-8 Russian helicopter, comes in to land in Badkyz Reserve, Turkmenistan.

The *Golden Fleece* at dusk, moored in the lea of an ice cliff. Antarctica.

ABOVE: Cinebulle pilot Dany and I wait for the call to launch at sunrise. Lopé, Gabon. (*Photo courtesy of James Aldred*)

LEFT: Me in the fancy dress gorilla suit. Odzala-Kokoua, Republic of Congo. (*Photo courtesy of Terry Payne*)

Filming Yeti crabs on the bottom of the ocean off Costa Rica in a Triton submersible with Will and pilot Dave. (*Photo courtesy of Andrew R. Thurber*)

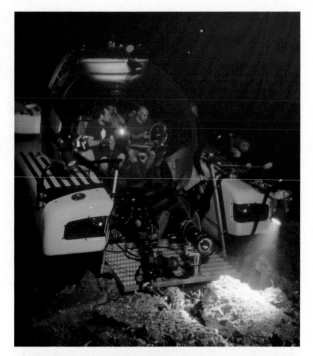

The chilling wild stare from a lioness. Samburu National Park, Kenya.

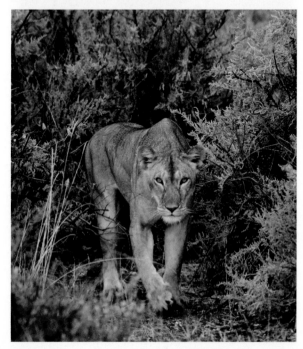

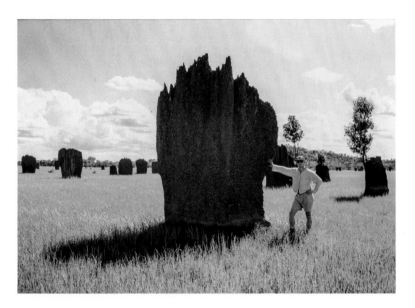

Me alongside a magnetic termite mound. Northern
Territory, Australia.

Monkeys and typewriters – a black and white capuchin
tries its hand at camerawork. Curu, Costa Rica.

How to load a taxi, African style. Republic of Congo.

Porter preparing to carry two cases (46kg) with a makeshift rucksack. Republic of Congo.

LEFT: An orphaned baby orangutan. Nyaru Menteng Orangutan Reintroduction Project, Borneo.

BELOW: Sir David Attenborough at the North Pole.

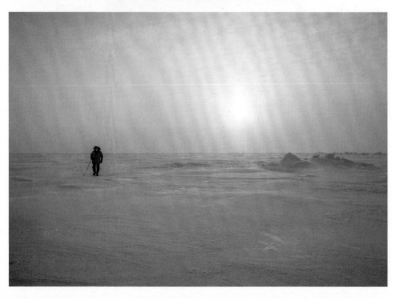

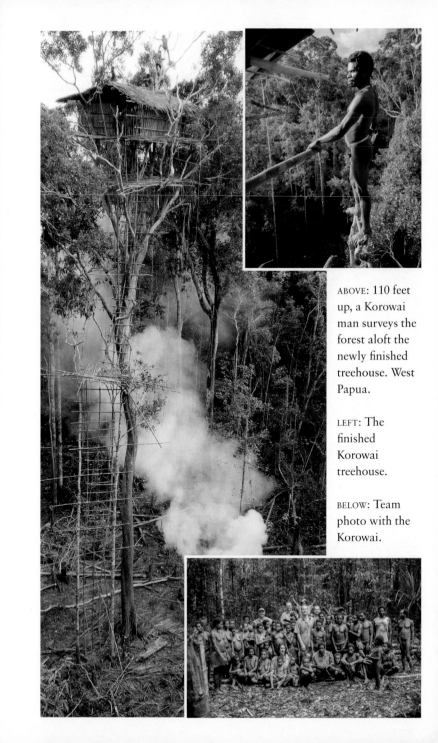

ABOVE: 110 feet up, a Korowai man surveys the forest aloft the newly finished treehouse. West Papua.

LEFT: The finished Korowai treehouse.

BELOW: Team photo with the Korowai.

paleoanthropologist and archaeologist) to study the three great apes* and is positive about being able to save them from extinction.

In Jakarta we are met by fixer Akai. He works his legendary magic and gets us and our equipment seamlessly through Indonesian customs – no mean feat. Then Matt and I fly on to Pangkalanbuun via Semarang. I love the names of places in Indonesia – try them out loud, they really trip off the tongue.

Matt and I arrive late afternoon and check into the Hotel Blue Kecubung. With both of us tired and jet-lagged we agree to meet downstairs for dinner with a view to getting an early night. We order two bottles of Bintang, Indonesian beer, and talk through the plan for the next ten days over dinner. The key thing is getting an interview filmed with Dr Galdikas: while she has agreed to give us the time, she is an extremely busy woman and notoriously difficult to pin down.

It is around 8pm and, having finished dinner and beers, we are both now wide awake. As we leave the restaurant in the basement, we pass the open door of the hotel nightclub. It is gloomy but there are lights on the stage at the far end where a small band is setting up. Matt and I look at each other and say, 'Just one more beer then?' We walk in and sit at the bar. There are only four or five customers in the whole place. One beer leads to another and the band starts to warm up. I turn to Matt and say, 'I think Elvis should make an appearance here. I'll be back in two minutes' – and

* The other two were Dr Jane Goodall, now considered the world expert on chimpanzees, who studied them at the Gombe Stream Project in Tanzania; and primatologist and conservationist Dian Fossey, who studied mountain gorillas in Rwanda. She also wrote the book *Gorillas in the Mist*.

race off up to my room. Matt calls after me, 'Grab the behind-the-scenes camera.'

Now, don't ask me why, but on one visit to the USA I bought a cheap rubber Elvis mask complete with quiff and gold glasses; I suppose I bought it for potential fancy dress. That Christmas I opened a fun present from my wife and sons and it was a lightweight white Elvis fancy-dress outfit to go with my mask. Because it all folds down to a fist-sized bundle I now travel with it on certain shoots.

I quickly slip into my Elvis travel costume and return to the basement nightclub. As I walk through the reception area the receptionists' jaws drop and they immediately start texting on their phones. I sit back down next to Matt in the bar and the few customers and staff staring from the shadows all start frantically texting too. Within minutes at least 20 new customers have arrived and the band has started playing. The lead singer has a wireless microphone and keeps wandering close by us at the bar – each time he waves the microphone under my nose, encouraging me to sing. Before too long a few hundred more people have entered the club and it's getting quite crowded. Goaded by the man with the microphone and more beer, I get up and sing with the band. The whole crowd are on their feet – best cure ever for jet lag, perhaps my new vocation, so I milk it. Thankfully, Indonesians are used to bad karaoke singers and put up with my voice and Matt on drums until the early hours. During this time, I do occasionally see Matt with the small making-of video camera and hope he hasn't worked out how to use it.

14 AUGUST 2003

2° 43' 49" S
111° 38' 53" W

Orangutan Care Center and Quarantine,
Borneo, Indonesia

Slightly worse for wear, Matt and I arrive at the Orangutan Foundation's care and quarantine centre at 6.45am. We were told to be here sharpish to meet with Dr Galdikas so that we could interview her. We set up and wait, both cooking in the 30 degree heat and 80 per cent humidity.

Thousands of orangutans die each year in Borneo because of the pressures from logging, palm oil plantations, mining, paper production, and associated deforestation. People are often frightened of these big apes and do unspeakably cruel things to them when they come into conflict. Although illegal, adult orangs are often injured or killed and sometimes their babies are taken as pets. If the authorities are tipped off then they will help organisations like the Orangu.an Foundation to confiscate or rescue the animals and take in the orphans. Here at the OCCQ, injured animals are nursed back to health ready to be returned to the wild. In the absence of mothers, carers take the orphaned youngsters to 'forest school' every day to teach them the skills they'll need to survive in the wild.

After waiting several hours we are told that Dr Galdikas won't be coming. To be honest we are both pretty annoyed, not helped by the lack of sleep. We had been warned she was a busy lady and didn't always keep to schedule. So, we continue with filming other parts of the story around the centre.

2° 43' 49" S **23 AUGUST 2003**
111° 38' 53" W OCCQ, Borneo, Indonesia

For the last ten days, the same pattern has continued. Matt and I arrived early at the centre in the hope that Dr Galdikas would turn up for an interview, but no joy. We knew it would be tough to get some time with her, but we're concerned because we're due to fly home soon. We have covered almost all the other aspects of the story. Interviews with the vet, shots of the 'babysitters' who take the baby orphaned orangutans out to 'forest school'. Shots of rescued adult orangs in their pitiful cages. All the dedicated workers who care for the animals at the centre.

Today, just like the previous ten, we arrive at the centre at 6.45am with our fingers crossed but not feeling too hopeful. But then, at 7am, who should walk out but Dr Galdikas! She thanks us for our patience and apologises for keeping us waiting for so long. 'You know how it is with politics and meetings, I am run off my feet. But today I am yours for the whole day and we can do whatever interviews you like. Also, why not accompany me this afternoon when we release one of our orangutans?'

This is looking a lot more promising. We start with an interview with Dr Galdikas next to the caged orangutan due for release. I have the camera on my shoulder and Matt is going to be asking the questions. Dr Galdikas has armfuls of fruit and is feeding the orang through the bars as she speaks. The interview is going well and we are covering some tough topics to do with conservation, illegal logging and why it is difficult for orangutans such as this one to find a suitable habitat to release them into. Unfortunately, Dr Galdikas runs out of fruit and the orang starts to search for more inside her top. In among some hard-hitting interview

gems she interjects with, 'No, I don't have any more fruit for you.' The orang probes deeper in her blouse: 'No, there's none in there.'

I try to hold the camera steady on my shoulder, wondering if there's a shot I can cut away to. I'm desperately trying to hold it together. How childish.

'No, those aren't fruit. Those are my breasts,' she continues as the orang fumbles about.

Thankfully, at this point the interview has reached a natural (or unnatural) conclusion and I am able to place the camera down. We have some nice sound-bites, probably just enough to lead into the actual release.

I then film the scene as the orang is transferred into a smaller steel transport cage and loaded into the back of a pick-up. We go in convoy to the dock-side where the cage is lowered into a small boat. From here she is going to be taken to an area of protected forest on the edge of Tanjung Puting National Park for what they call a 'soft release'. The shot of the orang reaching out through the steel bars and looking at the forest beyond is a graphic image and will make a gripping background for the continued interview with Dr Galdikas. There isn't space for Matt to join us in the boat, so it's going to be up to me to ask the questions. I climb aboard and sit next to Dr Galdikas.

Now, I'm not familiar with the engines they use in Indonesia, but they are pretty basic and, as I discover as soon as the boatman starts it up, very noisy. What should have been an hour or so of time to film and talk with Dr Galdikas turns out to be a disaster. As we set off, there is no way I can record her voice over the din of the engine – I can barely even hear her right next to my ear. I pick off various shots to cover the story instead, and then we sit and talk – or rather,

shout – for the next hour. It's tragic that I'm unable to record any of it.

Shouting over the thumping boat motor, Dr Galdikas speaks very frankly and openly with me not only about her love of the orangutans but her worry about them and the destruction of the forests, her constant battles with bureaucracy and corruption connected with trying to stop illegal logging in the national park and surrounding forests. She says she's tired of it all and would like to give up but can't, because she has a responsibility to carry on. I ask if her, now adult, children might continue in her footsteps, but she says they're not that interested.

I feel privileged to have had this time with Dr Galdikas but also sad at what she's said. I believe her when she said she was tired of the constant struggle. I'm all too aware of the fate of Dian Fossey, who, as a white woman in Africa, obviously pissed off someone enough with her dogged conservation drive against corruption that it got her murdered. There are plenty of organisations working with the common goal of saving the orangutan and its habitat. I just hope that it isn't all too late.

We arrive at the dock and the cage is unloaded. I film as the orangutan is released back into the wild. Although this animal is now free from a cage, she isn't in her own neighbourhood. She will have to learn where all the right fruiting trees are and, like others released here, will still be reliant on humans to supplement her diet.

What are we doing to this planet?

28 SEPTEMBER 2004

27° 42' 14" N
85° 18' 24" E

Kathmandu, Nepal

There has been political turmoil and trouble in Nepal for nearly a decade. Maoist rebels have run a campaign of violence trying to overthrow the monarchy and the country has been in and out of a state of emergency. It is still currently a 'category 1 hostile environment' but has been relatively calm recently. So long as we follow strict guidelines, the BBC deems it safe for a team of us to go in to film a bird migration story for the upcoming series *Planet Earth*. One of the guidelines is to avoid crowded places.

Fellow cameraman Barrie, producer Vanessa, assistant producer Jeff and I land in Kathmandu and have one night here before flying on to Jomsom. Today it happens to be the religious festival of Kumari* and, naturally, we aren't going miss out on seeing the pageant and colour of Nepali tradition. Durbar Square is where the festival is held and is of course crowded, with a heavy military presence. When I say crowded, it is heaving. There is not a square foot of space amid the crowd. People covering steps and plinths, peering out of every window, precariously perched on ledges and in trees. A real carnival atmosphere as the crowd awaits the chariot that will be pulled through the streets carrying the new Kumari. There is no sense of threat or tension but Vanessa does shout in my ear, 'Don't get shot as according to the risk assessment we aren't supposed to be here!'

* This is the Hindu religious tradition of worshipping young pre-pubescent girls as manifestations of the divine female energy.

28° 46' 58'' N **30 SEPTEMBER 2004**
83° 43' 23'' E Jomsom, Nepal

The flight to Jomsom is with Gorkha Airlines. Nepali pilots are among the best in the world and flying through the peaks and valleys of the Himalayas I can see why. All our luggage is carefully weighed out – takeoff weight at altitude is critical. Too heavy and the plane just doesn't get off the ground. There is only one song choice for flights like this: I put on my headphones and on my Sony Walkman cue up Nancy Sinatra: 'You Only Live Twice'. For 25 exciting minutes the pilot skilfully ducks and weaves his way around the clouds to fly up the Kagbeni valley. I get glimpses of snow-covered jagged peaks through the gaps in the cloud, often way above us on either side. This is a harsh and unforgiving-looking landscape, but beautiful. The scale of the Himalayas is immense. Finally, the scene opens up and I can see the runway of Jomsom below to the left. The pilot continues up the valley, getting alarmingly close to the mountain slope on our right. He then banks hard left, turns 180 degrees to line up on the runway and put us down perfectly. One of the biggest mistakes when flying in the mountains is that if you go up a valley that is narrowing and don't turn in time you won't have space to turn at all. The scars of one such disaster are visible here.

Everything is unloaded from the plane and Barrie and I sort our camera kits into two piles. The cases are then loaded up onto horses and Sherpas, with each of us carrying our share. Barrie and Vanessa are going to be based further up the valley, while Jeff and I work directly up the slopes from here.

Jomsom is at 9,000 feet and the air is thin. The horses and Sherpas set off at a pace but, without time to acclimatise yet, I find walking with my rucksack

really hard going. Jeff and I work our way up to the tiny village of Thinigaun, about 600 feet higher on the south side of the valley. A timeless cluster of stone-built, flat-roofed houses sit on a small, flattish plateau on the mountainside. Rustic with wooden doors but a view to die for.

We are here to film demoiselle cranes as they undertake one of the toughest migrations in the world. Having spent the summer feeding up in Mongolia and China, they now head south to India. To do that they have to cross the Himalayan range and one of the easiest and most direct routes is through this Kagbeni pass. Just below Jomsom is the toughest part of the journey, through arguably the deepest, steepest valley in the world. The bottom of the valley here is at 8,700 feet and is only 100 metres wide. Either side, 14 miles apart, are the two tall peaks of Nilgiri (23,166 feet) and Dhaulagiri (26,794 feet)* and high winds gets channelled up through here.

The cranes gather in numbers just upstream, where Barrie and Vanessa will be filming. In the mornings before the wind picks up, the early birds take off and fly south through the narrowest part and on towards India. Very soon, though, the air starts to warm and the southerly wind picks up so the later birds struggle against the wind and are blown back. They then have to use the thermal air currents and spiral to gain height, so they can fly at a steeper angle to get more speed to fly against the rising wind. If they leave too late then the winds are too strong to fly against and some of the birds have to thermal to as high as 26,000 feet and fly right over the top of the mountain range. The added complication for the cranes' migration south is

* To put it in perspective, the peaks are each nearly five miles high. Believe me, that's a big valley!

the chance of being caught by golden eagles. These big predators also need thermal currents to be able to get height in order to stoop and attack their prey. So, the early-flying cranes are safe but the later they leave it, the more chance of being picked off by a soaring eagle. Hopefully, between Barrie and me, we will capture the full drama.

28° 45′ 57″ N **30 SEPTEMBER 2004**
83° 43′ 45″ E Thinigaun, Nepal

Jeff and I hike up another 800 feet on the south side of the valley with the camera and tripod to get a better vantage point. I'll either go home very fit or in a body bag.

The distances and scale of the landscape here are huge, but the air is remarkably clear and from here we can see five or six miles up the valley and about three miles straight across to the north. Scanning with binoculars, we start to see small skeins of cranes way down near the river. Those early birds are wise and their escape south looks straightforward. The shots look scruffy and distant so I rely on the fact that Barrie will get them flying near the river.

Quickly as the morning progresses, I start to feel the breeze pick up. Looking down the valley we can see small skeins of cranes turning back, presumably beaten back by the headwind. Even with my longest lens on, 840mm telephoto, the cranes are too distant and too small to warrant filming so far.

Way in the distance, Jeff spots two eagles drifting on the thermals. Good at least to see all the players are here.

30 SEPTEMBER 2004
Thinigaun, Nepal

28° 45' 57'' N
83° 43' 45'' E

Another wheezing hike up the hill this morning. We see more and more cranes but they seem to be following a route much closer to the other side of the valley.

Optical delusion

Once again the early birds make it through the pass and those that fly later are forced back and have to thermal higher. Despite the fact the cranes are too distant still to film, I use the time to practise following them with the long lens. Getting my eye in.

Then, looking down the camera, I spot an eagle soaring. It is tiny in the frame, a long way off and very high. I tell Jeff and ask if he can see any cranes.

'Yes, down and to the left of where you are pointing. Right on the other side of the valley, just against the skyline.'

Not wanting to lose the eagle I keep the camera on it and at the same time scan the sky with my left eye. I can just make out the skein of cranes; they too are bloody miles away, but they are below the eagle.

Now this is where the skill and practice come in. With such a long lens it is not only imperative to have a decent tripod but also a steady hand. I am still on the eagle, I haven't lost it and it's descending. I run the camera and at 50fps.* I can hear that comforting purr of film running through the gate. I am locked on to my target and the eagle is heading down.

Down and down the eagle goes, a tiny speck in the viewfinder. It flies through the skein of cranes and they scatter. I keep the rate of tilt down the same and, as luck would have it, I am still on the stooping eagle. Tinier still below the eagle in the frame is a crane desperately trying to get away. They are both falling at exactly the

* 50 frames per second – slow-motion filming.

same speed. I know at some point that the foreground rocks are going to come into my frame, so I have to think about letting them leave the shot. Perhaps then I can quickly change position before the hit.

So I stop tilting the camera down. To my surprise the eagle and the crane both stop too. Bugger.

I turn to Jeff to own up.

'Bugger! The eagle and the crane I've been following turned out to be just two specks of dust on the focusing screen.'

Up until then I thought my camerawork had been first class, locked on to a fast-moving bird maybe three miles away on such a long lens. No such luck.

28° 46' 58" N **OCTOBER 2004**
83° 43' 23" E Jomsom, Nepal

Jeff and I call the horse taxis and move back to Jomsom. We decide to work the other side of the valley as that's where the cranes seem to be flying.

The spot we've chosen is about 3,000 feet above Jomsom and the first hike takes us three hours with a backpack. We cheat and use a horse to carry the tripod, spare batteries and film.

This is a much better spot and the cranes are now recognisable to the naked eye. Slowly I am able to get some usable shots.

OCTOBER 2004
Jomsom, Nepal

28° 46' 58'' N
83° 43' 23'' E

Over the next few days we acclimatise, get fitter and make better time climbing the 3,000 feet up to our vantage point.

Into thin air

While waiting for the cranes to show we watch the flights come and go from the airport below us. From where we are positioned, we can hear the engines rev on takeoff, and we watch the dust trail behind the planes as they gain speed. Every time, though, from our high perspective it looks like they run out of runway and drop off the end towards the river. Needless to say, they all make it and climb slowly towards Kathmandu.

After five or six days I'm able to film some of the key shots: the climax to the story of the demoiselle cranes' migration. One large skein tries to travel down the valley but is forced back by the wind. The birds ride the thermals higher and try again, but still the wind is too strong. They then circle, catching thermals for another two hours. Higher and higher they fly and then turn south. Even though they are now quite distant their distinctive 'V' formation is clear and they fly over the Nilgiri ridge just to the right of the highest point. They must easily be at 22,000 feet. It is a spectacular image with the snowy peaks and ridge beneath them. Success. (And no, these are not specks of dust in the viewfinder this time.)

The downside of working in the mountains is the hard slog uphill every day. Two hours short of breath, sweating and heart pounding in your chest. The great thing about working in the mountains though is that the air is fresh, the views spectacular and you get very fit. Plus, at the end of the day, if you are feeling brave or stupid, you can scree-run back down to the hotel in less than 20 minutes!

28° 46' 58" N **10 OCTOBER 2004**
83° 43' 23" E Jomsom, Nepal

Phone home The air is so clear here that the stars at night are spectacular. I'm really keen to get a night-time time-lapse of the stars wheeling over the summit of Nilgiri. As I'm knackered after 12 long days of hiking and filming, and partly so that I'll be further from the light pollution from Jomsom, I decide to stay up the mountain overnight. So, in the morning when Jeff and I hike up to our usual spot, I also pack my time-lapse gear, a tent, sleeping bag and some food.

At the end of the day, Jeff heads back down the mountain with the Sherpa and horse and I stay up at 12,000 feet. In order to shelter from the wind, I pitch my small tent on a ridge on the lee side of a low cliff. I line up my time-lapse camera and set it clicking. Then, even though it is still early, I climb into my sleeping bag to catch up on sleep.

As I lie there gazing out through the tent flaps, the stars look out of this world. I haven't called home for a while so make a short call to Maggie on the satellite phone. All is good.

I then think to myself that I haven't spoken to my dad in months, so I give him a quick call too. 'Hi, Dad, it's Gavin. How are you?'

'I'm extremely well, thank you,' he answers in his usual fashion. 'Where are you calling from? There's a slight delay.'

'Well, I'm on the satellite phone and I'm calling from Nepal. I'm currently at 12,000 feet up in the mountains on my own on a tiny ledge ...'

At that the phone cuts out and I can't get it to turn back on. I won't be able to call my dad back until I'm in Jomsom again the next evening. I just wonder what he thinks has happened.

28 MAY 2007

50° 51' 39" N
129° 4' 49" W

Triangle Island, Canada

Considered one of the most remote and vulnerable places in Canada, Triangle Island, named for its geometric shape, sticks 650 feet out of the Pacific Ocean and is roughly 30 miles off the north-west tip of Vancouver Island. On its peak stands the remnants of a lighthouse built in 1910. The island is hit by frequent hurricane-force winds and was considered uninhabitable even for the hardiest lighthouse keepers and so was abandoned in 1919.

It is now home only to the wildlife and has British Columbia's largest seabird colony with over a million Cassin's auklets* – half the world's population – 80,000 rhinoceros auklets and 60,000 tufted puffins. The rocks around the shoreline are ribboned with breeding Steller sea lions – the second largest rookery in the world. Male Stellers can grow to nine feet long and weigh more than a tonne. With the island being such an important wildlife refuge, human visitors are limited to only ten people a year. This year assistant producer Ed and I are two of the lucky ones.

To get to Triangle we sail 80 miles up from Port Hardy on Vancouver Island, with intrepid skipper Pamela on her quite luxurious yacht, *Precious Metal*. We then ferry our camera, camping and food supplies by dinghy to the shore where we are met by the three scientists, Mark, Rachel and Kyle, doing seasonal bird research work.

* A small, quite chunky seabird that lives in the North Pacific.

Walking the last 100 metres over slippery seaweed-covered rocks to the shore is treacherous and nearly costs us a bottle of whisky when I slip and fall. Luckily, my cat-like instincts save the medicinal nectar but cost me two inches of skin off both shins. We wave goodbye to Pamela, who will (hopefully) return to pick us up in four weeks, and then hike our kit from the shore up to the lone scientists' hut.

With space cramped, Ed and I pitch our tents on the only available flattish piece of ground – the helipad clearing – on the proviso we shift them fast if there is a medevac situation.

We are here to film the 'births, deaths, marriage' behaviours of Steller sea lions. The scientists kindly show us to the best location, a half-hour walk around the coastline to the south-east peninsula, with a few interesting climbs and jumps to avoid the Pacific swell. Apart from Hawaii, there's nothing for 6,230 miles to the south-west until you hit Papua New Guinea. That's a lot of ocean for wind and swell to pick up nicely.

The whole island has that distinctive musty smell of guano (seabird shit). It's not unpleasant but gets in your nose, lungs and clothing. Mixed in the wind is a constant sound of bird calls, both from nests and burrows on the slopes as well as from birds circling overhead. As we approach the sea lion colony, the sound crescendoes with a mix of human-like coughs, squeals and growls. The most prominent sound, though, is from the males barking. Deep barks – not unlike bloodhound on hearing the postman rattle the gate. Once at the edge of the sea lion colony, the scientists return to their studies and leave Ed and me to set up my filming hide. Despite their size, the sea lions are surprisingly skittish and one has to be extremely careful when approaching so as not to scare them. Although they are covered in a thick layer of blubber, they can easily get injured if

they were to stampede over the jagged black rocks. So, when choosing a position for the hide I have to bear in mind being able to get in and out of it unseen by the colony. After an hour or so's deliberation, we choose the spot, elevated from the colony by a seven-foot cliff edge – just enough to keep me safe from getting squashed. There is a nice approach from behind, through a 'V' of rocks to a small flat platform and then down into the hide. Perfect.

6 JUNE 2007
Triangle Island, Canada

50° 51' 39'' N
129° 4' 49'' W

The last few days have been productive. The female Steller sea lions have been giving birth left, right and centre. I filmed one birth right in front of the hide, with a backdrop of three to four hundred sea lions stretching off like overweight sunbathers on the rocks. Being so close, I was able to get a good variety of shot sizes, including big close-ups of the cute baby as it drew its first breath.

You may not know but video-camera viewfinders are black and white,* as that gives the highest-quality image for focusing. I'd been filming for about 20 minutes before I took my eye from the viewfinder to see first-hand the sweet newborn pup through the hide opening. To my horror it looked like a scene from a Tarantino movie. There was blood and gore all over the rocks, gallons of it. Down the camera it had been a sweet moment between mum and newborn baby. In colour,

* Not today though. With the advent of newer screen technology, viewfinders are now thankfully colour.

it seemed non-broadcastable. Let's see if they can 'fix that in post'!

The weather is taking a turn for the worse, with the wind and swell picking up. I think it's wise to pack the camera and lenses into waterproof cases as usual, but also to take down the hide and move it all further up the cliff just in case the swell picks up. Ed and I climb to the first nearest ledge, a good 40 feet up, and stash the cases, hide and tripod there. I put a few heavy rocks on it all too, just for good measure. The trip back to camp is, shall we say, a bit more exciting. There's already a three-metre swell running and we have to choose our moments very carefully when crossing areas of the rocks.

50° 51' 39'' N
129° 4' 49'' W

9 JUNE 2007
Triangle Island, Canada

Tentbound

We've been hunkered down in our tents for three days now with somewhat fierce wind and driving rain coming in from the south-west. Thankfully, we had the sanctuary of the scientists' hut and have told stories, played cards, cooked meals and played dare with ten-year-out-of-date food supplies found in the depths of their store. Looking out to the peninsula, I have never seen waves so big. When they hit the rocks, water has been exploding, sending spray a good 150 feet up. To try to get to where the camera is stashed would be suicide. I'm just hoping we've chosen a ledge high enough and far enough from the shoreline.

10 JUNE 2007

50° 51' 39'' N

Triangle Island, Canada

129° 4' 49'' W

Thank God the weather has calmed down a bit. I was starting to go a bit stir-crazy cooped up in my tiny tent. It's still not good enough to go and film, but I suggest we ought to try to go and check on the camera gear.

Ed and I get togged up in our wettest wet-weather gear and set off round the coast. The swell and waves are still very intimidating and we have to be really careful and take no risks. With 400 metres to go to the hide position, we cross one of the beaches and something catches my eye. It is a small bit of plastic, recognisable as the catch off a waterproof Peli-case – not a good sign! We carry on round, dodging each seventh wave crashing high on the rocks. To my horror, there at the base of the cliff is one of the Peli-cases. Ed and I race across to it over the slippery rocks. The case is intact but with a few scuffs. I open it and all the batteries packed in foam cutouts are fine and dry. Phew. Ed and I scramble up the cliff to the other kit. It's shifted about a bit but amazingly is all there. It would have taken some explaining to the office if we had lost £80,000 worth of kit by leaving it out in a storm for three days!

Feeling adventurous and glad to be out of our tents, we then decide to round the corner to see where the big waves are still crashing in. There is one last slope to climb up and sea spray is being thrown over at a great height every 15 seconds or so. Keeping a firm grip on the rock, we crawl to the top on all fours and peer over. It is like a special effect from a movie. The swell is driving 30-foot waves straight at us – that's more than twice the height of a double-decker bus, well above our eyeline. Fortunately, before hitting us they explode on a jagged rock 50 metres out, taking the force out of them and

sending white foaming spray high into the air, drenching us like spectators at a log flume. I flinch at each wave – instinct telling me I shouldn't really be here. Ed and I retreat and carefully make our way back to the hut.

10 JUNE 2007
Triangle Island, Canada

The sun comes out and the sky is nearly blue. It's almost as if the storm never happened. Ed and I put the hide back in place and I have another fruitful day's filming.

While I'm in the hide, though, a huge male sea lion takes up residence right behind it, blocking my exit. Peering out through the gauze window I can see he looks very comfortable; this is now his territory and he is not about to move. I try clapping my hands to see if I can displace him so that I can escape, but he just lifts his head and plonks it back down. After several attempts to get out without being flattened I have to radio Ed for help. I ask him to approach from the opposite side and distract the sea lion.

Ed shouts, 'Sea lion!' a few times until the animal looks up. Now I see how huge a brute he is (not Ed) – at least nine feet long and weighing maybe 800kg. He is fully fuelled up on testosterone and although he might only be ten years old, I don't fancy my chances.

I choose my moment and make a dash for it. The sea lion sits fully up, ready to battle – but I've outwitted him and am now safely past. I'm glad he isn't in the least bit frightened of us and that we haven't scared him off his patch. On the contrary, he's trying to scare us off.

For the next seven days, every morning and evening we have to shout 'Sea lion!' and I have to play 'run the gauntlet' with this big male. But as soon as I'm

in the hide, it's as if I've disappeared like magic and he settles back to sunbathe.

17 JUNE 2007
Triangle Island, Canada

50° 51' 39" N
129° 4' 49" W

Pamela arrives back in her yacht, *Precious Metal*. She's seen from the weather reports that there is more bad weather coming in and thinks we should take the opportunity to get off the island with all our kit while we can.

We then stay on the boat for a few days, coming ashore with the basics to film, but with the weather starting to deteriorate we decide to cut and run – allowing us 18 hours to motor back to shelter behind Vancouver Island before the weather system hits us.

As we leave Triangle, a grey whale swims alongside the yacht for a while and dives right underneath us. I can't help wondering if it's the one that I filmed back in 1996, 2,000 miles further south down in Baja California.

3 NOVEMBER 2014
Cairns, Australia

16° 55' 3" S
145° 46' 59" E

Over my career I have travelled and worked on all seven continents. I have been baked by the harsh sun in deserts and have struggled for breath at altitude in mountain ranges. I have battled with plants in the jungles and unwillingly hosted and fed many a parasite. Today comes a completely new challenge, however, and one I'm not

New frontiers

233

sure I'm fully ready for. I have boarded the ship MV *Alucia* owned by American billionaire and philanthropist Ray Dalio who is keen to promote science and exploration in our oceans. This ship is no ordinary ship: it is 183 feet long and pimped to the max. Staffed by a delightful, expert and dedicated crew, it can comfortably cater for 20 guests. The ship has active stabiliser fins that help it to stay steady in rough seas, a helipad and helicopter, full SCUBA diving kit for up to eight divers, a decompression chamber (in case of emergency), kayaks, satellite Wi-Fi, you name it. And unlike any boat I've been on, *Alucia* also has two submersibles,* both capable of diving to 1,000 metres. That's one full kilometre beneath the surface! To the untrained eye the two subs look very similar. Each has a large acrylic sphere mounted in a fiberglass-clad aluminium frame and carries a massive bank of batteries in two pontoon pods underneath. These power electric propulsion, lights, controls, scientific and camera equipment, and life support. The slightly smaller Deep Rover is a two-man sub. You squeeze into the five-inch-thick, five-foot-diameter sphere from a hatch in the bottom. The larger Triton Nadir is a three-man sub and you enter by lowering yourself in through a hatch on the top. This sphere is over six inches thick to withstand the pressures of the deep and is way more spacious at almost six feet diameter. Add three seats, a pilot and two passengers, controls for sub and cameras, packed lunches etc. and suddenly it is looking quite cosy for an eight-hour dive! (No, before you ask. There is no toilet.)

This is the first filming trip for 'The Deep', one of the episodes for a new BBC series called *Blue Planet 2*.

* A submarine is autonomous whereas a submersible needs a support vessel for launch, retrieval and for recharging air tanks and batteries.

Producer Orla asked me if I'd be interested in filming the bulk of this programme and of course I leapt at the chance of the adventure. Although I've filmed underwater on and off for 15 years I have never dived deeper than 25 metres and I have never been in a submersible before.

In charge of the sub team is Buck. Ex British Navy, as many of the team are, he exudes an air of confidence and discipline. Despite the team's military precision and strict protocols in maintaining and setting up the submersibles for each dive, they are a good-natured bunch with much laughter punctuated by technical talk.

Under a blue sky we set sail from Cairns, on the north-east coast of Australia, and head out through a gap in the Great Barrier Reef with about another day's cruise to get to location further out in the Coral Sea. The sea looks inviting, fresh, and although I can't see beneath its surface sheen I know that below these waves lie natural treasures to be discovered.

The plan is to find and film allegedly the most abundant fish on the planet, the lanternfish. Lanternfish, so called because of their light organs that can bioluminescence blue-green light, are one of the most common types of fish in the open ocean, living in the deep sea to depths of 1,000 metres. Not a huge amount is known about their biology but we know they stay deep in the day and then migrate to shallower water to feed at night, before returning to the dark depths again at dawn.

To track the lanternfish, we will be liaising closely with tuna fishermen who have noted when gutting their catch that the stomachs of the tuna are often full of lanternfish.* This would indicate there are huge shoals here, sometimes so thick that they show up as

* Tuna are frenzy feeders, they are very fast and efficient hunters favouring hunting smaller fish in shoals. They catch and eat their prey whole and can fill their stomachs in about 30 minutes.

a solid red bar on the ship's sonar appearing to be the ocean floor. Our aim is to get in amongst one of these shoals and film the bioluminescent show. On our way to finding a possible location we are prepped for what lies ahead. Orla, myself and assistant producer Will, are first each weighed so that the ballast on the sub can be calculated for optimum buoyancy control. We then watch a safety video about the submersible and undergo a short briefing from Buck about the life support on board. I am pleased to note that should the first option of keeping us alive – the carbon dioxide scrubber that can control the atmosphere within the sphere for up to ten hours – fail, then there are three more back-ups to keep us alive. The last resort, a lithium blanket, can absorb CO_2 for up to four days. I really hope they don't foresee a point where we will be stuck on the bottom of the ocean for that length of time, but good to know they've thought of everything.

We're also taught how to get the submersible to the surface should our pilot become incapacitated – essentially turning some valves to blow the tanks – and that for any emergencies 'X-ray' is the word to use to get undivided attention from the ship's crew. It all seems straightforward but in my head I can't help but imagine being trapped in that tiny acrylic sphere somewhere in the depths of the ocean in the dark with the BIBS[*] (life support option number two) in my mouth as the sub fills up with water. Even though I am an experienced diver I can't say I relish the thought.

[*] Built-in breathing system.

4 NOVEMBER 2014 16° 33' 3" S
Cairns, Australia 147° 20' 01" E

For the next day as a 'new boy' on board the ship I am forbidden to touch anything on the submersibles whilst they are being prepped with lights and cameras. I keep out of the way and watch the process. All I can do is bring the sub team cups of tea and biscuits as they slave away in the heat, mounting two cameras on the front of Nadir. It does however give me time to think. I suddenly wonder how I'll react when I'm in the sub and the hatch is closed. I'm not normally worried about enclosed spaces but this whole situation is different. We will be underwater with no way out until we surface again. Will I get claustrophobic and freak out? Will I have to spend the next two weeks sitting on board the ship embarrassed whilst someone else takes my space and goes down in the sub to operate the cameras?

Up on the bridge the sonar picks out an unusual layer that we suspect might be a huge shoal of lantern-fish. The sun is just setting, sinking below the waves on the horizon, and its rich red glow paints the sky. The sea conditions are good for us to launch so I squeeze one last wee out before getting into the sub for eight hours. The plan is to launch and descend to 1,000 metres[*] and hopefully on the way down we will meet the mass migration of lantern fish on their way up at dusk to feed. We can then ascend with them and film their bioluminescence.

[*] The depth of the sea was about 2,000 metres and this sub was only safe up to 1,000 metres. As the other sub Deep Rover was out of service, we performed the dive tethered to a large buoy with a 300m line so that we wouldn't exceed the safe limit for single sub operation. No cowboys here.

With Will filming for 'behind the scenes' I follow Buck and Orla and lower myself down through the hatch of Nadir and sit in the left seat. It's remarkably calm and quiet in the sphere, shielded from the noise of the ship's engines and air conditioning. Buck runs through the safety briefing once more and I physically check for the BIBS over my left shoulder. By my feet are two large batteries that power the cameras along with three packed lunch boxes. In front of me is a nest of wiring for the pan and tilt, zoom, focus and iris controls for the cameras outside the sub in their deep water housing. Attached to the acrylic sphere with suction pads are two video recorders with screens. And now on my lap are two laptop computers for controlling camera settings. It's cramped to say the least and will be a technical challenge to operate all this in the dark.

'All set?' Buck asks and then he closes and locks the hatch, sealing out the last sounds from the ship. I'm pleased to say that I feel remarkably calm – and excited. The team start the launch procedure and the sub trundles towards the stern of the ship on its carriage and rails. The huge hydraulic A-frame at the stern lowers and we are hooked on. Buck communicates with the team by radio and eight tonnes of submersible, with us in it, are lifted off the deck. The A-frame then swings slowly over the back of the ship and gently dunks us in the water. The designated 'swimmer' then climbs from an inflatable dinghy on top of our sub to unhook us and tuck the lifting straps neatly to the sub frame with the lifting ring easily accessible. This is for ease of retrieval once we've completed our dive, but also as a safety measure should an underwater retrieval be necessary and they need to attach a hook to us to winch us up. The swimmer gives Buck the thumbs up to signal it is done.

We float and bob in the waves, our eyeline is just above water level and we have a good view looking back at the floodlit *Alucia*. Buck turns on our 'headlights' then requests permission from the ship for us to dive. It's a little nauseous rolling with the waves, but as soon as our air tanks are blown and we sink below the surface the sub stabilises. Now there's silence, a real sense of calm. I look up to see the reflection on the underside of the waves as we start to descend. Soon, apart from our own lights, all around is darkness.

It's a weird sensation sitting in this acrylic sphere. The all-round visibility is so good you almost forget you're in a submersible. It's like being in a strange underwater dream-world. Buck communicates with *Alucia* to let them know all is well and then kills our lights to let our eyes adjust to the darkness in order to spot biolumines-cence. Buck flips the electrical breakers and the control panel gives a red warning light, an electrical ground fault, whatever that means. 'It's an earth leak from one of the lighting cable connections, a common issue and nothing to worry about.' He is happy to continue with the dive and it takes 20 minutes to sink to 300 metres where the tether stops us from going deeper. On the way we see very little life and certainly no sign of a massive shoal of lanternfish. Buck turns on the lights occasionally to see if there's anything out there. Every now and then a squid whizzes by like a tiny rocket. Some of them get confused by our lights and shoot out a jet of ink when they bump into the sub.

I didn't really know what to expect down here and I know we can only see about 20 metres, as far as the lights illuminate, but certainly this little patch of sea seems pretty empty. After seven unfruitful hours, at around 2am, and having devoured our packed meals, the submersible batteries are running low so we decide to call it a night. Buck calls the ship to ask for permission to surface.

The reply: 'Yes, glad you're on the way back up as surface conditions have deteriorated.' The bigger the waves and swell the more difficult it is to retrieve the sub to the ship.

An hour later and we are back at the surface and the conditions are certainly not great. It's dark and being eye level with the waves it feels quite threatening. The retrieval of the submersible is very well rehearsed and takes a team of six, all in radio contact, to coordinate. We get hooked up to the A-frame okay and then the captain turns the *Alucia* into the weather and cruises slowly forward. This creates slightly flatter calmer water at the stern of the ship towing us in gently. Even with stabilisers though the ship is heaving in the swell. Once they winch us out of the water the sub starts to swing around like a nine-tonne conker on a string. There are control lines on the sides of the sub but they can't stop such a weight and we start to sway wildly side to side. Buck gives the command to quickly lower us back in the water. I can tell from the tension in everyone's voices that this is now quite a serious situation. Once back in the water the sub stops swinging. They try again to winch us out but the same thing happens. This time we narrowly miss swinging the acrylic sphere into the steel structure of the A-frame and Buck gives the command to abort once more: it's just too risky and they don't want to damage the sub – or us in it.

Once back in the water Buck says, 'I'm sorry about this but I'm afraid we're going to have to do a sea evacuation. We've rehearsed for this many times but have never had to do it. They'll bring the Zodiac next to the sub, I'll open the hatch and then one of you will quickly exit and I'll close the hatch. The guys in the Zodiac will help you on board. I'll then do the same for the next person. Finally I'll exit too and we'll then retrieve the empty sub.' This is risky because of the

chance of a wave flooding the sub when the hatch is open which could potentially cause it to sink.

Remembering my near drowning in only six feet of water in Ascension Island, I ask Buck if there are life jackets, just in case. He rummages behind the seat and Orla and I don a lifejacket each.

One by one we have to time our jumps with the waves, from the sub to the Zodiac. The darkness pierced by the harsh floodlights from *Alucia* and sea spray on our faces all heighten the tension. Outstretched arms catch and guide us unceremoniously into the wet bottom of the boat. Then, once safe, we make the slightly easier transfer to the ship.

I stick around to watch them retrieve the sub. It's pretty hairy watching such a huge weight swinging around on the lifting rope. But with Buck in command they manage to get it back on deck without incident. Quite an introduction for my first experience in the world of submersibles.

16° 31' 22" S **18 NOVEMBER 2014**
147° 9' 32" E Cairns, Australia

Over the last two weeks we've dived each night. Most dives were not without some sort of technical issue with the cameras, communications or electrics. We haven't seen any lanternfish, frustratingly, but that's the way it goes sometimes. The highlight was being buzzed by a three-metre swordfish at 300 metres depth. It was the most beautiful animal, a shiny steel blue, somehow 1950s looking in its design, with a long elegant sword, over a metre long, swept back pectoral fins and a tall dorsal fin that rides high above its head. Finished with an exquisite crescent-shaped tail fin. It cruised underneath us first before disappearing into the darkness. Then it returned coming almost straight at us – quite intimidating in a way as, with the acrylic sphere, you feel like that sword is going to run straight through you. It then did one final pass right in front of us. Typically, the pan and tilt wasn't working for the camera on that dive so I was unable to tilt up to get a shot. I did manage a sneaky iPhone snap though for the memory and proof.

Talking through with Buck and the sub team I question why the submersibles seem so unreliable. After all, we managed to put a man on the moon in 1969 and a remote robotic rover on Mars in 1997. It is explained to me quite succinctly. The difference in pressure between the sea level and space is one atmosphere. The difference between sea level and just ten metres underwater is also one atmosphere. For each ten metres you descend underwater you add another atmosphere's pressure. So at 1,000 metres depth it is 100 times the pressure at sea level. Add to this corrosive salt water and it makes engineering and

electrics even more complicated. It's crazy to think that allegedly more people have been into space than have been below 1,000 metres underwater. So when you cross the seas or an ocean on your cruise liner, 95 per cent of the sea floor just one kilometre under your feet has never been explored.

30 APRIL 2015 8° 10' N
Pacific Ocean, Costa Rica 83° 51' W

A few months later, myself, assistant producer Will and scientist Andrew Thurber arrive on the *Alucia* in style, flying by helicopter direct from San Jose to land on the ship's helipad. We are in the Pacific Ocean about 70 miles off the west coast of Costa Rica. It's a short sharp three-day shoot to film Yeti crabs for the same episode as before for *Blue Planet 2* with the same top-notch crew.

Yeti crabs are about six inches long and so named because they are light in colour and covered in what looks like furry hair. They are blind and live in the dark depths of the ocean, beyond where any sunlight penetrates. The story is interesting because these crabs live on methane seeps: sites on the ocean floor that leak out methane and hydrogen sulphide gas. The crabs have evolved their hairy claws for a purpose – they wave them in the methane bubble streams and cultivate bacteria on the hairs. The crabs then harvest and eat the bacteria using their comb-like mouthparts. All this is happening in complete darkness 1,000 metres below the waves.

It's mid-morning and conditions are perfect. We plan to have both submersibles launch and dive together.

Working in tandem the two subs can support each other, with Deep Rover backlighting the sea bed for our cameras. Will and I climb in through the top hatch of Nadir and join pilot Dave with our packed lunches. Andrew gets ready to travel down as scientific advisor in Deep Rover piloted by Toby. The sub launch team get us into the ocean with their usual professional efficiency and we commence our descent. Deep Rover is close behind (above) us.

As we sink down the light starts to fade. We pass a few small shoals of fish and the odd squid swims by. Apart from that there is little else to see, the water just gets a deeper and deeper blue. The deeper we go, the darker it gets, the sunlight being filtered out and absorbed by the water. At around 300 metres it is completely dark to the eye. Looking up through the sphere I can faintly make out a glimmer of light from the sun, but only just. Within another 50 metres it is properly dark like we have sunk into an ink pot.

We hear over the radio from Deep Rover that they have buoyancy issues. They are getting a recurring alarm from the battery compartment, and although not too concerned, they decide it best to return to the surface to investigate and fix the fault. After consultation with the ship, this doesn't seem to be a safety issue for us so we continue down, expecting Deep Rover to be joining us shortly.

Finally, after nearly an hour's descent, we can see the muddy bottom (with our lights switched on). Dave lets the ship know and then they give us a heading and bearing to where the methane seep is. Dave sets the course and we motor on with our eyes peeled for the small rocky area, home of the Yeti crabs. Within 15 minutes or so we find it. Amazing. From what I can make out it's a really small area, no more than 50 feet wide and 20 feet across. Dave

skilfully adjusts our buoyancy and tiptoes the sub in close, taking care not to stir the silt.

'There!' we all say at once. Tucked in amongst the rocks are 15 or so small white-looking crabs. It's the movement that caught our eye, they are all waving their claws side to side, dancing, almost as if swaying to music. I'm amazed at how accurately the ship could guide us in to this, such a small location on an otherwise seemingly featureless ocean bottom.

Together we choose the best spot to put the sub and I describe to Dave how I'd like him to try and angle the light. It then takes another 20 minutes to position and set down, pumping all the air out of the ballast tanks so we sit heavy on the ocean floor for stability for the cameras.

The next four hours' filming go well. The wider shots are poetic with the crabs swaying hypnotically to and fro. I'm also able to get details of their hairy claws waving in a stream of methane bubbles, cultivating and feeding their cultures of algae. Also dotted around are small shrimp and they seem to patrol the perimeter of the crabs like jackals round a lion kill. Every now and then a shrimp will dart in – it seems they are scavenging algae from the crabs. This is turning out to be a nice little behavioural sequence and all shot from a nine-tonne sub sat on the bottom of the ocean at 997 metres.

Dave has been in intermittent contact with the ship to update them of our status and to check if Deep Rover is fixed. We have now been in Nadir for over six hours, we've eaten all our packed lunches and more importantly the CO_2 levels are rising as the active ingredient of the scrubber gets depleted. Knowing it takes an hour to ascend to the surface Dave tells us it's time to go.

I position the cameras in their stow position and Dave radios the ship.

'SO,* SO, Nadir. We have finished our filming and wish to ascend to the surface.'

No answer, so Dave repeats.

'SO, SO, this is Nadir. We have finished filming and wish to ascend to the surface.'

Still no answer. We often have communication difficulties in the sub so Dave says he will start our ascent and the comms will probably be clearer once we get closer.

'All set to go?' he asks us.

'Yes thanks,' we reply in cheery mood.

Whilst I'm fiddling around tidying the joystick and camera controls for the ascent I notice that the CO_2 warning has gone to amber on the Toughbook monitor. Not an issue as we are about to head up.

I then notice Dave rather frantically looking from side to side at the valve controls. He is trying left then right.

'Everything all right?' I ask him.

'Er, no actually. Nothing seems to be working.'

'That doesn't sound right. What do you normally do?' I ask him.

'Well usually I'd pump air back into the ballast to get positive buoyancy and off we'd go. But for some reason nothing is responding.'

I glance at Will and at the carbon dioxide amber warning. Dave tries to radio the surface again but no response. He then fiddles more with the various controls. Has Dave's judgement been affected by the higher than normal CO_2 I wonder? Seven or eight minutes have now gone by and Will is looking slightly concerned.

Being helpful and to lighten the mood I suggest Dave turns the computer off then on again to see if that fixes it. It is running Windows after all.

* Surface officer.

Dave does so and reboots it. Still no joy.

I glance back at the crabs happily doing their dance at 997 metres when I hear the chilling words as Dave tries the radio again: 'X-ray X-ray X-ray.'

At the first X-ray my stomach clenches slightly. Those three words mean this situation is not good. We haven't heard any response from the ship for a while now so in case they can hear us, Dave wants to get their attention.

I look at Will and he has gone slightly pale. In my head things are spinning. I'm thinking I don't think we are going to die down here, but I certainly don't like the thought of sitting here in the dark for hours or days waiting to be rescued. If we are properly stuck then Deep Rover could bring a rescue line down and hook it on for the ship to winch us up. But for all we know, Deep Rover is still out of action.

The sub team on *Alucia* are hugely experienced and many of them are on the international submarine rescue team. Everywhere they dive with the *Alucia* submersibles they know where the nearest rescue subs are as a back-up. The nearest one to us now is in San Diego – that's three days' sailing away. Three days of us sat in the dark with basic survival rations and no toilet and currently no communication to the surface. The ship obviously knows exactly where we are, they can see us on their radar. I visualise lights appearing from the darkness in three days with a hydraulic claw hooking a towline onto the slings on our sub.

The CO_2 level is still rising but Dave is calm and professional. He is methodically working through the issue and having rebooted the system again he tries the valves. Bingo. 'It all seems to be working again now,' he sighs with relief. 'Who knows what was going on there!'

We can hear the pump working away, pumping the water out of the ballast. After a minute or two Dave

uses the thrusters to start us on our ascent. Nothing. Full blast on them stirring silt all around us and losing visibility altogether. Still nothing.

'I think because we went heavy on the bottom we're stuck in the mud. We need to try and break the suction,' Dave says.

So whilst Dave activates the thrusters the three of us sway side to side to try and rock us free. What must those Yeti crabs think?

It works though. And soon we are on our ascent. Dave is monitoring the CO_2 and tells us to stay calm and still.

'The more you move and breathe the more CO_2 you produce,' he tells us. I respect his experience and confidence.

Ten minutes later Dave tells us. 'I'm not able to vent any air from the tanks to control our ascent. We have a good 40 minutes to the surface but we will need to secure anything loose in the sphere. We are going to rocket up uncontrolled and although I don't think we will breach, we will surface quite quickly and we might bounce around a bit.'

Soon the radio crackles into life, it's the ship. Dave tells them 'We are ascending passing 700 metres. I am unable to vent so please clear the ship from the area as we are coming up fast.'

As we pass 300 metres all the controls start to function correctly and Dave is able to vent air and slow our ascent.

'Again. God only knows why that is. We will take a look once back on board,' he says.

The recovery of Nadir and us to the ship is straight-forward. Apart from the small short drama, it's been a good day's filming.

1 MAY 2015 *8° 10' N*
Pacific Ocean, Costa Rica *83° 51' W*

The sub team stayed up late last night to troubleshoot the issue with Nadir. It turns out that there is safety switch on the hatch lock that communicates via Wi-Fi with the Toughbook control computer. It won't allow operation of any controls if it thinks the hatch isn't fully closed and locked. Like the best detectives, the sub team found out that when we were in the sub the Toughbook had connected to one of our iPhones instead of the hatch switch, thereby disabling all controls.

Alucia's captain, Frank, calls a meeting to review their findings and we run through the whole scenario. I say, for the record, that I have complete faith in the Alucia submersible team. I am starting to understand the complexities of deep water travel and exploration. It is pioneering technology, a new and exciting frontier, and for the record, I tell them I have no hesitation in diving in either sub with any of the *Alucia* pilots.

We go on to do another dive, this time with both submersibles operational. The dive goes without a glitch and the yeti crabs are doing their thing, dancing the night away.

29 MAY 2016 *27° 43' N*
Gulf of Mexico *91° 17' W*

We are at 1,000 metres depth about 190 miles south west of New Orleans. This deep water site, the GC233 brine pool, was first observed about 25 years ago. I have seen photos of it before coming here, but no image could really set it up.

As we approach, water so clear it's almost as if we aren't underwater at all. The brine pool is up ahead and just coming in to the spread of our lights. It is roughly oval shaped and about 30 metres in length. In contrast to the ocean around it, the pool is a dark grey green, a sinister colour, and has what appears to be a layer of mist on its surface, not unlike a village pond on a cold January day. It is ringed by a three-metre-wide band of deep sea mussels that give it a defined edge. I can't see down into the murky depths of the pond and the whole scene feels eerie.

A brine pool is a super saline pond or lake on the bottom of the ocean. The salinity of the water is up to eight times that of normal seawater, it's so dense that it stays trapped in the depression it seeped from. The water is so salty that no life can survive in it. But there are signs of life here. Movement catches my eye and I see it is an eel snaking its way through the mussels. Then I spot another, and another. There must be 20 or so of them over the area. This is what we've come to film. These eels secrete a slime from their skin and this is able to protect them short term from the effects of the brine. The eels survive by scavenging on other fish and creatures that happen to succumb to the effects of the brine and die. Every now and then an eel will swim across the pond, through the mist. If they can sense or smell food they dip into the brine to retrieve it. But the brine is so toxic that if the eel lingers too long it too will succumb. Filming from the relative safety of the submersible, it's quite tragic to see the odd fish swim lazily over the pond. Then when it gets too close, the toxins start to take effect. The fish begin to spasm, twisting and writhing in discomfort, until perhaps ten minutes later all movement stops and their contorted bodies sink slowly into the mist.

I also film one eel that misjudges its scavenging dives. It too becomes poisoned and starts to writhe. Trying to get away to clearer water it is obviously confused and instead it dives again and again into the mist and brine, tying itself in knots as it suffers. More by luck than judgement the eel finally wriggles its way to the edge and is able to recover.

I will not forget this experience, but witnessing and filming this pool is with mixed emotion. I enjoyed the technical challenge of directing the second sub to backlight the pool for us. Using it too in shot to give a sense of place and scale. The backlit mist looked extraordinary and the mechanical shape of Deep Rover made it feel like I was filming on a different planet. However, seeing these, often beautiful, deep sea fish swim unwittingly into the toxic mist was quite tragic.

31 MAY 2016
Gulf of Mexico

27° 2′ N
92° 30′ W

Mud volcano

We are about a six-hour cruise from the brine pool location. Nadir and Deep Rover launched about three hours ago and we have been cruising the ocean floor now, at 575 metres, looking for a known methane seep. The *Alucia* tells us we are in exactly the right spot but all we see is flat, silt, sea bed. Just as we are about to return to the surface and rethink, we see the first eruption. Just ten metres in front of our sub a swirling mud column rises swiftly and vertically out of the silt. Then a few metres ahead another. My cameras are rolling and the spectacle escalates. We quickly work out what is happening. Methane bubbles, larger than a watermelon, are erupting out of the sea bed. As they rise, they drag with them the loose silt,

forming billowing vertical columns of mud that hang in the still water. The silt continues to swirl in each column like chocolate clouds. The scene doesn't seem real, I feel like I am in outer space, orbiting a distant planet as explosions happen on its surface. Pilot Buck manœuvres Nadir through this battlefield to the edge and I request Deep Rover to take a path on the opposite side from us so I can again use its lights to backlight the silt columns. Seeing the other sub through the eruptions helps us realise the scale. The active area is almost the width of a football pitch and the columns of silt rise ten meters tall. It is such a surreal scene. Without doubt the weirdest natural phenomenon I have ever witnessed. Like the brine pool from yesterday, this doesn't feel like planet Earth. What more is there yet to discover in our oceans depths?

63° 26' 53" S
56° 38' 26" W

14 DECEMBER 2016

Antarctica Sound,
Weddell Sea, Antarctica

This is my seventieth dive in submersible Nadir. I have now spent nearly a combined 500 hours in this little bubble. Along with producer Orla and the sub pilots from the ship *Alucia*, we have been exploring and filming in the icy waters off the peninsular in Antarctica for the last week. The story we are trying to illustrate is the Antarctic circumpolar current, essentially the heartbeat for nutrients around our oceans. This really is cutting-edge exploration and to our knowledge only one other submersible has dived these waters. Diving in freezing cold waters amongst icebergs adds yet more challenges to an already technically challenging endeavour. The ship's captain, Peter, and crew

coordinate closely with the sub team to assess weather and tide, and safe locations to launch the subs. The biggest worries are getting trapped under ice or being crushed between two icebergs. Neither would have a happy ending. The subs can only travel at about 3 to 4 knots so can't really run against the current very well, or race ahead to get out of trouble. The water temperature hovers around 0°C and lumps of ice are visible across the surface ranging in size from a tennis ball to a New York City block. Some of the largest icebergs are grounded, meaning they are static and literally resting on the bottom. Others are still huge but are floating with the current. Icebergs are notoriously unstable and are known to occasionally roll over. If we were to be near a large iceberg that did that we may well get dragged down or even crushed underneath it against the sea bed.

Having launched successfully we are already on our descent along with the other sub, Deep Rover. We have passed 300metres, the previous depth record for a manned vessel in Antarctica, and are now, apart from our own lights, descending in total darkness. The water is teeming with life, a living soup, made up predomi-nantly of krill – a shrimp-like creature filtered and eaten by baleen whales. This particular dive location has been chosen for its depth, 1,000 metres, the limit for our subs. We aim to set the new world record for deepest dive in the Southern Ocean.

After an hour of descent our digital depth gauge nears the 1,000 metres mark and the silty bottom comes into view. Pilot Buck feathers our buoyancy and we gently touch down. A new world record.

After some brief celebration we continue our dive looking for interesting creatures to film at this depth but on this occasion find nothing more than krill and silt. Classic.

63° 29' S
56° 25' W

14 DECEMBER 2016

Antarctic Sound,
Weddell Sea, Antarctica

*World record
– deepest
champagne*

It's our last dive in Antarctica, in fact the last one for the series. Although not hugely productive from a filming point of view, we are in high spirits as this shoot has gone extremely well. As we start our ascent from the darkest depths, chief pilot Buck springs a surprise on us. Well hidden at his feet in a cool bag, he pulls out a bottle of Veuve Clicquot Ponsardin Brut and three glasses. What a fantastic way to toast the end of our two and a half year adventure together. I too have a surprise, and from a bag at my feet I pull it out and start to dress. Orla and Buck are initially confused but soon recognise that Elvis has joined the team. As we break the surface and are winched aboard the *Alucia* 'A little less conversation, a little more action' blares from the internal speakers of the sub and the crew of *Alucia* look on in disbelief (or is it embarrassment?). Elvis rocking with Orla and Buck in the acrylic sphere – another world first?

Along with the rest of the sub team and the crew of *Alucia*, myself, Orla and Buck have pushed the boundaries of deep filming a notch or two forwards. Through their skill and expertise they have shown me a whole new world beneath the waves. Forget journeying to Mars, there is still so much to be discovered on our own planet. I can't wait for the next deep sea adventure with this wonderful team.

Buttered Side Up

26 MAY 1992

49° 57' 8" N
97° 16' 13" W

Prairie Dog Railway, Winnipeg,
Manitoba, Canada

Nearly made a very expensive mistake today. I've been *Oh f—*
filming the Prairie Dog steam railway for a story about
how the railroads opened up North America. Everyone
has been extremely helpful and I have had unlimited
access for filming. I've taken shots on the footplate
with the driver and the boiler stoker: the fire in the
firebox and details of the levers and dials. I've sat on
top of the coal in the tender filming looking forward
at the smokestack. Tracking shots of the train with me
filming from a vehicle on the road travelling alongside,
à la Chitty Chitty Bang Bang. The weather has been
glorious and all has been good.

The filming has gone so well and, as I have got more
than I imagined I would, I start running out of shots
and angles. I think: as a final shot to the sequence it
might be nice to have a dramatic wide angle on the
centre of the tracks, with the train coming towards the
camera and straight overhead. I speak with the driver
and he is happy to give it a go. I explain that I will
set the camera running a good 30 seconds before the
train gets to me and will be well clear of the tracks.
I climb under the train in the station with my camera
just to double check the clearance – there is a good
four inches to spare above my camera handle and the
lowest part of the train.

I drive a few miles down the road and place my camera on an oak sleeper in the centre of the tracks. Check focus and exposure: all set. The railway line is dead straight so I will see the train at least a mile away. That will give me plenty of time to start the camera and get out of the way. I wait.

Fifteen minutes or so later, I can see the smoke and steam rising as the train approaches. Leaving plenty of safety room I start my camera and back off. The train is doing only 20–30mph. As it nears my camera, I watch in horror as the track starts to dip under the weight of the locomotive. I hadn't bargained for so much flex of the rails, the sleepers settling slightly in the gravel. Suddenly the noise, the train whistle and whoosh, the train was passing. Through the wheels, crankshaft and coupling rods, I catch glimpses of my camera, my baby, my investment. As soon as the train has passed and it is safe, I rush back on the track to cut the shot and check my camera. The bottom of the train must have missed hitting it by fractions of an inch. Thankfully it is okay.

Sometimes after an event like this I feel such an idiot. It is obvious now that 100-plus tonnes of machinery might just dip the track. Imagine the insurance claim form:

Please tell us full details of the accident:	*I placed my £18,000 camera with £13,000 lens on the railway track and it got run over by a train.*

20 JUNE 1992

41° 45' 54'' N
105° 22' 32'' W

Sybille, Wyoming, USA

Prairie dogs – the main prey species of the black-footed ferret – live in large colonies called towns. They are herbivores and essentially overweight members of the squirrel family. They live underground in extensive burrow systems. Historically, the prairies of Wyoming were riddled with burrow entrances, and cattle and horses would often tread in them and break their legs. So, in the late 19th and early 20th centuries traditional cattle farmers – cowboys – saw prairie dogs as an enemy and shot and poisoned them. This meant that the black-footed ferrets were poisoned too, as well as their food source generally being depleted. An added issue is the ferret's susceptibility to catching and succumbing to the disease, canine distemper. Ultimately, human persecution and introduced disease led to the black-footed ferret's extinction.

In 1981 in Meeteetse, Wyoming, Lucille Hogg's dog brought a dead animal to her door. She didn't recognise what it was and so the next day took it to a taxidermist for identification. He inspected it and asked where she'd found it, because it looked like a black-footed ferret and they had been declared extinct in 1979. The authorities were alerted and they formulated a rescue plan. The remaining wild population of black-footed ferrets were found and caught: just 18 individuals. In 1987, a breeding programme was set up to try to save the species. Black-footed ferrets were now officially the rarest mammal on Earth.

Producer Miles Barton and I are here to make a BBC documentary about the story, aptly named *Wanted Alive*. The Wyoming Game and Fish department are

obviously very worried about bringing the disease, canine distemper, into the captive breeding facility at Sybille, so they have a very strict quarantine procedure. Every bit of equipment going in has to be wiped down with alcohol and disinfectant swabs. Anyone entering has to leave their 'outside' clothes, shower and go through a germ-free 'airlock', putting on sterile clothing inside the breeding facility. This process has to be repeated each time we leave and return.

Once inside the breeding facility, we film the different veterinary and scientific processes involved and get shots of the ferrets in their cages and artificial burrows in the lab. Black-footed ferrets are endearing-looking animals. They are slender with a short black-tipped tail and short black legs with large front paws, their fur tan to yellowish. An adult can grow up to two feet long. They have a short nose and teddy-bear-like ears, but a distinctive feature to me is the ferrets' black Zorro mask. The babies or kits are super-cute mini versions of their parents and look like a child's fluffy toy.

There is a second set-up with several animals in larger outdoor cages living in natural underground burrows. The cages are about 20 feet by 20 feet and have natural bare soil substrate with some grass and a few sagebrush bushes. The animals are kept as 'wild', meaning minimal or no contact with humans. The idea being that when they are released back into the open prairies they will be 'wild' and already used to burrow life.

The breeding programme has been successful so far, with animals already released back onto the prairies of Wyoming. The chances of getting footage of ferrets in the wild, though, are very slim. There're only a few dozen out there, and they are nocturnal and shy. The outdoor cages look natural, however, so I ask if I might be able to film in there. The scientists and vet say I can try but they don't think I'll have any luck. They

check the cages daily and rarely even get a glimpse of the animals.

With their blessing, though, I set up a very simple sheet of camouflage cloth across the inside corner of one of the cages. I position one light outside the cage with a diffuser on it. This will simulate moonlight so I have light to film by should I be lucky enough to see anything. I wrap up warm as it's cold outside, and enter the enclosure before dark. I am prepared to stay there all night.

Just 20 feet from the burrow, I wait. Within half an hour I see some dust rising out of the burrow entrance: the ferrets are stirring. I feel hopeful. Another ten minutes go by and then a head appears. Like a sock puppet, it shoots up, stares at me, and then ducks back down. A moment later it appears again, but this time it lingers long enough for me to run the camera. The sound of the camera, although quiet, is enough to send the ferret back down.

A few minutes later two sock puppets pop up: they both stare at me and then at each other before ducking down again. This becomes a game.

Within another five minutes, two of the rarest mammals on Earth are coming right out of the burrow and literally dancing sideways towards me – the same kind of behaviour that a kitten would display. These ferrets are clearly not too bothered by me being in their cage and I start to get some shots of them. Then, just as I think the night's filming is going well, the black-footed ferrets incorporate me into their game. They rush forwards and look behind the camouflage curtain before rushing back. Now they definitely know I'm here. Obviously not feeling threatened, they then proceed to chase each other around the cage, darting behind my curtain on each lap. After a few more rounds like this they are literally running over my lap. I am laughing to myself because having thought I wouldn't even see one of these rare, shy animals, now

they are literally in my lap. I am able to get some natural-looking shots of them by their burrow, but for most of the time above ground they are just mucking about.

By 2am they have gone back underground, presumably exhausted after putting on a display for me. I wait another two hours then go back inside to thaw out and tell Miles and the scientist how it's gone.

42° 13' 20'' N **30 JUNE 1992**
106° 21' 42'' W Shirley Basin, Wyoming, USA

Back in Miles and I join the black-footed ferret wild release
the wild team and volunteers out on the prairie for their census
at one of the release sites. They want to keep tabs on how well the ferrets are doing in the wild. Some of the released animals are radio-collared so can be tracked when they're above ground. The monitoring team also use spotlights at night to pick up the ferrets' eye shine and confirm identification. Although we film some of this for part of the 'science' story, it's not natural nice light in which to film the ferrets in the wild.

Around 8.30pm the colours in the dusk sky look amazing and I film shots of the teams as they start their search. Crisp silhouettes of the vehicles on ridges – one looks like a *Ghostbusters* set-up with huge rotating aerials mounted on the roof. Other biologists are standing on their vehicle roofs with handheld radio tracking gear. Spotlights scan the prairie dog burrow entrances for eyeshine.

Despite searching all night only one signal is picked up: it is a weak blip that indicates the ferret is underground. The census team makes note. If that signal doesn't move for a few days they will assume the ferret has died and try to recover the collar and animal for autopsy.

Finally, around 4am the census team gives up and goes home. Miles and I stay out on the prairie to get shots of dawn and the sunrise. As colour starts to show in the sky and the stars disappear, I think I see movement at a burrow entrance about 100 metres away. Miles and I are both tired and perhaps our eyes are playing tricks. But as the light slowly comes up, we see it again. A black-footed ferret is popping its head up and darting between burrows. It is still too dark to film it on the long lens so we just watch down our binoculars. I'm chuckling to myself as it's almost as if this ferret has waited for the census team to go before putting on a show for us, darting back and forth between two burrows. I admit I feel a little smug that sometimes our perseverance as a camera crew means we witness things that some scientists might miss.

I love these animals; they're good-looking, the young ones particularly cute, and are full of character. I am optimistic that, with the human help they are getting, they will make a good recovery as a species living natural lives in the wild.

10 FEBRUARY 1993

36° 13' 9" S
175° 3' 25" E

Hauturu (aka Little Barrier Island),
New Zealand

The island I am currently on is an extinct volcano of around 11 square miles. Its rugged forested slopes rise up to the summit at 2,369 feet. It was once home to a range of endemic species which sadly got decimated over time by humans and invasive animals such as cats and rats that accompanied them. It was declared a

The rarest sound

wildlife sanctuary by the New Zealand government in 1897 and then between 1977 and 1980 the island was made predator free by a massively expensive, forward-thinking, pest eradication programme. Now there are no aliens here other than a few rangers, a scientist and one very privileged cameraman (me).

I've been here for seven days now working alongside scientist Chris, who is studying the native lesser short-tailed bats here. To the untrained eye they look similar to the vampire bats I filmed back in 1988, except these have slightly smaller noses and longer rabbit-like ears. Oh, and one thing I really like about them is that they're not out to bite you and suck your blood! They forage on the ground running around in packs, shuffling under the leaf litter for small larvae and beetles, surfacing now and again to chew and swallow their catch. So as not to disturb their natural behaviour, I have been filming in complete darkness using an infra-red sensitive video camera in Chris's observation enclosure. Filming has gone well and it's time to return his study animals back to the wild, back up the rugged slopes to where he caught them. Knowing there's a very remote chance of seeing a kākāpō I ask if I can accompany him. The kākāpō, native to New Zealand and the rarest bird on earth, was reintroduced to the island in 1982,* in the hope of breeding them back from the brink of extinction. The kākāpō is a giant flightless nocturnal parrot. From pictures I've seen it's a characterful looking bird, a lot like an owl with forward-facing eyes, and well-camouflaged with mottled moss-green plumage.

We set off at 2am in the dark, carrying the bats in a small netting cage. After an hour's strenuous hike

* Due to man's interference, Kākāpō numbers in 1993 were perilously low, between 41 and 55 individuals.

we arrive where Chris caught them and on opening the cage they scurry back to freedom. Then Chris leads me 100 metres further along the path and shows me a kākāpō court: a dustbin lid-sized depression cleared in the ground, dug against the base of a tree. The male birds dig a series of these bowls to woo females from; the design amplifies his low booming mating call to help project the sound further. The kākāpō that dug this one is clearly active as there's not a twig or leaf out of place. We mustn't linger here to avoid disturbing the birds, but just as we are about to leave Chris raises his hand. 'There. Do you hear that?' I strain my ears against the wind and, sure enough, I hear it too. Bahoom . . . bahoom . . . bahoom. Like a short low note played on a cello.

'Wow!' I say to Chris, a huge grin on my face. 'I can't believe my luck.'

Chris signals that we must leave and we start back down the trail. En route I reflect to myself how exciting it was to hear that sound, knowing how few people will have ever heard it. It's both sad – and yet hopeful. Sad that we as humans almost drove this benign parrot to extinction but hopeful that something is being done to correct our mistakes. I've never yearned so strongly for a male animal to have a successful night. His species may depend on it.*

* Kākāpō numbers are currently up at 149.

2° 8' 15" S
36° 47' 29" E

25 SEPTEMBER 1994

Bisil, Kenya

Close encounters of the furred kind Filming nights is knackering. Termites, unfortunately, are mostly active at night above ground, unless the ground is wet after rain and then you can see activity in the day.

Termites – The Besieged is a half-hour film about – yes, you guessed it – termites. I'm here with producer Andy, termite scientist Julius and driver Andrew. We are staying on site in a lightweight temporary camp.

Now, you might think termites aren't very interesting but over the years I have been totally drawn in by these tiny creatures and their complex lives. Their clever teamwork, architecture and defence. We know from fossil records that termites have been around for about 50 million years, so they must be doing something right. Each colony starts with a king and a queen and builds over a decade to around a million individuals. All of which are the direct offspring of that original pair. The termites are only about a centimetre long but collectively build a castle out of mud, spit and faeces up to ten feet tall.

In order to film foraging termites and the things that feed on them, each night we head out a short way from camp, spread out with our torches and tiptoe around looking for termites on the surface. Once one of us finds some, we bring the generator closer, run out an extension lead and carefully set up the filming lights. Then I tiptoe in towards the termites with my camera and tripod and gently sit it on the ground. Once I have everything set by dim torchlight, Andy then starts the generator and switches on the lights. Providing one of

us hasn't already scared the termites below ground with vibrations, I then have between one and five minutes' filming under light before the termites get fed up and head below ground. Four times out of five, one of us spooks them by treading on a twig or breathing on them. You can then hear a characteristic chatter as the termites bang their heads on the ground as a warning for all to go below. After many nights of low returns, this gets frustrating to say the least.

One night, after about six or seven hours of trying, I'm worn out and too pissed off to keep going. We give up and load everything back in the car. I can't be bothered to pack the camera away properly so I put it and some lenses on the front passenger seat. I'm in a huff so decide to march the half-mile or so back to camp.

I'm a few hundred metres from the car – and still a long way from camp – when I see an animal circling me in my fading torchlight. I look back to the car, which is only just starting. I look to the camp, which is even further. The animal is circling closer now and I can see it's a hyena. Much bigger when you see them on foot with just a dim torch in your hand. Not familiar with hyenas and what risk they might pose, I also don't know if the rest of its clan is lurking in the darkness. I start back towards the car; it seems a long way away and the hyena is closing its distance. Very quickly, not surprisingly, I am wide awake, alert and no longer in a huff about the filming. I am now concentrating on not being eaten. By the time I reach the car, the hyena has got much braver or more inquisitive and is within about ten feet of me. I hurriedly get in the car and put my camera on my lap.

Andy says, 'I wondered why you were coming back to the car and then I saw that bloody great hyena following you.'

Who knows whether I've had a lucky escape?

5 OCTOBER 1994

2° 8' 15" S
36° 47' 29" E Bisil, Kenya

A few days later, Andy and I are exploring the rocky outcrop behind our camp. We are wondering if it might be a good vantage point for a scenic shot or time-lapse clouds if the weather changes. The outcrop is maybe 100 feet high, made up of *Flintstones*-sized boulders with scrubby bush and a few large *Jungle Book* fig trees on the top. We amble up, keeping an eye out for leopards which love this kind of habitat – unlikely to see one, though, so close to Masai and their cattle. At the top, a fig tree is clinging onto the boulders with huge flowing roots. The main trunk is about four feet wide and goes straight out from the rocks, turning 90 degrees up before opening out in a beautiful shaded canopy. I jump down onto the trunk and walk out about 20 feet. Below me is a 30–40-foot drop down onto rocks. I look back to Andy, who is still up on the rocks. To my horror, draped on the trunk I'm standing on, under an overhanging rock, is a huge python. And it's sliding out towards me. With the drop below me I have no choice. It is do or die. I run straight back along the trunk and leap over the python onto the rock.

'Are you all right?' Andy asks, surprised at my sudden agility.

'I am now! There's a bloody great python on the branch under there and I think it's hungry.'

I don't dare look back over the edge, so I don't see the python again. Perhaps it's still sitting there, waiting for an unsuspecting baboon, hyrax or stupid cameraman.

7 OCTOBER 1994
Bisil, Kenya

2° 8' 15'' S
36° 47' 29'' E

Today two Masai men have come to us at our camp for help. One of their cows has fallen in a gully and can't get up. We take our vehicle and over the course of a few hours we manage to dig out a slope, then with five of us pushing and heaving we haul out the cow. The Masai are extremely grateful. They then chat with us for a while and ask why we've been pouring water on one of the termite mounds. We explain that we are only here for another three weeks and we are trying to simulate rainfall to induce the termites to fly. They laugh and think we are crazy. They tell us to just wait a few days and the termites will all come out naturally.

Good deed for the day

Sure enough, just as the Maasai predicted, after at least a dozen wasted water trips and effort by us, we have a decent shower of rain. Tonight every termite mound around us was in synchrony, glistening with thousands and thousands of winged termites as they take to the air. We use our generator to power the lights to film the scene. Backlighting the mound highlights every single termite like a glowing amber gem. It looks extraordinary, a spectacular event. As I know from my first trip to Kenya, the termites don't fly far – perhaps a hundred metres. When they land, they walk around until they pair up with a termite of the opposite sex. Within seconds of meeting and touching antennae they both instantly drop their wings and scurry off to find a hole or crack in the ground in which to mate and start their own colony. Talk about speed dating. I just find it remarkable that one minute the termites can be flying, and the next they voluntarily shed their wings. And this is a 50-million-year-old design!

58° 6' 26" N **9 JUNE 1995**
68° 23' 49" W

Kuujjuaq, Quebec, Canada

Needle in a Kuujjuaq is the northernmost Inuit town in Canada and
haystack has a population of around 2,500. Rather scruffy and
makeshift, it's sited on the banks of the Koksoak River
and is only accessible by boat or plane. We are staying
in a small apartment in a government block of flats.
This is 'base camp' for the next six weeks for myself
and Matt, assistant producer and friend.

This trip is for a BBC series, *Great Natural Journeys*,
and this programme is looking at the migration of the
George River herd of caribou. Caribou belong to the
same species as reindeer: the difference is that caribou
are larger and live wild in northern North America
and Greenland, whereas reindeer are slightly smaller,
live in northern Eurasia and are mostly domesticated.*
The caribou's migration is the longest of any land
mammal – they walk an annual round trip of about
500 miles. Starting in spring, they travel north as the
snow recedes. The females have their babies and then
feed on the sedges, grasses, herbs and mosses to fatten
up for the journey back south ahead of winter. This
herd is currently around 700,000 strong and can spread
over an area three times the size of England. We will be
working closely with the scientists studying them and
they have satellite-collared some of the females, so we
will have an idea where to find them.

For this first day, we want to do a recce to get the
lie of the land, so we join scientist Jim Schaefer who

* Santa Claus uses the Eurasian reindeer not the North American
caribou.

is heading out in a helicopter to track down some of the GPS-collared females. Part of his study is to work out why the size of the herd is shrinking. That requires him to chase down and catch the newborn caribou, take blood and weigh them. He wants to see if their weight is declining and if that is affecting their survival rate to adulthood. I take along my basic camera kit to document their data collection and hopefully get our first footage of caribou in the wild.

Finding the caribou requires the use of radio-tracking telemetry aerials on the outside of the helicopter. The technique is thus: the pilot climbs a few thousand feet and turns the helicopter to pick up a radio signal and direction. He then flies towards where the signal is coming from until one of us gets a visual. Once we catch up with the mum and caribou calf, he touches down so he and Jim can jump from the helicopter and chase down the calf on foot, quickly take the blood and measurement, get back in the helicopter and fly off for the next one. Simple, right?

On the ground the helicopter engine stays running with blades spinning, so helicopter safety and discipline are essential in order not to get chopped up. There's one tragic story of exactly this happening before. The helicopter had landed on a gentle uphill slope and, as the pilot and scientist ran forwards to chase the caribou, the pilot tragically lost the top of his head to the blades which were closer to the ground because of the slope. Distraught, the scientist then had to deal with the situation on his own, miles from anywhere.

Jim finds, catches and samples 27 calves today and, although it seems quite harsh on the animals, we watch each of them reunite very quickly with their mums and carry on their way.

Today's foray has given Matt and me a good idea of the terrain and habitat we are going to be dealing with. It's certainly rugged. A vast area of tundra laced with ice-lined rivers and dotted with thousands of ponds and lakes, most of which still have sheets of ice on the surface. The land is by no means flat, with the tops of the hills scoured to bare rock. On the lower land are pockets of boreal forest, stunted conifers no more than 20 to 30 feet high. At least they add a bit of visual variety to the landscape.

58° 6' 26" N
68° 23' 49" W

12 JUNE 1995
Kuujjuaq, Quebec, Canada

Saved by the saucepan

The satellite-collar data gets downloaded once a week, on a Sunday night, so at 8am on Monday morning, Matt, Jim and I plot the eight or so waypoints from the collars on a map and compare where those dots were the previous two Mondays. Caribou can cover up to 25 miles in a day so we have to project forwards and put a cross on the map to start our search. Matt and I are set to leave now, but before we go Jim asks if we have a rifle.

'Why would we need a rifle?'

'In case you have trouble from bears. Particularly hungry polar bears who can occasionally be found wandering the tundra!'

'Oh? Jesus! I never knew they wandered so far in from the coast.'

Jim gathers a rifle and ammunition for us and asks, 'Okay. Do you know how to handle a gun?'

Matt owned an air rifle as a teenager (though he did shoot himself in the finger and give himself lead poisoning) and I fired an Enfield .303 at school, so we both confidently answer, 'Yes.'

At that, Matt and I leave the office, armed and dangerous.

We head to the airport and meet with pilot Michel to load up the helicopter with camera and camping kit and a week's worth of food. Helicopter time is expensive but we have no choice initially for this shoot until the lakes and ponds thaw out – then we can use much cheaper float planes to get out into the wilds.

We fly east-ish for about an hour and a half – 200 miles – to where we've put our 'spot the ball' cross on the map. It's near to the Tuctuc River, if you know the area well. As we fly closer, we start scanning for caribou. Now, you'd think that finding a herd of 700,000 pale-coloured animals, each the size of a Shetland pony, would be easy. But we are looking in an area of around 150,000 square miles and the animals are unlikely to be all together.

Amazingly, we spot a reasonable-sized herd. We then fly on ahead about five miles, speculating what route the herd will pick around the lakes and ponds. Luckily, there are fresh trails from previous animals that have passed to give us a clue. Once we have chosen a spot to put our camp, we touch down and quickly unload all our kit. Michel and the helicopter then leave us with a rendezvous planned to pick us up in five days' time. Now around 200 miles from the nearest habitation – that's like London to Paris – our only communication with the outside world is by Spilsbury HF radio. If we fail to call in at 6pm each day then the pilot will return within 12 hours to rescue us.

The idea behind us choosing this location is that initially we will walk to 'meet' the caribou. On the second day the caribou should advance closer to our camp, meaning we won't have to walk so far to get to them. On the third day, if we have predicted the caribou route correctly, they will join us in camp. And on the

fourth and fifth days, we will have to walk to catch them up. That is at least the theory!

The sound of the helicopter fades into the distance and the silence is bliss. This is the most remote place Matt and I have ever been. It feels wild and exciting. Matt in his twenties and me just 31. What can possibly go wrong?

We set up our tents and camp tucked in among the dwarf trees by the edge of a small, picturesque lake. Dark crystal-clear waters dotted with stepping-stone, lichen-covered rocks. A few clusters of trees line the shore. Then we load up two rucksacks with camera kit and start to walk the five miles or so back towards where we saw the caribou from the air. Heavily laden down, there is little chat between us as we march ourselves breathless.

Several hours later we rise onto yet another ridge and scan with binoculars. Bingo – finally we catch a glimpse of the caribou way in the distance. Annoyingly, though, they are heading diagonally away from us and the wind is not in our favour. Also, it looks like they are crossing the river – we won't be able to follow so we decide to return to camp. The question, though, is where is the camp?

We haven't walked in a straight line as we had to weave our way round lakes and hills. This is slightly alarming as we have walked for miles. No gun, as it seemed too heavy to carry that along with all our kit. And the biggest schoolboy error: neither of us even thought to bring a compass. We hike to the top of the tallest hill and scour the landscape for our camp. It all looks pretty featureless – no landmark stands out, particularly and rather worryingly not even our camp. After ten minutes of looking it's starting to feel a bit desperate; our attempt to hide the camp to avoid it scaring the caribou has certainly been very effective.

Just as we begin to panic slightly, Matt spots a slight glint, something catching the sun. It's our only hope so we start the long trek towards it. En route, I spot some of our boot prints facing us, so unless someone else is out here we are heading the right way.

After hiking for a while, we can see it is definitely our camp and an hour or so later arrive exhausted and relieved. What Matt had spotted, and what probably has saved our lives, was the sun glinting off a saucepan I hung up in a tree when we set up camp.

Tomorrow we shall be more careful, as it could have ended badly on day one.

Matt and I set up the HF radio for our evening call to Kuujjuaq. I string up the aerial, all 100 feet of it, between the two tallest trees.

6pm.

'Kuujjuaq, Kuujjuaq. This is BBC. Over.'

Crackles and interference.

'Kuujjuaq – Kuujjuaq – this – is – BBC – Over.'

'Go ahead BBC. This is Kuujjuaq.'

'Just reporting in. All is okay, thank you. Over.'

'Thanks for letting us know. Have a good night and speak in the morning. Over and out.'

Towards evening I start to feel pretty ill with a really rasping sore throat and temperature, so I raid the first-aid kit and start a course of antibiotics. At home I would sit it out, but out here in the absolute wilderness I'm not going to chance it.

Matt and I cook a basic meal on an open fire before going to sleep. We share a three-person tent with the rifle lying between us. Just as I'm drifting off, I hear the haunting sound of a distant wolf howl. Fantastic.

I sleep like a log, however, after the day's hiking – and maybe the self-medication.

56° 38' N 13 JUNE 1995
66° 13' W Somewhere 200 Miles East of Kuujjuaq, Quebec, Canada

Up at 5am for breakfast and I'm feeling much better after a fistful of the drugs, thank God. Thick freezing fog with near-zero visibility so we can't go anywhere until it lifts, around 9.30am.

We hike up the nearest hill and scan for caribou but see none. Then we hike a few miles back to where we saw the animals yesterday. Again, nothing.

Rather than just sit it out, it makes sense to call the helicopter back in to find the caribou. Matt and I return to camp and radio Kuujjuaq. Michel is able to pick us up within two hours. We pack up camp and the kit and fly to find the caribou again. There is quite a good-sized herd about 15 miles to the north-west. We plot their directions and choose a place for a new camp. With a big smile that implies we are crazy, Michel leaves us again, the pick-up rendezvous arranged for three days' time.

Feeling more positive, we set up camp before heading off on foot with the camera gear – not forgetting a compass this time. The habitat is pretty much the same as before and within an hour we are with the caribou. Now this has to be the most fun part of my job, pitching my wits against nature. I take note of wind direction and the lie of the land and sneak closer with my camera and tripod. I manage to get set up in a position ahead of the herd so they will drift towards me. I tuck myself backwards into a bush. Matt does the same 50 metres back. I sit on the ground with the camera set low and my 300mm lens on. At first the nearest caribou is over 100 metres from me with more animals beyond. I film the wider shots of them grazing. Slowly they work their way closer and closer. I pick off shots of their

mouths cropping the grass and sedges and of their feet as they approach. Caribou have specialised hooves – four toes on each foot which splay out, stopping the animal from sinking in snow or on marshy ground. The wide-spreading toes also act a bit like flippers in water, which is why caribou are such strong swimmers.

There is one female with a very newborn baby, wobbling along like Bambi. The mum is oblivious to my presence and lets her calf suckle. Despite a bit of heat haze, they are nice, intimate shots.

With caribou, both males and females grow antlers each year. The males' antlers grow slightly larger, up to a metre wide and over a metre long. From a distance the antlers look dainty, but as these wild animals get closer, I change my mind. Sitting on the ground I now feel a little vulnerable. I continue to film as they graze closer until I get to minimum focus on the lens – eight feet. I have a green camouflage net over my face but slowly raise my head above the eyepiece. A caribou's antlers are now almost either side of the lens hood and it is grazing round my feet. Clearly, we didn't have to worry about our scent putting them off!

Suddenly the caribou raises its head – sensing there is something strange afoot. It doesn't panic, sprint or shred me to pieces, but instead just trots off round to my right to continue grazing. I love moments like this. I would have felt bad if I'd spooked the animal so badly that it had run to the horizon. I never thought we would get so close to these wild animals. If we have more luck like this over the next few weeks we'll be laughing.

57° 29' 48" N **16 JUNE 1995**
65° 18' 43" W Pyramid Camp, Northern Quebec, Canada

Whilst on location, research and detective work continue. Always tap into local knowledge. Get the locals interested in what you are filming and ask their advice. When we were back in Kuujjuaq we asked around for anyone who knew of a golden eagle's nest that might be in a filmable position. Golden eagles' main prey at this time of year is newborn caribou calves so they are a good protagonist for the story. A guide said he knew of a nest that was used year after year near Pyramid Camp. He radioed the camp and they kindly went to check the nest for us. We were in luck: it had two chicks. Plus, the camp was empty and they could accommodate us.

We flew in yesterday and late afternoon they take us by boat up the George River to the nest location. Negotiating some rapids in the icy meltwater river, the outboard motor on the tin boat cuts out and we start to drift downstream. As our guide frantically tries to restart the motor, we turn broadside, hitting rocks as we go. For a short while it doesn't look good: no paddle, no lifejackets. Even so, in these cold waters you wouldn't survive very long. I catch a glance at Matt, who looks particularly worried and nervous. It was only after the motor starts again and we are on our way that he confides in me that he can't actually swim.

A short hike from the river brings us to the eagle nest site. Perfect. The nest is perched near the top of a rocky cliff on the opposite side of a narrow, steep-sided valley, around 70 metres away. Through the binoculars I can see two chicks on the nest and there are fresh caribou calf skins and bones scattered

around. We couldn't have hoped for better, so quickly set up the hide for tomorrow and then leave.

We stop much further down the valley and watch the parent return. Good, it's not been put off by the hide.

Very early the next morning we return with camera kit. Our guide drops us off by boat once more and again we narrowly avoid capsizing and drowning. He will return in the evening to collect us. Scanning with binoculars, there is no sign of a parent on the nest so Matt and I hike up to the hide and I start to set up tripod and camera. Birds can't count, so when entering a bird hide, just in case they are watching, two of you go in and then a moment later one person leaves and walks off. The birds then think that whatever went into the hide has come out and gone. This simple technique works surprisingly well. Apart from helping with the gear, this is why Matt accompanies me to the hide.

As I'm setting up the camera Matt sees an eagle return and land just above the nest. Not wanting to frighten it off, he stays squashed in the hide with me. The eagle doesn't seem worried and presumably hasn't seen Matt clamber in. Best sit tight until it leaves and then Matt can go out.

There's never much space in a hide but this one certainly isn't built for two.

I manage to get a few shots of the eagle on the nest, pecking at an old carcass. The shot I am hoping for, of course, is an adult returning to the nest carrying a baby caribou in its talons.

Time ticks by. The parent bird leaves the nest but only to sit a little further along the cliff. Still not safe for Matt to leave.

After about five hours we're both getting hungry. All I've brought with me is water, an apple and a box of cream crackers. With boredom setting in, I challenge

Matt to see how many cream crackers he can get in his mouth at once.[*]

Finally, after 12 hours cramped in the hide, just as the light starts to fade, the eagle leaves the cliff and flies off out of sight. It's too dark to film now so we take our cue to pack up and leave for the boat.

I spend three more days in the hide, on my own thank God, but the eagle never returns with any recognisable prey. It would have been a bonus to have got this short sequence but it hadn't been on the cards for this shoot. We make the decision to move back on to the big migration.

58° 6′ 14″ N **26 JUNE 1995**
68° 23′ 54″ W Northern Quebec, Canada

Over the last two weeks our adventures have continued. Each five days Matt and I got picked up from the wilderness and returned to Kuujjuaq to restock supplies, charge batteries, wash socks, and ring home and the office, meeting with Jim on Monday mornings to look at the latest satellite-collar coordinates and predict where next to meet the caribou.

Tonight Matt is cooking, so I take our collective laundry down to the communal machines on the ground floor. There is a spare machine, so clothes in, powder in and go. It should be washed in 45 minutes so I go back upstairs and we eat dinner. I then clear the table and get dessert ready. Matt goes down to put our laundry into the tumble dryer.

[*] The record stands at seven. I am still finding crumbs in my rucksack and internal pockets of my hide after Matt nearly choked to death and spluttered cream cracker everywhere.

Forty minutes later, I head downstairs again to collect our clean laundry. I open the dryer and start to fold clothes. I then pull out some tiny clothing – a child's jogging bottoms and a baby hoodie: *I'm folding another family's clothing,* I think. I look in the other dryers but they are all empty. I go back to the dryer with the child's clothing and notice, on closer inspection of the tiny jogging bottoms, that 'GAVIN' is written in marker pen on the label. These are mine! The dryer was so hot it's shrunk all our thermals to child-size. Back in the flat I still can't speak for laughing as I hold up various miniaturised items of clothing to show Matt. This is like a page one bachelor mistake.

The weather is warmer and the lakes and ponds have thawed. We've been warned that the insects can get really bad at this time of year, particularly the mosquitoes. I look out of the window of the flat in Kuujjuaq this morning to see a change in fashion sense. The inhabitants of Kuujjuaq are all walking about with a kind of loose stocking over their heads, jackets made from netting mesh. I call Matt over and we both peer out through the net curtains like nosy neighbours. Every pedestrian looks ridiculous and we are both thinking: *What a bunch of wimps.*

A little later, we head out to the government office for the satellite-collar updates. We barely get 20 metres before we are both coughing and choking on mosquitoes. It is like a plague. The air is thick with the little biting bastards. I look at Matt and he must have at least 50 mosquitoes desperately feeding on his face. Windmilling wildly with our arms, we retreat back into the building, spitting mouthfuls of errant bloodsucking parasites. We aren't laughing now!

The locals are way ahead of us and the 'bug suits' as they are known were the fashion of the season for

a very good reason. Doused in insect repellent we head straight to the store and each buy one for ourselves. They are a bit like a loose-fitting hoodie made from mosquito netting, except the hood comes right over your face and zips down the front. We might look stupid but now we can breathe outside without choking on the clouds of miniature vampires.

With the lakes and ponds thawed, we switch to using much cheaper float planes to fly us into the wild. Our new pilot, Norman, seems incredibly young, perhaps only 18 or 19, unlike the de Havilland Beaver float plane we are loading up. That was built in the 1950s and looks like a prop from a Humphrey Bogart movie. Norman starts the engine and casts off from the jetty and then we taxi the length of the lake. This is my first time in a float plane taking off from water and it feels weird to be looking out of the windows as we rock our way over the choppy surface. Norman turns into the wind and speaks to air traffic control for clearance. It is then that we notice three sets of fresh scratch marks on the console, for the throttle, propeller and mixture levers: 'TAXI', 'TAKEOFF' and 'LAND'. Norman moves all three levers to the 'TAKEOFF' scratch mark and we are away. I glance at Matt: we are clearly both thinking the same thing. Novice pilot?

The plane's engine has a hearty roar to it and a plume of spray kicks up behind us. At first the plane moves forwards like a rocking horse as we cross the chop, but we quickly gain speed and the ride smooths out beautifully – it is like gliding across butter – and then we are airborne.

An hour or so later we are nearing where we think the caribou should be and, bingo, there they are. A huge herd just short of where we had predicted and put our pin in the map. We fly ahead a few miles and then circle to find a suitable piece of water with a long

enough stretch to land on. The lakes look like blue-black mirrors from the air and there are two that run parallel, around half a mile long with a spit of land between them that has a well-trodden caribou route. Norman lines up the three levers with the 'LAND' scratches on the console and we start to descend. He holds the joystick gently with his fingers crossed. We touch down and the floats cut two clean lines in the surface. As we are slowing, there is a loud clunk and Norman pulls the three levers quickly back to the 'TAKEOFF' scratch marks. He smiles and shouts, 'Rocks!' at us. We circle back round and this time he aims to the left of our wake line and flies, surprisingly skilfully, with the skids just cutting the water the whole length of the lake. This is apparently to test for other hidden rocks. All clear. He goes round again and this time we land without hitting anything. Norman punches the air as if it were a miracle.

The three of us get onto the aircraft floats and we paddle it closer to the shore like a giant canoe. Matt and I have to wade the cold waters to unload, negotiating several journeys through the slippery rocks to the shore.

Norman bids us farewell, taxies and takes off for Kuujjuaq. Just as with Michel, we hope Norman makes it back safely, because each time we are dropped off, it is only the pilot who knows exactly where we are until he logs it back at base – even though we have radio communication, we don't have a handheld GPS to tell anyone our exact location. I make a note to next time write down our coordinates before I leave the plane.

We've got lucky and guessed right – it is only a short hike back to the caribou. I film a nice variety of shots as the animals trek past us for a good five hours. The few times the caribou notice us they just stop and stare. Apart from the small number of animals that Jim has caught weighed and collared, I doubt

any of these caribou have ever seen humans before. Of course, they would have an innate fear of predators, namely wolves and perhaps bears, but no reason to fear humans. Maybe my bushcraft skills from the other day's filming aren't as good as I credited myself for.

This evening Matt and I celebrate a productive and rewarding day with some beers by the campfire. I hook a Sony Walkman up to a small speaker and we chat and listen to the soundtrack from *Pulp Fiction*.

It's dark and I'm about to head to bed when I look past Matt. There, on the edge of the firelight by our tent, is a huge wolf. Without taking my eyes of it, I say, 'Matt. There's a wolf just behind you!'

He thinks I'm joking and says, 'Oh, yeah!' He turns to look, though, and sure enough it was a wolf. 'Bloody hell.'

It is less than 15 feet away, raising its nose and staring at us. Clearly not too worried by us or the fire, or 'Son of a Preacher Man' coming from my Walkman. I am both excited and nervous.

Years ago, my granny gave me two classic books to read: *White Fang* and *The Call of the Wild* by Jack London. They sat on my shelf for ages until I brought them on this trip to finally read. *White Fang*, set in the Yukon during the gold rush, is the story of two men, Henry and Bill, and their dog-sled team trying to deliver Lord Alfred's dead body, in a coffin, to a remote village. They are followed by a pack of wolves that progressively get bolder and more aggressive, killing their dogs one by one and trying to steal and eat the body. I have literally last night just read the scene where the wolves come right up close to the fire having killed Bill. Henry has to keep the wolves at bay by throwing flaming sticks of fire at them.

I wasn't sure this boded well for Matt and me.

Despite the music and us talking, the wolf isn't frightened off. Instead it circles us, inquisitively raising

its nose, perhaps to smell us or our freeze-dried dinner plates. After five minutes or so Matt says, 'I'm going to try and get my camera from the tent.'

The two of us crawl slowly towards the tent, each wanting a photo of the wolf for the memory. It tracks us as we go, but it doesn't leave. We both return cautiously to the fire and take some photos. Even the flash doesn't seem to scare the wolf. I take a couple more of Matt smiling to camera with the wolf standing behind him, just ten feet away between our two tents.

It is only when Neil Diamond and 'Girl, You'll Be a Woman Soon' starts to play that the wolf leaves, slipping away into the darkness. But I have to say, that is the most amazing, if not surreal, wildlife encounter I've ever had.

30 JUNE 1995 57° 14' N
200 Miles from Anywhere, 66° 30' W
Northern Quebec, Canada

We have three more days of great success with the *Hunted* filming. Some of the caribou have come right past camp. I set up remote cameras strung up in the dwarf trees for a different perspective of them trekking by, but no luck.

Today we hike quite a long way to catch up with the section of the herd we've been filming. Matt and I circle a lake while the caribou take the shortcut and swim across. Once we are around the other side where the first caribou exited the water, another small herd starts to cross. I grab the camera and tripod and we race for some cover so as not to spook the swimmers. Leaping across the slippery moss-covered boulders, I slip and come crashing down on both my shins. Christ alive, the pain is excruciating. Initially, I really think I've broken something. Once I dare to look,

apart from the pain and ripped jeans, I can see there are no splintered bones sticking out – which would have been a massive pain and inconvenience bearing in mind where we are. Galvanised by the approaching caribou and chance of some swimming shots, I make it to cover and set up the camera. The caribou swim fast until they can touch the bottom. They then trot up through the boulders, more elegantly than I have just done, and exit just 25 metres from us before heading away up the slope. As the biting insects get bad the caribou tend to aggregate on the hilltops, where there's a breeze, to try to get relief. They bunch together so they can shield their sides from bites.

The sky is starting to colour with some dramatic cloud, but tonight the caribou seem twitchy and nervous. Matt and I stalk closer to a herd of around 200 animals on the crest of a hill. We tuck ourselves down by a boulder so as not to scare them away and I put on my 600mm telephoto lens for close-ups of them on the ridge silhouetted against the dusk sky. As I am filming, it becomes clearer still that their behaviour is definitely different. Maybe irritation from the onslaught of insects? At this time of year, an adult can lose up to half a litre of blood a day to mosquitoes and other biting flies.

Then Matt says, 'Gavin. We are being stalked by a wolf. Down to our right, coming up from the lake.'

I look up from the camera and see it. The wolf is dripping with water having just swum across the lake. It is stalking low and coming straight at us. The back of its head tucked down, nose and eyes focused on us. It has a very wild look about it.*

I swing the camera round as it would have made an awesome shot, stalking head-on. With the 600mm

* It was such an extraordinary moment that I still have a very vivid image in my mind of this.

on the camera and the wolf coming fast, I can't line up on it quickly enough. The next thing we know it is right in front of us, only ten feet away, too close to focus. Fearing it is going to pounce, I remove the camo net from my face to look at it; Matt does the same. The wolf stops, stands up normally and almost looks disappointed. It appears to shrug its shoulders as if to say, 'Oh bloody hell. I might have known it. It's you two again!'

At that it looks up to the crest at the swirling herd of caribou and sets off at a pace. I swing the camera back round and just manage a lousy shot before it and all the caribou take off out of sight. I race up the hill with the camera and tripod and Matt brings the two rucksacks. By the time we get to the top, the wolf and entire herd of caribou are nowhere to be seen.

It's frustrating when, in your mind, you seem to have the perfect scenario and light, with imminent drama about to take place and then, the next minute there's nothing.

But sometimes I'm happy just to have seen and experienced it. I didn't have to witness the harrowing death of a caribou. Yes, I'm sure it's happening every day out here on the tundra, but seeing anything die is not my idea of fun. Yes, I'll document a hunt when I see it – but I don't feel great afterwards. No matter how many gongs might sit on your shelf for it, witnessing a death is never pleasant.

Back at camp we prepare a nutritious dinner of dust with boiling water, better known as a freeze-dried expedition meal. These come in various qualities from good to bad. This one is a bad end to an otherwise good day, not helped by Matt laughing his head off as he watches me trying to spoon a mouthful through the mesh of my bug suit. Having worn it for several days now I just forgot I was wearing it. The food landed straight in my lap.

57° 14' N **3 JULY 1995**
66° 30' W Still 200 Miles from Anywhere,
Northern Quebec, Canada

Continual bad luck with this location. We found some caribou miles from camp but they are really on the move and we will never catch up with them.

When Matt and I have been hiking with the kit, we are each carrying around 30kg for the day. Although Matt smokes and I don't, he is six years younger than me so I feel he has the advantage of youth. Today was gruelling and a classic example of machismo that benefited neither of us.

We'd marched for around four hours trying to find at least a single animal to film, knowing we would then have four hours to get back to camp (if we could find it). We had to make reasonable speed on foot to be able to cover the distances when searching for the herds. We were both now physically quite tired after 20 days of long hours and all this yomping.

There is something psychological about being in front when you are tired. Following someone when they might be only ten metres ahead somehow feels more tiring. On the flat, Matt would stride ahead and gain sometimes 25 metres on me. I would then push myself, catching and overtaking him on the hills. This 'game' of leapfrog reached a peak today and by the time we did finally make it back to camp we were both exhausted.

I owned up to Matt. 'Look, I'm knackered. I know you are younger than me but I was hoping the fact that you smoked might level the playing field. You are way fitter than me and I'm struggling to keep up with you at the pace we've been marching each day.'

'What do you mean?' asked Matt. 'I've been really struggling to keep up with you! Some days I've almost said to you let's stop and take a breather!'

Both of us laughed at how ridiculous we'd been. We are a team and should just talk rather than muscle on and suffer. Healthy competition is good, but we need to pace ourselves over six weeks on this trip.

Having seen no caribou we decide to radio Norman to pick us up early – regroup in Kuujjuaq and then choose our next spot to search.

We set up the HF radio but the tallest trees for the aerial weren't high enough and we can't get a signal back to base. The nearest hill to speak of is a good half-hour's walk away and we feel too knackered to attempt that. It's quite windy, so I have the genius idea of attaching the HF aerial to my aerofoil stunt kite* to get some height. I lay out the kite strings as Matt wires the battery and then the aerial to the two screw connectors on the back of the radio. We launch the kite and I try to hold it stable. My issue is that the sun is right behind the kite in the sky and it is blinding me, so instead I have to steer the kite by watching the shadow on the ground just behind me. I hear Matt start to call.

'Kuujjuaq, Kuujjuaq. This is BBC.'

After a pause we hear, 'BBC, BBC, this is Kuujjuaq. Hearing you very loud and clear. How goes it?'

'Hearing you loud and clear too, Kuujjuaq. It's not going great today. The problem is …'

And, at that, a gust of wind catches the kite and it surges upwards, taking the aerial with it and ripping the connections straight out of the back of the radio. Bollocks.

* Essential item in my travel kit. Great fun on days when the weather is rubbish for filming. Has no struts so folds down to nothing and weighs less than 500g complete.

I attempt to steady the kite as Matt darts left and right trying to catch the loose ends. The aerial is snapping like a giant whip around Matt's head. All the while we are clearly both thinking that Kuujjuaq must wonder what is going on. The conversation cut midway through an inopportune phrase.

Matt manages to catch the whipping aerial and reconnects it to the radio. I hold the kite as steady as I can.

Matt, slightly breathless: 'Kuujjuaq, Kuujjuaq, this is BBC. Come in, please.'

'This is Kuujjuaq. What is your problem BBC? Over.'

'Sorry ...' And another gust catches the kite, again ripping out the aerial.

Three minutes later, after the repeat comedy of Matt charging around like a court jester, he reconnects the aerial once more. This time, though, he holds some slack firmly in his teeth.

By now, despite trying to be professional, I have tears in my eyes and this compounds my difficulty seeing the kite clearly. Matt manages to get through to Kuujjuaq and, luckily, before I wrench his teeth out, he gets the message clear that we need to be picked up.

Certain images will remain with me forever, and this is one of them.

16 JULY 1995
Pyramid Camp, Northern Quebec, Canada

57° 29' 48" N
65° 18' 43" W

This week we had a gyro-stabilised helicopter camera mount* to film aerials of the herds. Typically, as soon as we source this expensive bit of kit plus foot the cost of the helicopter, the weather turns bad and we are grounded for three days in heavy rain and thick fog. Cooped up in a small wooden hut.

Finally, our luck changes and the weather improves. We fly just 30 minutes from camp and find a huge aggregation of 50,000 caribou. They are all travelling along a ridge, working their way down to a crossing point. We are able to circle the animals in the helicopter without spooking them. This is better than I ever imagined it could be. The images look amazing and I shoot roll after roll. Eventually we have to land so I can reload my film magazines. The pilot chooses to put down in a bowl a mile ahead of the herd and he shuts down the engine. As I fumble in the changing bag with the rolls of film the first animals come over the ridge. On seeing us, instead of being scared and running, the caribou are inquisitive and deliberately choose to parade past the helicopter, coming within 50 metres. Thousands and thousands of pairs of eyes stare as they trek past. The sound is extraordinary. Along with the gentle pig-like grunts and brays, we can hear their footsteps and the distinctive clicks of their heels.

Once reloaded, the pilot starts up the chopper and the blades begin to spin. Instead of the caribou stampeding as expected, they all just stop and watch us take off.

* The Tyler middle mount sits in the back of the helicopter, where the passengers would usually be. The door is removed and I sit out of the side with my feet on the skids, the camera rigged on a gyro-stabilised arm that comes over my shoulder. (If ever needed, five minutes of flying like this is the best hangover cure ever.)

We then fly back to where the caribou are funnelling down to cross the lake. I am able to get shots of thousands of them as they wade, then swim, their antlers proud above the water. These images will cut perfectly with the shots Matt and I got from ground level.

This is the perfect rewarding finale to a real adventure filming trip.*

11° 45' 40" N
76° 26' 59" E

13 OCTOBER 1997

Bandipur National Park, Karnataka, India

Suspicious Today I saw something suspicious. A man ran across the forest track deep in the park. Our driver and guide saw him too and he raced forward to see if he could get a better look. There was no trace of anyone. Our driver suspected it was a lone poacher, probably after sandalwood, and said he'd report it to the forest guards.

11° 45' 40" N
76° 26' 59" E

15 OCTOBER 1997
Bandipur National Park, Karnataka, India

We know elephants to be strong yet gentle, intelligent animals. They live in family groups and have been a central feature of religious ceremonies in India for the past 5,000 years. After four weeks, this is to be our

* I have recently found out some tragic news: since 2001 the population of the George River herd has dropped dramatically from 800,000 to fewer than 6,000, a decline of 99 per cent. This is mostly due to commercial hunting.

last morning's filming them in the wild in Bandipur National Park, for a half-hour documentary called *Should Elephants Weep?* for the BBC *Wildlife on One* series.

Myself, assistant producer Lizzie, along with a driver and guide have spent almost 12 hours a day, every day watching and filming elephants. We have been working out of a small, dark-green, Indian Maruti Jeep fitted with a camera door.* The car is a pick-up style and smaller than a five-year-old elephant. It seems quite light and flimsy, like travelling in a biscuit tin on wheels. It is open, with a simple thin tubular steel frame over the back for a canvas cover should it rain. But despite feeling vulnerable around the elephants they are not a malicious species. When we've been parked, elephants have often chosen to walk very close to the car, some-times within touching distance. I like the fact they're comfortable with our presence. Also, with experience, it is fairly easy to read an elephant's mood. They have expressive ears and trunk and general body language, as well as vocalisations.

There has only been one occasion when I felt genu-inely threatened and it all happened so fast. We had been parked on the track for maybe half an hour, observing a family of 15 elephants munching their way through the bushes. All seemed calm. Then from out of nowhere, about 200 metres away, came a big female charging flat out. Her ears were back and trunk rolled up – not a good sign. The driver tried to start the Jeep as she barged through the rest of the family. Still the

* A camera door is a bespoke car door that incorporates a bowl fit-ting for the tripod head. The door sticks proud of the vehicle, a bit like a shallow balcony. This enables shots looking straight forwards and backwards down the side of the vehicle while stationary. And it means you can stay in the car, meeting national park rules.

Jeep wouldn't start. She was heading straight for us. Finally, the engine came to life and we took off down the track as fast as our biscuit tin would go, but the elephant was gaining on us. I braced for impact and the tracker leapt from the back of the Jeep into the front with me just as the elephant lashed out. The very tip of her trunk caught our flimsy 'roll bar', bending it with a loud thwang, and then she slowed her pace as we raced away.

We will never know what caused her to charge us. We were sitting still and quietly. It could be something simple. Elephants have very good memories and perhaps her calf had been hit and killed by a Jeep like ours on a main road. Who knows. But in all our hours of observation with the elephants this was a very rare event.

This morning I am woken by the usual jungle fowl 'cock-a-doodle-doo' at 5.30am. We are supposed to be doing a final three-hour filming stint in the park before moving on to Mysore, but the weather is bad so we decide to head off after a leisurely breakfast. Three hours later we arrive in Mysore and head to the hotel to check in and dump all the camera kit. Helpful porters bring the cases in as Lizzie and I start to fill out the hotel registration. Once the receptionist sees who we are she says, 'Oh. Mr Thurston? There have been 30 urgent phone calls for you this morning. Can you please call this number?'

The receptionist dials the number for me and I speak to Gajendra, our rather panicked contact in Mysore.

'Hi, it's Gavin here. I had an urgent message to call you.'

'Oh, Gavin. Are you all right?'

'Yes, thank you. Why?'

'We heard you had been kidnapped in Bandipur this morning. We've been trying to trace you. The bandit involved is called Veerappan and is very dangerous. The most wanted man in India. Please check into the hotel as normal and then go straight to your room. Barricade the door and do not open it to anyone. If anyone rings your room do not answer. I will be with you in 20 minutes and will then take you to a different hotel. Do you understand?'

'Er, yes. I understand. Will do exactly as you say.'

I don't relay the message to Lizzie until we are at the rooms, just in case someone in the lobby is listening. I'm feeling alert and nervous. This whole situation sounds serious.

I barricade the door with film cases and we wait. Gajendra arrives and we move to a more secure hotel.

The remainder of our filming in Mysore is without incident.

It isn't until weeks later that I find out the whole kidnap story. It turns out that Veerappan and his gang of bandits had been watching us for days. They were looking for a high-profile target before the Queen's visit to India on 12 October, and they knew that Lizzie and I were working for the BBC.

We had had a few meetings with two local cameramen, Krupakar and Senani, partly to be sociable and partly to pick their brains about good elephant locations for our film. They had both been very helpful. In return we were able to give them advice and encouragement for a film they were making about dhole, Indian wild dogs, also for the BBC. The two of them were staying in a small worker's cottage right in the park.

The night before the kidnap, Veerappan and his men broke into Krupakar and Senani's cottage and

roughed them up, trying to get information on where we were staying. The armed bandits helped themselves to bananas and then used the cameramen's tape recorder to record a message of demands to the chief minister. Despite being beaten, the two of them bravely held their tongues for hours, saying that they were the BBC team that Veerappan was after. Eventually, they gave in to the torture and said that Lizzie and I would be entering the park at 7am to go and film. They hoped by then there would be too many people around for the bandits to attempt a kidnap.

Veerappan and his men took Krupakar and Senani with them to the park entrance where they held up a safari vehicle with 14 tourists. They badly beat the Indian driver and left him for dead.

By 9.30am, when the tourist vehicle had not returned, the lodge thought they must have broken down so sent a second vehicle to find them. The gang accosted the second vehicle too. Keeping some hostages, they sent the tape cassette back with the driver of the second Jeep with their demands. The gang then took off deeper into the forest.

The hostages were held for 13 days before being released, thankfully unharmed.*

* Veerappan continued to evade capture, until he was shot and killed in a gunfight after being trapped by the Tamil Nadu Special Task Force on 18 October 2004. Though I will always be grateful, I haven't yet had the chance to meet Krupakar and Senani in person to thank them for courageously protecting Lizzie and me from kidnap.

5 SEPTEMBER 1999
Howletts Zoo, Kent, UK

51° 16' 2" N
1° 08' 49" E

Gorillas in my midst

Earlier this year I was approached by producer Brian to see if I would be interested in filming a story about two gorillas who'd been rejected by their mothers. They were to be taken from Howletts Zoo in Kent and introduced into the wild, in the forests of Gabon on the Congo border. It sounds pretty exciting and I'm a big fan of gorillas. So, of course, I said yes.

The gorillas are Kwam and KwaKwa, both females, aged two and three. They were rejected by their mothers at birth, an uncommon but not unusual occurrence, and would have died without maternal care. To save them, both were taken and hand-reared by keepers. They needed 24-hour attention, as any baby would. The main keeper, Colin Angus, essentially became their surrogate parent.

Howletts Zoo was owned and set up by John Aspinall. He was a lovable rogue – some might say a crook. He made his money running a casino in London back in the 1950s and 60s. In so doing, he met a lot of high-flying people and became very close friends with Richard John Bingham, better known as Lord Lucan. Lucan was involved in a huge scandal in 1974 when one night he plotted to kill his wife. He knew she would be on her own as the nanny had her night off. So Lucan, normally down the casino, hid behind the kitchen door downstairs in his basement, knowing his wife would come down for her evening cocoa. He'd taken the light bulb out of the ceiling socket and had a lead pipe wrapped up in a cloth. As predicted, his wife came downstairs, flicked the light switch, but of course the light didn't work. Lucan leapt out from behind the door and whacked who he thought was his wife over the head, bludgeoned her to death – but to his horror

he'd killed the nanny by mistake. Lucan was distraught. He went upstairs and was confronted by his wife, who he also attacked, but by then, 'the fire had gone out of his belly' and he was unable to murder her. She escaped the house and ran to the local pub for help. Meanwhile, realising his mistake, Lucan ran out, got in his car and fled. The next day his car was found abandoned in Newhaven. He was never seen again.

John Aspinall was Lord Lucan's closest friend. Though never proven, it is believed that Aspinall helped Lucan disappear. The reason I mention this, and find it funny how I ended up at Howletts, is because my grandfather, Dr Gavin Thurston, was the coroner for Lucan's nanny, and the last coroner in history to implicate and name a murderer in a case.

So that was an interesting connection with me. Here I am, filming an interview with John Aspinall, who allegedly had a part in this drama.

During the interview, Brian asks John how he got to run the zoo in the first place. John talks about his time as a gambler and then how he had his own casino. One of the questions Brian asks is, 'What's the most you've ever lost in a night and what's the most you've ever won?' The most he'd lost, he replies, is £5 million, and the most he'd ever won is the money to set up Howletts Zoo. Before that he lived in a plush flat in London, and kept various animals there. He even had tigers – not a very practical pet to have in a small flat – so getting Howletts and all the grounds was brilliant for him, because he was able to give these animals more space to live.

John is undoubtedly passionate about animals, many well cared for and kept in captivity for years at Howletts. But as he got older his ethos changed and John is now keen to see all the animals go back to the wild, to their native habitat. If he had the money, he said he would transport all those gorillas back to

live where they should be, in the forests of Congo and Gabon, eating their natural vegetation and having the freedom to climb trees rather than being caged up in Kent. That is his passion and his ultimate goal.

At the end of the interview, John turns to me and asks, 'Gavin, have you got any film left in the camera?'

I reply, 'Yes.'

And then he asks Brian, 'Do you mind if I say a few words? I'd quite like to say something myself?' John's recently had an operation for cancer. He doesn't look well.*

Brian replies, 'Yeah, of course.'

So we roll camera and sound. John looks into the camera. He is quite poignant, sad, saying that through his life he's had many close friends and people who've helped him out in times of trouble, people who have stood by him through difficult times. Now, towards the end of his life, he's realised that actually there were a lot of people he's never thanked. 'You know who you are, but I just want to thank people who've helped me through my life. Maybe I've been a bit selfish and stubborn and not said thank you, but I'd like to say thank you now.' After that I run out of film.

One thing that I'm of course desperate to ask John about is Lord Lucan, but being ever the professional I refrain. Brian, on the other hand, gets a bit cheeky towards the end of the day and asks, 'Now, John, tell us about Lord Lucan. What really happened?'

There's a pause for thought and John replies with a poker face, 'That is one secret I will take to my grave.'

Every Sunday, John has the keepers buy nice, tropical fruits. Papaya, pineapples, passion fruit, melon, bananas, kiwis, and God knows what else. The fruit

* John Aspinall died in 2000.

is sliced and prepared on big oval platters and put on the back of an electric golf buggy. John drives around the zoo and hand-feeds all the animals. They all get to know him through bribery, as all through the week they get normal fruit and then on Sunday these exotic treats. We head out with him and film this Sunday ritual. Brian sits in the front with John driving. Sound recordist Trevor and I sit in the back of the buggy with the camera and sound kit. Between us are these huge platters of fruit, and so, driving between the cages, listening to John guide us through the animals and areas of the park, Trevor and I help ourselves.

At one point we stop at a gorilla enclosure, and with John we climb a stairway about ten metres up to a walkway over the roof. John throws handfuls of fruit down for the gorillas – they're loving it. Getting to the last few cages, John says, 'God, that's funny. Normally, I time it perfectly so the fruit goes round all the primates, but we've run out for the last few cages.' Trevor and I look at each other guiltily, the taste of kiwi on our tongues.

After that we head inside the enclosure with Colin to visit Kwam and KwaKwa. We film an intimate scene of him play-fighting with them. Initially, they are quite nervous of us when we go inside the enclosure. They stay close to Colin, as if to ask, 'Is it okay to approach Gavin and the camera?' Slowly their confidence builds and eventually they come over, inquisitive and sweetly curious. Eventually tentatively climbing on me and giving me a firm and loving hug. One thing gorillas do which is really nice is they laugh and they smile. If you tickle them on their tummy, they act just like a child; they really giggle, and that's very endearing.

I quickly notice how strong they are. These gorillas are only two and three years old, and they easily match me. I can't imagine how strong an adult gorilla would be.

We meet Amos Courage, John Aspinall's stepson. From time to time – just as John used to – Amos goes into the cages with the gorillas. Wearing gloves and a thick, padded jacket, he rough-and-tumbles with the silverback and runs around the enclosure. Knowing how strong these gorillas are, there is a huge amount of faith between Amos and that silverback. If it was a violent animal it could easily rip him limb from limb. But there has never been any malicious intent from that gorilla, just genuine trust between the two of them. They've grown up together a bit like best mates. A relationship that allows the two primates, apes, to play together. It was a joy to watch.

We interview Amos as well: he's going to travel with Colin and us to Gabon. Amos confides his biggest worry about taking the gorillas back. 'They're not used to all the native fruits and foliage, they'll need to learn. Also there's all the bugs and bacteria – they've got to build the right gut fauna, you know. They're going to get diarrhoea when they ingest stuff from the soil.' They should strengthen up and be fine, but Amos knows it's not going to be an easy road.

The gorillas are going to Mpassa, a reserve by the river set up by Howletts in Gabon on the Congo border. It is run by primatologist Liz – she is a tough cookie, living out there in harsh tropical conditions and totally dedicated to rearing the rehomed gorillas to give them a fair chance in life. Mpassa is an area of pristine habitat, of rainforest or tropical forest, far from civilisation. That's why they've chosen the area to resettle the orphan gorillas – to distance them both from the pet trade and from the recent civil war which ravaged

Congo from 1997 to 1999. One of the side-effects of the war is that the animals in Brazzaville Zoo weren't fed properly – there wasn't enough food to go round. Many animals starved, and some were eaten by troops as bushmeat. Amos Courage, true to his name, went in and rescued the gorillas and took them to Mpassa. One horrific image that he described, moved to tears by it, is of the time he drove from Brazzaville to Lefini. He passed bodies along the side of the road. Clearly the army had gone through and machine-gunned people as they'd driven by, slaughtering the general public. He reckoned he passed several hundred victims. But Amos is so passionate about the gorillas that he took those risks in order to try to rescue them, to give them a safe sanctuary at Mpassa.

A bunch of orphans are already out there, the oldest of which is a female called Choupette, aged five. The local keepers go out with the gorillas every day and teach them what they can and can't eat. Then, every night, the gorillas are led back to a big wooden stockade-style cage and locked up for their own safety. They sleep out in the forest on their own, but the cages keep them safe from leopard attack and the like until they are bigger. Then, every morning, the keepers go back across the river, open up the cages and take the gorillas out for the day and keep teaching. Kwam and KwaKwa are going to join this group of orphans in the forest to learn how to be proper gorillas and live as a group.

Amos mentions his biggest concern about this whole mission, and that is the plane landing at Mpassa. The airstrip has been newly ploughed, he says. There is no tarmac or concrete. It is a grassy clearing in the forest, just about long enough, and they've prepared a basic airstrip along it to be able to run supplies in and out for the camp. Amos's comments are now haunting my thoughts.

28 OCTOBER 1999
Gatwick, Surrey

51° 9' 40'' N
0° 10' 30'' W

Myself, Trevor and production coordinator Jeanne meet up with Amos and Colin at Gatwick. Air Gabon has agreed to take the crate with the two gorillas and fly them to Libreville in Gabon. I film them being loaded onto the plane and so on, and off we go. Luckily for us, Air Gabon is being very helpful – so helpful, in fact, that they actually give us business-class seats, so we fly in the lap of luxury while the poor gorillas are down below, locked up in the crate, wondering what on earth is going on.

29 OCTOBER 1999
Libreville, Gabon

0° 27' 25'' N
9° 24' 36'' E

We land in Libreville and are supposed to be met by the fixer, who has the original copy of the permission needed to go and film airside as the gorilla crate is lifted off the plane by fork-lift. Unfortunately, the fixer appears to have been out drinking the night before and is late turning up with the permit. Meanwhile, we try to persuade our way, but are promptly 'detained'. We explain we have copies of all the paperwork, but the locals insist the original is needed. Annoyingly, during the 40 minutes of argument, the gorillas are unloaded from the aeroplane and we miss the shots of them arriving on African soil.

The next stage is to film the gorillas being loaded into the Cessna, a small aircraft. Colin is going to travel with the gorillas, which are staying in the crate in the back of the plane. Meanwhile, Trevor, Jeanne and I are going to travel in a larger plane with all the camping

gear. We are going to be at Mpassa for two weeks. Our flight is on a twin-engine plane, a King Air 350. It is more like an executive-style plane. Inside are leather seats, a walnut trim and drinks cabinet. Not the sort of plane you expect to be flying into a dirt airstrip. Amos looks it up and down, shaking his head, and I take note of his concern.

Our pilot, Grant, is South African. He has an American co-pilot, John. While Grant deals with the fuel, exterior checks and some paperwork, John 'supervises' the loading of our kit. We have so much that he ends up stacking it in the aircraft aisle. Peli-cases on the bottom and softer camping bags on top. I ask whether it's okay to fly like that and John confidently says, 'If it'll fit in, it'll fly. This machine has loads of power.'

Like Amos, I was thinking more about how the plane would handle the landing on a dirt strip, especially with all the baggage on board. There's something about John's cockiness I don't like.

I film the Cessna taxi to the end of the runway and then take off. The rest of us board the King Air and follow. Amos is in the seat towards the tail, Jeanne and I sit either side of the aisle with our backs to the cockpit and Trevor is facing Jeanne. As we settle in, John says, 'Seat belts are for pussies.'

We take off and soon catch up with the Cessna. I ask if Grant can fly straight and level so I can do a few shots out of the window, air to air. Unless pilots are trained and used to this kind of close proximity, flying this way is quite dangerous. John eggs Grant to get closer. I rally back that the distance is fine.

We start to pass through small clouds: each time we are engulfed, we lose sight of Colin and the gorillas. At one point, we come out of the clouds with the Cessna's wingtip just a few feet from ours. Both pilots react quickly and veer apart. John shuts up in the front. I

suggest we abandon air to air shots and go on ahead to land as I need to set up to film the Cessna landing.

As we start to descend, I look over my shoulder through the cockpit window and see the landing strip. It is worse than Amos described. In fact, it looks more like a ploughed field than an airstrip. I think we all sense it's going to be a bumpy landing. I'm never going to hold a steady shot so I put my camera on my lap.

As we descend Grant trims the wings and throttles back. We start to glide in. There is quite a bump when the main wheels touch down: the jolt rumbles through the whole plane. As we slow, the weight goes from the wings to the wheels. Then – the nose wheel touches down. Instead of rolling, it sinks into the soft ground and digs. The undercarriage folds and the nose of the plane goes into the ground. The propellers hit the earth, throwing dirt, bending and twisting to an abrupt stop. My camera disappears into the cockpit; the force is so hard that it snaps the shoulder strap round Trevor's neck, sending his recorder and mixer flying forwards. Camping bags and baggage all hurtle onto us and Jeanne and I are part-buried. The plane has come to a stop – then the cabin begins to fill with smoke. Amos opens the rear door and is out in a flash. I undo my seat belt and try to heave the bags off my legs. Trevor and Jeanne are attempting to stand and I reach forwards and undo their seat belts for them, bundling them towards the door. I look into the cockpit – John looks slightly dazed, while Grant is switching down all the systems. With the smoke thickening I head for the door. I almost stop to grab the making-of camera, but the commercial airline safety briefing booms in my head: 'Leave personal baggage behind'. My adrenaline is pumping and I jump to the ground and run from the plane.

The plane is wrecked. The nose is down and the tail high. Both propellers are contorted and twisted, the nose gear crumpled beneath. Fuel is dripping from the engines and smoke billows up. My whole body tenses, thinking it's about to explode in a ball of flame. Grant and John are still in the cockpit. I can see they are both conscious and that Grant is on the radio. They aren't signalling us for help and gradually they look calmer and calmer.

When they emerge, Grant looks shocked: his eyes huge and his shoulders hunched. John wanders off somewhere behind the plane. Grant assesses the runway. Our plane is right in the middle. There is no way the Cessna can land.

Still in our state of shock, we empty the plane of our gear and pile it all away from the stricken craft. I set up camera and tripod to film the Cessna but pray it doesn't try to land: even I can see there isn't enough runway for that. After a few more minutes, the plane appears and they do a few low passes over the dirt strip. We wave to try to show we are okay. They turn and head off to land elsewhere.

A truck arrives at the strip to collect us and our luggage. The guys look quite shocked when they see the plane, asking us what happened. It's then I realise John is nowhere to be seen. He's walked down to the camp, jumped on a boat and disappeared upstream. If he had stayed around, I think we all would have lynched him.

I pull out the satellite phone and speak to Brian back in Bristol. He's incredibly supportive, offering for us all to come home. However, Trevor, Jeanne and I decide we'd rather stay and do the job we've come here to do. We're obviously shaken but none of us is injured. Besides, the last thing we want is to get back onto a plane.

We make our way down to the camp and meet with Liz. She and the staff look after us extremely well. We settle into our tents and have a drink to try to calm our nerves, then get an early night.

30 OCTOBER 1999
Mpassa, Gabon
1° 41' 44'' S
13° 38' 09'' W

Waking up this morning, all of us feel the same: still slightly dazed by yesterday's crash and every single muscle in our bodies aches, like we've done an extreme workout. Since the impact, I guess, our bodies have been in such shock that we must have tensed up completely. An instant reaction, yet to such an extreme degree that it strains and tears every muscle in your body. All of us are hobbling around like old people.*

Colin and the gorillas landed safely in Franceville. Amos and I are to meet them via jet-ski. I've only been on a jet-ski once in my life, and that was in Arizona, recreationally. It was one of those big WaveRunners, a two-seater. This is the same, but the river we are on gives a whole other experience. Amos doesn't hang around on it, zipping up that river at probably 30 or 40 knots. The river runs wild, brown with mud and silt. Vegetation and overhanging trees line both banks, allowing only the occasional muddy clearing where animals come down to drink. He reads the river perfectly, meandering with it, having to bank hard around the bends at speed. As we push on, the river narrows down, sometimes a matter of six or eight feet, and we hurtle through tiny gaps in the overhanging branches. Then the river opens up to a few hundred metres wide. He certainly knows

* I can relate to that now, that's for sure.

how to operate that machine. While it's great fun, there is the lurking reminder that we are in deepest, darkest Africa, whizzing through the neighbourhood of hippos and crocodiles and God knows what else.

Finally, we get to the jetty where the boat is: poor Colin's had a pretty rough night. He had to share a hotel room with the gorillas, all the while worrying how we were, having not been able to contact us. He was glad we were all okay.

The gorillas are okay, too. This is their first time in Africa. It is all new to them: the smells and the sights they can glimpse out through the cracks in the crate as they are being transported, the sounds of the wild, the warmer air. They are taking it well and are calm and wide-eyed.

We load them in their crate onto the boat. Having seen the river for the previous hour or so, whizzing up on the jet-ski, I'm worried that in those tricky waters the boat could capsize. If the gorillas are stuck in this crate and the boat does capsize, they're going to drown. As a precaution, we unscrew some of the bolts and loosen the ties in case of the need for a quick escape.

There's me worrying the worst might happen, having just crashed the day before, thinking the gorillas might drown in the river. Anyway, I film the gorillas on their boat journey downstream. This feels like an adventure with a happy ending for the gorillas: they will be getting their freedom in the forest.

An hour or so later we arrive at Mpassa. Kwam and KwaKwa are taken to a holding pen where they'll be staying overnight, next to the orphans already there so they can hear and smell the other gorillas. Tomorrow they'll be introduced and go out for their first day in the forest.

1 NOVEMBER 1999 1° 41' 44'' S
Mpassa, Gabon 13° 38' 09'' W

I must say, it is great fun filming this – being with a whole group of gorillas. The gorillas that were already out here are so friendly and playful and, if they take a shine to you, they grab hold of your leg or your arm – as you're trying to walk and film – and they climb up. Sometimes I'll be walking along with three gorillas while trying to film at the same time, and, of course, they're very interested in the camera and the microphone.

Over the last few days we've been filming Kwam and KwaKwa learning about the forest. What fruits and leaves to eat, which to avoid. Much of the food is not up to the standard of the exotic fruits they occasionally got at Howletts, but they'll have to learn or go hungry. How to climb on branches and lianas and which thicknesses will take their weight. Initially, they are very clingy to Colin and wary of their new gorilla friends, their new gorilla family. But they've started to explore just a little. Hopefully, they will adjust and fit in. It would be the same for any of us, like starting a new job or school but in a new country too.

Meanwhile, up at the airstrip, engineers have been rebuilding the plane. They've put one new engine on, and two new propellers; they've patched up the crumpled nose landing gear and repaired the plane's nose cone. To prepare for takeoff, they've used a quad bike to drag the plane right to the start of the runway. Because the soil is soft, they've put down some boards and planks for the wheels, so at least the plane can find purchase for a rolling start. They've also drained most of the fuel – leaving just enough for the plane to get to Franceville, the nearest tarmac strip, about a

half-hour flight away – and they've stripped anything unnecessary out of the plane: all the executive seats, the drinks cabinet, the fridge. The engineers tested the engines a few times during the day, revving them up. Only Grant is going to be in it on his own when it takes off.

Amos went to film it and afterwards shows us the footage: it is one of the most gripping videos I've seen and just one shot that lasts 20 minutes.

The take starts with shots of the pilot chain-smoking heavily, away from the plane. The poor man, he crashed this plane, watched it being rebuilt on a dirt airstrip in the middle of the forest, and now he has to take off from that same dirt airstrip and fly half an hour solo to the tarmac airstrip in Franceville. It's pretty much solid forest the whole way, so nowhere to put down if he has engine trouble.

The pilot then shakes the engineers' hands and the aeroplane owner's hand and gets in the plane. He checks the switches and gauges three or four times. Eventually, he starts up one engine and lets it run for a minute or two. Then he starts up the second engine and lets that run. He revs both the engines a little bit more to warm them up. After several minutes the engines are up to temperature. He gives a rather feeble and nervous thumbs-up to the crowd gathered on the grass beside the dirt track.

With the brakes still on he brings the engines up to full throttle, then releases the brakes and the plane starts to roll forwards. Initially the wheels are on the planks and the plane moves easily but, as soon as it comes off the planks, the wheels hit the dirt. The plane almost slows to a standstill. But it manages to keep rolling with the engines still at full throttle. Out of focus in the foreground, the engineers are huddled together,

clenching their fists. The plane is still rolling forwards, rolling and rolling; it's building speed and the engineers move forwards. Come on, come on, come on! And the plane is now halfway down the runway, going faster and faster, engines still flat out.

In the foreground, the tension of the engineers watching builds and they raise their fists. You can hear them shouting over the engine noise. Come on, fucking come on! Come on, come on, come on! The plane is now three-quarters of the way down the runway and it's still not off the ground; it's not going fast enough. I feel as if I'm watching this man driving to his death. He's going to go off the end of the runway into the forest and the plane is going to explode in flames. The tension is intense. He's getting fasting and faster and near the end of the runway, but the wheels are still down and still rolling on the ground – you see the engineers move forward. Come on, come on, come on! And then the plane goes off the end of the runway, through the bushes and almost out of sight as the land slopes away. I watch and wait for the crash, the explosion, the plume of smoke and flames. The sound from the engines goes quiet and then the plane pulls up into sight – he's off the ground but only just above the treetops. As the plane peels round to the right you can see the relief in the engineers and they cheer. At least he's off the ground and climbing, if only gradually. The plane goes out of sight, clearing the tallest trees, and it ascends. The engineers get in the helicopter and fly after him.

I watch the video four times that evening, and each time when I see the plane appear, bank to the right and clear the trees, the sense of relief and surprise is huge. I really feel for Grant the pilot, having just crashed a few days before, to then be in that situation, where he's almost

compelled to fly it out of there. We all have our fingers crossed he's going to make it back to Franceville okay.*

<table>
<tr><td>1° 41' 44'' S
13° 38' 09'' W</td><td>**5 NOVEMBER 1999**
Mpassa, Gabon</td></tr>
</table>

Testing hierarchy — Kwam and KwaKwa are slowly settling in to life in the forest. Choupette, the oldest female gorilla, has the role of alpha female. Even though she's only five, she's a right madam and mean to all of us. She's taking the matriarchal role of the group seriously and is testing each of us. At one point I'm sitting on the ground filming details of two youngsters playing and Choupette walks right up to me. She's eye level with me and decides to put her jaws around my shoulder and bite. Her face an inch away, eye-to-eye with me, her teeth on my shoulder. She starts applying the pressure, biting harder and harder and harder. I can't fight her off – I know her strength. It would be like taking on Mike Tyson. I know that if I show any weakness or panic she might bite me properly, or she'll keep picking on me because she'll know she's dominant. I try to be calm and talk to her. In my head I'm thinking, *Shit, this hurts*, but I was gently saying, 'Hello, Choupette, that's nice, that's

* When we were back in the UK, Jeanne, the production coordinator, got in touch with the pilot to check he was okay. The pilot explained that as he was building speed for takeoff, halfway down the runway the cockpit started filling up with smoke. He was frantically trying to switch off anything not needed – while trying to control the plane. Accelerating, keeping it straight on the dirt runway with the trees looming up ahead of him, he struggled to keep his nerve and switch off whatever he didn't need, trying to work out what it was that was causing the electrical fault. Even when he did take off and he cleared the trees, he said that the engine that wasn't replaced was only giving him 60 per cent power. He was very lucky, really. Bloody lucky.

nice. Oh yes, that's very funny. Yeah, yeah, yeah, come on then, let's go and play.'

Luckily, before the pain gets too bad, before I really have to yelp out, she sees I'm not reacting in the way she hoped. Thankfully, she gives up and walks off. I really thought that she was going to do me some serious damage. I love her personality, but what a bitch.

7 NOVEMBER 1999
Mpassa, Gabon

1° 41' 44" S
13° 38' 09" W

After ten days of filming the gorillas, it is time for us to leave. Not by plane, for obvious reasons, but instead we head back upstream by boat and are met by a truck that takes us back to Franceville. Time for us to board our first plane since the accident: a twin-engined charter for the short hop to Libreville. I'm fine on takeoff, but when we come to land at Libreville I'm a nervous wreck. It is the same for the international flight back to London, fine for takeoff and the long flight, but coming in to land my new anxiety and stress make my whole body tense up and my nails dig into the armrest. It will be like this for the next year, every flight I take; the landings will really stress me out, have my heart pumping and adrenaline going.*†

* I'm over it now but the shock of crashing on the dirt landing strip affected me for ages.

† Kwam and KwaKwa were well for a while but unfortunately KwaKwa only lived for another six months and Kwam only for another year and a bit. As Amos feared, growing up in Kent didn't really prepare them for the bugs in the forest, perhaps because they didn't have mother's milk from a gorilla in the wild. But to some extent it is quite a success story. Since then, more than 60 gorillas have been returned to the wild, and the success and survival rate is as high as 85 per cent. It's difficult to judge it, but I think the risks

4° 48' 29'' S
11° 52' 53'' E

JUNE 2001

Pointe-Noire, Republic of Congo

Back to
Africa

Back in Central Africa to film chimpanzees again – this time a six-hour drive north of Pointe-Noire on the coast of Congo.

Producer Vanessa and I are working with an organisation called HELP Congo set up by a young Frenchwoman, Aliette, to save primates and in particular chimpanzees. The first chimpanzees were rescued from appalling conditions in Pointe-Noire Zoo. Some older chimpanzees were then rescued from Brazzaville Zoo when the war escalated in 1997. Other chimps here are orphans from the bushmeat trade. The idea is to give them a better life and some freedom. To facilitate that, the Congolese government donated an area of wilderness: three forested islands in the Conkouati Lagoon. Now, several groups of these rescued chimps live wild on the islands, free of cages and bars. They are monitored and checked on daily and taken food supplements when needed. The younger chimpanzees have to learn new skills in order to cash in on what food is here, and that's one of the things we are to film for episode ten of *The Life of Mammals*.

Vanessa and I flew out a few days ago, from London to Paris to Libreville, where we overnighted at the, now familiar to me, Hotel Atlantique. In the morning we flew Air Congo to Pointe-Noire, where we were met by

of taking a gorilla from England back to the wilds of Central Africa are worth it. Yes, some gorillas might die, but to experience that wildlife, that freedom of the natural world, of where they belong, even if it's for a short period of time, tops any life in a cage in Kent.

Jess and Ben from HELP and loaded up the truck for the six-hour journey to Conkouati.

En route we passed a few checkpoints. At one of these, two drunk teenage soldiers armed with AK-47s checked our passports. They then took an unhealthy interest in both the camera equipment – and Vanessa and Jess. It was a tense and uneasy few minutes negotiating in my schoolboy French, trying to keep the situation light. As they insisted they wanted the women, I told them, '*Vous ne voulez pas dormir avec elles – elles ont tous deux une maladie vénérienne*' – 'You don't want to sleep with them, they both have venereal disease.' Thankfully, at that they laughed. I handed them some beers and cigarettes and we were allowed to continue on our way. (Vanessa and Jess weren't pissed off with me if you were wondering. They realised I'd said it to defuse an extremely tricky situation that could otherwise have ended very badly.)

We arrived at the camp and unloaded just as it got dark. Before dinner, Jess showed us down a boardwalk through the mangroves to the 'bathroom', also known as the lagoon. It was slightly unnerving swimming in the dark as I'm sure crocodiles live in areas like this, but great to have access to water after a hot, dusty and stressful journey.

Vanessa and I spent the next few days meeting the chimps and filming various behaviours. These few days have also worked as a recce and planning time for the sync pieces with David (Attenborough) – now we know what is feasible. One of our main considerations is the safety of working closely with these chimps. We know from experience that they are extremely strong and slightly more temperamental and unpredictable than gorillas. There are plenty of documented cases of people being seriously injured by chimpanzees and this is usually with captive or

troubled chimps such as these. Who knows what some of these animals have suffered at the hands of humans.

We are filming on one island with the younger chimpanzees. Clearly, the chimps love Jess and the local guys who work here at HELP: they are like surrogate parents to them. There is another island with reintroduced adult chimps which is not considered safe for humans to visit. Four years ago, the director of a French film crew ignored this warning and was badly attacked by an adult male and he was left with broken ribs. Those chimpanzees are from Brazzaville Zoo and probably suffered years of mistreatment and torment.

We start to worry as David and sound recordist Chris are late arriving from Brazzaville and we can't get hold of them on their satphone. They too will have had to go through the various less than friendly army checkpoints. They arrive safely just as it is getting dark. I'm always impressed by how David, now aged 77, copes with this arduous travel. Not to mention the change of climate from UK weather to hot and humid tropical jungle.

3° 57′ S JUNE 2001
11° 23′ E Conkouati National Park, Republic of Congo

A short car journey from camp we load into two boats to head to one of the islands where some of the younger chimpanzees have been released and are living. Islands are dotted all through the brackish waters here, some lined with mangroves and others properly forested. David delivers the first piece to camera while being paddled in a pirogue. I film from a second pirogue tracking alongside. Behind him the chimps excitedly swing, straddle and vault their way

through the mangroves, calling and whooping as they go. Their movement is confident and fluid, clearly a well-rehearsed manoeuvre along this route as they know these pirogues mean food delivery. It's rare to be able to see and travel alongside a primate in full swing. Normally in a forest one would lose sight quickly and it's all you can do to just keep up, never mind watch and enjoy. I am very happy with the shot: *'These chimps are orphans. Their parents were killed for the bushmeat trade and many of them were pets kept in unsuitable conditions. Now they are part of a unique experiment in which they are being taught the skills they will need in order to survive by themselves in the wild.'*

Myself, Chris, Vanessa, Jess and two other chimp carers then head ashore to set up for the shot of David arriving on the island by pirogue. As his pirogue approaches the bank, a rather excited five-year-old chimp called Belinga runs forward and climbs in to greet him, nearly capsizing the boat. I continue to film but we are all readying ourselves to rush in to help defend David if the greeting is too enthusiastic. David, as we know, is a natural and holds his cool while trying not to fall out of the boat at the same time as conveying the right body language to Belinga. All is fine: Belinga takes David's hand and leads him ashore.

The next 20 minutes or so are just magic. David sits on a fallen branch and hands palm nuts to a few individuals who then demonstrate their nut-cracking skills. Belinga steals the show, using an almost baseball-bat-sized branch of hardwood to deftly crack the nuts. There are nervous moments when Belinga swings the club too wide, and comedy moments when mishit nuts shoot off into the forest. David speaks to camera about how primates can learn skills like this and that these skills vary from population to population. This is the beginnings of culture.

We move to a different location for the next to-camera piece. David stands in chest waders in the lagoon with the water up to his waist. Dotted around him are delicate white waterlilies and beyond is the edge of the forest. As David speaks, behind him the chimpanzees walk and wade their way upright through the water, up on two legs.

David says: *'Suddenly, an image from our remote past comes vividly to life. The time when our distant ancestors, in order to keep up with the changing environment, had to wade and keep their heads above water in order to find food. That crucial moment when our far-distant ancestors took a step away from being apes and a step towards humanity.'*

The hairs stand up on the back of my neck and I am close to tears. To have Sir David Attenborough just in front of me so eloquently explaining a part of evolution and our ancestry, while behind is a vision of the origin of early man. It all makes so much sense to me. The image and sound of those 25 seconds will stay with me forever. This is another one of those days when I appreciate the experience beyond the job.

This evening we celebrate with dinner and 'Casanova' red wine from a large plastic barrel. The trip has been a success and everyone is happy. David is on great form and stays up with us late into the night, entertaining us with rich and funny stories as he so often does.

David and Chris leave for the UK while Vanessa and I stay on to film some extra shots. We get a call from the office on the satphone. It's an urgent and rather angry message from David and Chris. As they were going through security at Pointe-Noire airport for their evening flight, they had a few of their cases open on the desk for the officers to check. Just then there was a power cut and they were plunged into darkness. The

lights came back on within a minute and the officers gestured that they could close their cases and proceed to check-in. It was only when David got back to the UK that he realised his wallet and a few other things had been stolen from his briefcase. The reason he was cross was twofold. Firstly, after all his travel experience he was annoyed that he'd fallen for such a scam. Secondly, he was angry because they had stolen his London Freedom Pass, which allows him as an older resident to travel for free on public transport in London. As David doesn't own a car or drive, this is literally his freedom pass. David made the effort to ask the office to call us and warn us about this scam.

Vanessa and I head to the airport prepared. It's the usual Central African mayhem: people and bags everywhere with no defined queues. I love the slight edginess to it all; I feel I have to have my wits about me. It is already dark outside when we push our four trolleys with 14 cases through to security. They ask us to put the cases on the tables and open them for inspection. I take charge and with my schoolboy French tell them we'll do them one at a time. There are four or five officers all reaching for items and asking, 'Qu'est-ce que c'est?' – 'What is this?'; 'Peux-tu me le donner?' – 'Can you give it to me?'

They are impatient and try to make me open all the cases. I resist and open them one at a time, sealing each one with cable ties once they've checked it. Vanessa and I each have a case open when clearly they see something they want. Just as David warned, they must have given the signal as the lights suddenly go out. I wait three seconds and then turn on my torch, which I'd readied in my pocket. I light up my own face and say, 'Surprise!' And then shine the torch at them. They all have their hands in our cases and withdraw them quickly. They

look really shocked and are obviously thinking, *What the f…* A minute later, power and light are restored to the airport and we are flagged on without further checks.

It appeared to us that the whole airport was in on this scam and we were given a really hard time at check-in. They were charging us full rate for every kilo of excess baggage, and their scales were very much rigged in the airline's favour. I spent half an hour or so negotiating, showing them our excess baggage receipt with the weight for our journey out. They wouldn't budge an inch. Our bags by now were sat just outside on the tarmac, in sight but out of reach. Vanessa and I just had our hand luggage, including the wheelie case with the exposed film rushes. The duty manager said that unless we paid in full the bags were not going on the plane. Now I don't mind paying what is due for excess baggage, it isn't even my money, but this time I knew they were ripping off the BBC. Also, conveniently, their credit card machine wasn't working so we could only pay in cash! Before I came to the airport, I had spread my money between various pockets. I reached in and pulled out some wads, British pounds, US dollars and euros, and flashed them at the manager, asking if I could pay in multiple currencies. Seeing the colour of money, he led us behind the counter and round the corner to his office. I gave him all the money and he sat behind his desk and counted it three times. Vanessa and I stood in front of the desk. His mood lightened and he said, 'Okay. *Tu peux y aller maintenant*' – 'Okay. You can go now.' I thanked him but explained I needed a receipt or I wouldn't be able to claim the money back from the company. Finally, begrudgingly, he agreed to write me a receipt. While his back was turned, fumbling for a scrap of paper, I quickly reached forward and pinched £200 back from the pile and slipped it in my pocket.

Vanessa's jaw dropped and she looked at me horrified. I said to the manager, '*Merci pour votre aide dans le tri pour nous*' – 'Thank you for your help in sorting this out for us.'

He handed me the receipt, we shook hands and Vanessa and I left. Just before I turned the corner, I glanced back to see him slip all the cash in his pocket.

We were the last to board the flight but I waited at the top of the steps of the aircraft until I saw all our cases loaded. I didn't trust the bastards still not to pinch it all. That would be the ultimate kick in the teeth after an arduous shoot.

JUNE 2001 51° 21' N
Home, Bristol, UK 2° 37' W

Vanessa and I land back in Heathrow and amazingly our bags have started to come out on the luggage belt, always a good sign. I leave Vanessa with the bulk of the kit on trolleys and go to collect the larger cases from the out-of-gauge belt.

Two hours later back in Bristol I call Roger, our driver, to ask him to drop off the film rushes at the BBC to be sent for processing, but he says that there was nothing left in the car. I call Vanessa – shit, she doesn't have them either! With a sudden sense of dread, I have a vision of the last time I saw the small wheelie case with the rushes in – it was by a pillar next to the baggage carousel in arrivals at Heathrow.

A call to the airport and the person who answers tells me there's a good chance the case will have been removed and detonated by now. 'The anti-terrorist team are quite hot on that. Hang on, though, and I'll go and have a look.'

The next three minutes drag on and I feel slightly sick. Flashbacks of the amazing sync pieces whizz through my head. The thought that I'll have to confess to David.

'Looks like it's your lucky day, sir. Your case was still there and I've just looked inside and there are still 14 film cans in there.' 'Thank God for that! Thank you so, so much. Someone from the BBC will be there to collect it shortly.'

When I next see David, I thank him for the warning about the airport scam, and tell him how I avoided the same fate. Rightly or wrongly, I also tell him about the excess baggage rip-off. Although he doesn't verbally condone my actions, I think he understands my desire for revenge. I never tell him that Vanessa and I nearly lost the rushes, though!

7° 56' 3" S
14° 19' 03" W

26 APRIL 2006

Ascension Island

Along with producer Andy and underwater team, Doug and Hugh, we fly to Ascension Island with the RAF, who use it as a staging post en route to the Falklands. Halfway between Congo and Brazil, 700 miles from anywhere, it's a small isolated volcanic island barely seven miles across, slap bang in the middle of the Atlantic Ocean.

Pub fact: it is the location for one of the BBC's relay stations that broadcasts the World Service to West Africa and Latin America.

I am here to film the aptly named Ascension frigate birds that nest only here. It's for a new ten-part BBC series called *Planet Earth*.

Being volcanic, much of the island resembles another planet. It was once home to millions of seabirds but, like many places, has been royally screwed by humans, mainly by the introduction of rats, cats and goats, which decimated the ground-nesting bird population. Now the seabirds choose only to breed on the much smaller Boatswain Bird Island, 270 metres offshore. This is where there are Ascension frigate birds, Madeiran storm petrels, black noddies, masked boobies and red-billed and white-tailed tropic birds. Myself, researcher and underwater assistant Hugh and a scientist have permission to land here by boat to film.

As with all seabird colonies, there is a very distinctive almost musky smell of bird shit: strong but weirdly not offensive. Centuries' worth of this guano build up to tens of metres thick. To get to where the birds nest, we follow a precarious historic footpath. It's still marked by rusting old metal stakes driven into the cliff with fragments of rusted chain as a handrail. This is the route up Boatswain Bird Rock used by guano miners back in the 1920s.* Once at the top, all the birds look surprised to see us but they have little fear and I set about filming. The term 'sitting ducks' springs to mind.

The soundscape is evocative, like somehow stepping back in time. No man-made sounds, only seagull-like calls, screeches and cackles all mixed by the wind. Not overbearing but very 3D. The frigate birds also clap their beaks, a gentle noise like the drumming of fingernails on large bamboo. As the sun starts to set the light turns warm and glorious. Frigate birds fill the sky, hundreds of them just effortlessly hanging on the air

* Guano is a crumbly rock formed by centuries of accumulated bird excrement. It is rich in nitrogen, phosphate and potassium and makes an excellent fertiliser. It is particularly sought-after today by organic farmers.

in the evening light. With the camera pointing straight up, their silhouetted profiles look like an armada of pterodactyls. An historic image. I try to imagine what it would have been like on Ascension Island a few hundred years ago, when millions of these birds would have taken to the skies.

The tricky thing for this sequence is to get a nice wide shot of this little island and give a real sense of the scale and numbers of birds. It is too shaky to film anything good from the boat, so the best bet would be to film from the beach on Ascension. I want to get the shot looking east at dawn as the sun rises behind Boatswain Bird Island. It should look imposing in silhouette with its tall, steep, rugged cliffs and its halo of soaring birds. Hugh and I recce the hike to the beach. It will take around three hours to get in with the kit, but probably eight hours to hike back out. The other option is to be dropped at the beach by boat and then picked up in the morning. Much simpler. Probably.

It takes us two hours to chug round from Georgetown and the boat holds position about 50 metres from the beach. The water is fairly calm with only gentle waves breaking. Hugh and I get in the water with two waterproof Peli-cases each and swim ashore. We swim back and forth with more cases until all our equipment is on the beach. Then the boat leaves us and will return in the morning.

The first thing we find out is that the waterproof cases aren't entirely waterproof. Thankfully, only a tiny bit of seawater has seeped in and nothing is wet or damaged.

I set up the camera and tripod and we wait until the sun sinks lower and the light becomes more dramatic. I then film the seabirds wheeling above the small island in the warm light. It looks impressive and gives promise for the same shots in the morning.

Hugh and I eat and chat before getting some sleep, the sound of the waves breaking through the night mixed with the haunting calls from the seabirds.

27 APRIL 2006
Ascension Island

7° 56' 5" S
14° 19' 02" W

I wake before dawn and ready the camera. As soon as there is colour and enough light in the sky, I start to film. It is as good as I'd hoped for, with hundreds of birds hanging in the air above the island, while others peel away and head out to the ocean to fish.

Another near miss

Hugh and I pack up the camera kit, sealing the vulnerable bits in plastic bin liners before putting them in the 'not so' waterproof cases, ahead of the boat arriving to pick us up.

The swell has picked up overnight and now slightly larger waves are breaking on the pebble beach. Doug, the underwater cameraman, swims close to shore with a life ring on a rope attached to the boat. I wade out up to my thighs to pass the cases out through the waves to Hugh and Doug treading water, and the kit is towed back to the boat with them in batches. The waves have power and are coming up to my chest; I have to brace for them, standing sideways on the rolling pebbles. The last case is in their hands so I wade out to join them. That's when a large wave catches me and the pebbles roll from under my feet. I gulp a mouthful of water into my lungs and start to cough while desperately trying to get a footing. As the waves roll downwards, I catch a glimpse of Hugh, Doug and the life ring being towed out of reach and know I have to make a grab for it. It is a weird situation: I am so close to shore and so close to the life ring and yet I know I'm going

to drown. That one small unexpected gulp of seawater, not being able to get a footing, the next wave hitting me. Panic almost sets in, Hugh and Doug facing the boat unaware. Swimming in sandals is hopeless but with one last desperate lunge I manage to get one hand on the life ring. Doug and Hugh look at me surprised as I cough up seawater to clear my lungs.

I am an experienced swimmer but that one just got me. It all happened so fast and actually really shocked me. For one brief moment I genuinely thought I was going to drown.

Later, someone on the boat shows me a photo they'd taken at the moment I was trying to put my hand on the life ring. It's quite a shocking image of me drowning, but thankfully I didn't.

20° 01' S
13° 50' E

8 AUGUST 2006

Kunene Region, Namibia

Endangered Black rhinos are much misunderstood and have a reputation for being solitary and aggressive that is not altogether true. In Africa they have been persecuted and hunted almost to extinction for their horns. Save the Rhino Trust (SRT) was set up in 1982 by the late conservationists Ina and Blythe, to try to halt their demise. Friend and presenter Saba spent a year working on the project, and during that time Blythe told her of a secret place in Namibia where black rhinos gather in numbers to socialise at night. *Saba and the Rhino's Secret* documentary aims to follow Saba's journey as she tries to reveal the true nature of the black rhino.

Having travelled up the skeleton coast we join the SRT anti-poaching patrol that uses camels to cover the 2.5-million-hectare area as the going is too tough even for 4x4 vehicles. With their expert guidance, we hope to find and film a rare black rhino in the wild. We pack most of our kit on the camels, but so as to be ready I carry the camera and tripod built to film.

After walking over rough terrain in full sun for five hours, the rangers pick up some rhino tracks. Rhino are understandably skittish, so I go on alone with the ranger to find our quarry. Although distant, we can see not one but three black rhinos in the shade of a small tree. The ranger checks the wind direction and we move downwind to approach closer. Yes. It is a mother with a juvenile and a baby. Better than I could have wished for and the breeze is in our favour.

The Damaraland desert is dry, harsh and rugged – covered in stones and with the odd bush and tree. It certainly doesn't offer much cover for stalking close to rhinos or for hiding from them if they were to charge. Trusting my guide, we inch closer and get to within 50 metres. He stops by a wardrobe-sized bush and suggests I set up and film. While lining up the camera I ask, 'Is this safe? What happens if they charge us?'

He answers, 'If they charge then dive under here.' He points to the small bush beside us that would barely stop a cyclist never mind a one-tonne rhino doing 30mph.

I can only trust his judgement and start to film. Through the heat haze I see the mother and the juvenile standing still, the baby then lies down to sleep.

Several hours go by and there is little shot variety I can get. Suddenly the ranger and I look at each other and then at the rhinos. The wind has swung through 180 degrees just like that. Three seconds

later the rhinos are on their feet and mum looks well pissed off. I run the camera and zoom out as they start to charge. With three rhinos at once coming at speed towards us, we both dive into the base of the bush. Part of me is willing mum to send my camera flying, but for self-preservation I want her to just run away. The thundering of their approaching hooves crescendos fast, but at the very last second, just two metres from the camera, all three turn 90 degrees right and carry on running. Realising they are retreating, I leap up and spin the camera round to film them disappearing in a trail of dust. Thankfully, rhinos have poor eyesight and I think mum saw the camera and tripod as a tree stump so didn't run into it.

What a buzz. The ranger is grinning from ear to ear – I think he also enjoyed the rush.

Please, if anyone reading this book has been charged simultaneously by more than three rhinos, I'd love to buy you a beer and hear the story.

Also, the illegal wildlife trade is the fourth most lucrative criminal business and estimated to be worth at least £14 billion a year. Please consider donating to hardworking charities that are trying to combat this.

19° 18' S 54° 49' E 11 AUGUST 2006
Ongava, Namibia

This is the last day's filming after an epic four-week road trip around Namibia. We are missing one crucial sequence: the opening to the film.

Saba wants to construct a scene where we set up the perceived idea that black rhinos are aggressive.

Opening scene: Saba on foot in the African bush watching a black rhino. The rhino sees her and gets wind of her and charges. Saba has to escape by climbing a tree.

It's only a 30-second teaser and most of these shots we can re-enact, but for the scene to be believable we need at least one shot of Saba with a rhino in the same frame.

Ongava is a private game reserve adjoining the south end of Etosha National Park. It is fenced and has a small number of black rhinos which they have kindly agreed we can film. One small bonus here is that there are no buffalo, which makes it slightly safer being on foot.

For the final afternoon we head out in two vehicles with an armed ranger. He knows that rhinos will often come to drink from two waterholes at the end of the day. We split up to maximise our chances, half the team going to the first waterhole and Saba, Nick (sound), the ranger and me going on to the furthest waterhole. If the other team see a rhino first, they will radio to call us back.

As we pull up to the waterhole, two black rhinos have just finished drinking and are turning to walk away. We all quickly and quietly get out of the vehicle and set off with the camera and sound. I suggest that Saba and the ranger head to the left of the rhinos and we go to the right. That way, when we catch up with them, I'll have the rhinos in the foreground with Saba facing them and the camera. We move fast but cautiously, keeping an eye on the rhino and Saba.

As Nick and I worm our way through the bushes dotted in the grassland I say to him, 'I would never consider doing this elsewhere in Africa as this is prime habitat for buffalo.'

A bit further on I hear a low 'Whoom … Whoom' call and recognise it as ground hornbills. Knowledgeably, I whisper to Nick, 'Ground hornbills! Impressive birds, you usually see them in fours,' and on we go.

After walking for ten minutes, we have caught up and are now level with the two rhinos and I can see Saba beyond. I quickly set up the camera and tripod, frame up the shot and hit record, giving Saba a wave to cue her.

Saba steps forwards from the side of a bush, acting as if to get a better view of the rhinos. On cue, the rhinos look up, are startled and take off to the right. Saba then beckons to Nick and me. Thinking she can still see the rhinos, we rush over to perhaps get another shot.

Instead she said, 'Guys, there are lions right here!' *Christ, I'm an idiot,* I think to myself. There was me thinking how safe we were and that those noises were ground hornbill contact calls!

The ranger takes charge: 'We have to get back to the car. This is a pride of seven females and I have been hunted by them before when out on patrol. Stay close.' He puts a round in the chamber of his rifle. Locked and loaded, safety off. To our right, the west, the sun is nearing the horizon. It will be dark within 20 minutes or so.

We go no more than 20 paces before a lioness appears from the bushes 30 metres ahead of us. She is advancing, crouched low to the ground, ears back and looking extremely wild and mean.

The ranger says, 'Stay close and keep moving towards the car.'

At that the lioness charges and the ranger fires over her head. She doesn't even flinch and continues her charge. The ranger fires again, this time into the ground

just in front of her. Gravel kicks up into her face and she stops, hissing at us.

In those split seconds, a whole mix of emotions spins through my head. Clearly, I'm nervous and adrenaline is running high, but my underlying thought is that I don't want to see this lion shot.

The ranger keeps us moving, his gun trained on the lioness. 'Keep watch up ahead. There are six more lionesses here somewhere.'

I am wide awake, alert. Moments like this, when charged with adrenaline and fear, I find it's almost like I have taken a performance-enhancing drug. As I scan the grass and bushes ahead of us, I can see every blade of grass, every leaf, every insect. I know from experience to look through the gaps, searching for a glimpse of fur or the twitch of an ear.

We have 300 metres to go and the lioness is stalking low, just 25 metres behind us the whole way. I ask the ranger how many bullets he has and he confidently replies, 'Plenty.'

It is an intense five minutes or so but we make it back to the car. The lioness has dropped back to 50 metres but has still followed us all the way.

I look to the west and the orange orb of the sun is balanced on the horizon. Four bee-eaters are silhouetted artistically on a branch of dead tree. I ask the ranger, 'Can I grab a quick shot of that?'

Keeping his eye on the lioness, he answers, 'Be quick.'

I frame up and run the camera, the four birds fly off on cue. Then the ranger says with authority, 'Get in the car now.'

I get in and, as I shut the door, the other six lionesses poke their heads up from the grass. They had been with us the whole way and we hadn't seen one of them.

It is so easy to get drawn in to 'getting the shot'. Today we were very lucky not to have been killed by a lion.

I was annoyed at myself, though, not just for being so distracted by getting the opening of the film but because, through TV tunnel vision and our own stupidity, we could have seen a lioness unnecessarily shot and killed.

34° 19' 30" N
87° 46' 54" W

2 MAY 2011

Dismals Canyon, Alabama, USA

A very close call

On 27 April there was a 'Super Outbreak' of tornados in the USA: 216 touch down, leaving catastrophic destruction in their wake. In total, 324 people are killed, of whom 238 are in Alabama.

I am in Franklin County with my son Tom as camera assistant to try to film dismalites – tiny larvae of a native insect that emits a dim blue light to attract food – when an EF5[*] tornado, the highest category, sweeps through. It hits the two towns, Hackleburg and Phil Campbell, either side of us, killing 72 people. The tornado funnel measures 1.25 miles wide on the ground with peak wind speeds of 210mph. It passes within half a mile of the cabin we are staying in.

I write an email to producer Huw back in the office in Bristol:

Dear Huw,

Greetings from storm-torn Alabama! Are you in Winnipeg with Ben to do the garter snakes? I hope they perform.

[*] Enhanced Fujita scale.

The dismalite shoot is going slowly but has potential. As has often been the case on the *America* series, weather has disrupted proceedings somewhat. The first day and night here Tom and I recced the canyon thoroughly. The canyon was pretty, with delicate ferns, columns of dancing insects in the sunlight, salmon swimming lazily in the shallows – all good. We did some test shots to assess exposures at night of the dismalites which were plenty, but very small and dim. We were encouraged. Claire* arrived and met us in the canyon around 11.30pm. However, storms were approaching and the canyon did not seem like a wise place to be! By 3.30am we were on tornado watch. The storms were pretty severe. In the morning the river level through the canyon was up by 10 feet, with fallen trees and debris being washed down at speed. By midday the storms were building in ferocity and the tornados were touching down across the southern US states. We put on the TV and as usual the USA seemed to be overdramatising the situation: the warnings were on every channel. As more and more tornados were reported we paid closer attention and Claire got out her map of Alabama. The storm by now was hitting our cabin pretty hard and it seemed unwise, if not impossible, to escape. We cleared the main room in our cabin and emptied the stone fireplace and lined it with blankets – the storm was now quite scary. Just as the weather channel announced that the tornado was going to hit Phil Campbell in four minutes (where we were, according to Claire's map) the power went out, we lost the weather TV warnings and were in the dark. I looked out of the window through the trees and the sky was a weird

* Australian entomologist hired to help out and as consultant.

green-black just to the south-west and there was an extraordinary roar like a freight train passing 10 feet away. I tried to remain stoic to set an example to Claire and Tom but I was pretty scared. Within a minute or so the roar faded. Soon after it seemed like another huge tornado passed about half a mile to the north-east with the same dark-greenish sky. After that the storm continued but slowly calmed down.

A few hours later the rain too eased off and we walked down to check the canyon to see if it would be safe to film that night. The steps and bridge were still covered by a raging torrent so we couldn't film.

On Wednesday evening we were able to get into the canyon and film. I shot some silk-laying and feeding behaviour on infrared and we left a tracking time-lapse running with two Canon 5Ds*. The dismalites are so dark I am having to shoot 30-second exposures at f1.4 on 2000ISO!!† Each 10-second time-lapse is taking around six hours. The glow is so dim that we are unable to see any hint in real-time shooting.

The power came back on yesterday after six days so we are no longer having to drive 20 miles to go and recharge. They had sold out of generators, torches (flashlights), batteries, jerrycans, water, etc. We drove to Hackleburg and Phil Campbell just to see what the tornado had done after we'd

* Thankfully, with the advent of digital time-lapse, I no longer have to stand there and manually click the button to take each shot. (These young whippersnappers don't know how easy they've got it!!)

† In 2011 this is a higher sensitivity than you'd normally want to use as it introduces noise/grain into the picture.

heard reports of 40 people dead and 60 missing! We had no idea it had been so severe. The two small towns either side of us were destroyed, wiped out. I have never seen anything like it.

We do not have a Varicam* until Mandi† arrives on the 6th so cannot film any of the aftermath. There is also now martial law in the two towns due to looting. The army didn't arrive until after Obama had made his visit three days after the tragedy. There are still apparently 100s of people missing in Alabama. There is a smell of rotting flesh in the air here and we have been advised to boil the water before we drink it!! Nice thought.

Flood warnings for tonight so the canyon may not be such a good idea – we are keeping an eye on it. The forecast looks good from what I can tell. We also need to check that Huntsville airport is still operating normally and that the curfew is not still in place as Claire's flight is at 7.20am tomorrow (Tuesday). We may decide to drive there in daylight today if there is no travel allowed at night in Huntsville.

Other than that we are in good spirits. Little or no phone reception here and internet v. slow. Speak soon.

Gavin

* The Panasonic Varicam was the current video camera of choice for everyday filming.

† Producer.

Don't Try This at Home

Farne Islands, UK

Apart from a few studio days in Bristol, this is my first
proper freelance job, filming nesting terns on the Farne
Islands for *The Trials of Life*.

*We're going
to need a
bigger boat*

I say goodbye to Maggie and Thomas and drive 350
miles from Bristol up to Seahouses, where I'll be staying
for the week. I meet up with assistant producer Neil,
who came up a few days earlier to set up my week-
long shoot, and we head to the harbour. En route Neil
explains that he's organised a boat just for me, run
by a local man, Billy Sheil. It will take me the three
miles across to the islands each day, and give me the
opportunity to film some tracking shots from the boat.
Then Billy will drop me off on the islands and return
to take me back to Seahouses at the end of the day.

We arrive at the dock and I unload my precious
and expensive new camera gear from the car. Neil
helps me across to a boat moored up on the dock-
side. I look at the boat and think, *Bloody hell, that's
quite small*. Neil jumps aboard and I pass my camera
gear to him. Then, as I jump aboard, to my slight
horror Neil passes my kit over the side of that boat
and down towards the sea. I rush to the edge of the
boat to see my camera being taken by a skipper on
an even smaller boat – a fishing boat just 20 feet
long and with a small central wheelhouse you could
barely squeeze Captain Birdseye in. The sides of the
boat are only shin-height so look ideal for tripping
overboard, and they don't look like they'll offer much
protection from sea spray and waves for my valuable
camera gear.

Neil must have read my concerned face and laughs, 'You didn't think the BBC would hire a 20-passenger boat just for you, did you? You'll be fine on this smaller one. Billy has been doing these trips for decades and never sunk once!'

I don't let on to Neil that my real concern is that I can't afford insurance for my new kit. I'm putting camera kit of more value than my flat into this tiny rocky boat to head three miles offshore.

8° 58' 23'' N
79° 31' 00'' W

27 JULY 1989

Panama City, Panama

Turns out the BBC were very happy with my footage from the Farne Islands. Now I am back in Panama again to film sequences of stingless bees and gladiator frogs, also for *The Trials of Life*.

Waiting to get off the plane, I happen to look out of the window to see my silver camera case flying out of the cargo door and hitting the tarmac. A baggage handler picks it up and throws it onto the cart with the other bags. I feel sick, helpless and angry, and just hope my new ARRI baby is okay.

We collect all the kit and pass through customs without an issue: the customs officer remembers me from the year before and my kind 'donation' to their New Year's Eve party.

Panama held a general election in May and the military dictator, Manual Noriega, didn't like the result, so he voided it and continued to rule by force. This angered the local population and the USA, who then recently indicted Noriega for drug smuggling, money

laundering and racketeering. President Bush even asked Noriega to honour the will of the people but to no avail. The USA reinforced its Canal Zone garrison, and has upped training and other activities as a show of strength to put pressure on Noriega. So, tensions are high in the city and there is a greater military presence on the streets than on my last visit here.

Once again, we are staying in the Holiday Inn in Panama City. The first two hours are spent in my room trying to fix my lens, which the baggage handlers knackered by throwing it off the plane. I have learned the hard way not to travel with the lens on the camera. The impact on the tarmac has stripped the thread on some screws of the lens mount. I am able to bodge a fix using shreds of matchsticks in the holes and Araldite glue. Thankfully, the happy hour deal is still on in the bar downstairs.

28 JULY 1989
Holiday Inn, Panama City, Panama

8° 58' 23" N
79° 31' 00" W

Assistant producer Neil calls me from his room. 'Look out of the window!'

Unrest in Panama

I rush to my window and draw back the net curtain.

The skies to the west are thick with parachutes. More US military planes are drifting over the bay with even more troops piling out of the back. I feel nervous. Is this war? I grab my stills camera to take some pictures but then chicken out. I'd never make a proper journalist.

Neil knocks on my door and I let him in. Analysing the scene, it seems that the US are just trying to intimidate Noriega. They've purposely chosen a day when the wind direction is such that the parachute training will drift the troops right over the top of *La Comandancia*,

the headquarters for the Panamanian Defence Force under Noriega's control, and let them land back at the Albrook Air Force base.

Well, the display certainly intimidated me!

On the way down in the lift to the lobby with our kit we chat with the rather nervous porter. He explains in his broken English that they are all fed up with Noriega and scared too, and that the sooner the Americans capture him and take him to trial, the better. But the porter fears for his life and makes us swear not to tell anyone what he's said. Too many people disappear if they say bad words against Noriega. I find it horrifying that people are living in fear like this.

Neil and I are working out in the forests towards Gamboa and are going to be driving out each day. Our route takes us past the Albrook Air Force base and Fort Clayton. These have swelled noticeably in military hardware and activity since I was here last year with Alan. America is showing its military might to try to unnerve General Noriega.

After a relatively peaceful day filming stingless bees in the forest out near Gamboa, Neil and I head back to the hotel. The skies are grey and the atmosphere feels oppressive; it is threatening to rain. As we approach the US military base, there is definitely something afoot. Apache helicopters and armoured vehicles are alternately lined along the whole length of the road as far as we can see. The helicopters are hovering with menace just six feet off the ground, each bristling with missiles on their stubby wings and with machine guns underslung from their bellies. The armoured vehicles have troops in full combat gear manning the turret machine guns. All are poised for an imminent attack. Not quite knowing what to do, Neil stoically drives on past to the hotel. We have to

assume it is more US military bravado still attempting to force Noriega to give himself up.

Back at the Holiday Inn, happy hour calms our nerves.

29 JULY 1989
Panama City, Panama

8° 58' 23" N
79° 31' 00" W

After a night of no gunfire, Neil and I assume it's okay to go back to the forest to film. We head out on our usual route. Neil is driving and I have my stills camera on my lap. This time, it is the Panamanian Defence Force (PDF) showing their presence. Along the roadside in the city are lines of troops in combat gear, some armed with guns and others with batons and riot shields. It all feels very threatening. There are very few cars or other people out on the streets. Something is going down and it feels like we shouldn't be here. *Unrest is escalating*

As we round the corner, we can see there is a protest on. The University of Panama building is set back from the road behind a chain-link fence. Under the trees outside on our left, a crowd of students are gathered, chanting and holding placards. Some of the students are throwing stones across the dual carriageway at the lines of PDF troops on our right. Seconds later, the troops open fire, shooting across the road and over the heads of the students and we are driving through the thick of it. Neil steps on the gas. Other cars swerve off the road, one skids across the grass and through a fence. I shrink in my seat as much as I can and tuck in by the door pillar in the hope it might offer some protection. Leaves and branches rain down from the trees and I see an oil drum litter bin dance and spin past the students as it is hit by bullets. I can't see if the bullets have hit

anyone, I really hope they haven't. Neil races ahead and 30 seconds later we are clear from the trouble, the sound of gunshots now behind us.

We drive out to the forest in shock and silence. Once on location we get out of the car and just stand, again in silence, for at least an hour. What have we just witnessed? What the hell is going on? Will it be safe to return later?

We are soon distracted by the sights and sounds of the forest as we set up to film the stingless bees. It's such a 3D landscape with a soundtrack to match – the underlying buzz from cicadas punctuated by an orchestra of tropical birdsong, with distant monkey calls thrown in for good measure. The forest here draws me in and immerses my senses. Once I have my eye to the viewfinder, my vision is filled with the endearing faces of the bees, five or six of them guarding the tubular wax entrance to their nest. The worries of what happened earlier fade completely. Nature in its beauty and complexity is an easy diversion from the rigours of human turmoil.

That evening we drive cautiously back into the city. There is no evidence of this morning's trouble and we make it safely back to the Holiday Inn.

Going up in the lift to our rooms we quiz the hotel porter about what happened. He stops the lift between floors and opens up to us for 30 minutes about the horrors of Noriega over the last year or so. He begs us to report what is going on to the world. We have to explain that we are not journalists but just here to film wildlife. I try to reassure him that the world is watching, just as we had seen what happened in Tiananmen Square in China earlier that year. Things will improve and I am sure that the USA will get Noriega.

———————————

25 OCTOBER 1991

Kitale, Kenya

1° 3' N
34° 46' E

I've been out in Kenya again with producer Nick for just over a week. We are filming a few segments for a programme about ants and termites called *The Little Creatures Who Run the World*. It's to be presented by respected American biologist, E. O. Wilson.

The little creatures who run the world

We start off just outside Nairobi, filming the formidable driver or safari ants. These ants can form the biggest single colonies of any animal on Earth, with up to 20 million individuals. They have been known to kill, dismember and eat a tethered horse, devour human babies, and have even been used as a form of execution for convicted criminals. These are Africa's answer to South America's army ants. Very similar behaviours – scientists call it convergent evolution.

Building on my experience of filming the army ants back in 1989, I feel I am getting better shots. I have perfected the technique of being able to track alongside the columns of ants as they head out to raid. I have even built a makeshift rig using the headlamp bulb out of our hire car, to be able to film right inside the nest. The one thing I haven't been able to do is adequately defend myself from this army. I have been bitten and stung to buggery and it bloody hurts. At least I am not a tethered horse or convicted criminal and am able to get out of the way when the attack becomes too much. Just like the army ants, these guys have started to cut through all the stitching on my walking boots.

Sadly, the weather has been too dry for good ant activity so we switch our schedule and decide to move

on to other locations. We will return here at the end of the trip when hopefully we have had some rain to stimulate more raiding.

2° 5' S **29 OCTOBER 1991**
36° 46' E Kajiado, Kenya

We head south to Kajiado where there is a species of ant that only eats termites: the termite-raiding ant. They are commonly known as Matabele ants, named after fierce warriors who overwhelmed other tribes in Africa in the 1800s. I think they could be my new favourite insect.

These ants are large, about 20mm long, so even to the naked eye you can see the details of their eyes, their long jaws and the small golden hairs on their bodies. These ants have character and seem expressive with their antennae and posture, not unlike a dog with its ears. But they are also relatively sleek and look like they mean business.

The colony has scouts that head out across the landscape searching for termites active on the surface. When a meandering scout finds termites, it heads straight back to the colony.

Within one to five minutes the army is ready. Up to five hundred ants emerge in a column and head off three or four abreast to their quarry. You can almost hear the sound of marching boots. Once they get within a few feet of the foraging termites, the lead ants stop and wait for all the others to assemble alongside. Then, as a body, they attack. I liken it to the whistles that were blown to signal the troops out of the trenches. The ants move in without mercy, biting and stinging termites left, right and centre. The termite soldiers try in vain to repel the attack but these ants seem invincible.

Within another few minutes the attack is over. Again, almost as if one of the team has blown the whistle. The Matabele ants gather up the dead and dying termites, sometimes as many as four in their large scimitar-like curved jaws. Other ants also pick up their own injured if they can still be of use to the colony. Then the column reforms and the army marches back, triumphant, to their nest.

I love them. They are such a good subject to film because there is obvious drama. You don't have to be a scientist or expert to tell what is going on. The goodies or underdogs are the termites, the baddies or lovable rogues are the ants. They raid two or three times a day, so very quickly we get all the shots we need for a dramatic sequence.

Then we head to Lake Bogoria National Reserve. Here, 30-foot-tall termite mounds dot the landscape, with a spectacular backdrop of flamingos and geysers which ribbon the lake. It is the perfect place to film shots that demonstrate the amazing building skills and architecture of termites.

Thousands of elegant pink flamingos parade the shallows and stoop their long necks to feed on the blue-green algae that flourishes in the warm waters of the lake. For me, though, the highlight of visiting Bogoria is being woken up at 11pm by the guard who tells me, with a huge smile on his face, that a hippo has just shat all over my hotel chalet door. To be fair, I did ask him before I went to bed to wake me if the hippos came to feed on the lawn, as I'd never seen one up close at night before.

1° 3′ N 2 NOVEMBER 1991
34° 46′ E Kitale, Kenya

We are back in Kitale for a couple of days as there has been more rainfall in this area. Saiwa Swamp National Park, just a short drive away, is supposedly another good spot for driver ants and we might have more luck with the raiding shots we are missing.

Nick and I are feeling drained and both have the shits. I stay in bed for the day and Nick goes to the doctor to get some treatment. As we probably both have the same bug, he gets two lots of the drugs.

Later in the day, the pills are helping Nick but don't seem to be making me better – if anything, my stomach cramps are worsening. There is the ominous sound of distant thunder (not just my stomach) and the house is plunged into darkness by a power cut. My diarrhoea gets worse and I start to see blood in it. Worrying, to say the least.

I get up again in the evening to use the toilet but Nick is in there so I have to rush to the outside loo. As I sit there and the world falls out of my bottom, I have a weird burning sensation in my feet, legs and buttocks. I was already feeling weak and confused but this is strange and getting painful. I turn on my head torch and look down. Driver ants are on a full raid of the outhouse and I am sat in the midst of it all. Without dignity, I half pull up my shorts and run outside. The ground is seething with ants and I stumble quickly through them to the house. Despite the pain of the bites and stings, and now feeling really ill and faint, I can't help but laugh. The irony of searching Kenya locations to film these ants raiding – and they had found me in my darkest hour.

I brush off the ants and stumble inside to take a shower.

Later that night I have to rush to the toilet yet again. Sitting there by candlelight I feel very faint. I am now losing a lot of blood in my stools. The next thing I know, I'm coming to on the toilet floor. My head hurts where it's hit the concrete and I am staring up at the candle burning on the windowsill. I pull up my boxer shorts, crawl to Nick's door and knock for help. 'Nick. Sorry to wake you, but I feel really shit and have just fainted. I'm losing quite a lot of blood and am now very worried.'

I hear Nick hurriedly get up, pulling on some clothes, 'Okay. I'm coming.'

At that, he flings open his door, whacking me on the head and knocking me out cold. When I come to, I am in his arms as he is carrying me back to my bed. He is very apologetic, not knowing that I was lying on the floor outside his room.

Before first light in the morning, Nick helps me out to the car and we drive down to the surgery he'd been to the day before. I am first in the queue and the doctor sees me straight away. He takes my temperature, pulse and blood pressure and asks me a few questions. Then he takes some blood, puts a drop of it on a microscope slide and looks at it right away.

'The good news is, you don't have malaria. You do, however, have amoebic dysentery. Here's a prescription for Flagyl. You can pick it up next door.'

As I thank the doctor, Nick pays the bill and picks up the prescription for me. I comment to the doctor that you would never get that swift a test and treatment in the UK. The fact that he took the blood sample and looked at it himself, making a diagnosis there and then, is amazing.

The doctor replies, 'We have to do that with serious diseases. If we'd waited until tomorrow for a diagnosis you would probably be dead.'

A few minutes later I take the first dose of the anti-biotic. Maybe it is psychosomatic, but I feel 80 per cent better within ten minutes.

We are eventually able to finish the driver ant sequence. I keep thinking to myself, *Thank God I didn't pass out in the outhouse toilet*, With the number of ants I saw raiding that night I think Nick would have only found my bones and head torch in there in the morning.

32° 42' 59" N
114° 56' 23" W

6 JUNE 1992
Yuma, Arizona, USA

Mad dogs and
Englishmen

I'm here with producer and friend Neil, and this is the first shoot for a new Attenborough series called *The Private Life of Plants*. In initial meetings back in Bristol I mentioned that I thought six 15-minute programmes about plants were going to be hard to fill. Plants are, after all, mostly static unless the wind blows them or you film them in time-lapse. After my years at OSF I know how time-consuming time-lapses are, and not always successful. Imagine my surprise when I found out I had misheard and it was to be six 50-minute programmes!

This story has potential, though, because it is about tumbleweed. You may be familiar with it from watching Western movies. It often features blowing through one-horse towns just before a gunfight. Tumbleweed is a generic term for some desert plants that grow flat along the ground, usually in dry sandy or rocky habitat. At the end of the growing season, once they have flowered, the plants dry and shrivel up – a bit like a flat open hand closing into a fist. The ends of the 'fingers' where the flowers were are now dry seedpods. When the wind

blows, the plant's shallow roots can become dislodged and then the dry ball-shaped plant tumbles across the landscape and in doing so spreads its seeds.

The idea is that Neil and I film this process and the sequence will end with the tumbleweed being caught by David in his hand. He will then stand up and deliver his explanation, pointing out the mechanics of the plant.

Yuma is just a few miles from the Mexican border and very hot. The temperature ranges from about 30°C in the morning to 42°C at midday. Those are temperatures taken in the shade! We are working in the open with no shade at all.

We have film permits for an area of undulating sand dunes about a 30-minute drive out of town, just off the main highway. After filming the early stages of the plant's growth and details of flowers, we are slightly stumped because there is not a breath of wind to be able to film the tumbleweed blowing across the dunes. Time for a trip to Walmart.

We return to the dunes armed with a generator, an industrial-sized office fan with 50 metres of extension lead, a rake and two brooms. Sorted.

We choose our area to film in and place the generator midway so the extension cable will reach the whole stretch for the 'wind machine'. I set up with the camera and long lens and poor Neil has to charge across the sand dunes carrying the fan and dragging the electrical cable, blowing the tumbleweed ahead of him. In the dry desert heat this is no mean feat. I am in stitches filming this bizarre scene but the shot works well. The wind, blowing sand and bouncing the plant along look totally natural. Neil, however, is very red in the face and looks like he's about to pass out.

Next, it's my turn to work up a sweat. I mount a specialist lens, called a straight-scope, on the camera. This enables me to get the lens very low to the ground

and it focuses very close with a wide angle of view. I can then run with the camera and track the tumbleweed as it rolls over the dunes – Neil obviously running along too with the fan to blow it. As we are setting up for this, a vehicle stops on the main road 100 yards from us. A man gets out and hurriedly takes a photo of us over the roof of his car before getting back in and racing off. Strange behaviour. We carry on filming.

Running with the camera over the scorching-hot dunes I can now sympathise with Neil's suffering. It is dangerously hot. I drink gallons of water but can't quench the dryness. It sweats out faster than our bodies can absorb it.

We are absolutely fried and just about to pack up when an Arizona state trooper pulls up in his vehicle. He seems nervous and unclips his holster. He shouts across to us, 'What are you guys doing?'

Sensing tension, I reply in my best British accent, 'Hello, officer. We are filming tumbleweed for a new David Attenborough series about plants.'

He relaxes slightly and re-holsters his gun. 'I might have guessed it. It's just that we had a report a little while ago of suspicious behaviour on the highway and thought it must be illegal immigrants. Have a good day.' Then he does a U-turn and drives back into town.

'I might have guessed it?' questions Neil. 'How many people does he have coming here with generators and fans filming tumbleweed in the middle of the desert and the heat of the day?'

For the record, once we had finished filming for the day we got back to the car and Neil's keyring thermometer, which was on the car seat, had burst. The scale went to 55°C and clearly had been pushed way beyond that.

15 MAY 1993

51° 24' 52" N
2° 36' 18" W

Bristol, UK

I've been filming for a BBC documentary called *The Witness Was a Fly*, about natural history forensic evidence used in criminal investigations. Today is a story about a robbery from a solicitor's office safe where the burglars used explosives to blow the safe and steal some papers and money. Historically, every safe has an insulating layer of sawdust between the outer armoured steel or cast iron and the inner layer. When safes are made, a sample of that sawdust is kept, along with the serial number for the safe. If a safe is blown then fragments of sawdust go everywhere and even the tiniest particles will get caught in the thief's clothing. Detectives can analyse the 'diatoms' from a suspect's clothing and match them to the sample stored by the safe manufacturer. This can be used as evidence in a conviction. (Diatoms are single-celled algae that have silica glass cell walls. They can be up to 0.5mm across and have intricate, often beautiful patterns. There are estimated to be over 2 million different species and they produce up to 40 per cent of the oxygen we breathe.)

We are at a replica set of the solicitor's office, built in a warehouse in south Bristol. We have two special effects explosives experts on hand to blow up the safe for us. They've pre-drilled holes in the hinges of the safe to weaken it and ensure the door will come off. They confide in me that they're quite excited because they have a new explosive to try out called Semtex. It's supposed to be quite good. I am running three cameras on the safe to cover the action from different angles; each camera is behind a protective Perspex shield and sandbags.

353

Permissions have been sorted for the use of explosives at this location and the police and emergency services notified that the explosion will be at exactly 2pm. At 1.57pm, with everything set, everyone on production moves to a safe distance outside the warehouse. I stay behind with one of the special effects guys as he arms the detonator. I then set all three cameras running and we leg it out of the warehouse. Outside, the countdown begins. Five, four, three, two, one and flick goes the detonator switch.

It is an enormous explosion, the loudest I've ever heard. I feel the shock wave in my chest and through my feet. My ears are now ringing and all the car alarms are going off in the car park. We rush back in through plumes of smoke and settling dust. It's a scene of carnage. I stop the cameras which, amazingly, are safe and unscathed behind their Perspex shields. The safe door has been blown clean off and is lying distorted eight feet from the safe. The office parlour palm leaves are shredded and the two fake-oak-panelled office walls have been blown over backwards. A minute or so later, three police cars and two fire engines turn up with sirens blaring and lights flashing.

Lesson learned. Special effects look great on screen but be wary if you are ever on set with those guys. Especially if you hear the word Semtex.

12 NOVEMBER 1998

3° 21' 44'' S
40° 00' 23'' E

Ocean Sports, Watamu, Kenya

I'm in Kenya with producer Marguerite to film some stories about crabs for the coastal programme in a series about Africa. The BBC have booked us into a cheap place on the coast at Watamu called Ocean Sports, known locally as Open Shorts. Now, I'm all for staying somewhere cheap and basic if there's no choice, but we are a few hundred metres from a fairly swanky resort hotel and I can see their lush palms taunting me from above their azure blue pool.* The posh place is called Hemingways and it's where writer Ernest Hemingway stayed when he was in Kenya. Hemingway was a keen hunter and fisherman. I don't know whether you've read his book – I'm ashamed to say it's one of the few Hemingway books I have read – called *The Old Man and the Sea*. It's a short story about an experienced old Cuban fisherman and his three-day battle to catch an 18-foot marlin. No doubt his writing was based on his own sport fishing experiences, perhaps here in Kenya.

We are here to film crabs that climb mangrove trees, fiddler crabs that signal with one oversized claw, and soldier crabs that march in 'armies' on the tidal flats.

* While writing this book, I've googled 'Ocean Sports' just to see and it's had a makeover.

We set out with a basic kit* to recce the locations and talk through approach and the behaviours we are likely to see, along with cheerful Italian crab scientist Stefano, who's studied here for a number of years and is going to be our expert consultant and guide.

The mangroves look beautiful: lush green leaves, interesting tangles of branches and all growing on curved stilt-like roots, like a pianist's poised fingers, stretching down and anchoring in the mud. Further from shore, the roots dip into the milky blue-green water of the creek.

It's beautiful but don't be fooled: this is a harsh environment. The tidal range is around three metres – ten feet. So twice a day the seawater comes in and floods the tree roots and twice a day recedes to leave mud and roots exposed. The sun beats down from above and temperatures can reach 34°C in the shade. The mangrove trees, of course, have to be extremely salt-tolerant. Pour salty seawater on your garden plants at home and you'll kill them!

We walk out through the sticky mud and pick our way through the open channel among the stilt roots. Mud turns to water and we start to wade. Stefano is talking all the while and kindly passing on years of knowledge to help us in our film quest. He points out that crabs are understandably nervous creatures as they are predated on by birds. I am by now seeing very fleeting glimpses of things moving in the trees and scurrying out of view.

* Basic film kit packed in a backpack: ARRI HSR3 camera with two 400-foot magazines (enough for 20 minutes' filming – less if slow-motion), three batteries, Zeiss 10-100mm zoom, Canon 300mm f2.8, 1.4x and 2x teleconverters. Hand carrying: Ronford tall and short tripod legs and Ronford F4 tripod head. All up weight: c.28kg. My principle now is: always take your camera on the recce. Sod's law has taught me that it could be the one time I see the animal or behaviour I've come to film.

Stefano pauses and scans the branches with his binoculars: 'This could be a good place to set up and start.'

Taking care not to drop anything into the muddy saltwater, I start to set up. First, I place the tripod I've been carrying, I extend the legs to get the right height and tread its feet into the soft mud underwater and level the tripod head. Then I ask Stefano to lift my camera out of my backpack and hand it to me. I rest it on the tripod and screw the thread into the baseplate. Secure.

Next, I get Stefano to reach in and pass me the zoom lens. Often when shooting a sequence, I start with the wider shots. Once I've got my 'eye in' and am learning the animal's behaviour, I'll then put the longer lens on and go for the close-ups.

So far so good. Haven't dropped anything into the sea.

Scanning the trees and branches with the camera I now start to see my quarry. Bloody hell, they are small. And most certainly shy. It appears that when they see us, they hide round the other side of the tree trunk or branch they're on.

Stefano explains that if we stay stock still then after a while the crabs will carry on as if we aren't there. To avoid disturbance, Stefano and Marguerite back away to leave me to it and I start to have success.

One of my strategies is to have a canvas bag that I hang from my tripod. This holds whatever lens I'm not using and a 2x teleconverter. When I change lenses, I can swap them over quickly, dropping whichever lens I take off into the bag. Because in this situation I'm keeping my movements to the absolute minimum, I take the teleconverter off and replace the lens on the camera without taking my eye from the viewfinder. I slowly reach beneath the tripod to the canvas bag and, without looking, rest my wrist on the edge of the bag, a technique I've used for years, and drop the converter

in. I hear a splash. Sadly, I've rested my wrist on the far edge of the bag and instead of dropping my lens into it, I've dropped it straight into the muddy seawater. What an idiot.

I search the muddy bottom with my hands and find my lens. We then retreat straight to the hotel, where I rinse it in fresh water and, although counterintuitive, soak it in a mug of bottled water for an hour to dissolve whatever salt might still be on it.

When I finally dry and clean the lens it is absolutely fine. No scratches or ingress of water. Phew.[*]

3° 21' 44" S
40° 00' 23" E

15 NOVEMBER 1998
Ocean Sports, Watamu, Kenya

I'm not getting much sleep as it is hot and humid and there are no fans in the rooms. More worryingly, I'm being hammered by mosquitoes every night – I'm taking prophylactics but the more you are bitten, the more chance of catching malaria. Despite fixing my mosquito net with gaffer tape, the little bastards are still getting in as there are so many holes. Oh, and the food here is dreadful. In fact, both Marguerite and I are getting quite ill.

3° 21' 42" S
40° 00' 25" E

17 NOVEMBER 1998
Hemingways, Watamu, Kenya

The BBC haven't saved any money this trip by not putting us up in the posh place, because we've now lost a few days of our time being on and over the toilet

[*] Twenty years later and the lens is still optically amazing.

rather than actually out filming. Yes, we both have food poisoning. But the BBC have given us special dispensation to move next door to the posher establishment, Hemingways. Hopefully, we can recuperate quickly in air-conditioned rooms with better food, fewer rats and mosquitoes, and get back to filming asap.

20 NOVEMBER 1998
Hemingways, Watamu, Kenya

3° 21′ 42″ S
40° 00′ 25″ E

Having been back out filming all day today, we return to the hotel just as the sun is setting. I can see there's some activity at the fishing dock of the hotel. There's a kind of tall wooden gallows and, hanging from it, a massive sailfish. I don't know much about fish, but it looks like a giant swordfish-type thing, or marlin, hanging head down, dead. Next to it is a large American with a cigar in his mouth, posing in front of it for a few trophy photographs. Two local Kenyans are busy cleaning up fishing tackle and emptying the boat of stuff.

Killing for sport

Curious to see such a huge sailfish, I wander over to have a look. I've never seen anything like it. It's absolutely huge and its colours in the warm last rays of the sun are absolutely stunning – these extraordinary rainbow iridescent pigments in its scales. The other thing I didn't realise about sailfish is that they don't swim around with that great big sail on their backs open up all the time, it can actually be used for display. They can flick it up almost like opening an umbrella and the huge sail, which must stick up proud by about four or five feet, when it folds down is beautifully streamlined because it disappears into a groove down the fish's back. Just beautiful in its design. So sleek you can see how they can zip through

water so fast. Fish like this can apparently do in excess of 60mph.

Looking closer, I grab hold of the sail and pull it out; I'm fascinated by it. The American comes over and I say, 'God, what a magnificent fish. The colours in it are absolutely stunning.'

To my surprise, the American very humbly replies, 'Yeah, you should have seen the colours on it when it was alive. This is nothing compared to what it looked like when it first came out of the water.' He continues, 'Actually, I'm really ashamed that I've caught this fish. I literally saw the life slip out of it. I saw the colours fade as it died on the deck.' And then he admitted, 'I have total regret having caught it. I really wish I'd never caught it. It's only going through the process of catching it that I now realise that I should never have done it. It's such a beautiful animal – and now that's it! I never thought I'd feel like this.

'I'm going to tell all my buddies never to do it. I'm going to have to live with regret.'

51° 31' 28" N **1 AUGUST 2002**
3° 43' 40" W Porthcawl, Wales

Today could not have been more fun. Together with five BBC friends, Stephen, Jenni, George, Simon and Laura, we film the reconstruction of cavemen feasting on a woolly mammoth for a BBC natural history series, *Wild New World*, about the ancestral wildlife of North America.

For this sequence it was cheaper and considered more realistic to have a full-size model made instead of using computer graphics. The job was put out to tender

to local theatrical model makers and several quotes came in. The BBC obviously went for the cheapest quote, which was for the mammoth to be made from polystyrene, covered with fur, with two enormous tusks fashioned from fibreglass. The BBC had to cut the cost further, so ordered the mammoth to be made with only three legs – a saving of around £100. The whole life-size model was made in five sections so that it could be transported to location more easily.

The five of us load up the newly made mammoth sections, some costumes and props into a small removals rental truck in Bristol, with a separate car for the camera kit. It is then a drive of an hour and a half to an area of moorland just outside Porthcawl in Wales. This habitat looks very similar to areas of North America where the mammoth would have roamed. A fairly featureless landscape with sedges and grasses, low-lying shrubs and heathers. Filming permissions have been sorted with the local council a few weeks before, which allows us to have a small campfire as well, providing we have a fire extinguisher to hand.

It is foggy when we arrive on location, where we are allowed to drive a few hundred metres down a track to get away from the main road. There we assemble the (three-legged) mammoth, set up a small circle of rocks and prepare the fire. Meanwhile, George, Simon and Laura get togged up in authentic caveman costume, while I sing the theme tune from the *Flintstones*. Armed with spears and flint knives, they set about pretending to carve meat, bought from the supermarket, from the huge mammoth carcass. Apart from the missing leg it is all looking quite good. The mammoth's stomach is open with bloodied ribs sticking out. I deliberately film through bushes and smoke to help blur the edges and add depth to the shots. The mammoth tusks look particularly good and give a nice focus to the scene.

The mammoth looks huge alongside the crouching figures of George and Simon, cooking meat by the fire.

The clouds clear to blue sky and the sun comes out. Filming is going well. I am just getting close-ups of meat being cooked on sticks when we notice two smart 4x4s pull off the main road and slowly drive towards us. There are four rather official-looking suited men in each car. We stop filming for a moment and walk to meet them as they pull up and get out. As they shake hands with us and the cavemen, they are looking over our shoulders at the mammoth lying slaughtered on its side behind us.

'We're from the local council and have come to ask what you are doing here,' says one of the men. 'We've had a couple of reports from locals telling us that New Age travellers were camped on the common. Apparently, there's a slaughtered sheep too and an illegal open fire.'

Production coordinator Jenni approaches and hands over the council permit. 'I'm Jenni from the BBC in Bristol. I've been corresponding with your office for the last few weeks sorting film permissions for this reconstruction of cavemen feasting on a woolly mammoth. I did speak to a lady yesterday to remind her we were coming.'

'Oh yes, I did hear something about this in the office. So sorry. I thought it far-fetched that someone would slaughter a sheep in broad daylight and so close to the main road. Good luck with your filming.'

Instead of leaving, he then gives us a five-minute rundown of all the famous people he's met during his time working for the council. It's surprising how many Hollywood film stars must visit Porthcawl!

Also, we're all left wondering how bad the eyesight must have been of whoever called in to tell them of the New Age travellers on the common. Despite the fact that a mammoth's around 60 times the size of your average sheep, there's nothing New Age about three cavemen and a woolly mammoth. They're from 10,000 years ago.

1 AUGUST 2002 51° 13' 46'' N
Wookey Hole Caves, Somerset, UK 2° 40' 16'' W

A few days later I head out with producer Stephen and caveman Simon to film another sequence for the same programme – this time a reconstruction of a caveman being attacked by a bear in a cave. The location is Wookey Hole, just south of Bristol. It's a system of limestone caverns that run deep into the southern escarpment of the Mendip Hills, where evidence shows they were once occupied by hominids in the Stone and Iron Ages. The BBC have hired a professional animal impersonator to dress up as the ancient bear. Between this man and his wife, they clearly have a monopoly on bear parts. He's played the bear in the John West salmon ads and the ape in a Tarzan movie; she's played the part of the bear wearing a yellow jacket and pork pie hat advertising German Hofmeister beer – 'Follow the Bear'. * I wonder to myself what their kids might do for a career or what they wear to fancy-dress parties …

It is very difficult to keep a straight face while Stephen is giving a nine-foot-tall bear and a caveman direction for the shots, especially as the bear is talking back. 'I wonder if Simon comes at me from the left with his spear and I counter the attack with a swipe from my right paw. I can angle my claws for Gavin so they catch the light nicely. I've cleaned them up so they'll stand out nicely in the darkness.'

Stephen gives his replies, though I side with the bear on his suggestion. The caveman only contributes grunts while pointing with his spear. Full marks for staying in character.

* Pub fact: the first few of these adverts were the final work of film director Orson Welles in 1983.

With minimal lighting in the cave and the right choice of camera angles, I think the final sequence is actually quite credible. Except when I watch it, I can still hear the bear disagreeing with some of Stephen's direction and it's nowhere near as funny as the John West salmon advert.

———

20° 4' 1" S 4 JANUARY 2007
44° 39' 26" E

Kirindy, Madagascar

Madagascar is an extraordinary country in terms of its unique flora and fauna. Although it is most famous for its lemurs, producer Miles and I are here to film reptiles for *Life in Cold Blood*. We have ten days to film various wild behaviour before David (Attenborough) arrives for the sync.

We fly via Paris to the capital of Madagascar, Antananarivo. From there it is a shorter flight to Morondava. Miles needs to get some local currency to pay for vehicles, food, accommodation, etc., so we stop at the bank in town. Once we have cash and some basic supplies (beer) we set off for Kirindy. The journey is hot and en route we travel through the famous baobab avenue. Huge, fat, ancient trees that wouldn't look out of place on a James Cameron sci-fi set. As we approach the camp the mud track leads us into dry scrub forest, more sticks than leaves. The camp is a collection of tidy wooden huts with grass roofs and this will be home for the next week.

Now, the one thing I know about Kirindy is it's a great location for fossas. The fossa is Madagascar's largest predator and looks pretty cool. It looks like a cross between a short-legged cougar and a kangaroo on all fours, and grows up to five feet long including

its sturdy tail. It has short, dark reddish-brown fur and I'd just love to see one.

Despite there being lemurs and mongooses galore, I'm here to film a bright-green day gecko* that begs for honeydew from sap-sucking insects. After staring at virtually invisible insects (they are so well camouflaged) for seven days, I finally see and am able to film their behaviour. The gecko climbs three feet up the tree to the plant hopper and starts to bob its head. The insect responds by flicking tiny droplets of honeydew from its abdomen, which the gecko catches each time in its mouth. Result.

My personal highlight on this trip though, is running out to look when someone says there is a fossa coming. Sure enough, 100 metres down the dirt track comes this weird creature from the undergrowth. It starts to trot towards me and I get a really good look at it. I think about running to grab my camera but know I won't make it back in time, so instead just enjoy the moment. The fossa continues coming until it's almost ten feet from me. It gives me a cursory glance before turning in towards the camp. I follow at a distance and disappointingly it goes straight to the rubbish tip behind the kitchen to scavenge on broken egg shells and rice. I am chuffed to have got such a good, long and close look at it though.

24 JANUARY 2007
Joffreville, Madagascar

12° 29′ 42″ S
49° 12′ 9″ E

David, Chris (sound) and Ruth (production manager) join us here on the edge of the Montagne d'Ambre National Park. Over several days we film the sync

* Unlike most gecko species the 'day gecko' is so-named because it is active in the day.

intros for the spectacular rainbow chameleon which uses colour for courtship and threat display; Oustalet's, the largest of all chameleons at over two feet nose to tail; and *Brookesia micra*, the world's smallest chameleon which grows to just over an inch long. The island of Madagascar has a range of unique flora and fauna and these two examples show the diversity just within chameleons that have evolved in the same habitat.

It's been a successful trip and it's time to head home. At the hotel in Antananarivo we start to check in online but Miles can't find his passport. We search our bags and then Miles rings the hotel in Joffreville as he thinks he may have put it in the safe there. No. The hotel staff check his room, down the side of the mattress, everywhere, but no.

David and Ruth go to the airport as they are on a different flight to us. Miles, Chris and I then check each other's bags again for the missing passport, but no joy. Chris is going on to another shoot and his flight isn't until the morning. Miles calls the British embassy in the UK to get their advice on a replacement passport and they tell him that the nearest embassy is in Mauritius and it will take seven days! So, I head to the airport alone with all the kit and check in.

I'm thinking, *Poor Miles*, but he could be stuck somewhere worse on expenses.

A few hours into my eleven-hour night flight I decide I'd better take an aspirin to combat deep vein thrombosis (washed down with a gin and tonic of course). In the dark, I reach into my camera bag under the seat and unzip the pocket where I keep the tablets. I feel something unfamiliar against my knuckles in the lining of my bag. I fumble further in the dark and find a secret pocket. In it is a small passport-sized booklet and I pull it out. Already I start to feel sick,

my stomach clenching. Switching on the overhead light, I open up the photo page and there to my horror is Miles's face. I feel nauseous and have a flashback to that first day three weeks ago when Miles went to change some money. I have a visual of him at the door of the car – 'I've just slipped my passport into your camera bag for the moment.'

I had to get a message to him. Typically, the one time I want to make an urgent (and expensive) telephone call on an aeroplane is the one time the plane doesn't have those fancy phones on board.

I can't sleep for the rest of the flight and, as soon as we touch down in Paris, I call Miles to let him know. He isn't angry, just relieved he isn't going to have to sit in Madagascar for seven days.

Once off the plane I manage to find the air crew who are flying the same plane back in a few hours, but they aren't allowed to courier anything, especially a passport. I then try to find FedEx or UPS, or some other courier service near Paris airport, but again no luck. I call the BBC Bristol office as soon as it opens and they arrange for someone to meet me at Heathrow and sort getting Miles his passport back.

Miles jokingly still blames me, but he was the one who put the passport there, and he even searched my bag.

My lasting memory from this trip though will undoubtedly be seeing the fossa. Such a good sighting, and so close. Having witnessed widespread habitat destruction across Madagascar I can't help worrying about charismatic animals like the chameleons and that fossa. I just hope that for generations to come, others like me can get that buzz of seeing creatures in the wild.

Kings of the Jungle

APRIL 1990

Okeene, Oklahoma, USA

Myself, Nigel (producer), Fraser (sound) and Jenny (assistant) land in Oklahoma City to find that, despite being booked, there is no rental minivan available for the four of us and our kit. The only other vehicle they have that we can all fit into is a stretched limousine. So, an hour and a half later we drive into Okeene in style.

The town sits in a sea of flat arable farmland and has a population of around 1,200 people. 'Welcome to Okeene,' says the sign. 'Proud past – Bright future.' We are here to film their rattlesnake roundup, which has happened annually since 1939. Locals head out to catch rattlesnakes as they emerge in the spring, and although the Okeene roundup does impose bag limits, rattlesnakes are brought back to town in their thousands. There are prizes given for the longest and heaviest, or the one with the most rattles. Eventually the rattlesnakes are slaughtered and some of the snake meat is cooked up and eaten. The skins are sold to make boots, wallets and other trinkets.

The organisers of this year's Jaycees rattlesnake roundup are expecting us: the British Broadcasting Corporation, and as we drive into town there are literally tens of people out to greet us. One vehicle is waiting and signals for us to follow, hazard lights on. As we drive slowly through town more people wave us a welcome and some children run alongside our car. I wind the tinted electric window down a few inches and wave like the Queen. Clearly the BBC is a big thing

here. We check into the motel and then are guests of honour at the pre-opening night's dinner.

Producer Nigel gives a short speech and thanks the organisers for allowing us to come and film – and for their hospitality at this 50th anniversary roundup. The people in this small town have been kind and welcoming, and I know they think this is going to be a celebratory film rather than an exposé of the barbaric capture, taunting and slaughter of snakes. I wish we could be direct about that, but then we wouldn't be allowed to film.

36° 6' 59" N **APRIL 1990**
98° 19' 6" W Okeene, Oklahoma, USA

Snakes! Why Today is sunny and hot and there is a great carnival
did it have to atmosphere in town. There are various food stalls selling
be snakes? the usual burgers and chicken wings but also rattlesnake, smoked or deep-fried. Trade stands too dot the high street, selling mostly cowboy paraphernalia with, of course, rattlesnake products such as snakeskin wallets and rattle key rings. I pick off shots to set the scene. Next, we get invited over to the 'Pit of Death'. This is a hexagonal arena set up outside, about ten feet across with four-foot sides made out of sheets of plywood. There is a crowd of 50 or so people peering in over the edge, adults, teenagers, children. Even the odd parent seeming to hold toddlers precariously close to the edge for them to see. Some onlookers have an expression of shock, while others grimace in disgust. In the pit are literally hundreds of rattlesnakes. The floor is covered with snakes two or three deep, apart from the opposite side where a man in a Stetson, jeans and tall cowboy boots stands with his snake hook. Although initially it's impressive to see so many snakes, I am also aware of how scared

they must be. They must all be feeling very threatened. Occasionally, the cowboy sticks his boot up in front of the snakes to get them to strike at it. These snakes are not being aggressive, they are striking in defence. I film for 15 minutes or so as the cowboy gives his spiel. It is mostly educational, about the biology of the snakes and toxicity of the venom, but is marred by machismo. He tells the audience how many times he's been bitten. I am thinking: *Once bitten, twice stupid*. Each time he'd been bitten he'd ended up in hospital and he goes on to brag that he had his heart stop on him twice. Again, I am thinking: *What do you expect if you go catching venomous snakes and then taunt them to get them to strike at you?* I pick off shots of the crowd's reactions: people appear to be both fascinated and horrified.

I then want to put my camera on the floor of the snake pit to get the snakes' point of view of the threatening cowboy boots. The simplest way to do this is to climb into the pit. I don't really see this as risky or I wouldn't do it. As well as the cowboy in the pit there are several other men around on the outside with snake sticks who can hook snakes back if they slither towards me. I climb over the side close to the cowboy: the crowd thinks I'm mad. Nigel hands me the camera and I kneel down and set it up on the floor. It has a wide-angle lens, so I set the focus quite close and stop it down to help the depth of field.* I then climb back out of the pit and the cowboy lets the snakes slither around and on my camera. I run the camera with a remote cable and can only guess what the shot looks like. Once I feel I have the shot, the guys move the snakes away from my camera with their hooks

* Depth of field or DOF is the distance between the nearest focus point and the furthest. By stopping down the lens aperture, the depth of field increases. There are charts so you can work out the DOF for any lens set at a given focus and aperture.

and I climb back into the pit to retrieve it, getting a few more handheld shots over the cowboy's shoulder of the crowd as he talks. He holds a snake firmly by the head and forces its jaws open to show the crowd its fangs. I can see tiny drops of venom on the end of those delicate hypodermic-needle-like teeth.

We move on to see where they kill the snakes. It's quite brutal. They hold the rattlesnakes firmly with long metal tongs and place them on a wooden block. Then their heads are cut off with a machete. I find the process quite shocking. It may sound bizarre but I find these rattlesnakes beautiful. Evolution has created this masterpiece of a living creature: it is well camouflaged in its natural habitat; it has good night vision but also heat sensors to help it hunt; and has complex venom that can kill its prey quickly. It has a rattle to warn off larger animals and if you hear this when you are out walking you instinctively know what it is.

Historically, I can kind of understand the idea that killing off rattlesnakes might reduce the chance of farmers or their horses and cattle being bitten. However, it means that the rodent population, the rattlesnakes' main prey, isn't kept in check and so nature goes out of balance. Plus – not that I agree with killing the snakes – but if it is necessary, why not do it in the field rather than catching and dragging them into town? Seeing how the snakes are treated and stressed before finally being killed just seems unnecessarily barbaric and medieval.

The people of Okeene have been kind and helpful so I do feel guilty that we haven't told them expressly about the angle for this story. I hope, though, that when they see the finished film it might help change their minds about the ethics of their roundup. Hopefully the younger generation will adopt a more educated ethos.

3 MARCH 1991

Nairobi, Kenya

1° 16' 29'' S
36° 48' 48'' E

The BBC has booked assistant producer Rupert and me into the Boulevard Hotel in Nairobi. It is on a busy road near a casino and it is swarming with prostitutes. It is quite an uncomfortable place to be: we are hassled in reception, the bar and restaurant. I wonder if it's what women had to put up with walking past building sites in England in the 1970s and 80s, wolf-whistled and catcalled by builders and scaffolders. Unpleasant.

This is our staging post to travel up into southern Sudan to film a sequence of the Dinka people for a new BBC series, *Lifesense*. The Dinka are a community of closely related people who live along both sides of the White Nile. They follow a traditional pastoral lifestyle, growing crops and moving seasonally as the rains flood the White Nile plains. The story we are interested in is their relationship with cattle. Although they drink the milk, they don't keep the cattle for profit or meat, but instead for status and cultural pride, rituals and marriage dowries.

Civil war has ravaged Sudan for decades, with the loss of millions of lives, but there has been a ceasefire for many months and it is supposedly safe to travel there again now.

Alex is going to be driving us up into Sudan. He's a fair bit younger than me and grew up 'messing around' in the East African bush. He now runs his own guiding and outfitting company, having served an apprenticeship under two renowned Tanzanian hunters. I'm sure we will be discussing our differences of opinion on hunting – but best not to fall out with him as he is providing camping and food supplies. We will also be travelling with his uncle, Frank. A Kenyan road

engineer, who I've heard described as an English oak, with years of experience in southern Sudan, mostly in road repairs and mine clearance for relief aid agencies. We will meet Frank en route, in a place called Kitale.

The slight hitch is that Alex's Toyota is currently in the garage being fixed, so we are going to have to delay our departure by a day or two. We are supposed to be back in Nairobi in nine days, so these repairs are going to eat into our filming days.

1° 16' 29" S **4 MARCH 1991**
36° 48' 48" E Nairobi, Kenya

Rupert and I make use of the downtime by going to speak to the Desert Locust Control team at Wilson airport: quizzing them for potential sequences on quelea and army worm plagues for the series. Returning to the Boulevard, we kill some more time playing tennis while being heckled through the fence by more prostitutes: 'English, English we love you!'

Rupert beats me, twelve games to four.

Later we have drinks with an Englishman staying at the hotel. He is one of 281 foreigners recently evacuated from Mogadishu in Somalia. Rising violence, due to an escalation in the Somali Civil War, means foreigners have to request military assistance to escape the country. The US Navy and Marine Corps came to the rescue. He was on the last helicopter out and proudly tells us that he stole the American flag off the embassy roof as a souvenir, and was handed a sledgehammer by a marine and told to scupper the radio room just before they left. Better that than leave it to the Somali militia.

Wake up at 3am with diarrhoea.

7 MARCH 1991
Kitale Club, Kenya

1° 00' 06" N
35° 00' 33" E

I've been going stir-crazy in Nairobi. It's times such as
this when the job sucks: I'd much rather be spending
the time at home with Maggie and the boys.

*Let the
road trip
commence*

Finally, Alex gets his vehicle fixed and we start our
journey to Sudan. His dark-green Toyota Land Cruiser
is from the late 1970s and looks well-worn but charac-
terful. Canvas water bags hang from each of the wing
mirrors. These are a clever idea for our drinking water,
because as the water evaporates through the canvas it
keeps the water cool. Boxes of food fill the rear, along
with my film equipment. 'House of Manji' biscuits
are clearly going to feature quite heavily in our diet.

The scenery as we drive up through Kenya is stun-
ning: epic vistas looking down and across the Great Rift
Valley as we head north from Nairobi. On the far side
I see turret volcanoes that hint at the force of nature
that formed this 3,700-mile-long fault 35 million years
ago. The traffic is heavy on the pot-holed roads lane
discipline is dreadful. Many of the lorry drivers seem
to have a death wish. From what I can judge, most are
from the Chinese school of driving, spending more time
driving at oncoming traffic or undertaking (excuse the
pun) on the gravel verges than on their own side of
the road. Clouds of billowing diesel smoke intermit-
tently mask the view. For much of the journey north
of Nakuru, we travel through productive agricultural
land until, eight hot hours later, we arrive at the Kitale
Club. It is like stepping back into the colonial 1900s,
only now very threadbare. Here we meet Alex's Uncle
Frank who gives us, well, a frank lowdown on the
journey we are about to undertake.

'You understand that Sudan has been at civil war
for much of the last 30 years? 1.3 million people have

died as a result of fighting or famine. It's been calm now for the last nine months but that doesn't mean to say that things can't flare up again. I have been travelling up into southern Sudan for the past 20 years now, building and repairing roads and airstrips to facilitate aid agencies getting into the country. I have been caught in rebel crossfire several times but no one, nor any of my vehicles, has ever been hit. If we get into a situation like that, get out of the vehicle and lie in the ditch to the side of the road. The rebel fighters are generally scared and ill-trained and will loose off all their ammunition, usually over their shoulders as they run off into the bush. We can then get back in our vehicles and carry on. I want you to know that it can be a dangerous place to travel, but as long as you are okay with that I'm happy to take you there.'

Slightly shell-shocked by the reality of the situation – but both Rupert and I have confidence in Frank and Alex so agree we are happy to continue.

Frank explains that it will be a day's drive up to Lokichogio on the southern Sudan border. Then, all being well, another day and a half to the location where we will spend two days filming with the Dinka.

4° 12' 05" N **8 MARCH 1991**
34° 21' 24" E Lokichogio, Kenya

North to the After last night's briefing from Frank, I can't say I slept
border soundly. I am slightly apprehensive about the whole trip.

The drive up the A1 to Lokichogio is interesting but tedious. Ten hours of mostly straight good tarmac road through harsh stony desert. We pass many small shanty towns, collections of corrugated tin huts that must be

like ovens in this heat. Rupert and I take it in turns to ride with Frank in his significantly more comfortable Range Rover.

The landscape gets progressively hotter and drier. Every few miles we dip through floodways across the road. It is hard to believe that water ever flows here, but now and again we see the evidence of flash floods by way of debris caught up in the bushes and trees. I've seen no wildlife at all for the last eight hours. Occasionally, in the middle of absolutely nowhere, we see lone Turkana warriors out walking. As soon as they see our vehicles they race flat out towards the road to try and intercept us. A few times they manage to get to the road before we pass, so out of courtesy we stop and offer them water. They try to sell us their spear and headrest, the only possessions they have.

We make it to Lokichogio, a true frontier town. This is the launch site for humanitarian aid into Sudan, Operation Lifeline Sudan, a consortium of UN agencies and 30-plus other aid organisations. I see UN white Toyota Land Cruisers galore, and UNICEF, WFP, Save the Children, Oxfam are all present here. I'm suddenly aware of the scale of operations to help civilians in this drawn-out civil war.

We stay overnight in a fenced compound, sleeping on our bed-rolls on the ground with our mosquito nets hung from the side of our vehicles.

4° 44′ 59″ N **9 MARCH 1991**
33° 35′ 53″ E Kapoeta, Southern Sudan

Armed In the morning we join a convoy of vehicles all heading
convoy our way. Safety in numbers, apparently. One of the
vehicles is Frank's fuel tanker, heading north full of
diesel to replenish stocks. After an hour of chat and
form signing at the Kenya border, we are cleared to
leave. The convoy travels through no-man's land and
we repeat the chat and form filling at the Sudan border.
We've also picked up a ramshackle armed escort: 20
camouflage-clad, AK-47-wielding soldiers from the
SPLA – Sudan People's Liberation Army. They look
young, undernourished and tired.

The route quickly deteriorates to a pot-holed
gravel road, slowing our progress. We drive through
many small grass-hut army camps guarded by teenage
soldiers. We are stopped at the bamboo barrier each
time and asked, 'Where are you going?', to which Frank
replies with a smile, 'London.'

'Okay, where are your travel permits?'

Frank shows them an old copy of *Time* magazine.
The boy soldiers look slowly through some of the
pages and nod. Then Frank hands out a few single
cigarettes and they say, 'Okay. You can go,' and the
barrier is raised for us. Each camp has the trees and
bushes cleared around them in a 200-metre radius. On
the outskirts are low beds made from sticks, and by
each bed is a grave-sized trench. Frank explains that the
trees are cleared to give visibility of any approaching
enemy. The soldiers sleep on the low beds and can roll
straight into their trenches for protection if they come
under fire.

I find these scenes shocking. This is life for these young
men and boys. Most have been conscripted or kidnapped
from their home villages and brought here to fight. Driving

on we pass numerous burnt-out and abandoned army vehicles with bullet holes or shrapnel damage. More reminders of the reality of the civil war that has ravaged this country for decades. I'm beginning to wonder whether we should have travelled into Sudan – after all, it's just for a natural history television sequence.

After a few hours we stop to stretch our legs. Rupert and I both walk off to find our separate trees to pee against and are immediately shouted at by Frank.

'STOP! Get back on the road!'

Frank explains that the roadsides are still littered with active land mines. So, from now on, pee breaks are always on the road!

At the next camp our convoy is stopped. The SPLA tell us we cannot continue until nightfall as the next section of the journey is riskier, with a chance of being ambushed. The road is slower through hillier terrain with many rocky gullies to cross. Rupert and I nervously sit out the five-hour wait. Frank, sensing the tension, reaches behind his driver's seat and then throws something at us. 'Have an orange!' he bellows. It is a clever distraction – as Rupert and I peel the fruit it breaks the spell of worry.

Night falls and the SPLA climb back in and on the vehicles, AK-47s swinging wildly with safety catches off. The route is indeed rockier and slower. Each time we have to edge slowly through a dry riverbed nerves rattle in my stomach. The anticipation of being shot at is a truly horrible feeling.

We finally arrive in Kapoeta at 2.30am and pull into a crude gated compound known as 'Bruce's Camp'. Exhausted from the journey and stress, I eat some House of Manji biscuits, slide into my bed-roll and fall asleep quickly. My last view of the night is of fuzzy stars in the black sky through my mosquito net.

4° 24' 36" N **10 MARCH 1991**
33° 35' 53" E Kapoeta, Southern Sudan

Deeper Up at 5.30am for tea and biscuits before heading off
through war- in convoy again. Today we have an SPLA soldier riding
torn country with us in the front of our Toyota. Incredibly, he sleeps
most of the way despite the bumpy road, his head
leaning on his hands cupped over the barrel of his
AK-47. The butt of the gun rests in the footwell. I
check and again the safety is off!

The road is much better and we make good progress
through the scrubby, dry, barren land. No apparent
wildlife apart from the odd bird. Apparently, poaching
of wild animals for meat has made them both scarce
and understandably skittish. Along the way I count
another 40 or more burnt-out war-damaged vehicles,
including the 'scene of blood' as described to us, an
ambush which destroyed five vehicles and killed the
occupants.

We stop briefly at one checkpoint in a small village
called Lobira. Here, Frank gives a present of some
T-shirts and a chess set to an old friend and his
family.

We arrive in the small town of Torit in the early
afternoon and stay in the Lifeline Sudan UN Mission
compound. There are bomb shelters everywhere.

There's no sign of Frank's tanker which was with
us in the convoy. Bob, his mechanic, has gone back to
find where it's got to. Apart from worrying about the
safety of its driver, we can't go on without it.

14 MARCH 1991 4° 44′ 59″ N
Torit, Southern Sudan 32° 34′ 26″ E

We've been stuck in Torit now for four hot, long, boring days. The low point of our wait has been having to use the communal corrugated tin toilet hut in the centre of the courtyard. Possibly 50°C in there in the day and full of a million flies that stir up from the grizzly depths to land on your face, eyes and lips while you are otherwise disposed. Absolute hell. So much so Rupert has been unable to 'go' since we arrived here.

The UN guys have informed us that the town of Bor, just 130 miles to the north-west, was bombed heavily in the night. Many casualties. Also, a UN Toyota was ambushed and riddled with bullets by Teposa rebels. The driver escaped but the passenger was killed. All aid relief flights are being cancelled and many aid workers have left on hearing the news. It seems the period of calm may have ended. Frank explains that to head back south again means going through one of the most dangerous areas. There is a good chance that Torit might too get bombed in the night. The safest option for us is to continue further north to Kongor, then into the less populated area where we are to film the Dinka. The tanker has finally shown up so we are going to carry on north. We should never be in this much danger filming for a wildlife series but for now we have no option.

More army checkpoints. More old copies of *Time* magazine being handed out as 'passes', more cigarette 'thank yous' to the young guards.

Another 75 miles, often driving parallel to the Nile, and we have passed around 120 lorries and armoured vehicles which have been ambushed and wrecked during the years of the war. More shocking is driving past

the UN vehicle that was shot yesterday. Windscreen smashed and riddled with bullet holes, this is where a UN peacekeeper lost their life less than 24 hours ago. Fresh blood is on the seat and gravel road. It turns out we've just passed through prime Teposa rebel country and they are clearly active. Frank reassures Rupert and me that it is probably just one or two rebels and that they'll have run scared after this attack and will probably lie low for several days now. He then reaches behind his seat. 'Have an orange!'

As it gets dark, we stop for the night in the middle of nowhere. Frank tells us not to use lights.

Fall asleep to the sound of hyenas calling.

7° 0' 17" N 15 MARCH 1991
31° 21' 16" E Kongor, Southern Sudan

5.00am. Wake up to a beautiful dawn chorus. The natural calming peace and beauty of birdsong. I really notice how normal it seems to hear this. It is how Sudan should be. I feel a weird sadness that these birds and nature have to put up with man's fighting and unrest in this war zone.

We continue north on worsening roads and are nearing our final destination when we come across more abandoned war-damaged vehicles and a Russian-built MiG fighter jet with a folded undercarriage 100 metres or so from the road. Frank says it's a Libyan aircraft sold to the Sudanese Air Force. It ran out of fuel when the pilot got lost after a reconnaissance sortie. We stop the vehicles and wander across to take a look. A Dinka man is living under the wings, having built low mud walls with a crude thatched-grass extended roof. I love the idea of the super-high-tech aircraft

capable of 1,400mph being used as a nomad's shelter in remotest Africa.

Twelve miles short of the village of Kongor, the front left leaf spring suspension on the aged Toyota breaks. We spend an hour doing a makeshift repair with a splint made from two sticks, a long strip of inner tube and a roll of gaffer tape. We limp into Kongor before dark.

16 MARCH 1991
7° 0' 17" N
Kongor, Southern Sudan
31° 21' 16" E

Finally, after a brief meeting this morning with Mr Kwal – a drunk field superintendent – and some Dinka chiefs to explain what we would like to film, we have their approval and permission. Frank stays in town and Alex, Rupert and I then drive with Mr Kwal for about an hour across the sparse but bumpy grass floodplains to meet with the Dinka. First, we are met by hordes of running, smiling, cheering children who swarm round the car. We receive a friendly greeting from the men in camp, handshakes and smiles indicate we are welcome. Because of the welcome, this is the first time I have felt kind of relaxed in days. I can barely believe we've finally made it here. The journey has been extremely stressful and I don't even want to think about the drive back.

The Dinka camp is basically a round football-pitch-sized dusty area with a few sparse trees. There are several round mud huts with conical roofs, shaped rather like chocolate teacakes. It is like stepping back in time. The children are all running around naked, brandishing sticks and spears; the women too are naked except for goatskin or cloth skirts. The men wear either simple cloth or Western shorts. Everyone seems to have jewellery: necklaces and bracelets of ivory, polished

copper and blue stones. The ivory is mellow and its surface crazed and weathered, clearly all very old.

Having rigged my camera, we wander off to start getting shots. A closer look at the camp reveals it is broken up into many smaller circles, all marked out with short sticks stuck in the ground. Each circle belongs to a family. At the end of every day the boys who have been out with the cattle to graze them bring them back to camp. The cattle know which area to return to and are then tied up to the sticks and are milked by the women. In the centre of each circle is a pile of sun-dried cow dung that the women have raked up in the afternoon. This dung is lit at dusk and it smoulders through the night, providing heat and smoke. The smoke helps keep the mosquitoes at bay. The resulting ash is what the Dinka dust themselves with after washing, and it's what gives them all that ghostly white-looking skin. I learn that this acts as both a sunscreen in the day and as an insect repellent at night.

As the red sun starts to set, lines of cattle head towards us with a gorgeous orange sky behind. Layers of dust kicked up by the cattle's hooves hang low to the ground like a mist. The bulls are most impressive as they have the most exaggerated, elegant, sweeping horns. They look stunning in half-silhouette. I put the camera low on the tripod and pick off shots. There are times when I'm filming when I know the shots will be in a finished programme and this is one of them. We meet the cattle boys, aged between maybe nine and fourteen, as they arrive and I continue to film as the camp fills up. There must be at least 500 cattle now and dust has suffused the air.

As dusk fades the boys tend their prized bulls. They mix ash and urine into a paste and polish their horns – this is believed to help shape their elegant curves and perhaps promote growth to make them bigger. The

bulls seem to relish the attention. Then the boys take their bulls on a lead and parade them around the camp, singing as they go. Wandering songs that are clearly telling a story sung in a simple scale with repetition and rhythm. This is partly how the boys show off and try to attract a girlfriend or wife. The whole process is very much like lads in the UK polishing their cars, cranking up the stereo and then driving up and down the high street – showing off and trying to attract female attention. I suppose boys will be boys, regardless of the culture.

As we walk round the camp filming by battery light, there is a real air of calm with these people. We are welcomed and chatted to even though we are strangers in their 'house' and we have no common language. At one point I am grabbed by the shoulder and pulled back. A boy rushes forwards with a spear and I am immediately on guard, thinking the worst. But then he thrashes at the ground with the spear and points my light down to where he has hit. By my sockless, sandalled feet is a young cobra with its head staved in, its tail twisting in its final death throes. A long, long drive from medical help or antivenin – this boy has probably just saved my life. I shake his hand and thank him in English, and although he doesn't understand my words I think he can read my grateful body language.

Pleased with our initial filming but exhausted by the travel and stress of the past week, Rupert and I head over to where Alex has made a basic camp. We eat a crude hot supper and then I gratefully lie down on my bed-roll, raised off the ground on a camp bed.

Before I fall asleep, I reflect on how peaceful it is here with the Dinka and the beauty of a simpler lifestyle. That magical bond and respect between them and their cattle. Yet it is tragic that these people have been caught up in a civil war for many years. Communities like this

have been bombed and villages burnt to the ground. Women have been raped and men abducted and sold as slaves in northern Sudan. Why is it that some humans are hell-bent on destruction?

7° 10' 38" N
31° 3' 19" E

17 MARCH 1991
Somewhere West of Kongor, Southern Sudan

You learn something new . . .

I'm woken by a mix of birdsong and whispers. In the half-light of dawn I open my eyes and am surrounded by smiling Dinka children. Every move that Rupert, Alex or I make attracts an audience. We are the entertainment. Toilet duties are difficult and not exactly private.

Before the sun rises, we are back in among the cattle. I film the animals being untied from their stakes and then lines of them heading off across the floodplains to graze, just as the sun pulls itself up on the horizon.

Once the cattle have gone, I film the women going about their chores around camp. They spread out the fresh cattle dung from the night to dry in the sun, then head to collect water. A few cattle and their calves stay in camp and I film a woman milking in traditional style. Then I see something extraordinary. One of the women raises the tail of a cow and buries her head in its rear end. I do a double-take before raising my camera to film. As she pulls her head back to take a breath, she sees me starting to film and rushes off, embarrassed. I lower the camera and signal to her that I won't film, and she resumes this rather unpleasant-looking action. I watch from a distance. Once the tail is back down, she proceeds to try to milk the cow.

Really puzzled by what I've just seen, Alex, Rupert and I ask Mr Kwal what the woman was doing. He explains that sometimes when a cow stops giving milk,

if you blow into its vagina it can stimulate milk production again. I can sort of see how this might be possible, but what puzzles me is how on earth did someone discover that this technique works? I wonder if they teach this at vet school everywhere? Just imagine back in England when old MacDonald the dairy farmer's best Friesian cow has stopped producing milk. He rings the veterinarian who comes straight out. After a brief examination, the vet raises Daisy's tail, does the deed, wipes off his face and then gives the farmer a bill for £120. Seven years in vet school to do that??

During the heat of the day – and it is bloody hot – Rupert, Alex and I relax on our camp beds in the shade of a makeshift awning. We are surrounded and watched by children the whole time.

In the late afternoon, once again I film as the cattle start to return. More beautiful sunset shots, polishing of the cattle horns, parading and singing. I also do some clean sound recordings of the songs.

Frank joins us for dinner and he's brought beer.

18 MARCH 1991
Somewhere West of Kongor, Southern Sudan

7° 10' 38'' N
31° 3' 19'' E

Today the weather is grey and overcast, not good light for filming, especially compared to the last two glorious evenings. Alex brews up some tea and we sit and chat, hoping the sun might show. As the morning progresses it gets hotter and more humid, but still no sunshine. Rupert and I lounge on our camp beds. I reach to the ground and run sand through my hands as I read my book.

By mid-afternoon it is clear the weather isn't going to improve, so we pack to leave. I'm just putting my

camera in the back of the Land Cruiser when Rupert, paler than ever, says, 'Gavin, there's a fucking great big snake under my bed.'

We rush back to his camp bed and I gently pick up the end and flip it over. There, coiled up, is the biggest puff adder I've ever seen. At least five feet long and chunky with it. All the children back away. If this thing bites you, you wouldn't survive more than a few hours.

I can't believe that this snake has been there all day. It must have slid in overnight, as we have been surrounded by children since first light. We've had our bare feet on the ground inches from its nose. I ran sand through my hands from beside my bed, again inches from its nose, and amazingly it hasn't struck at any of us.

Sadly, one of the men comes over and kills the poor thing. I have mixed emotions: sad that this beautiful snake has been killed, but if any of these barefoot children or Dinka people had then been bitten it would be certain death for them.

We say our thank yous and goodbyes and leave the peace of the Dinka community.

Just to complicate matters, we now discover that none of the electrics are working on Alex's Toyota so we have to tow it to bump-start the engine.

Back in Kongor we share beers with Frank and some UN guys and hear that the fighting in southern Sudan has flared up and all aid transport into the country has been suspended. There is a convoy heading south from Kapoeta tomorrow night and joining that is our safest way out to Kenya.

I sleep very little at the prospect of the next few days' journey.

19 MARCH 1991
Torit, Southern Sudan

4° 44' 59" N
32° 34' 26" E

This trip was only supposed to be nine days long and now we have been out of contact with home and the office for 12 days. It's another three to four days' travel back to Nairobi.

Shit scared

We bump-start the Toyota again and carry on to the small town of Lobira. With more car troubles we don't arrive until 1am. Frank normally hangs his mosquito net from the eaves of a thatched stone-walled building there – next to the friend he gave the chess set to. As it is late, we pass through the village and stop about a kilometre further down the road. That way we can get going in the morning without being hassled by the villagers.

Within 20 minutes of us getting into our bed-rolls, we hear gunfire coming from the village. Frank tells us to pack the vehicles and get ready to flee. He thinks the village is under rebel attack from the hill just behind. 'Don't use any torches or light. They probably already have our position as they would have seen us stopping here earlier.' I'm frightened and my legs turn to jelly. I rummage in my rucksack and grab my Swiss Army knife. It seems like a futile thing to do, but I tell myself that if we have to run for it, I can survive with that tool in my hand.

Soon the gunfire gets heavier and then we hear mortar rounds. We can see a fire has started in the village and the sky is staring to be lit with a warm glow. The gunfire and explosions intensify. Alex and I ready the tow rope to the Toyota in case we have to bump-start it and get away. We stand, frightened, listening and watching the fire ravage the village. I can't begin to imagine the horror and fear of those poor villagers as what little they have is being destroyed.

After half an hour or so the gunfire and explosions die down and the flames seem to be subsiding. Frank suspects that the attack is over and the rebels will now flee.

We get out our bed-rolls again but I am too scared to sleep.

4° 23′ 42″ N **20 MARCH 1991**
33° 3′ 38″ E Lobira, Southern Sudan

At first light we give Frank our BBC first-aid kit and he drives back into the village to see if he can help. Without him and his vehicle we are stranded, as we can't bump-start the Toyota. So we wait.

An hour later he returns and tells us what happened. The village was razed to the ground, many villagers had burns and two men had died of gunshot or shrapnel injuries. The thatched building, where Frank normally hangs his mosquito net for the night and where we could have stayed last night, was being used as an ammunition store. The two guards had fallen asleep with a hurricane lamp burning. It must have toppled over and set light to the building. What we had heard and seen was the ammunition going off – not a rebel attack as he'd thought. That whole building had been destroyed, blown up, and the fire had spread through the village.

Frank says there is nothing we can do.

We pack up and carry on our journey.

Later that afternoon we arrive in Kapoeta. Buildings are smouldering. It has been attacked in the night. The rebels crashed through the perimeter wall of Bruce's Camp and killed some of the staff. This is where we

would have stayed if we had made it this far last night. Frank doesn't stop – he says the villagers are angry and may set on us.

Just outside town, we join a convoy of about 60 vehicles waiting to escape Sudan. At the front is a Toyota four-wheel drive pick-up with a massive machine gun mounted in the back. In addition, we have about 40 SPLA soldiers, each armed with a battered AK-47. To almost everyone else here it seems totally normal to have African teenage boys swinging guns about without a hint of military discipline. To me it hits it home the situation we are caught up in, and I certainly don't feel any safer travelling with our compulsory armed escort.

We wait for dark before setting off, once again getting towed to start our engine. I travel with Alex, while Rupert is behind with Frank in his Range Rover. Because of our faulty electrics we have no lights, so have to stick close to the lorry in front. The convoy moves fast: I assume all the drivers are as scared as we are at the prospect of the journey through Teposa rebel territory. We struggle to keep up with the lorry in front: our jerry-rigged repair on the broken leaf spring is taking a pounding on the rough roads. We have no option but to push on. Every now and then I can see the lights from all the vehicles stretched out along the road ahead. Right out at the front, way ahead of everyone, is the pick-up with the machine gun. It seems pointless them being with us. I think they are just racing to get to the relative safety of the next village.

Then, going through one of the dry riverbed gullies, we hit a rock. Hard. It takes us a few seconds to get unstuck and drive our way back out of the riverbed. During that time the lorry whose lights we had been following and driving by has sped on ahead out of sight. It is pitch-black and there is no sign of Frank's Range Rover behind. We are on our own now in rebel

territory. All we can do is drive on, so I grab the big Maglite torch and hold it out of the window to light the road ahead. Alex drives as fast as he can, trying to catch the lorry. It is nerve-racking. We both travel in silence, fully alert and on guard for any sign of danger.

For the next two hours I can see no one ahead and no lights following behind. It is now nearly midnight and we are approaching one of the army checkpoint bamboo barriers. As we slow and pull up to it, a young soldier in fatigues steps out from the darkness carrying an AK-47. I swing the torchlight on to him. Big mistake. He is probably as nervous as we are. Blinded by my torchlight he drops to one knee and aims his machine gun straight at me. In a split second all I can think to do is spin the torch round into my own face and shout, 'Don't shoot. Don't shoot. It's only me, I'm English!'

At that, thankfully, he lowers his gun muzzle and looks relieved. He flags us forward to the barrier. I start to talk but he doesn't speak English. I thank him for not shooting me and give him an old copy of *Time* magazine and a packet of cigarettes. He is very pleased with that and opens the barrier.

We wait in the army camp for Frank to catch up and I tell him what has happened. I really thought I was going to die. I dazzled a scared 14-year-old, gun-toting African conscript, in rebel country, in the middle of the night.

Frank puts a reassuring hand on my shoulder and says, 'Well done. You did the right thing. Have an orange!'

We then have to continue on our own.

It is 50 kilometres to Lokichogio and it will take us another two nerve-racking hours.

21 MARCH 1991
Lokichogio, Kenya

4° 12' 05'' N
34° 21' 24'' E

I'm finally able to call Maggie and tell her I'm okay. I call the office too – they've been frantic as we should have called in five days ago. John, the series producer, has been very worried, as he was the one who sent us to Sudan.

All I can think of is the family that Frank gave the chess set to. They asked for it months ago when he was last there. I remember the man's face lighting up with a smile and a handshake while his two young boys jumped up and down with delight. They had lost the chess set and everything they owned when their house burnt down, along with the whole village of Lobira.

3 JULY 2001
Kluane National Park, Yukon, Canada

60° 40' 58'' N
139° 47' 21'' W

For the last few days, producer and friend Miles and I have been filming a sequence of pikas, a small relative of the rabbit. They live only in nunataks, rocky outcrops surrounded by glacial ice. A cute-looking animal a bit like Stuart Little,* only with grey fur and no red jumper. They live at quite a high elevation, where the yearly temperatures can drop to minus 28°C in the winter. To get to the location in the Saint Elias Mountains, we fly up to 7,000 feet in an aeroplane fitted with skis and land on the ice. I have confidence in our pilot as he isn't 18 and doesn't have scratch marks on the dashboard to mark the throttle, mixture and pitch positions.

* From the 1999 film about the Little family who adopt a charming, talking mouse called Stuart.

Landing on top of the glacier is amazing. A clean bright white landscape in the sunshine. Blue skies and the air is so clear. A mile or two to our south is Gnurdelhorn Peak at almost 11,000 feet; 24 miles to the west is Mount Logan – at 19,550 feet the second highest peak in North America. I can see the mountain range stretching way beyond in all directions for hundreds of miles. The weirdest thing is – and this is the first time I've noticed it – I can see intact vapour trails from jet aircraft extending from one horizon to the other. Probably the main route from Anchorage, Alaska, to the rest of the USA. The vapour trails appear to curve, starting at a point on one horizon then diverging overhead before meeting again at the far horizon. The aircraft are obviously flying in a straight line at a set height above ground, but from where I'm standing they're describing the curvature of the Earth in the blue sky. This is the first time I'd seen a graphic illustration that the Earth was a sphere. I suppose normally you don't get a sky big enough to notice.[*]

60° 40' 58" N
139° 47' 21" W

6 JULY 2001
Kluane National Park, Yukon, Canada

Pikas don't hibernate so have to collect all the food they need to survive the harsh winter in the very short summer growing season. Each adult pika can make up to 10,000 trips gathering huge mouthfuls of vegetation, which they then store deep under the rocks and boulders for winter. The cutest image is when a pika collects a big bunch of flowers in its mouth before running back 'home'.

[*] Apologies to the Flat Earth Society.

In order to complete the sequence and give an idea of how remote and barren the landscape they live in is, this morning we head up in a helicopter to film aerials of the glaciers and nunataks. As usual the camera is mounted on a Tyler middle mount, the arm of which comes over my shoulder, my feet resting on the skids. I have wrapped up warm, as flying at 70–80mph at 7,000 feet over the mountains with the door off is bloody cold.

The shots are going well and Miles points out another feature at the top end of the glacier we've been filming. The pilot speeds up to get there quicker and out of the corner of my eye I just see my lens hood fly off the camera. I try to keep my eye on it as it falls but have to lean back into the helicopter to tell the pilot to stop. He loops back round and we scan the glacier for five minutes or so.

Eventually, Miles says, 'Look, it's going to be cheaper to buy you another one than to hover around looking for it. Don't forget it's $1,200 per hour in this thing!'

So, sadly, I don't find my lens hood. But Miles is probably right. If you happen to be filming pikas in the Yukon, look out for my lens hood.*

Unfortunately, as a result of global warming these cute creatures are in decline and are now on Canada's species-at-risk list. Each year, with warmer winters there is less snow, therefore less insulating effect to keep the pikas warm underground. As the pikas don't hibernate, the colder it is, the more food they need to eat to keep warm. They are either dying off from the cold or running out of food and starving before the spring.

* Turns out a replacement lens hood actually cost me £850. So we should have hovered for another 45 minutes and could probably have found it!

28° 34' 56'' N
80° 38' 49'' W

AUGUST 2001

Cape Canaveral, Florida, USA

I'm back filming the space shuttle at Cape Canaveral. This time it's a piece to camera with David that is to come near the closing sequence for the series *The Life of Mammals*.

Talking with producer Vanessa, I suggest it would be dramatic if we could be at the base of the space shuttle on the launchpad and track backwards with David, using the camera on a Steadicam to reveal the whole shuttle by the end of the shot. The plan is then to cut to NASA footage of the launch. When I filmed here before, we couldn't get permissions to be closer than three miles away once the shuttle was on the pad. This time, however, because we are working with David, we are accompanied by the head of NASA Cape Canaveral and he is able to grant us the permissions. I film the piece as we had planned:

'*This has been the launchpad for humanity's greatest and most complex achievements and highest hopes. From space shuttles to space stations. And it's from here in the year 2020 that our species might launch its most ambitious project yet, to settle on another planet. To send a mission to Mars.*'

David nails it in one take.

I then say to Vanessa and the head of NASA, 'You know what would make an amazing shot? Looking down from on top of the gantry, past the shuttle in the foreground, to see David walking away. It would accentuate the size of the shuttle and lead in nicely to the launch.'

'How many of you need to go up there?' the head of NASA asks.

'Just me with my camera and tripod,' I reply.

'Right, come with me.'

At that, I walk with the head of NASA to the base of the launch gantry. He speaks to someone at the lift and, the next thing I know, the two of us are travelling up 200 feet to the top of the launch gantry. Once at the top, he holds my camera and tripod for me while I run up and down a couple of walkways to find the best spot. Once I've chosen the place and set up my camera, I wave down to David to give him the signal to walk away from the shuttle. Size-wise compared to the 184-foot-tall shuttle, David looks as small as an ant. The shot is as good as I'd imagined.

I pause here for a moment, looking down at the cockpit windows below and try to think what it would be like to sit in there for takeoff. The two solid rocket boosters beneath me hold a million kilograms of fuel alone. Crazy to think that in a few days this massive craft with seven people on board will be 200 miles up, orbiting the Earth.

I doubt any civilians have had access to this position with a fully fuelled-up rocket on the launchpad. I feel very lucky to have been allowed up here – this is probably the closest I am ever going to get to going into space.

It makes me think about what David has said in conversation about the cost of space travel and I have to agree. Although I'm in favour of science and research, instead of exploring how to colonise another planet, why not spend all that money on looking after the one we live on?

16° 34' N **16 JANUARY 2003**
10° 58' W
Bougari, Mauritania

Politics Early in 2002, Tara Shine, a 29-year-old PhD student
from the University of Ulster, found crocodiles in
a remote area on the edge of the Sahara Desert in
Mauritania, north-west Africa. Local tribesmen knew
of these crocodiles but they were undescribed by
Western science. These are Nile crocodiles that are a
relict species and have genetically adapted over 5,000
to 8,000 years to survive dry seasons and drought by
living in burrows and caves. To avoid the heat of the
day, these crocodiles are now mainly active at night.

I travel out from the UK with friends Aidan (assis-
tant producer) and Ralph (assistant cameraman) to
film the story for Tigress Productions for a programme
called *Lost Crocodiles of the Pharaohs*. We meet up
with Tara and German herpetologist Hemmo in
Nouakchott, the capital of Mauritania. We load up
our camera cases, camping kit and supplies into two
4x4s driven by two local drivers and set off on the
350-mile journey east to a small seasonal wetland
area, Hodh El Gharbi.

We stop off in one of the last major towns before our
destination and our two drivers head into the market
with Aidan to pick up fresh produce. Ralph, Tara,
Hemmo and I wait outside by the cars. As is quite
often the case in these small towns, a small group of
people gather to look at us and we start to chat. Tara
has spent a year or so in Mauritania by now and so
can make simple conversation in Arabic. Ralph and I
are only able to chat with those who can speak French.
Before too long they ask Tara where she is from and

she replies, 'Ireland.' Then they ask Hemmo and he replies, 'Germany.' They then turn to Ralph and me and we both reply, 'England.'

At that the attitude of the few people at the front of the crowd changes dramatically. There is sudden clear anger in their faces as one of them begins to fire questions at us in French.

'*Pourquoi voulez-vous envahir l'Irak? Pourquoi l'Angleterre déteste les Arabes? Pourquoi les Anglais détestent-ils l'Islam?*' – 'Why do you want to invade Iraq? Why do the English hate the Arabs? Why do the English hate Islam?'

They pass the words back through the crowd that we are English and we are with America against Iraq. People start shouting at us with venom and the crowd pushes forwards at Ralph and me, our backs against the car. The front men start to hit home their questions with fingers pointing against my chest.

What started out as typical town interest in visitors has suddenly escalated to hatred of the two Englishmen. I can see this situation turning more ugly very quickly. With my brain struggling to find the words in my French vocabulary, I start our defence.

'*Nous ne détestons pas les Arabes ou l'Islam. Les Anglais sont contre la guerre en Irak. Nous ne voulons pas faire la guerre*' – 'We do not hate the Arabs or Islam. The people of England are against the war in Iraq. We don't want to go to war.'

The front men in the crowd do not seem convinced and are still aggressively shouting.

I then muster the French words I'm trying to think of: '*Tony Blair est un branleur.*'

The man nearest me says, '*Quoi*?' – 'What?'

I repeat louder:'*Tony Blair est un branleur. Nous ne l'aimons pas*' – 'Tony Blair is a wanker. We don't like him.'

The man smiles and turns to the people to his side and tells them what I've said. They smile and pass on my comment back through the crowd. In an instant the crowd's attitude changes and men are reaching forward to shake our hands. Amazingly, those French words I shouldn't have been learning at school perhaps just saved Ralph and me from a lynching.

Aidan and the two drivers return with fruit and veg oblivious of what has just happened and we continue on our way, waved off by the now friendly crowd.*

16° 34' N 20 JANUARY 2003
10° 58' W Somewhere Near Bougari, Mauritania

It's quite extraordinary to find crocodiles in a sandy and rocky desert environment. This is one of the hottest and driest places on Earth. There is a rainy season here and what little water there is collects in small, shallow ponds and under rocky overhangs of the ephemeral rivers. This is where we find most of the crocodiles and filming them at night is exciting. Although these crocodiles are allegedly less aggressive and smaller than their river-dwelling cousins, they can still grow up to seven feet long and at that size will still give you a nasty nip! So, creeping around after dark with head torches and a camera, you have to have your wits about you.

* As a man who travels for my job, I was angered and saddened when the decision was made by the US and UK to invade Iraq in March 2003. I have seen first-hand the effects of war and would not wish this on anyone, regardless of colour, creed or race. Almost without exception people are friendly wherever I travel, but now, just by virtue of being an Englishman, our government's decision to go to war would affect people's attitude towards me when I visit certain countries.

As it's a presenter-led programme, Tara is often lying on her front peering under these overhangs to make it easier to get a sense of scale, place and drama. Squeezed under these gaps are good-sized crocs and they gape and hiss to show they aren't happy with us being there. We are, of course, not trying to provoke an attack, but considering how close we are working to these crocs they are remarkably calm and tolerant. Perhaps the fact that Mauritanian traditional peoples have lived alongside them for centuries, and have revered and protected them from harm, has made them more placid towards humans. The people believe that, just as water is essential to the crocodiles, so crocodiles are essential to water – and that if they were to disappear from this habitat, so would the water. There is logic in their thinking and has led to mutual respect here between humans and wildlife. I like that.

27 APRIL 2003

9° 50' S
45° 20' W

Green Wing Valley, Piaui, Brazil

Brains

Green Wing Valley, or Boa Vista as it is known locally, is about 20 miles from Gilbues in Piaui state, Brazil. It is home to Mauro and his family, who have owned the land for many generations. The valley is filled with verdant green cerrado forest framed by dramatic red sandstone cliffs. There's a plethora of wildlife but what I'm here to film is the habituated group of brown capuchin monkeys and some rather clever behaviour.

I travel to Sao Paulo with my camera kit and meet up with my good Argentine friend, Emilio. He's an

excellent naturalist and photographer but is also my lifeline as translator. From there we travel together to meet with Mauro and his family.

Until a few years ago, Mauro used to make his money as a poacher, collecting wild and rare species for the pet and collector's trade. Because of its steep sandstone cliffs, Green Wing Valley is ideal for nesting macaws, namely the blue and gold, red and green and red-bellied. Mauro would literally risk his life scaling these 200-foot-high crumbling cliffs, dangling on homemade ropes. He also risked fines and prison, as these species are protected. Eventually he learned that he didn't have to take those risks and could make more money showing tourists the wildlife in his back yard. One of the species he is particularly fond of is the brown capuchin and he treats them like extended family.

Over centuries the capuchins have evolved a unique skill. As one of their sources of food they collect golf-ball-sized palm nuts from the trees. They then tap them on the branch or with their fingers. From the sound they can tell whether there is milk or a nut inside. If they sense it has milk, they bite off the top of the nut and drink the milk like vodka from a shot glass, slamming the nut back on the branch to dislodge the flesh and then eating that too. If they sense it's a nut inside, then they strip off the green husk and discard the nut on the ground. The monkeys will return in a few days, by which time the stripped nuts have dried in the sun. Then they'll carry these dried nuts to the nearest anvil, which could be a hundred metres or so away. The anvils are usually blocks of sandstone that have fallen from the cliffs, from coffee-table-sized chunks up to rocks as big as a car. On nearly all of these anvils in this region is a round, well-worn pebble. The monkey takes the

nut and places it in a small depression on the sandstone, and then, holding the pebble aloft, slams it down and cracks the nut. Like the chimpanzees I've filmed displaying similar behaviour, these monkeys have varying degrees of skill. Some can crack the nut with one well-aimed hit, whereas others take multiple hits to break the shell. Once they've had success, they then break away the broken shell and eat the nut kernel inside.

The remarkable thing is that somehow they worked out how to do this. If you try to break the nut using a 'hammer' of sandstone, of which there are plenty lying about, the sandstone hammer just crumbles. At some point in history a capuchin must have used a pebble or stone from the river, which are of much harder flint, and the nut cracked. These capuchins over time have carried river stones, some of them half their own body weight, miles from the river to anvils all through the forest. The monkeys are disciplined too and often place the pebble back on the rock once they've finished using it.

Seeing and filming this whole process is like witnessing a condensed summary of our own evolution. Very distinct processes that make it clear how they might have arrived at each one. How much longer will it be before a capuchin knocks two of those flint river stones together to produce a spark of fire, just as our ancestors must have done 400,000 years ago.

9° 50′ S **4 MAY 2003**
45° 20′ W Green Wing Valley, Piaui, Brazil

At Mauro's house, Emilio and I each have a tent to stay in. One evening we are sitting at the table and, as it gets dark, I nip back to my tent to fetch my torch, which is by my bed. I unzip the tent and, as I walk in wearing my flip-flops, I hear the distinctive alarm chatter of foraging termites banging their heads on the underside of my groundsheet. I stop briefly to listen then walk forwards in darkness and grab my torch. Turning it on, I face it down to the ground to check if I can see the termites. Instead, to my horror, I see a small rattlesnake, coiled and rattling its tail. I must have placed my foot right next to it on my way into the tent. God knows how I wasn't bitten as my flip-flops wouldn't have offered any protection. Interestingly, though, the rattlesnake clearly doesn't want to bite me; it was just rattling its tail to say, 'Please don't tread on me.' Mauro comes in and carefully lifts the snake on a spade and walks it several hundred metres from the house to give it a safer home.

Emilio and I while away the evenings talking with Mauro and teaching his children a bit of English. I also teach them how to play chess. One by one over the course of the three weeks we are there, all five of his children are eventually able to beat me at the game. Even little Marco who is aged six! Time to go home.

12 SEPTEMBER 2005

5° 10' 29" N
115° 58' 59" E

Kalimantan, Borneo

Back to Borneo. It was once a wild island covered by forest but, even though when you look at satellite photos today it still looks green and healthy, on the ground I'm learning it's a very different story. Producer Lucy and I are here in central Kalimantan to document the plight of the orangutan for one programme of a three-part series on apes for the BBC. Having now filmed orangutans a number of times, I'm really quite taken by them and get progressively more sad as I discover how our actions as humans are wiping them off the planet.

Reduced to ashes

We are working closely with Danish wildlife conservationist Lone Droscher, who, with guidance, set up the Nyaru Menteng Orangutan Reintroduction Project. Similar in principle to the Orangutan Foundation care centre, the Nyaru Menteng Orangutan Reintroduction Project was originally set up to house 100 orphaned or homeless orangs. Now, it is the largest primate rescue centre in the world, with around 600 orangutans and 200 staff. They take in orphaned and homeless orangutans as their forests are taken over by man.

I don't know if you remember the problem of smog through South-east Asia in 1997? Hundreds of commercial flights had to be cancelled because of smoke from illegal forest and peat fires. In 1996 the Indonesian government decided to turn a million hectares of supposedly unproductive peat swamp forest into rice paddies. It was named the Mega Rice Project (MRP). Whether it was a good idea or just a corrupt one we will never know. What happened, though, was a disaster.

Between 1996 and 1998, over 4,000 kilometres of channels were dug through the swamps and deforestation started in earnest. All the good hardwood was floated out down these water channels and sold. Any timber that wasn't viable for sale was burnt in situ. The channels helped drain the area and lower the water table. This exposed the peat which then dried out and caught fire from the burning wood. Peat burns easily and slowly but produces lots of smoke. Before, the forest was under two metres of water in the rainy season; now, the peat was left high and dry and this vast area was just going to burn and burn. On top of that, the channels made it easy for illegal loggers and poachers to penetrate deep into the regrowing forest and do their worst.

The hardwood had been cashed in, the forest destroyed, the water drained. Although not optimum habitat for orangutans, thousands of them, along with a multitude of species, were killed, displaced and made homeless as a result of this failed project.

Seven years on, Lucy and I travel there to film. It is heartbreaking. It looks post-Armageddon. Barren. The ground mostly black with lines of white ash from fallen burnt trees. Smoking charcoal skeleton trees poke up into a grey, hazy sky.

Two hundred metres inside some remaining adjoining forest is a tall metal tower used to take various scientific measurements. I climb up it to take some shots. The tower pokes proud of the treetops and is surrounded by what looks like pristine forest. Just beyond that, though, is the most upsetting sight. A graveyard of skeleton trees stretches way off and out of sight. In fact, 50 miles beyond what I can see. Only then do I grasp the size of this disaster. I feel both angry and sad. Seeing this has the biggest impact on my views of conservation. What are we doing to this planet?

There is an even bigger ongoing problem and that is palm oil. It is in 50 per cent of all supermarket products and is a big cash crop for Indonesia. Sadly, to make space for palm oil plantations, rainforest gets cleared: 7 million hectares to date. And as our demand for palm oil increases, more forest is destroyed to make way for more plantations, leaving wild orangutans with nowhere to go.

We just have to change our habits, and soon.

12 JUNE 2009

1° 30' S
132° 30' E

Korowai Tribe, West Papua

Human Planet

When I was a lad, I remember going to the King's Road in London to see the boy racers whizzing up and down in their souped-up cars. Ford Escorts with wide wheels and bolted-on spoilers, cherry bomb exhausts and chrome pipe extensions. It was one way those lads could show off to their mates and catch the eye of certain girls. Deep in the jungles of West Papua, lads growing up don't have the trappings of Western society, or tarmac roads to display them on. Instead, they show off by doing what they know best: building treehouses. Treehouses on steroids, to be precise.

It has taken seven days to travel out to this isolated forest location. The last three days have been intrepid, involving a charter flight into a remote grass airstrip followed by two days heading up river, through stretches of shallow rapids, in long dugout canoes. We camped overnight and then were met by a few of the Korowai elders from the tribe we are visiting to film. They wanted to check us out before they led us on a six-hour

hike with porters back into the forest to their home.
Many tribes and families here have had their lives
changed dramatically by missionaries coming in and
preaching the word of God. Introducing this Western
concept has broken down a lifestyle that has worked
for centuries. These Korowai elders have seen how it
has ruined other tribes and have so far protected their
own from Westerners: most of the tribe we are going
to meet have seen no more than a handful of 'white
people'. Our aim is to document this disappearing
lifestyle for the new series *Human Planet*.

We arrive in a partial clearing pretty exhausted from
the walk, to be met by a mostly naked Korowai tribe.
We are so taken aback that we form a line and initially
just stare, the tribe doing the same back at us. They are
much shorter than us and the tallest man barely comes
up to my shoulder. In some ways they are not unlike the
Bayaka forest people of Congo. The youngest children
are completely naked and young boys wear simple waist
belts made from rattan and rolled-leaf penis sheaths.
The older women wear grass skirts and are otherwise
naked, some carrying woven string-like baskets – one
containing a baby cassowary. They also wear a variety of
necklaces made from cowries and pig's teeth. The men,
too, are naked but all wear penis sheaths of different
descriptions: rolled leaves, seedpods and even a hornbill's
beak. Many men have small netting 'man bags' in which
they carry their long, straight smoking pipes and local
tobacco. Some people have their noses pierced with small
shards of bone or pig ivory, and I notice many have small
blueish tattoo markings and scarification. It is fascinating
and captivating to see fellow human beings looking so
different from us. I am sure they are looking at us and
thinking the exact same thing.

After a few moments of shock at our differences,
smiles break out and we are greeted warmly with

handshakes. They had known of our visit, as our fixer, Jim, had been negotiating ahead of time, and had built us our own sleeping hut, eating hut and long-drop shelter.

13 JUNE 2009 1° 30′ S
Korowai Tribe, West Papua 132° 30′ E

After a surprisingly good sleep we head to the Korowai's current treehouse, where we need to explain exactly what we are here to do and why. They still haven't given us full permission to film them build a new treehouse until they are happy about our intentions and they feel they can trust us. Bear in mind that these are fiercely tribal people and will fight to the death over disagreement with neighbours or kill unwanted intruders.

One by one we all climb 25 feet up a single pole ladder with notches for rungs. It's quite precarious and the last step is a deliberate overhang to get onto this giant hut on stilts. This affords them some protection should an intruder try to climb up.

The hut is built using natural resources from the forest and has palm leaf walls and roof. It's around 30 feet long and 15 feet wide and there is a small fire smouldering on a round pad of mud that acts as a hearth. Down the middle of the hut is an invisible line: men sit on one side, women on the other. So producer Tom, anthropologist and translator James and I sit with the men to discuss. Tree climber and assistant James hovers in the background with the behind-the-scenes camera. Rachel, the researcher, sits with the women.

While we are talking via translator with the Korowai men and elders about why we want to film and where

the pictures will be shown, Rachel chats with the women with no common language. We can't help noticing the body language 'conversation' that's going on: the Korowai women are fascinated by Rachel's hair and clothing while she shows interest in their tooth and cowrie necklaces. Then the Korowai's fascination turns to Rachel's breasts: why were they not down by her waist like theirs? They start to unbutton her shirt to see. This is becoming a very distracting sideshow to our important meeting. Once they have Rachel's shirt off, they can see the secret: the Gossard Superboost bra, and are intrigued by its design – how the straps come over her shoulder and the cups support her breasts. The women start mimicking the bra by cupping their own breasts. The next thing to happen is the women remove Rachel's bra and begin fondling and admiring her breasts. It seems such a perfectly natural conversation – but not necessarily by Western standards and certainly not with blokes around. When two of the men have to leave the tree platform there is laughter among the others.

Without knowing it, though, Rachel has revealed more than just her breasts – she has shown trust in the women and broken down a cultural barrier. I truly believe, along with our talk with the elders, that this helped them decide that we were okay as a team and was why they agreed to let us film.

I have full admiration for how Rachel handled the whole situation and wonder how I would have reacted if the men had stripped me off and tried to make me wear a penis sheath.

14 JUNE 2009 1° 30' S
Korowai Tribe, West Papua 132° 30' E

Having scouted the nearby forest, the Korowai show us *The big build*
the chosen tree. It is a monster, towering 140 feet up
and poking itself out from the rest of the canopy. The
whole tribe sets about work to the accompaniment of
song. Undergrowth is cleared and burnt on small fires,
saplings felled by the women, who clean the stems and
deliver them as building supplies to the men. Rattan is
stripped and prepared into 'ropes' for tying the wooden
construction together.

By lunchtime the men have already built a firm but
rickety-looking ladder that reaches up 30 feet. Assistant
James, meanwhile, has rigged two climbing ropes up
into an adjacent tree. These are for me to climb on
so I can film level with the men as they build higher
and higher.

The most amazing thing for me is seeing the men and
women still using stone axes. Perhaps wrongly, we had
brought gifts of steel axes for the tribe, and although
the men are grateful they quickly switch back to their
stone ones and make short work of even the broadest
of trees. Each time a tree is felled it is accompanied
by whoops and shouts from the whole tribe: I suppose
the Korowai version of 'Timbeeeeer'.

By the end of the day the ladder of sticks is 60 feet
up. As the light starts to fade we head back to camp
for dinner.

The Korowai are fascinated by all our Western trap-
pings and love seeing the footage played back on our
small monitor. Although very few of these people
know what a TV is, they totally get the concept and
are unfazed.

We sleep in our purpose-built hut on a wooden
rack of sticks two feet off the ground. Each of us has

a mosquito net and I diligently tuck mine in all round for peace of mind from scorpions, spiders, millipedes and snakes.

I am woken in the night by a loud snorer. There is no way I can sleep through it and in the dark I can't see who the culprit is. So I get up, shielding my torch, and wander across to where the snore is coming from. It seems to be coming from Rachel's bed. How on earth can she generate such an outrageous sound? I very carefully raise a pinprick of light onto her face, only to see it definitely isn't her snoring. I then look under her bed rack and there, fast asleep, is the culprit. A bloody great pig. These pigs are raised as pets and as piglets they are carried everywhere. Once they are older and too big to carry up in the trees they have to fend for themselves, but still hang around like pets. This pig is clearly enjoying a bit of company by sharing our hut with us.

I dig out some earplugs from my case and fall back to sleep.

1° 30' S **16 JUNE 2009**
132° 30' E Korowai Tribe, West Papua

The building of the treehouse has raced ahead. The Korowai have started on the platform base, 110 feet up.

Today I have my first go on the ropes alongside the builders in their tree. I weigh around 80kg and the heaviest Korowai man probably 50kg max. I'm a giant compared to their slight build and I sense they have worries about me climbing. They have never seen ropes and harnesses before and take an interest, watching James deftly whizzing up and down the trees on them. But as nylon is not a familiar material to them, I don't think they fully trust it or me on it.

I am filming about 45 feet up, shooting details of them tying the rattan, hauling up more cut branches and so on. At one point I go to readjust my position and my foot slips off the rung. In a split second four hands are on me to steady me. Clearly, the guys have stayed close to me and are watching my back. I am really touched by the fact that they were worried about me. I suppose they do the same for each other, as they don't have any form of safety gear other than a penis sheath, and that isn't going to save you in a 50-foot fall.

I thank them and then, to reassure them I am safe, I jump off the ladder and swing on the ropes. They initially look horrified, but then they see that the climbing ropes are very strong and will save me if I fall. After that they are less worried about the clumsy giant on their construction site.

22 JUNE 2009
Korowai Tribe, West Papua

1° 30' S
32° 30' E

Death in the toilet

James comes to tell me there's a dead pig in the toilet so I rush to see. It isn't 'in' the toilet but in the hut where the toilet is. I can't see how or why it's died.

25 JUNE 2009
Korowai Tribe, West Papua

1° 30' S
132° 30' E

Moving in

By now we have a good rapport with the men and, despite the language barrier, there is a lot of joking and mucking about. One of the men spins round at one point to show us he has decorated his penis with a bromeliad taken from the crook of a tree.

Today, big strips of bark are laid as floorboards and more used for wall panels. The roof is finished off and made waterproof with sago palm leaves. They've completed the treehouse in just 11 days. The whole tribe climbs up to check it out, taking with them babies, children, dogs and a pig. Men go up the ladder first, followed by the women, remarking that it's so they don't see up their skirts. The Korowai also have etiquette and manners.

There is a kind of party atmosphere 110 feet up as they light a fire using a fresh pad of wet mud from the forest floor. They cook sago palm and smoke their pipes. The younger men show their confidence by climbing right out on the ends of the branches. The views are spectacular, with nothing but trees to the horizon – not a single sign of other humans on the planet, not even a vapour trail from aircraft. Everyone seems happy and they are proud of their new skyscraper. Our filming story is complete.

Back on the ground at our camp the tribe has arranged a final feast for us. Earlier this morning they dug a fire pit, lined it with stones and lit a fire in it. After several hours they dug out the fire and lifted out the stones, lined the pit with broad banana-type leaves and put in a dissected pig. (Yes, I think it's the one from the toilet.) They covered the pig with more leaves (it's sounding like a cookery programme now) and then covered those with the hot stones. It was then left to cook for hours. Now they remove the leaves and take the cooked pieces of pork and barbecue them on open coals. I probably would have cooked mine a bit longer, but the meat drips with fat and is delicious. It is a grand send-off as I don't think they eat meat like this very often.*

* Not wanting to sound wimpish, I did get myself some worming tablets on my return home.

26 JUNE 2009
Korowai Tribe, West Papua

1° 30' S
132° 30' E

Time to pack up and say goodbye and I am actually quite sad to be leaving. These people welcomed us into their domain and looked after us well. There's a lot to be said for a simpler lifestyle without all our Western trappings, though I think it is really tough living as the Korowai do and their lifespan is nowhere near as long as ours.

Heading back to so-called civilisation

Talking with them over the last few days, the elders reveal why they've allowed us to film. Their culture and forest is being destroyed by logging. The teenage boys want money and so leave the tribe to go and work for the logging companies. The money is then mostly spent on cigarettes and alcohol. The elders recognise that when the trees are gone, the income will stop and there will also be no forest to live in. They felt that if they let us come and film then the world might learn about them as people. The elders don't understand about television but they say they know it is powerful. Something needs to be done to stop the destruction of forest.

The six-hour walk out of the forest and two-day ride downriver make the Korowai seem remote and untouchable. When we fly out from the grass airstrip it takes only 15 minutes over pristine forest until I see the first gravel roads, then the shiny tin roofs and then the tarmac runway of a new town. It makes me very sad. I can see what the elders were talking about. This new logging town is less than 25 miles from the Korowai tribe's forest home. Those logging roads, cut at right angles, will spread like a fast-growing cancer. It is only a matter of a few years before the Korowai will hear chainsaws from their lofty treehouses and soon after that they will be homeless.

0° 60' N **APRIL 2010**
0° 60' E
Barneo Camp, Arctic Circle

Frozen Planet During the Cold War the Americans spent more than
a billion dollars on a Ballistic Missile Early Warning
System consisting of multiple radar listening stations.
This would give 15 to 25 minutes' notice of a missile
attack from the USSR. The Soviet Union deployed a
different method: they put small groups of troops in
about 100 camps spread across the Arctic ice to just
listen. If they were to hear a missile fly overhead then
they'd radio Moscow and tell them. When the Cold
War ended, one team of troops put these ice survival
skills to an alternative use and set up an annual tourist
camp called Barneo Camp.

Every year, as winter ends, these hardy Russians
now fly planes north towards the pole and do fuel
drops. Then two helicopters start to leapfrog their
way from fuel drop to fuel drop, aiming to get about
60 miles from the North Pole. Once there they set
up a camp. Then the plane returns and drops a bull-
dozer by parachute onto the ice (occasionally these
fall through) for the men to make an ice runway. The
plane can then return and land with more supplies
and bring tourists in and out. From here people can
choose to walk, ski, helicopter or dog-sled the last 60
miles to the North Pole.

The opening to *Frozen Planet* is to be introduced
by Sir David Attenborough at the North Pole. A
team of us travel to Barneo Camp with him. Myself,
David, Alastair (executive producer), Vanessa (series
producer), Chris (sound) and Jason (Arctic specialist).

We take off from Longyearbyen, Spitsbergen,* and fly north in a high-winged Soviet Antonov jet, which itself seems a relic of the Cold War. Two hours later we land in the middle of the Arctic on the prepared ice runway. I love the low-tech black plastic bags filled with snow used to mark the edges of this ice landing strip.

Our kit and other supplies are unloaded while the plane's jet engines stay idle, presumably so they don't freeze up. Then the plane taxies to the end of the line of black snow-filled bags, the engines roar and off it goes, back to Longyearbyen. We are now left in eerie silence but for the sound of the blowing wind. Apart from the camp, a bulldozer and two parked 1960s Russian-designed Mil Mi-8 helicopters, there is nothing. We are surrounded by a flat frozen white landscape. It feels desolate and remote.

The camp is surprisingly comfortable considering where we are. It consists of a scattering of heated insulated tents and an outside Portaloo-style toilet. The Russians clearly have a sense of humour too as there is an area with a square cut out of the ice signposted 'место для стирки' – Place for the Washing. Also with us in camp is a team who are aiming to ski the last leg to the North Pole and a bunch of marathon runners who are going to set a record running the northernmost marathon (madness). The six of us share a tent while we wait for a weather window to make the last helicopter hop to the pole for the sync pieces. We lie on our beds and pass the time mostly with storytelling and jokes. Lying there, it always feels like we are moving slightly. I have a GPS app on my iPhone so turn it on to get our exact location. It gives me a readout but tells me we are travelling at three knots. I show it to the others and we

* An island of the Norwegian Svalbard archipelago.

suspect GPS inaccuracy because we are so close to the North Pole. I go and speak to Igor at the information desk and he confirms that we are actually moving. The camp is on sea ice in the Arctic Ocean and beneath us the water is 7,000 feet deep. We are literally drifting on the ocean current. Igor goes on to explain that this is a problem if you are walking to the North Pole – you can go to bed with only 60 miles to go, but you can wake up having drifted 20 miles further away. But he adds, 'With helicopter – no problem.'

After two days cooped up in our tent and fast running out of stories, our weather window arrives. The helicopter team starts to prepare the Mi8 for flight. They fire up heaters and blast hot air into the engines and gearbox for three hours to basically thaw it all out. We load up into the belly of this beast and take off to find the North Pole. Although there are only six of us, the helicopter can carry 20 plus cargo. We sit on simple bench seats down either side, with my camera kit on the floor at the back. The only other item is a spare black rubber tyre with red tape wrapped round it. I ask what it's for and the engineer explains. It turns out it's another genius bit of Russian low-tech kit. It is very difficult for the pilot to judge height when everything outside is white, so when they want to land they bring the helicopter to a hover, open the sliding side door and throw out the tyre. Firstly, if it disappears then they know the ice is too thin to land on. If it doesn't disappear then the pilot has a visual reference to gauge his height and position; he can keep it in sight and bring the helicopter in to land. On touching down, the pilot doesn't put the full weight of the helicopter onto the ice; the engineer jumps out and watches for cracks in the ice as the pilot lets the machine go heavy. If all good, then they can land

fully, remembering to put the 'landing tyre' back in the helicopter for the next time.

It used to be that the Arctic Ocean around the pole was one thick sheet of pack ice. The ice would accumulate year on year and average 3–4 metres thick with ridges up to 20 metres thick. But now the Earth has warmed, I see first-hand that this is no longer the case. Our journey north is mostly over ice but here and there are large areas of open water, blue ocean poking through. This is the start of the decline. Igor had told me back at camp that out of nine attempts by groups to get to the pole this year only seven had made it; the others had to turn back because of open water.

It turns out that finding the exact position of the North Pole is quite tricky. I had my iPhone GPS app on and, although the pilot can find the absolute zero on latitude 90 degrees N, the longitude flicks wildly all over the shop because when you're at the pole you can travel from east to west in just one pace. We touch down within 30 metres of the North Pole and set up as close to spot-on as we can. Chances are that because we are drifting on the ocean current we may well be a few hundred metres out by the time David delivers his sync piece.

'*I'm standing at the North Pole. The very top of the Earth. Up here, it's easy to see why the polar regions are so cold. The sun never rises high enough in the sky to warm my back. And those rays that do strike the surface are mostly reflected back by this great whiteness. But the fundamental problem is that there is no sun here at all for half the year.*' The filming goes well and we all feel on top of the world – literally.

Once back in camp the wind starts to strengthen a bit and we hope the plane is able to make it in to pick us up. By now we are definitely out of new jokes and stories. While waiting, I wander outside to stretch my legs. Just outside our tent is an inch-wide crack in the

ice. I run my finger in it to brush away the loose snow and it looks quite deep. I follow the crack over to the runway, where it travels halfway across before turning 90 degrees straight up the middle. Again, I run my finger in it to clear the snow and it still looks deep.

I head in to see Igor at the information desk and tell him about the crack. He wanders out with me and doesn't look too concerned but gets a second opinion. Five minutes later, four men return with an ice auger* and start to drill a hole in the ice. I watch with interest to see how thick the ice is: having seen a 30-tonne jet land on it I assume it is maybe eight feet thick. With the Russians all puffing away on cigarettes as they drill, I think to myself that I'll be here for a while, but within 30 seconds they are through. Seawater comes surging up as they turn the auger, and when they pull the bit back out it is clear the ice is only just over three feet thick. Apart from a few raised eyebrows and a couple of shoulder shrugs the team don't seem too worried.

Hours later, the plane arrives and I film as it touches down. Thankfully, it is quite a boring shot. Our kit is loaded up and we all climb on board. We take off without incident and fly two hours back south to Longyearbyen.

Once back on terra firma we hear that shortly after we left, the inch-wide crack opened up to about 20 feet right down the length of the runway and then at right angles, cutting the camp in two. The remaining tourists apparently got in a right panic and demanded to be flown out. The Russian camp staff calmly dealt with the crisis by floating everyone to the helicopter side of the crack on a giant ice raft. They then moved the mess tent and toilet across too by the same method and set about bulldozing a new runway. 'без проблем' – no problem.

* A giant corkscrew-like drill bit usually used for making fishing holes in the ice.

I wonder if they have also moved the 'место для стирки' – Place for the Washing – sign to this newly opened-up stretch of ocean.

30 AUGUST 2017

50° 35' N
127° 3' W

Vancouver Island, Canada

Today I am quite excited as I'm tasked with filming orca, the largest of the dolphin family, in the wild, travelling and hunting free in the waters around Vancouver Island, for a new Netflix wildlife series. I am filming from a helicopter and nowadays the rules about how close we can legally fly are, quite rightly, strictly enforced. To protect the orca from disturbance we aren't allowed to approach within 1,000 feet of any individual whale. There are also now strict rules if you are whale-watching from boats – you cannot approach within 100 metres.

As we are only interested in filming natural behaviour, even the 1,000-foot limit sometimes is not enough if we are upwind or directly above the orca. Their behaviour can change if they hear, sense or feel the sound of the helicopter engine or chop of the rotor blades, so we are all very conscious of our position and approach, even if it means compromising on the lighting angle. To make the filming possible at these distances, I am using a Cineflex: a gyro-stabilised camera system with a very long-range zoom lens, mounted off the nose of the helicopter. I operate and monitor the pictures by remote control from the back seat and have a headset to talk to the pilot and assistant producer, Lis.

The west coast of Vancouver Island is pounded by the swells of the Pacific Ocean. I am familiar with its power, having witnessed the storm that hit Triangle Island to the north when I was there in 2007. The orca seem to favour travelling and hunting in the more sheltered waters on the east side of Vancouver Island, where they are thankfully easier to spot and follow. Here, the interior is mountainous and divided by a network of fjords, inlets and rivers that divide the land into thousands of islands. Even when travelling by helicopter, when sizes and distances are deceptive, the area appears huge. The rugged steep slopes, forested with conifers, predominantly western red cedar, Douglas fir and sitka spruce, come down to meet the water on jagged rocky shores. Without the direct ocean swell, the surface of the inlet waters often has a calm sheen, which makes it much easier to spot any large mammals swimming. Each time the animals surface to breathe, their dorsal fins cut the water and cause a subtle V-shaped wake on the surface, giving away their position. When the orca are cruising with purpose there is a rhythm to their breathing pattern. They take three or four breaths on the move and then swim underwater for around three minutes. From the air you can kind of 'join the dots' of their ripples and predict where they will next surface to breathe.

This story is to illustrate the abundance of life on the west coast of North America and how it's all fed from the ocean. The rich waters allow plankton to grow and this in turn feeds huge fish stocks, mostly herring and salmon. These fish are then food for larger species such as seals and sea lions – which in turn feed whales and orca. It is now also known that the bird life, such as the American bald eagle, feeding on fish and then dumping fish carcasses and defecating on the land, contribute hugely to the fertility of the forests.

Where possible, we are trying to fly above the land, rather than above water, shooting through the tree-tops – which means the downward shock wave from the rotors doesn't translate into the water and scare or upset the animal we are trying to film. It's also nicer to be lower, as there's more chance of seeing the impressive orca dorsal fins in profile when they break the surface.

As we cruise over the forest, the harsh noise of the helicopter filling the space around me, I see a pod of seven orca on the move through the inlets. When they start to ascend to breathe, it's the white elliptical 'eyespot' marking just above their eye that you see first. Then I can make out their dark bodies distorted by the water. As the orca surface, in a swift-flowing rhythm, they exhale and blow a spray of white mist up about ten feet in the air; it hangs there briefly as the back and dorsal fin ride up to follow as they breathe in before descending again below the waves. At the moment their bodies arc out of the water, I see the sunlight reflect and glisten on their shiny backs. I feel happy. To see these animals swimming freely in their domain, where they belong.

Forty-six years ago I had stood outside Boots the chemist on Cheltenham High Street, looking through the developed photos of the first pictures I had ever taken. One of them was of an orca. At the time I had taken it, it was so exciting to see that huge animal up close. To see it fully out of the water jumping to hit a beach ball suspended above the pool. I was just one of the people in the audience watching wide-eyed and in awe, my finger on the button of my Box Brownie camera. Much has changed since then, not least our understanding and knowledge about 'killer whales', as they were commonly known. I know now that it was

actually a very sad situation to see such a beautiful, intelligent, social animal confined to such a small pool. Imprisoned.

I am sure that my first sighting all those years ago in Dudley Zoo must have played some part in inspiring me to follow this career path and have an affinity for animals. But there is no excuse nowadays for keeping them in captivity and certainly not for the entertainment of humans. With modern filming technology and 4K TV screens, at least now we have a way of showing people around the world the beauty of these animals in the wild. We are able to see better detail with our cameras than you ever could with the naked eye. That doesn't mean, however, that people shouldn't have the opportunity to go and see animals for themselves, and today's regulations mean that we can do it with minimum disturbance. To see orca now in their natural habitat, roaming free in their family groups in the wild, is a joy.

Flying around the island, man's influence on the planet is very evident and visible. The hillsides and mountain slopes are scarred by forestry – in contrast to the apparently pristine waters, although we know these are polluted too. Huge swathes of trees cut down, harvested, to be taken out on logging roads cut into the now bare hillsides. Canada has an international reputation as a trusted source of legally and sustainably obtained wood, but it is still very sad to see such widespread destruction.

The world's population has doubled in my lifetime and is expected to peak at 10 billion people in the next 50 years. We are getting better at least at talking about protecting habitats and wildlife, and there are many governments and organisations that are implementing change for good.

Some 1,000 feet below me, the orca dive and disappear. I reflect on seeing these orca in the wild and think how attitudes and legislation have changed, just in my lifetime – not just for the orca, but for all species we share this planet with.

There is hope.

ACKNOWLEDGEMENTS

By rights this section of the book should be the longest; I certainly didn't get to this point in my life without the support of family, friends and work colleagues. I am grateful to everyone who has helped me and who I have made friends with along the way. The mentions below are by no means exhaustive.

Thank you to my wife Maggie, who is the real star of the show, with more patience and bravery than I may ever appear to have.

To my mother, who raised me and my sister with love, taught me manners, please and thank yous. Thank you for those early days taking us exploring in Hampshire, and for camping holidays in Dorset and France – all set the seed for adventure. To my stepfather Peter who encouraged my photography and taught me practical skills through my teenage years.

To my son Harry who collated all my journals and schedules from my career and steered my early scribblings into something readable.

To my son Thomas, long-suffering and favourite camera assistant and business partner with way better judgement than me.

To my sister George, journalist and writer. Sibling rivalry has most certainly spurred me to finish this book and I wish you luck with yours.

Admiration and gratitude to Sir David Attenborough, the best travel companion and friend you could wish for. Thank you for years of inspiration and encouragement, and for kindly offering to write the foreword for this book.

Emily Barrett and Orion Publishing for approaching me to write – I never would have done it on my own.

To all those who've helped carry the bags and reminded me to take the lens cap off. In particular,

Matt Thompson, James Aldred, Ralph Bower, Robbie Garbutt, Katie Mayhew.

To Sean Morris and all at OSF Long Hanborough: my first break in TV.

To John Downer who saved me from bankruptcy.

To Brian Leith for the wildest Congo adventures.

To Erin for the delightful illustrations.

To some no longer with us but who helped put my feet on the ladder: Gerald and David Thompson, Ramon Burrows, Alan Hayward, Brian Armstrong, Dave Evans, Phil Moss.

Thank you to everyone not mentioned who has helped and guided me along the way: researchers, drivers, production coordinators, producers, fixers – the list is endless really.

If reading this book has made you want to do something to help our fragile natural world, please consider supporting the Borneo Nature Foundation, the wildlife charity for which I am a patron: www.borneonaturefoundation.org/en/